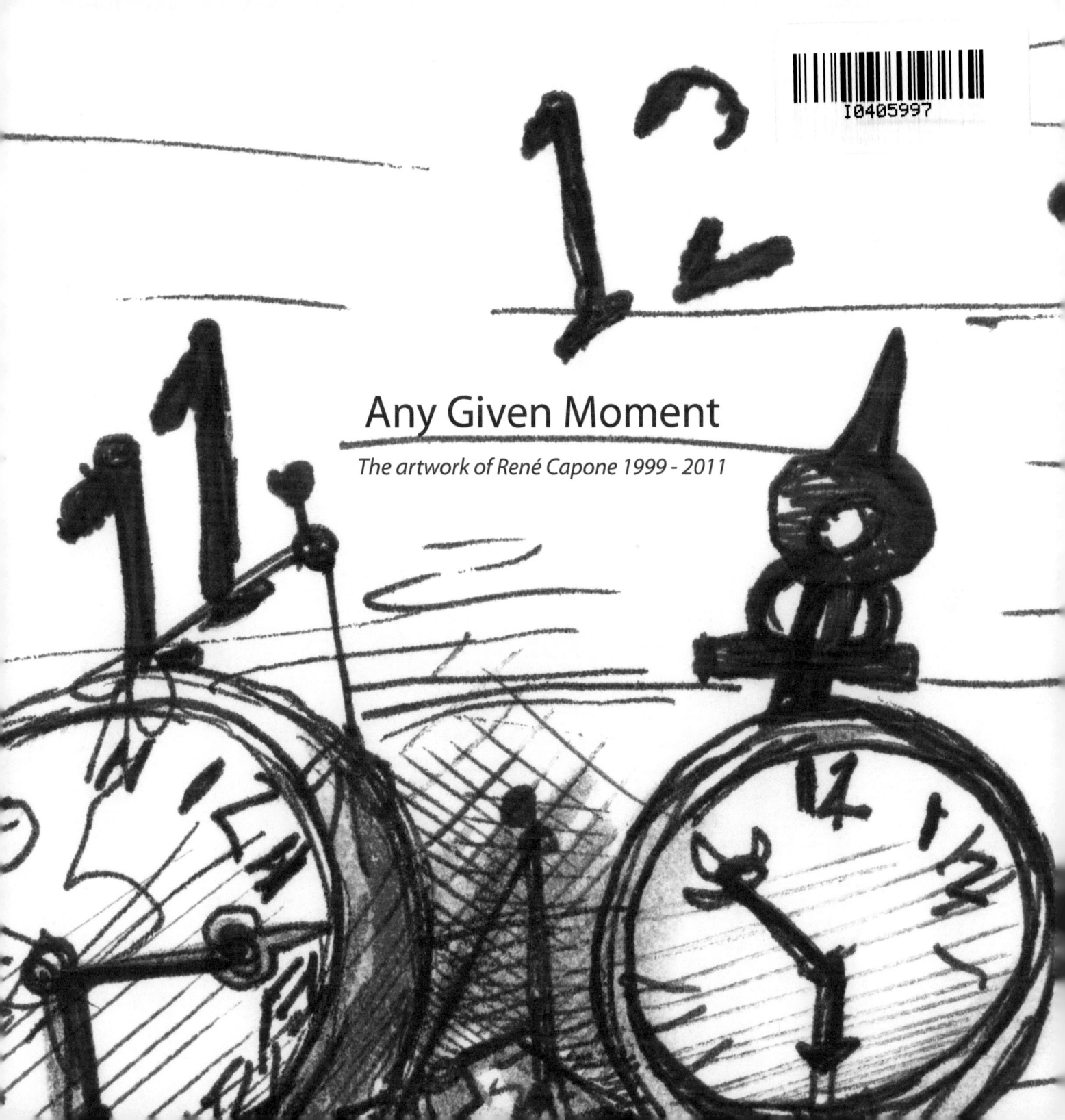

Copyright © 2011 René Capone

All rights reserved.

ISBN-13: 978-0615559438

ISBN-10: 0615559433

FORWARD

Presented here are selections from the paintings and drawings that have defined my life for a little over a decade. This work has found its way into other peoples' homes and lives, and for that I am eternally grateful.

For as long as I can remember, the images I have made have taken on a life of their own when it came to finding an audience. It is this relationship between my artwork and audience that has many times brought me out of personal darkness.

In most cases I am an advocate for the artist speaking for himself. However there is one man who summed up my artwork better than any phrase that I could conjure on my own. Adam Sandel, a journalist, screenwriter and instructor of mythology and folklore, had this to say in San Francisco's Bay Area Reporter:

Rene Capone's art conveys a sense of wonder, exploration and discovery. Set against a fantastical world of mythical dreamscapes, the figures in his work appear to be on a deeply personal quest for identity and their place in the world.

Capone brings a sense of visual storytelling to his work, which is rich in enigmatic symbolism and narrative detail.

With an evocative blend of childhood wonder and eroticism, Capone explores what he calls, 'the physiology of make believe,' creating mythic images and scenes that are mysterious, surreal and psychologically compelling.

In this richly imagined world of innocence, beauty, danger, and fear, Capone's images reveal a courage and vulnerability that is universal.

Adam Sandel was right; the figures in my artwork are on a mythic quest to find their place in the world. Luckily for me, many people have been willing to join me on that quest.

This book is dedicated to the people who have shown, and continue to show, interest in my artwork. Thank you from the bottom of my heart.

I also dedicate this book to anyone who has ever had one too many bad days. The world – and your life -- is yours … so change it!

Rene Capone - Artist Profile By Alan Bennett Ilagan

There is something slightly jarring about meeting Rene Capone for the first time. Like most artists whose work spills over with passion, pain, and moody evocation, you can't help but have a tiny expectation that the person will somehow be the physical embodiment of such emotion – a tortured, brooding, dark visage cloaked in furrowed brows and mumbling some incoherent statements of genius. Mr. Capone is instead a small, slightly waif like wisp of a creature, with a ready smile and sparkling, animated eyes – thoughtful behind delicately-framed glasses.

Dressed in a simple T-shirt and low-cut jeans, he sets a casual scene in his home, which doubles as a studio. On a side street in SoMa, the room is filled with early afternoon light. The beginning stages of sketches rest on a low table. Framed work hangs on the walls, ready for an exhibition. It is an ideal location, with the vibrant SoMa scene just down the street, providing the perfect backdrop for an artist like Capone, and it's a long way from his origins in upstate New York.

"Being a young child in New York state was a nightmare. But in high school I learned to be me no matter what. I came out in high school in a small town, so I took a stance and stuck to it. I was that rebel fag that goes around wearing way too much eye make-up. I gave up the eye make-up but I'm still a problem child at heart."

Finding San Francisco was like coming home. SoMa is its own living, breathing work of art – the streets, bars, and clubs have maintained their cool cachet in spite of growing gentrification. "It's surprisingly quiet, but if you're looking for noise you can certainly find it," Capone maintains. "The best bars and clubs are in the Soma district. Living in San Francisco is very inspiring because it is a place where people are sort of given a license to do and be whomever they want. I love interesting people so that gives me a lot of inspiration."

San Francisco ~ with its chaotic cast of characters and their wonderfully wacky stories ~ has long been a haven for creative types. The city and its moods are as variable as the fog, and its colorful history and ongoing development provide a fitting canvas for artists of all sorts. Capone's method is a natural, unforced one. "It starts with an idea," he begins. "Then I start looking for imagery and slowly start developing the paintings in my head. Then I make sketches, and lastly I start the painting. Most of the work happens in my head before it physically happens."

In the studio where he works, there is stillness and quiet – both evoking a sense of peace and contemplation – a moment ripe for pause and reflection on his working process, and all that has gone into where he is today. This year marks a milestone in Capone's life journey. "Roughly ten years ago I sold my first painting," he says. "It was a big deal back then, and it still is now. The idea that my artwork holds up enough merit to be included in other peoples' lives, other than my own, is very important and special to me."

In the past decade, Capone has grown as an artist and a man, and in that evolution is a deeper understanding of how his art fits into the world, and what that means. He is thoughtful when discussing his take on the value of art in today's world. "I learned that stories and imagery are the most important thing that we as people have to give to each other and those after us."

His latest exhibit is a switch from previous projects, featuring a main character – Hedgehog Boy – who explores the realm of fantasy, of the nether region between the sane and the insane – the time when a person delves into his darker thoughts, abandoning reason and convention, and stepping off the precipice of what's normal. Like his artistic protagonist, Capone also goes further than he has in any of his previous work.

"The show is a big turning point for me as I've never made a character and focused so much on him before," he explains. "There will also be a few paintings that are not of Hedgehog boy, but they are similar in tone, so I think they belong. It's the story of an outsider, who goes even farther outside by slipping into insanity, a rather fun and sexy insanity, but still fucking nuts. I've always been fascinated by the idea that one could get lost within his own mind. Hedgehog boy is what happens when one falls too deep within himself."

These are heady themes, and Capone's work deftly conveys the drama at hand. The pieces for his Hedgehog series are vibrant, bold, searing – utilizing rich pigments and in-your-face bursts of color and rough strokes. Magentas, deep blues, and traces of blood red punctuate the color scheme – entire backgrounds are soaked in hot fuchsia and red-tinged violets, while indigo and dark cobalt add a cooling, grounding base.

In a candid confession, Capone reveals that his use of bold colors is not merely out of preference, but necessity: "The truth is I'm a little color-blind and I use rich deep colors because I see them better. I have a lot of trouble with telling color apart and in some cases seeing something that is not even accurate, so I try to use colors vivid enough so I can know what I'm doing."

Though it's hard to believe that someone who is color-blind can utilize color so masterfully, it also goes a way in explaining some of his more daring choices. Even so, as much as his use of color charges head-first into the viewer's sight, there is distance too. In many of his pieces, the gaze of the subject is away from the viewer, lending both an intimacy and a sense of distance. When someone's looking away, it's easier to study and watch them – and Capone deftly draws the viewer in accordingly. It's an exhilarating juxtaposition, giving his work an unstable tension and drama.

The idea of contrast is a constant in Capone's work, and parallels the disparity of the diminutive young man and his powerful strokes of confident color.

"All the pieces in the show deal with dual identity and conflict of one's character…and how people deal with trauma. Hedgehog boy is actually a very complicated character in what appears to be a simple story, and it's far from original, but that's the point. I want to tell the story of someone who escapes from reality, completely unaware from the context that he is gay."

Whereas the Hedgehog Boy pieces reveal what happens when a person pushes the edge and breaks the boundaries, Capone finds stability in executing his artistic vision, and a cathartic element through his painting. He admits, "If I ignore my artwork, I notice everything I hold in balance starts to get shaky. I think I would be consumed by my own thoughts if I did not paint."

That sort of destructive consumption is realized in his Hedgehog Boy character, and it's that destruction which Capone keeps so brilliantly at bay through his art. For the moment, Capone is focused on the here and now.

"I can't think too much about the future imagery because my focus is on my current work. I always think that if I make the paintings the rest will follow, and it always does."

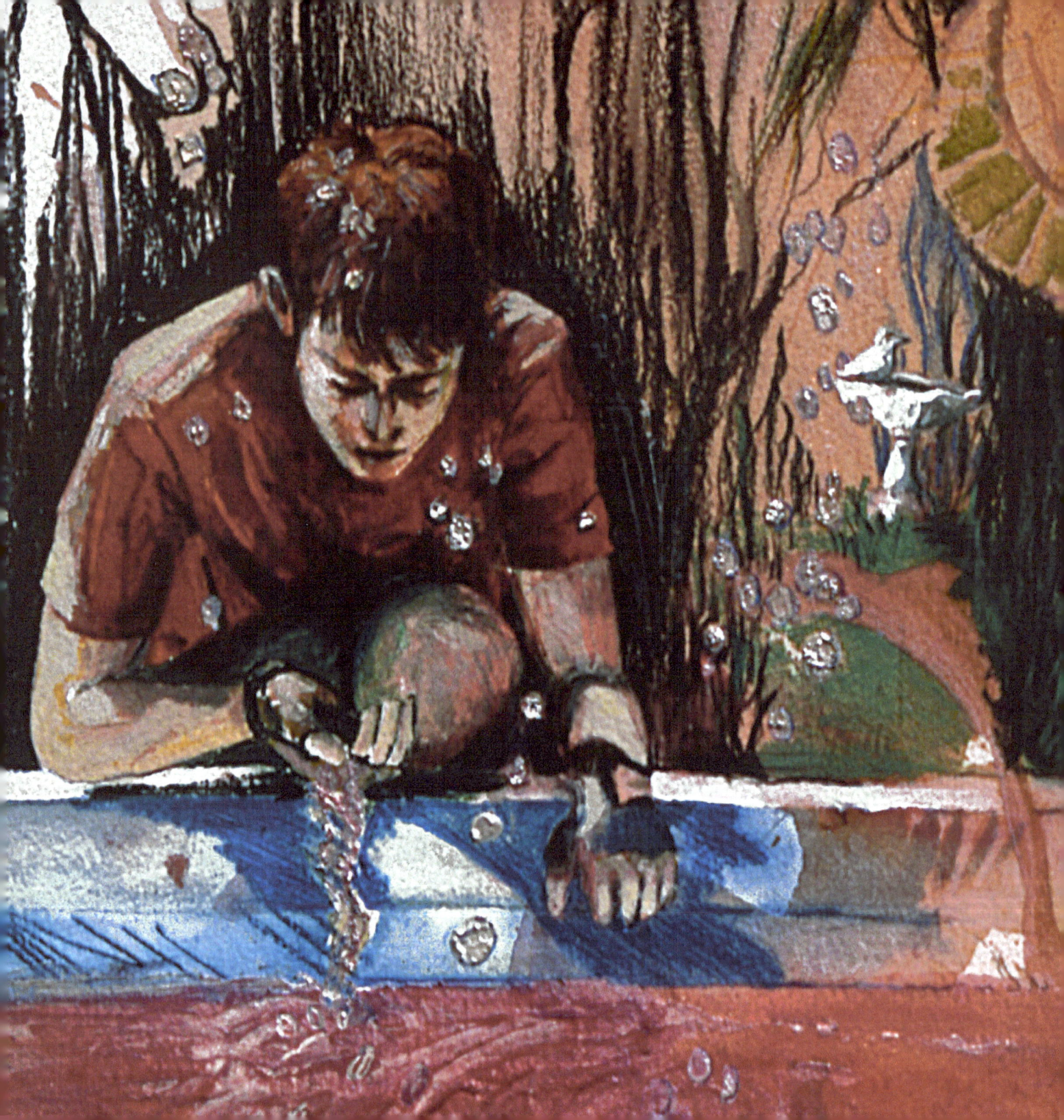

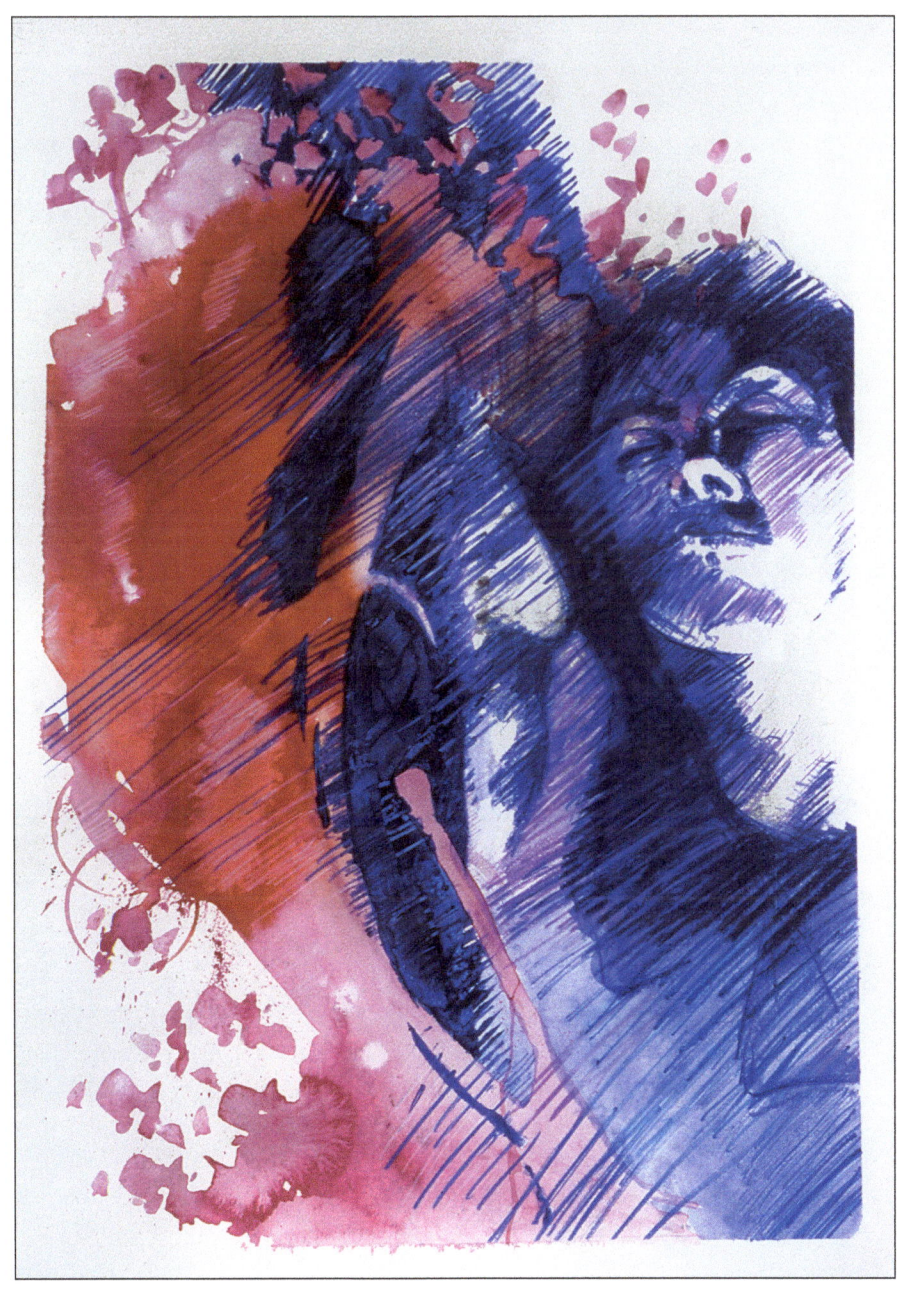

"I Dreamed About You Loving Me", watercolor, 22"x30", 2000

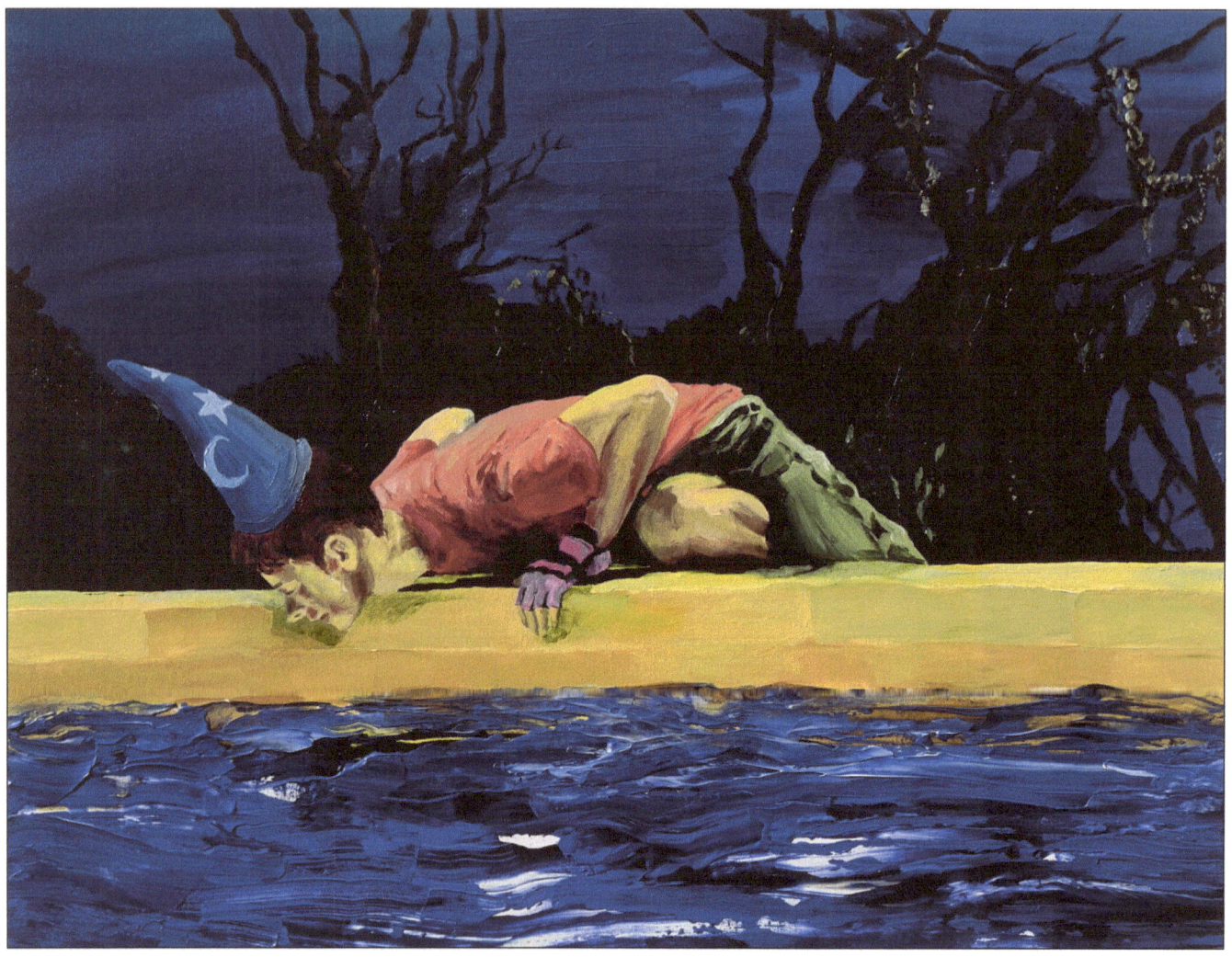

"If You Believe In Magic", acrylic, 36"x42", 2000

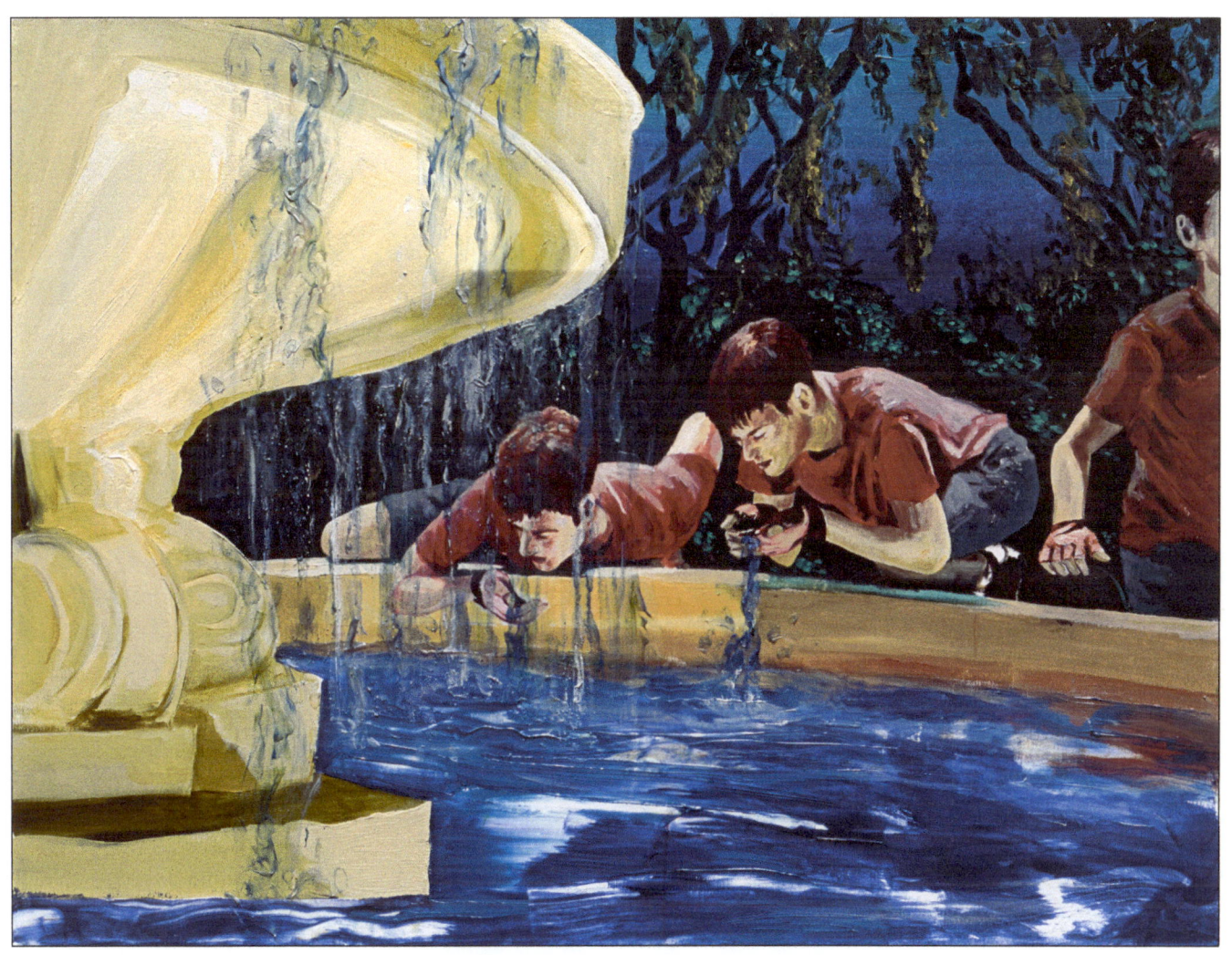

"Any Given Moment", acrylic, 36"x42", 2000

René Capone Artwork 1999 - 2011

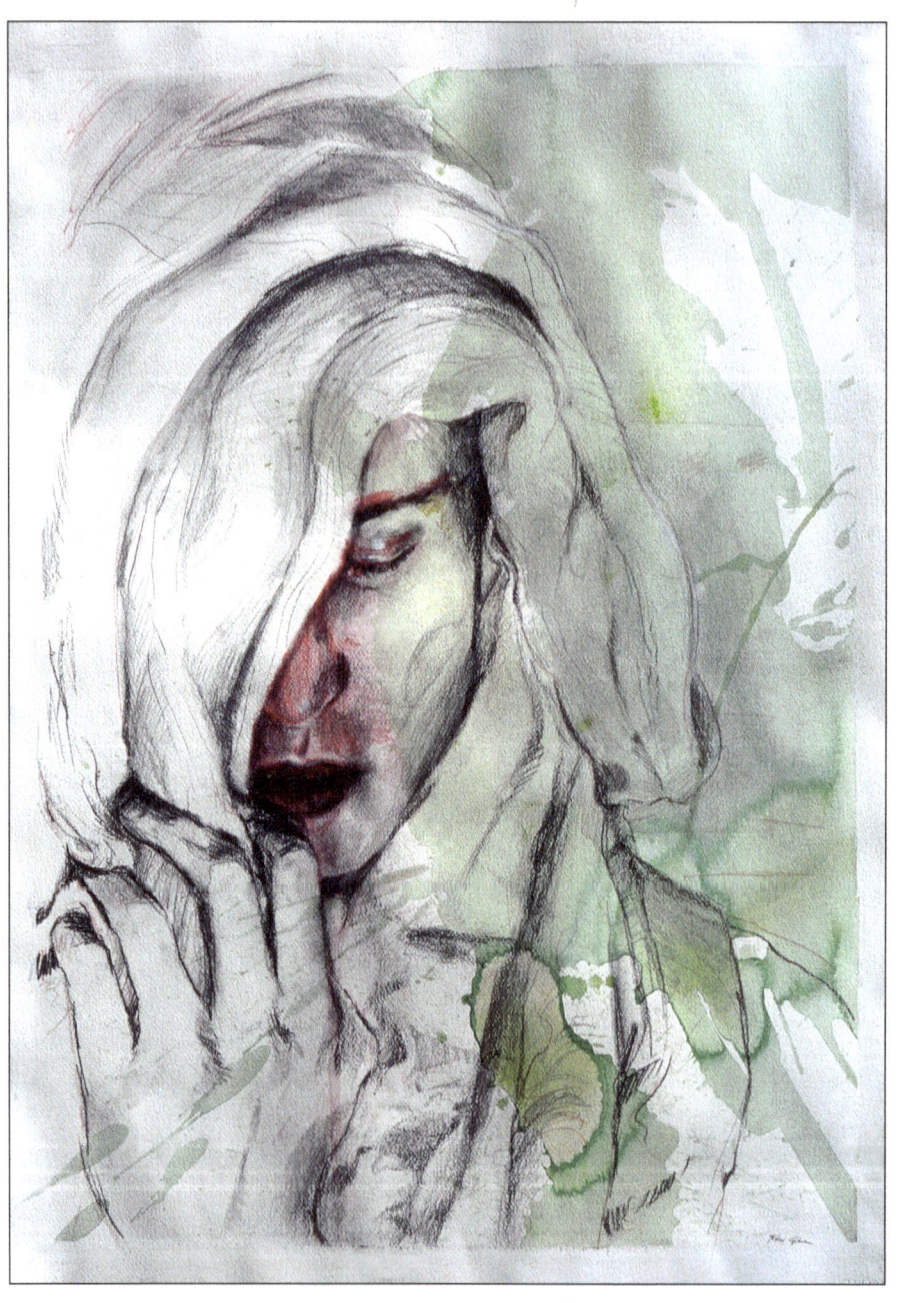

"Immaculate Intentions", watercolor and pencil, 22"x30", 2000

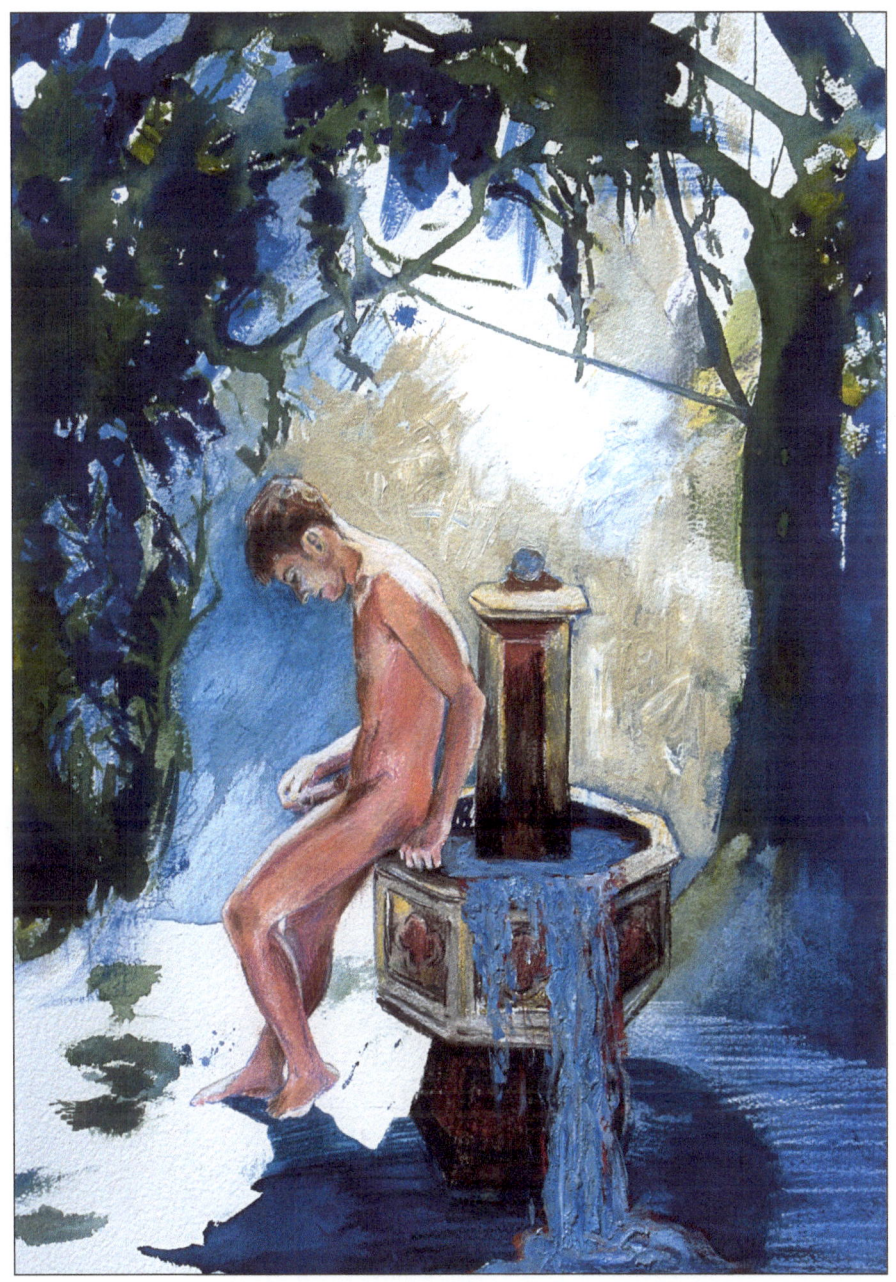

"Fountain", watercolor, 22"x30", 2000

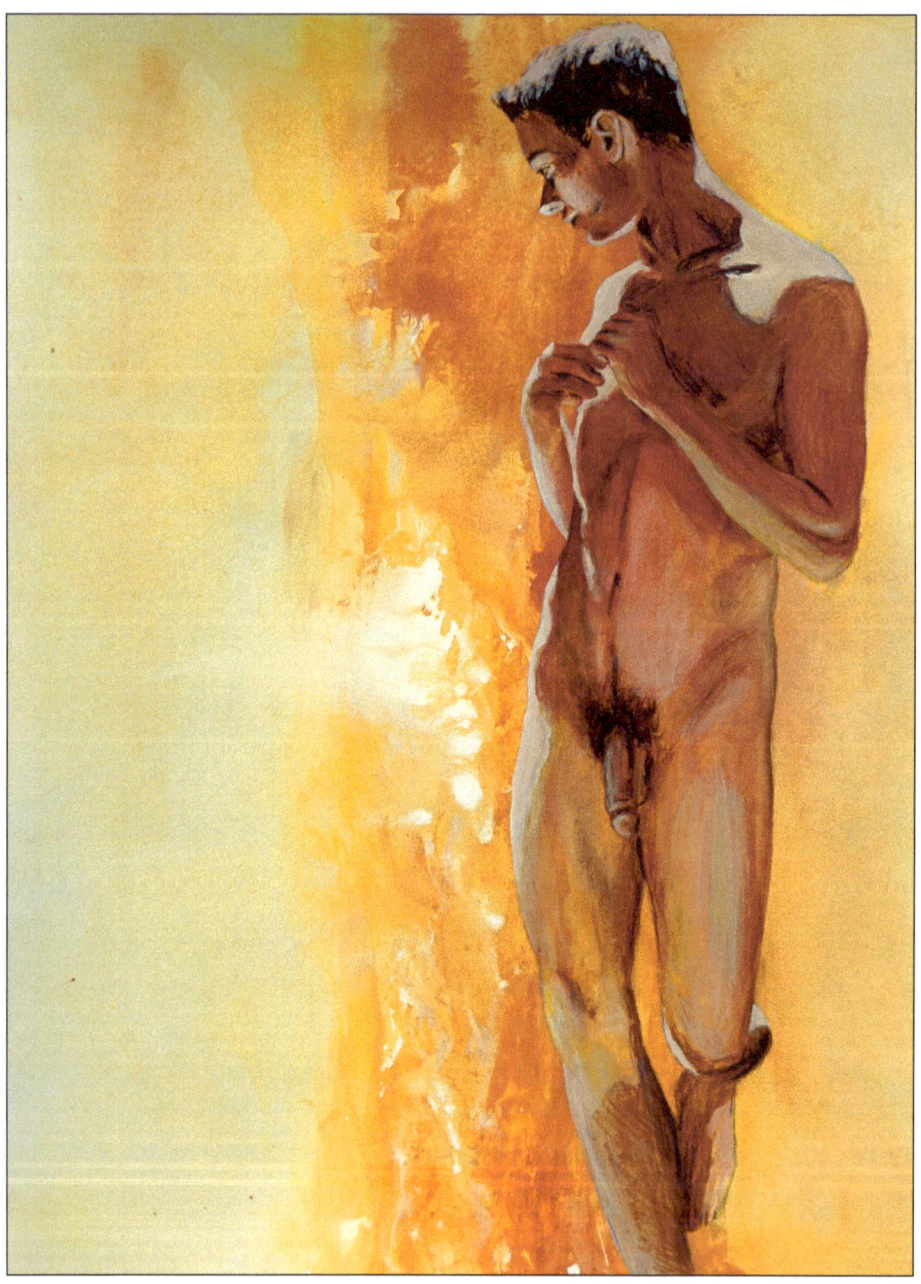

"Melancholy", watercolor, 22"x30", 2000

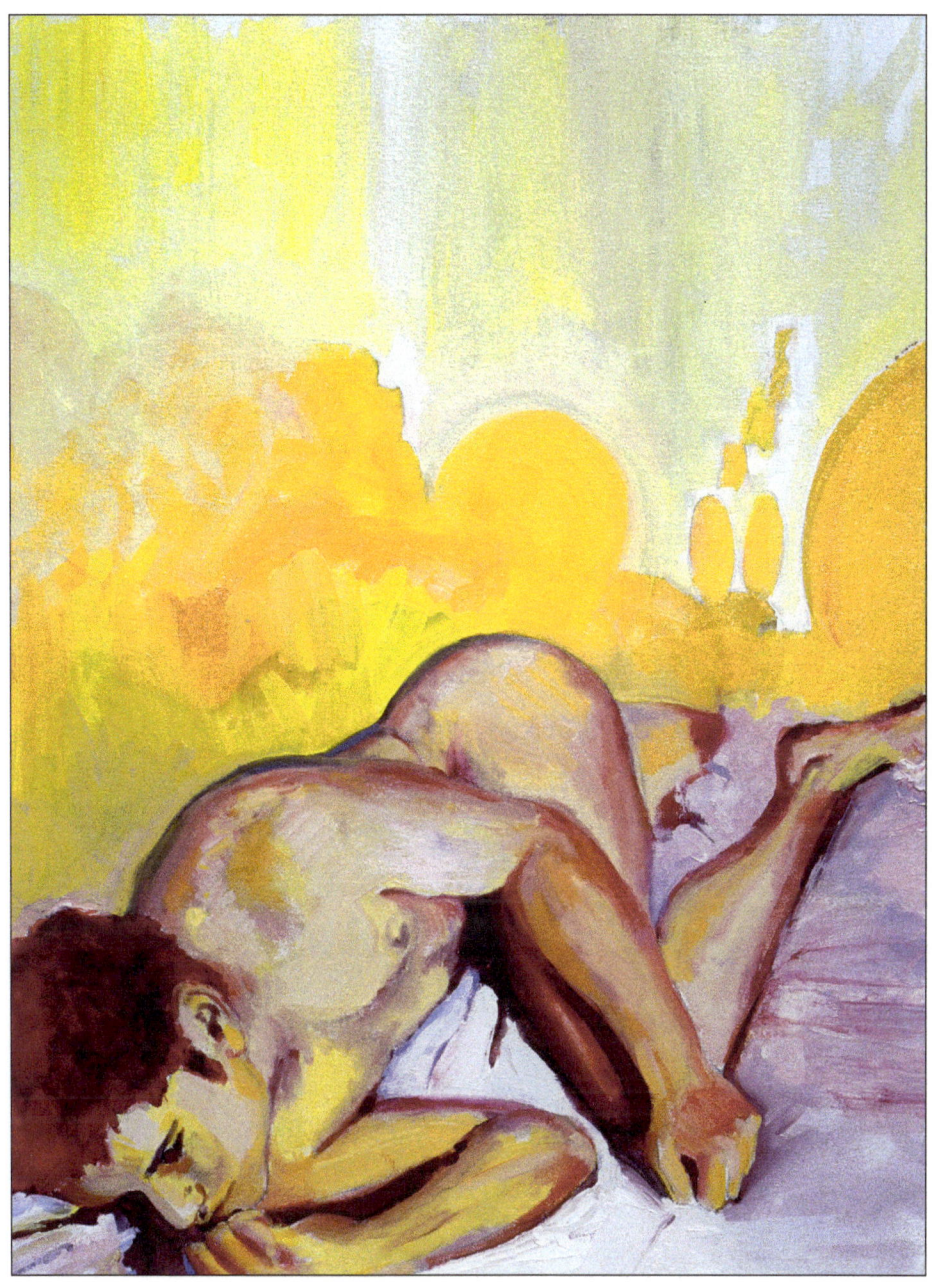

"Love You From Afar", acrylic and oil, 18"x20", 2000

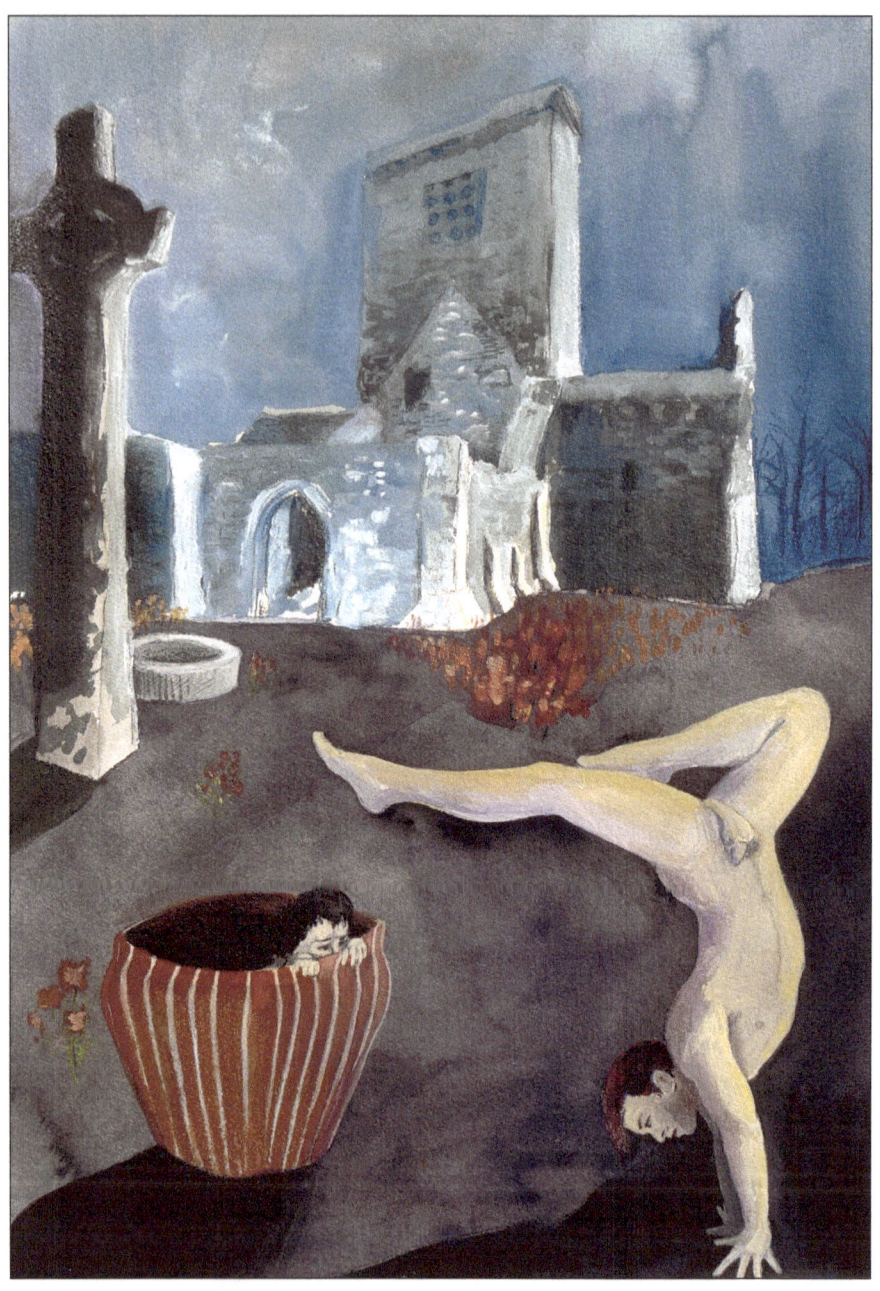

"Balance", watercolor, 22"x30", 1999

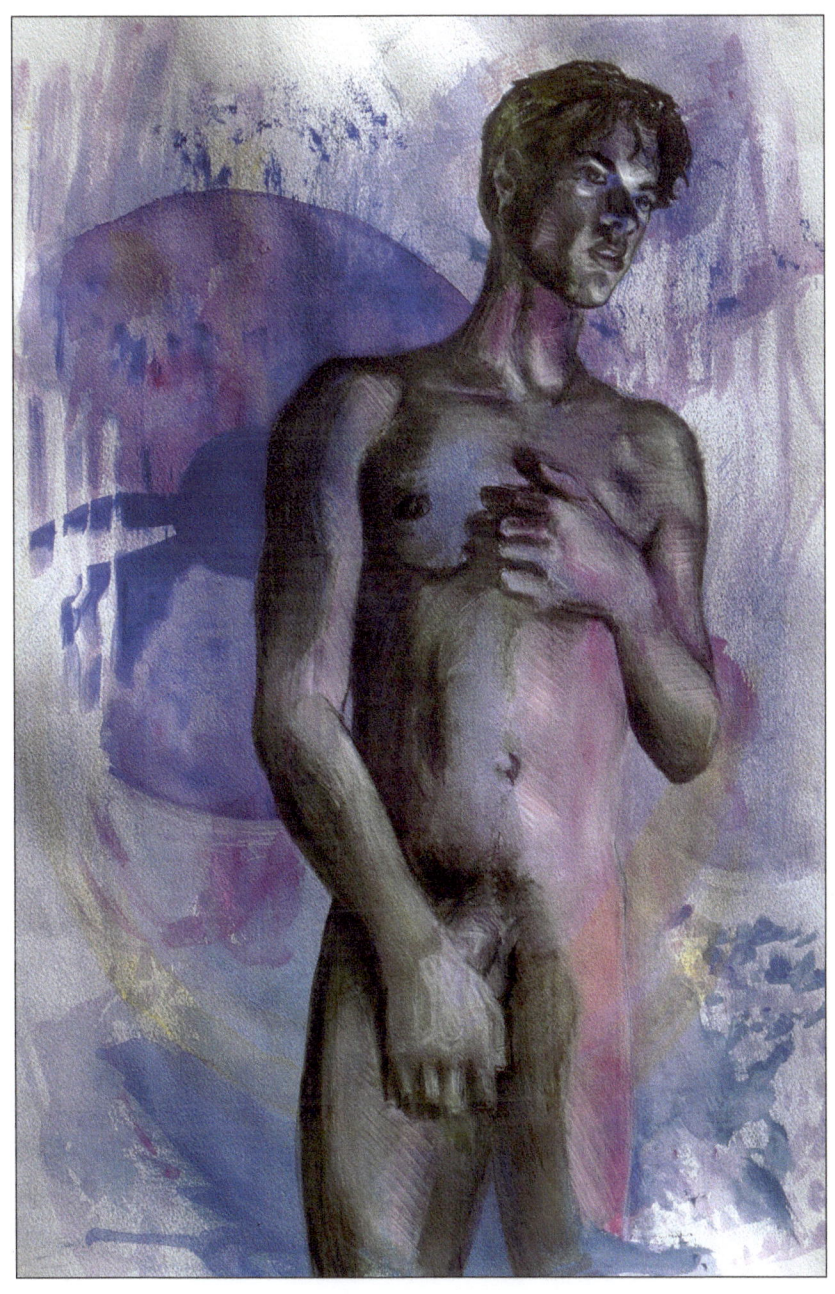

"Bearing Mysteries", watercolor, 22"x30", 1999

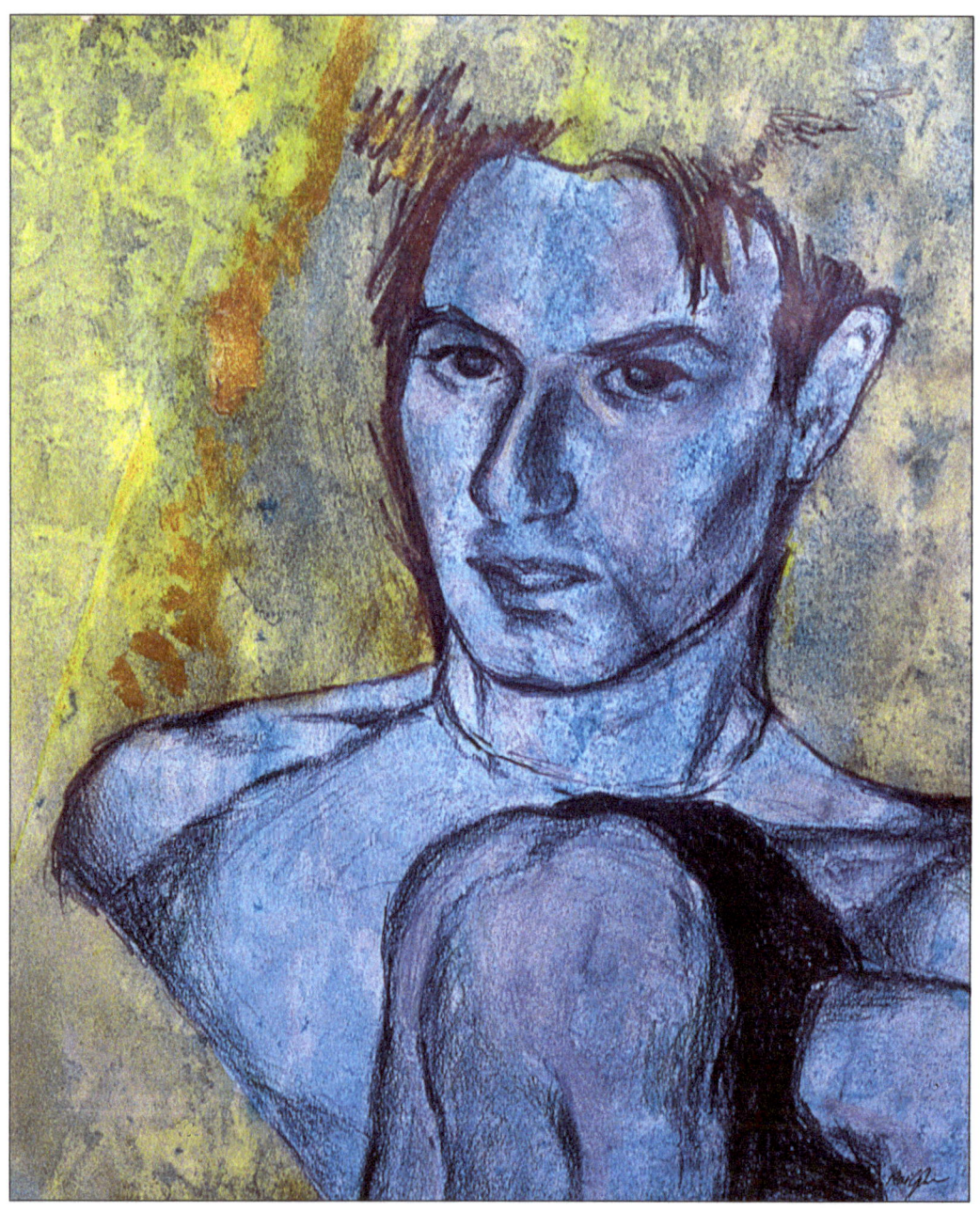

"Andrew", watercolor and pencil, 12"x14", 1999

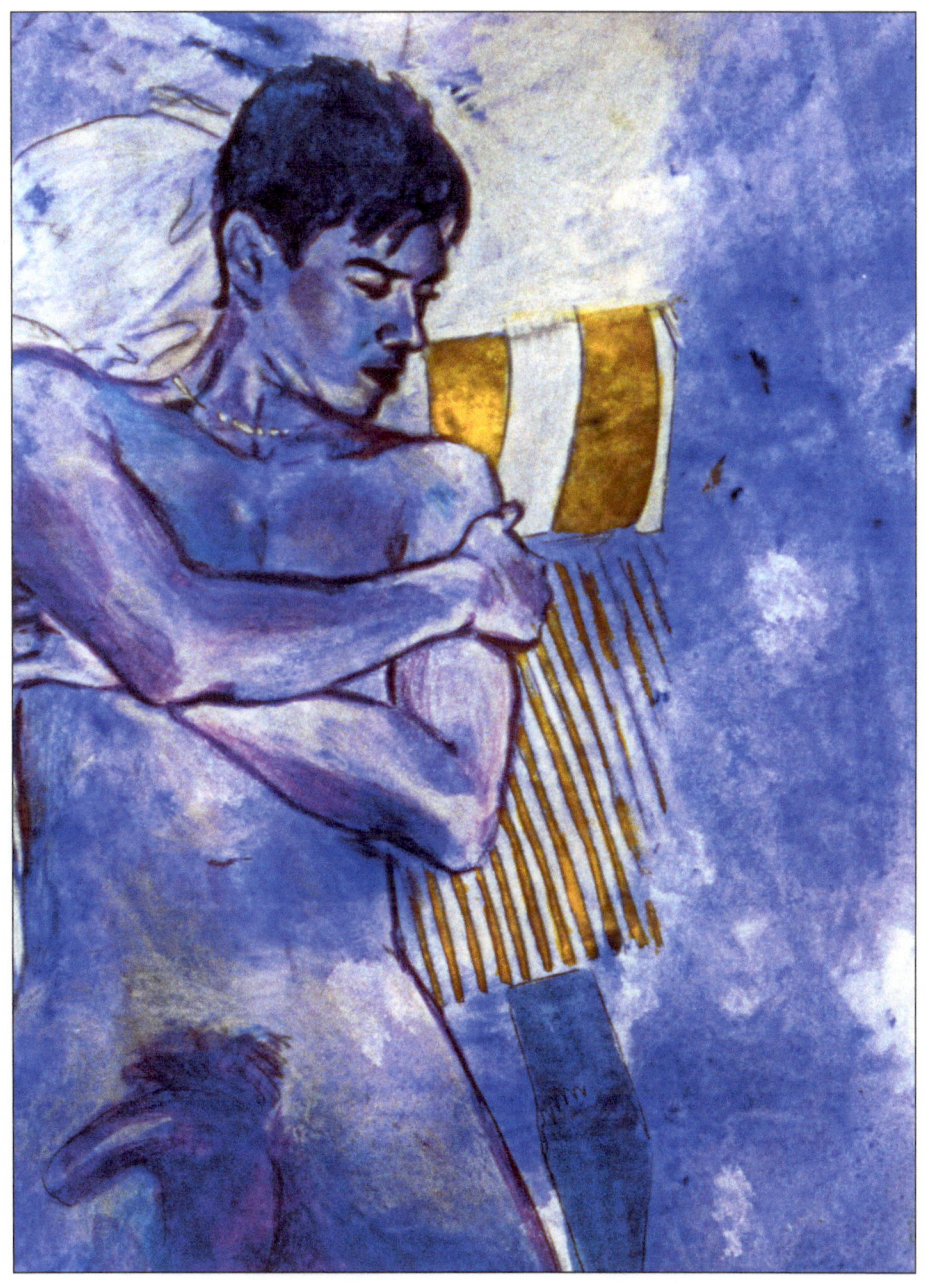

"Blue Andrew", watercolor and color pencil, 12"x14", 1999

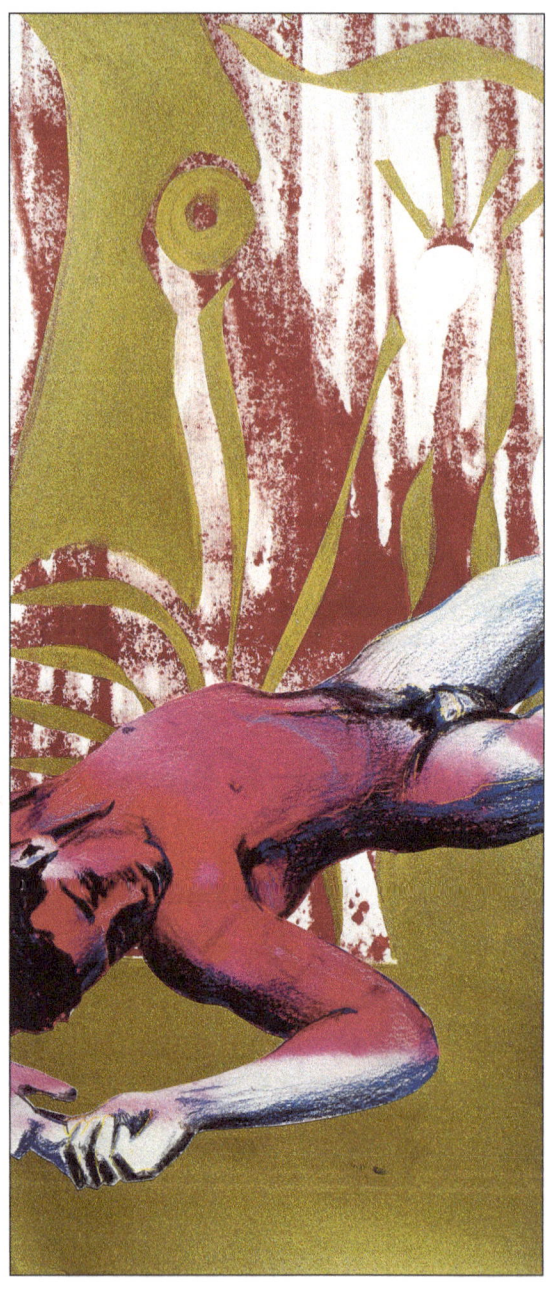

"To Kill A Dead Boy", watercolor, 7"x18", 1999

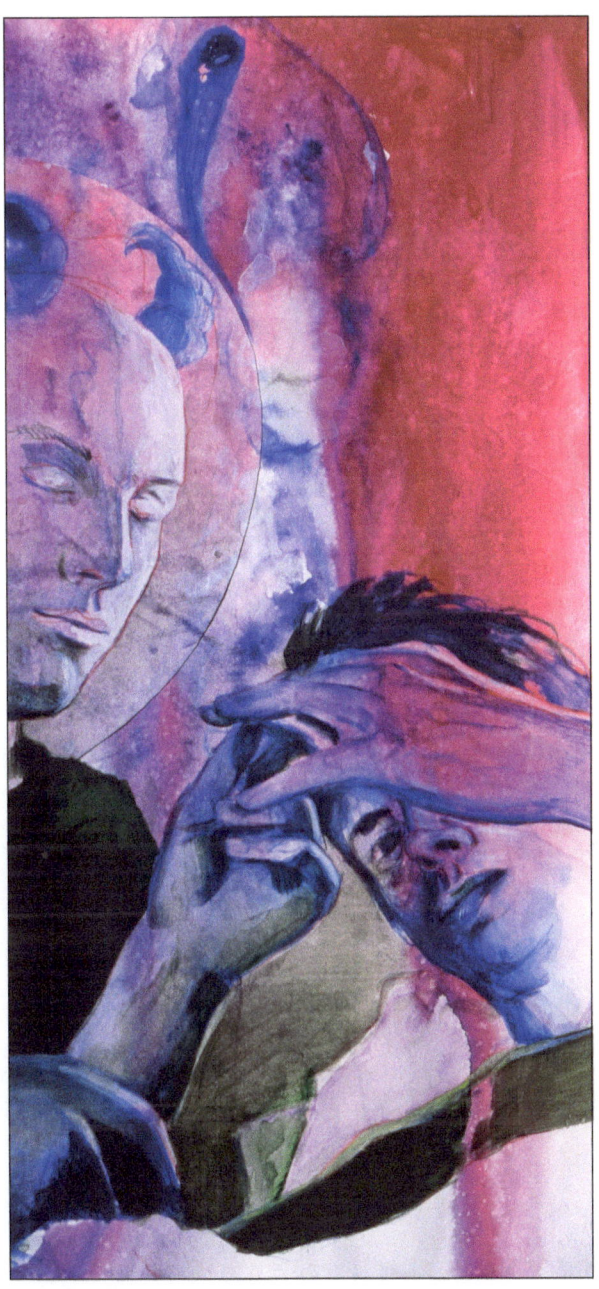

"Demon Within, Demon Without", watercolor, 9"x22", 2000

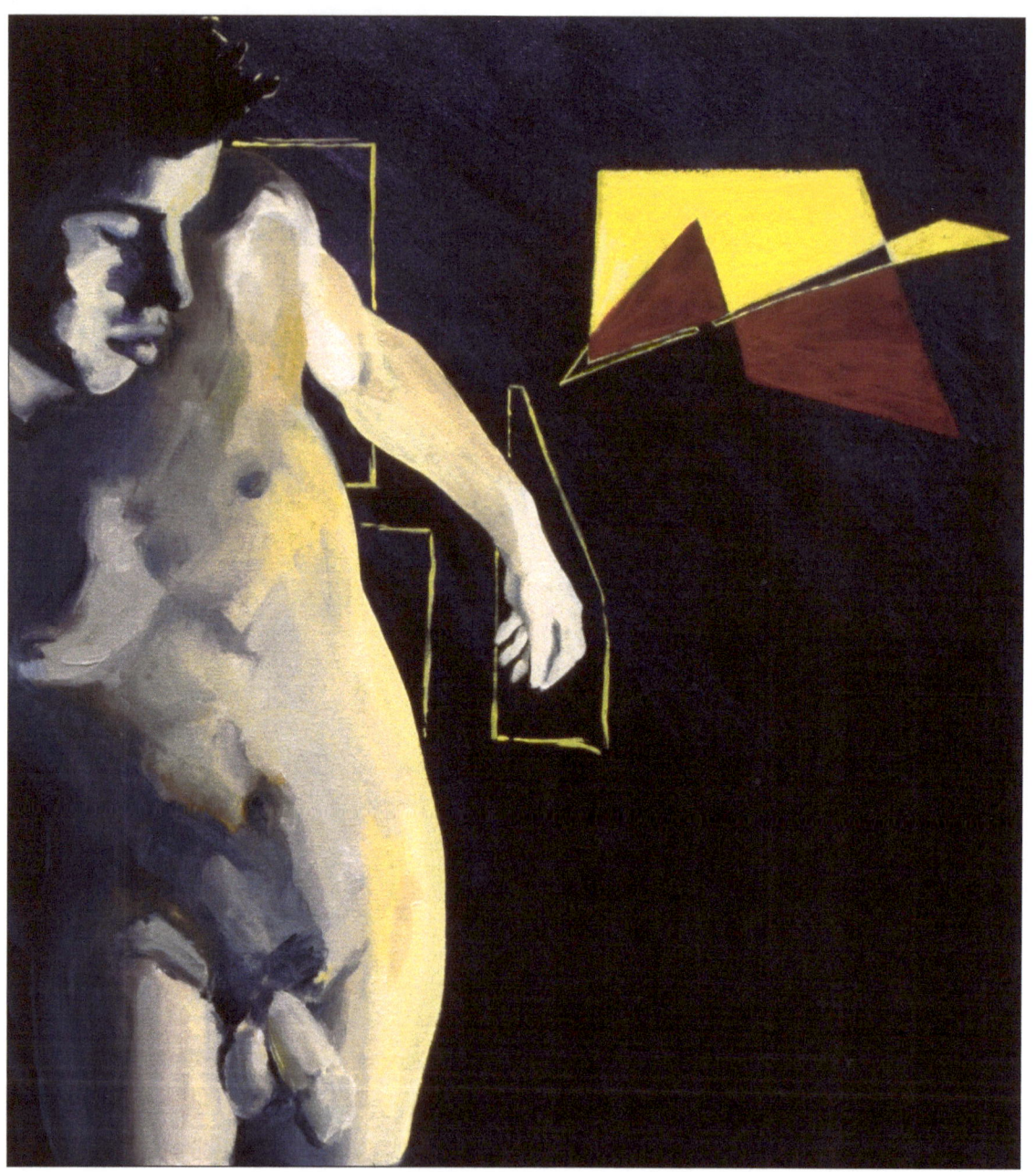

"Wounded Spaces", oil, 18"x24", 1999

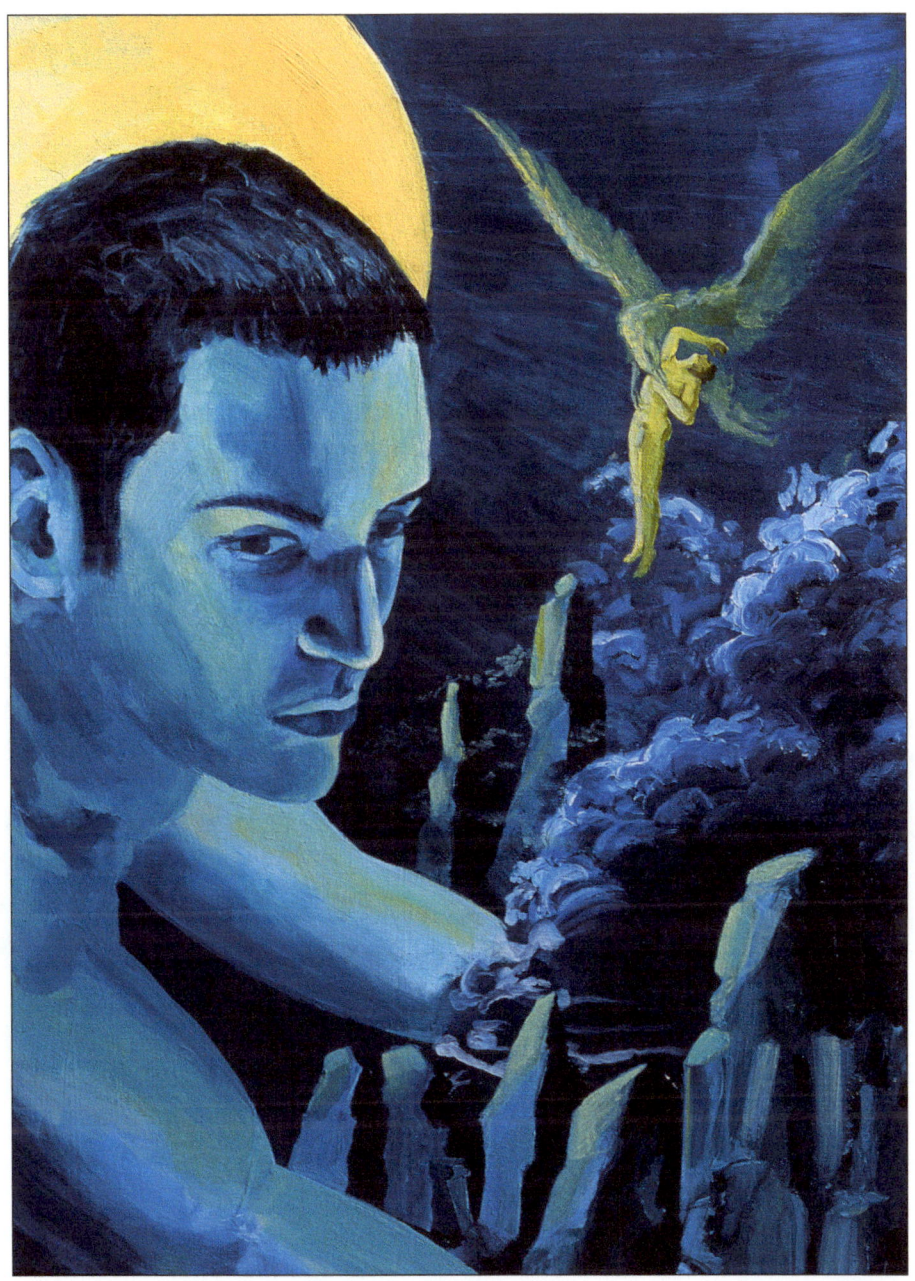

"Where the Sun Sails and the Moon Walks", acrylic, 20"x24", 2001

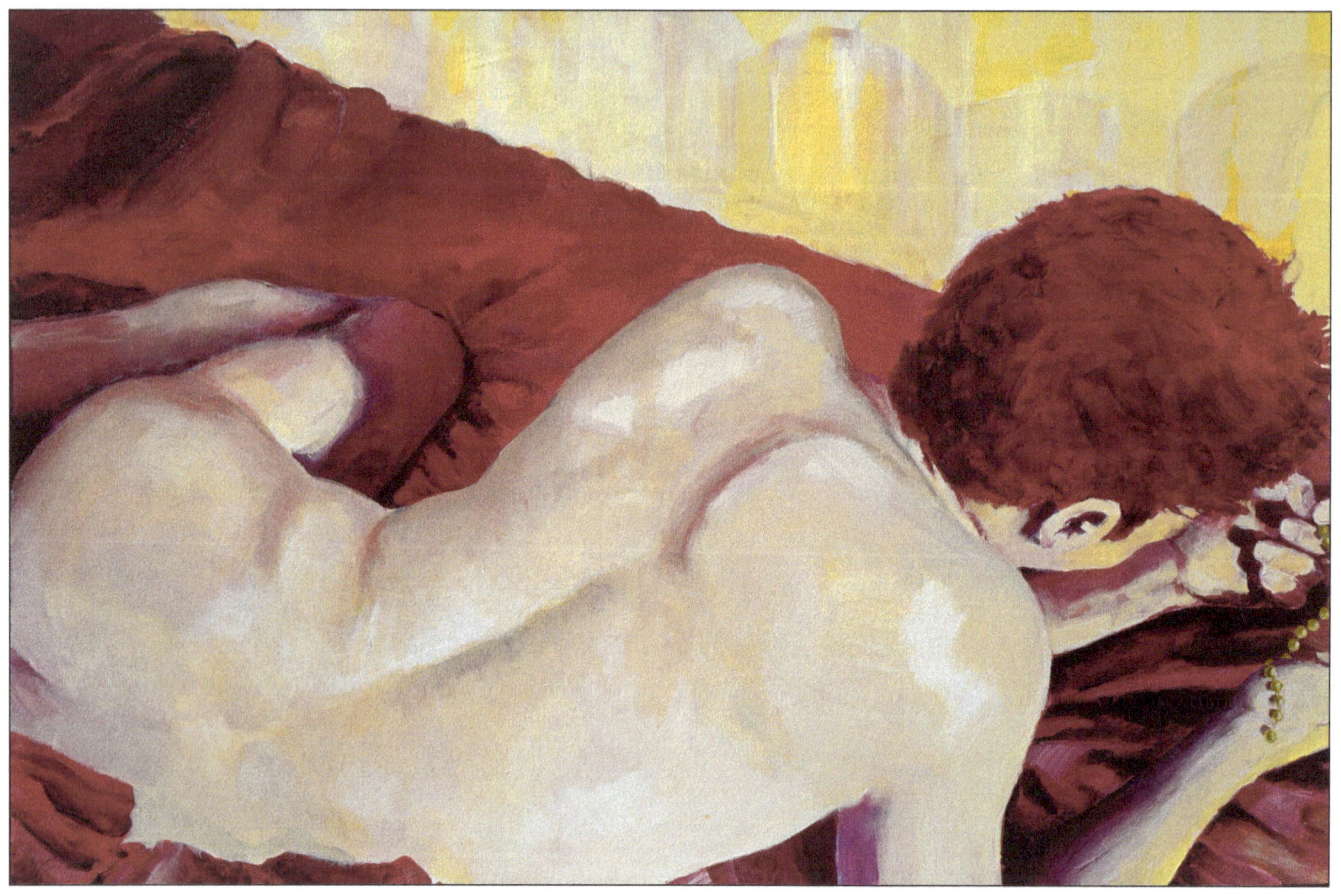

"Listen To The Night", acrylic, 24"x36", 2000

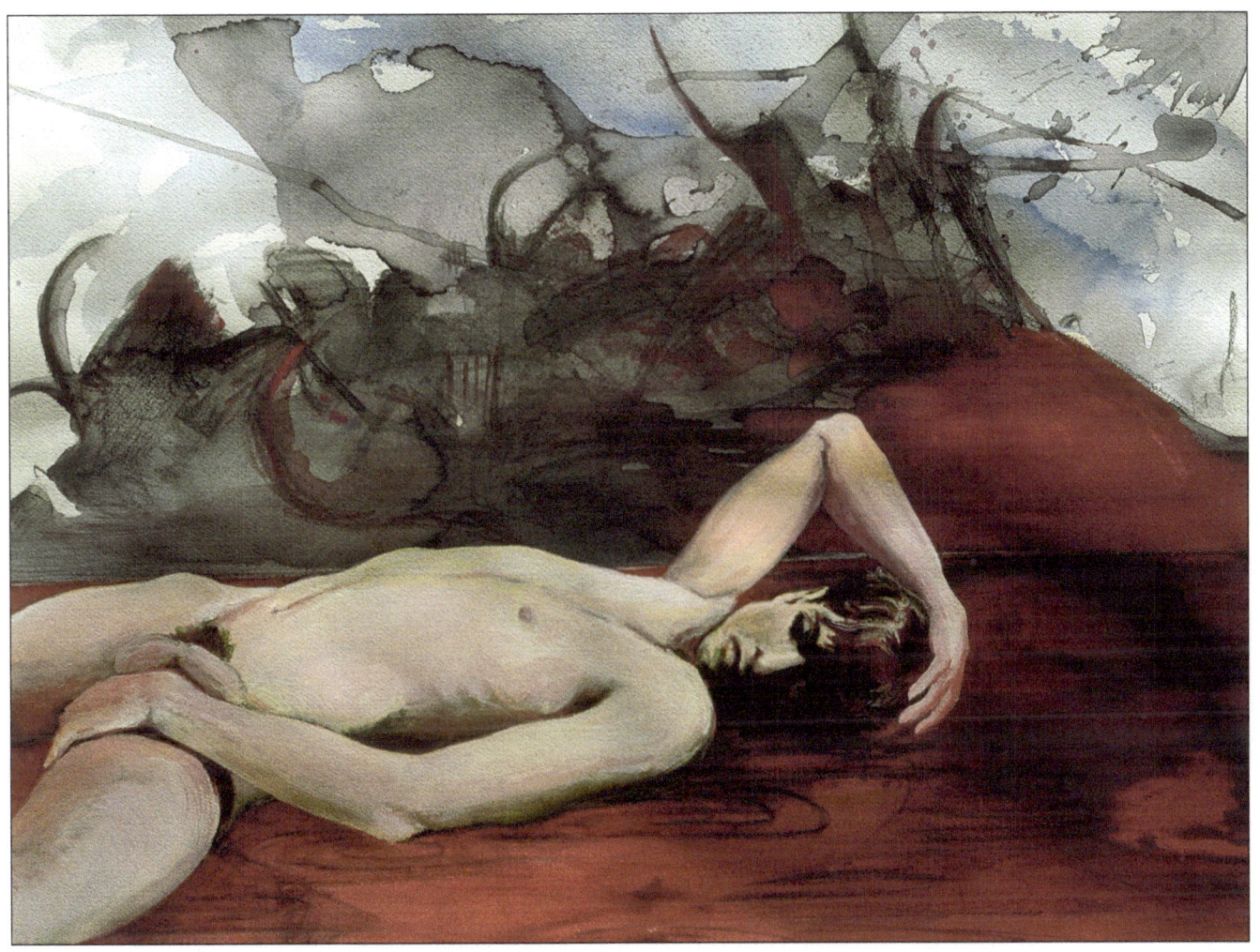

"Slowly Stealing What You Long For", watercolor, ink and acrylic, 22"x30", 2000

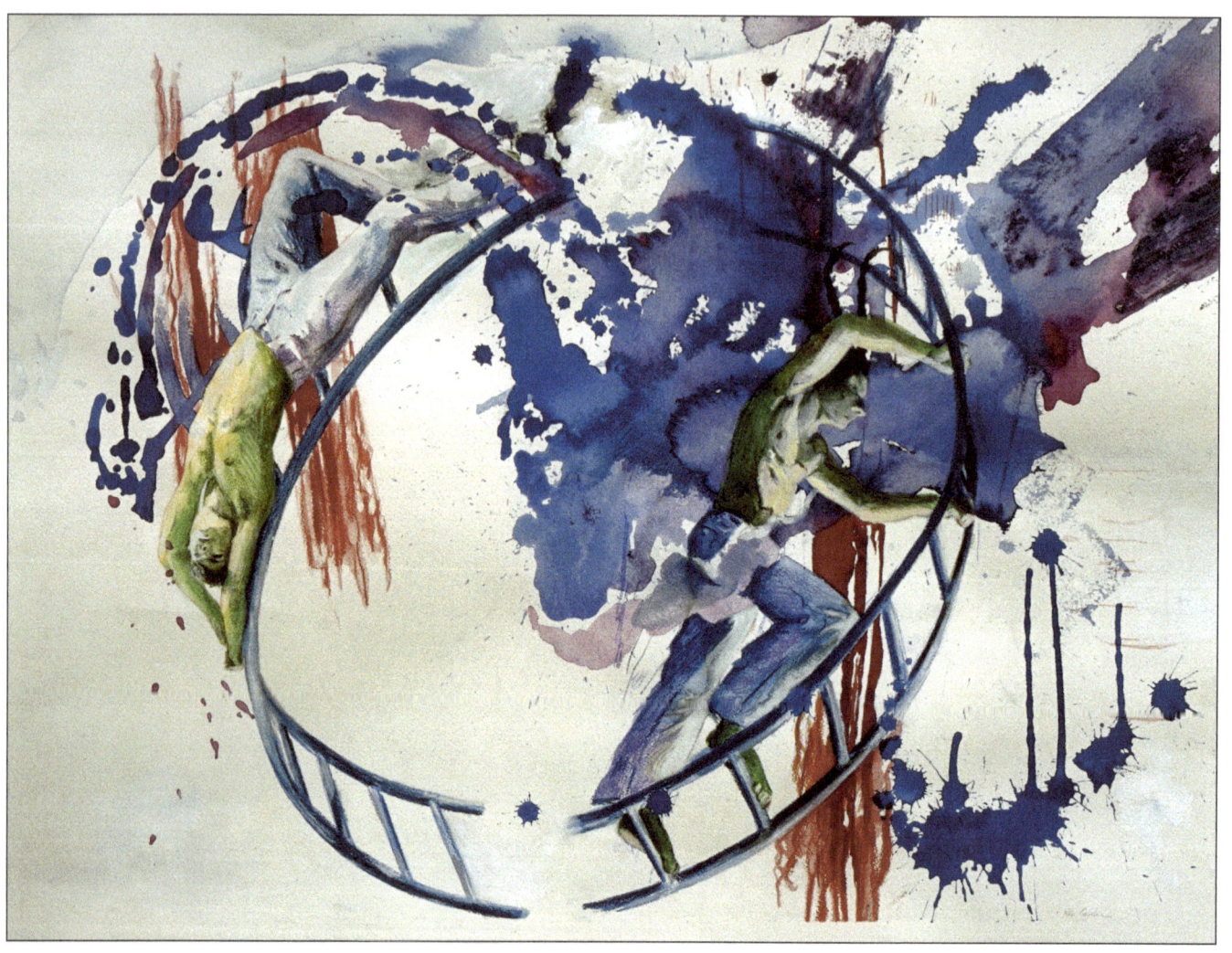

"Faith in Cycles", watercolor and color pencil, 22"x30", 1999

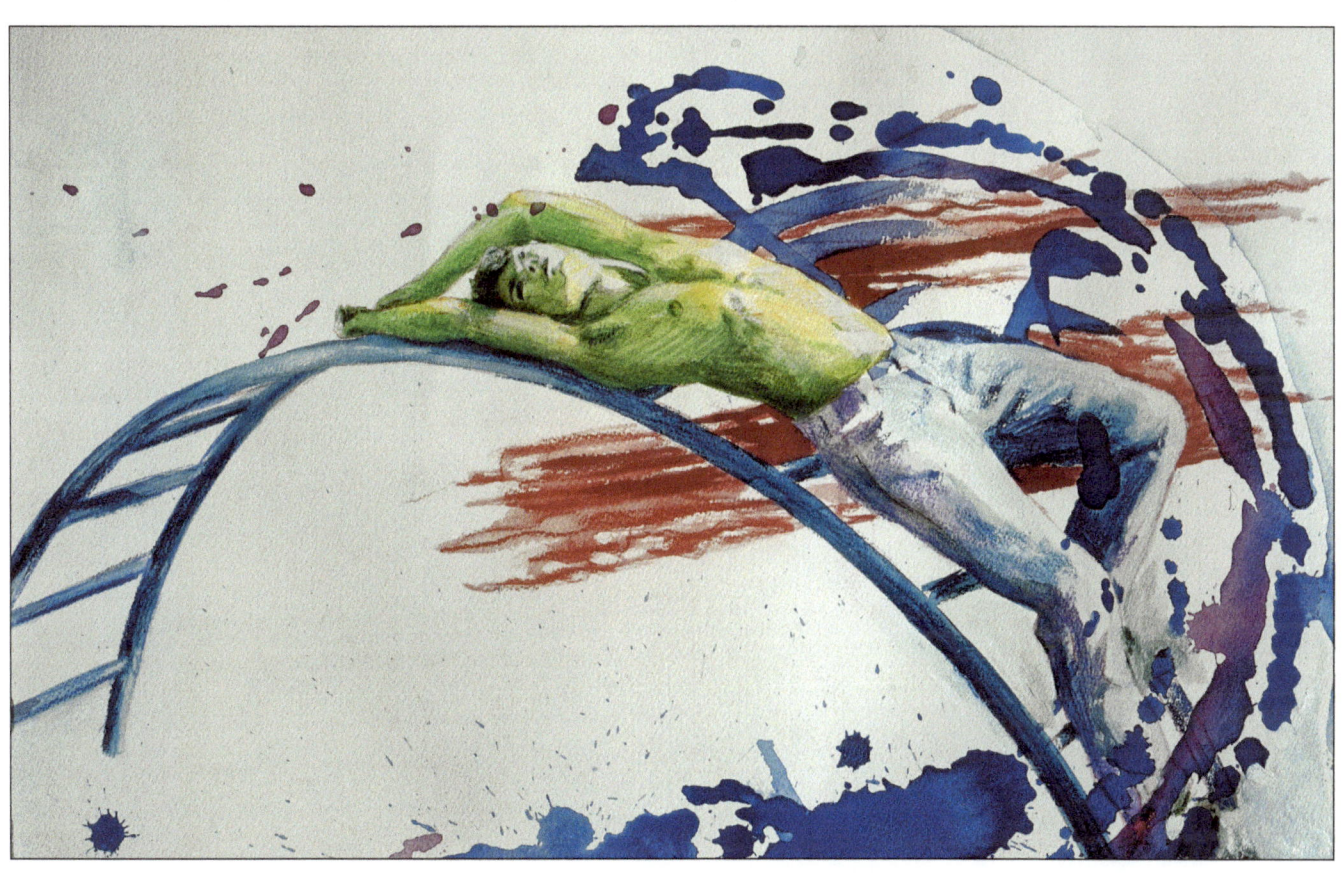

"Faith In Cycles" (detail)

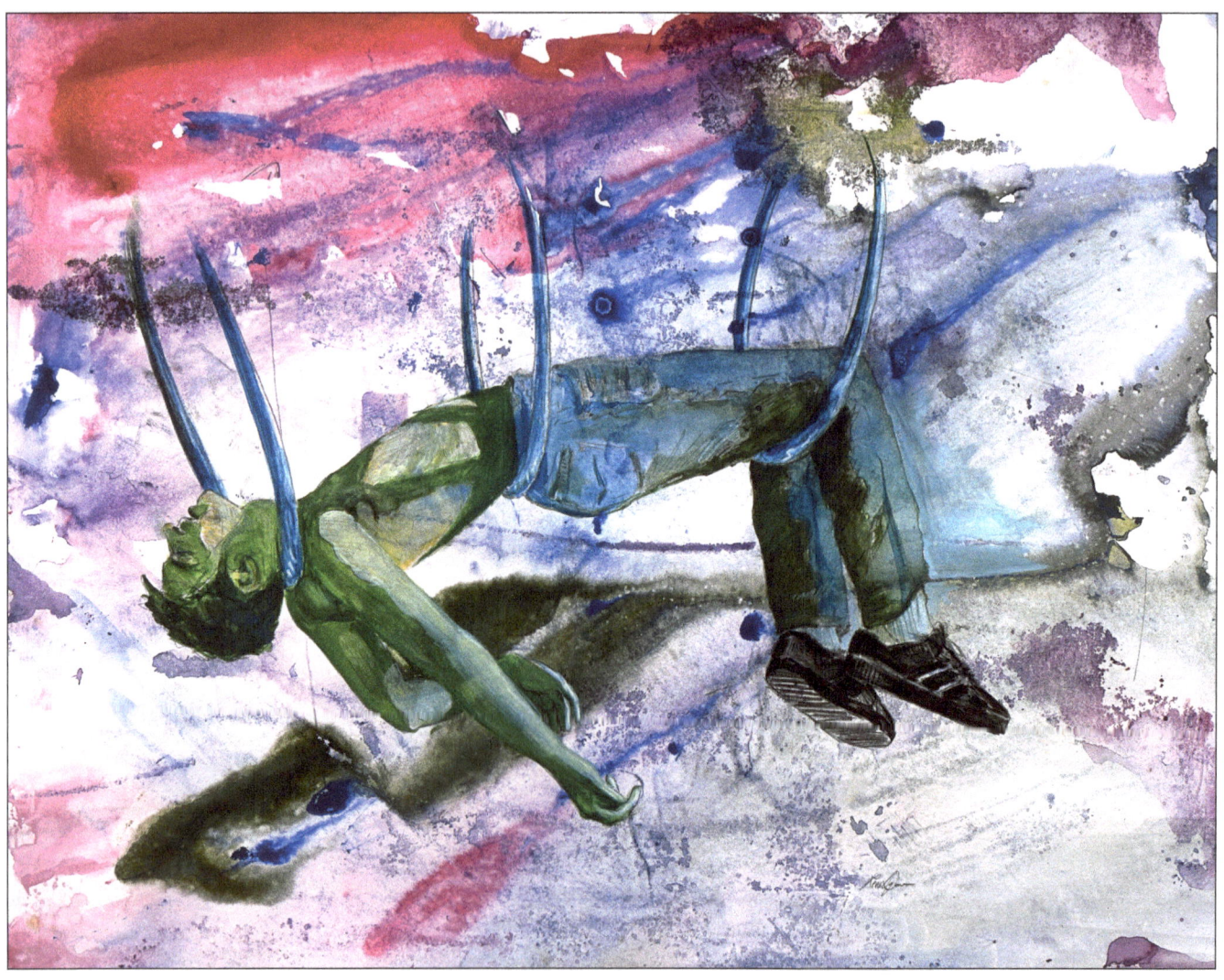

"Suspension #1", watercolor and ink, 18"x24", 2000

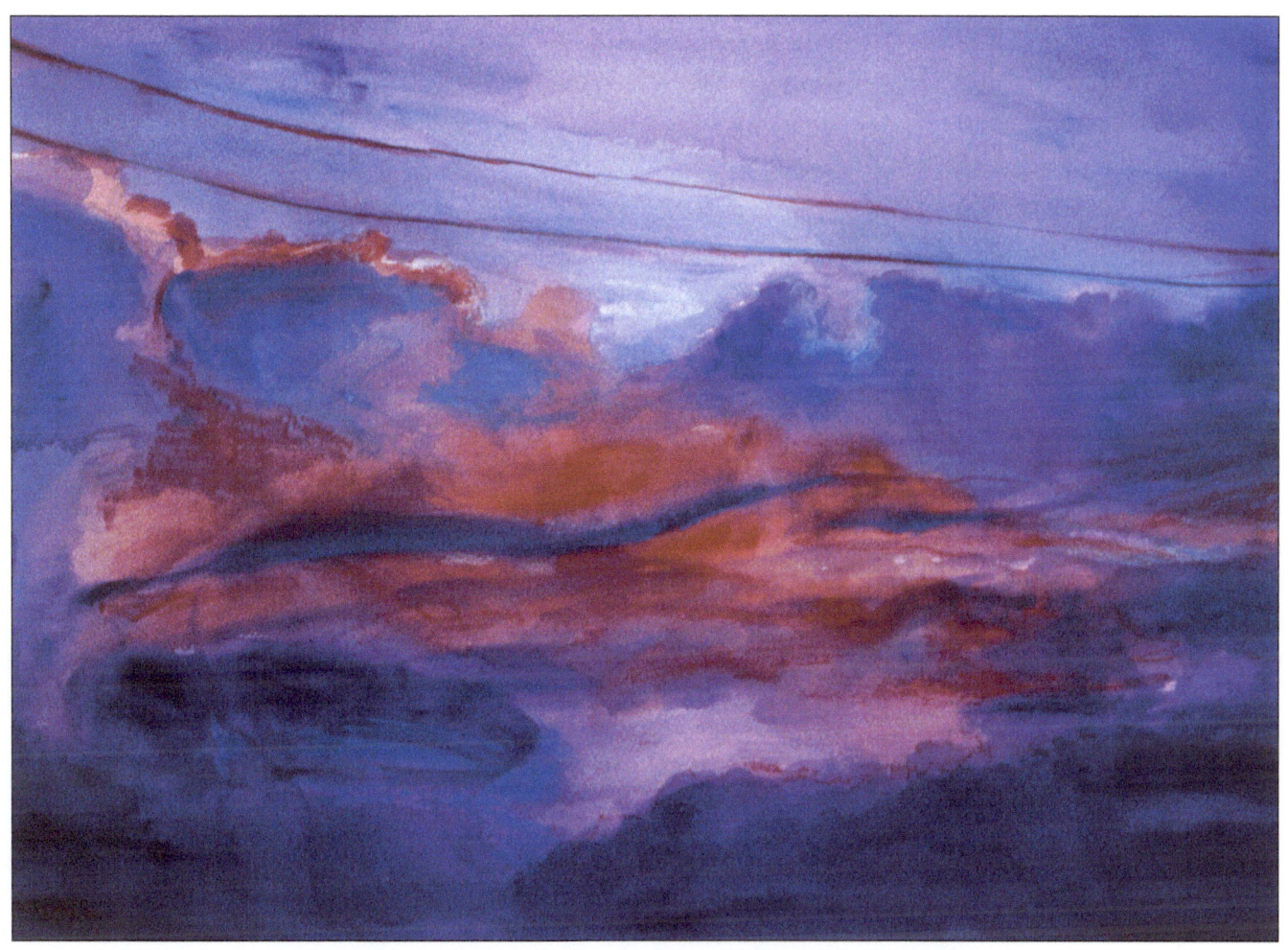

"Storms Over San Francisco", watercolor, 22"x30", 1999

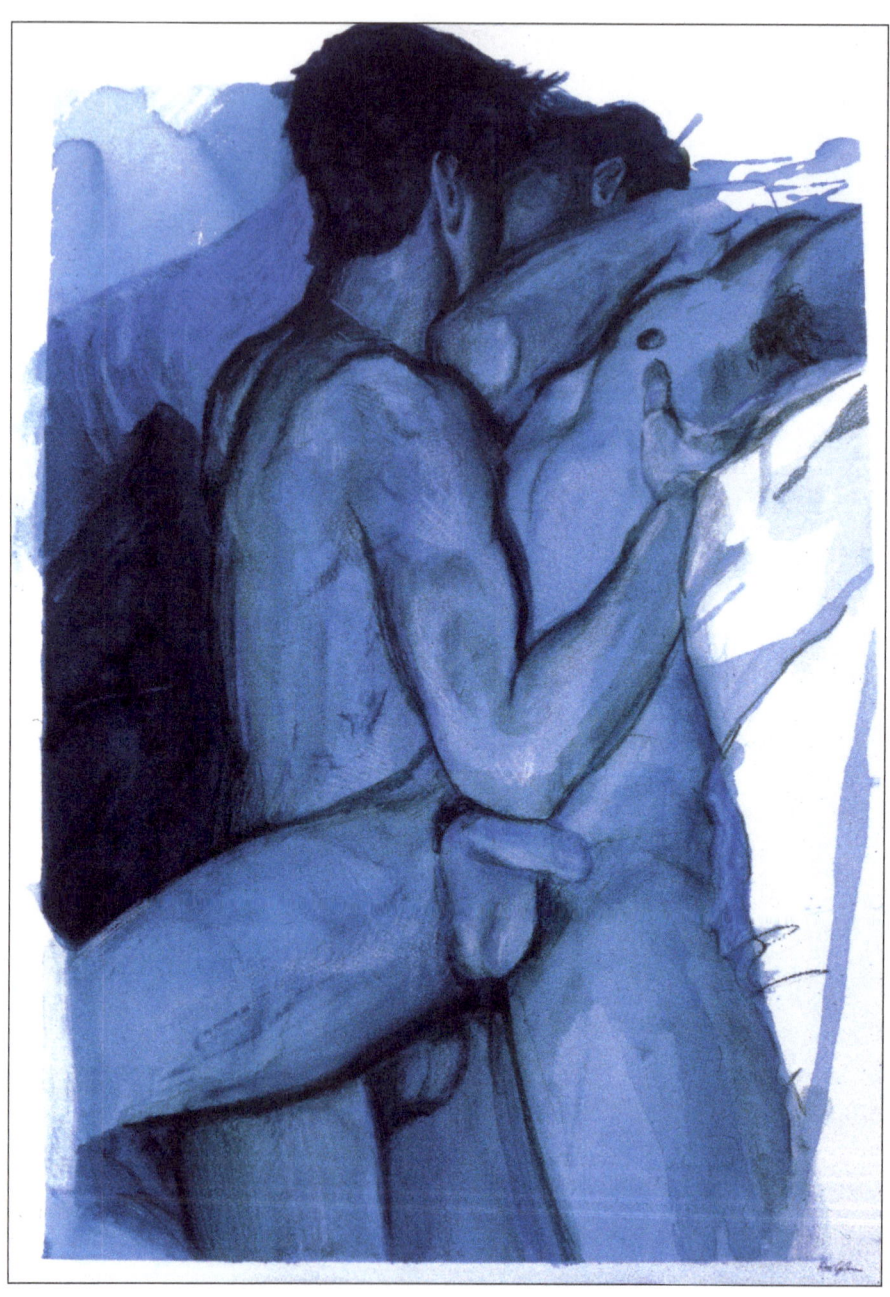

"Adagio", watercolor, 22"x30", 1999

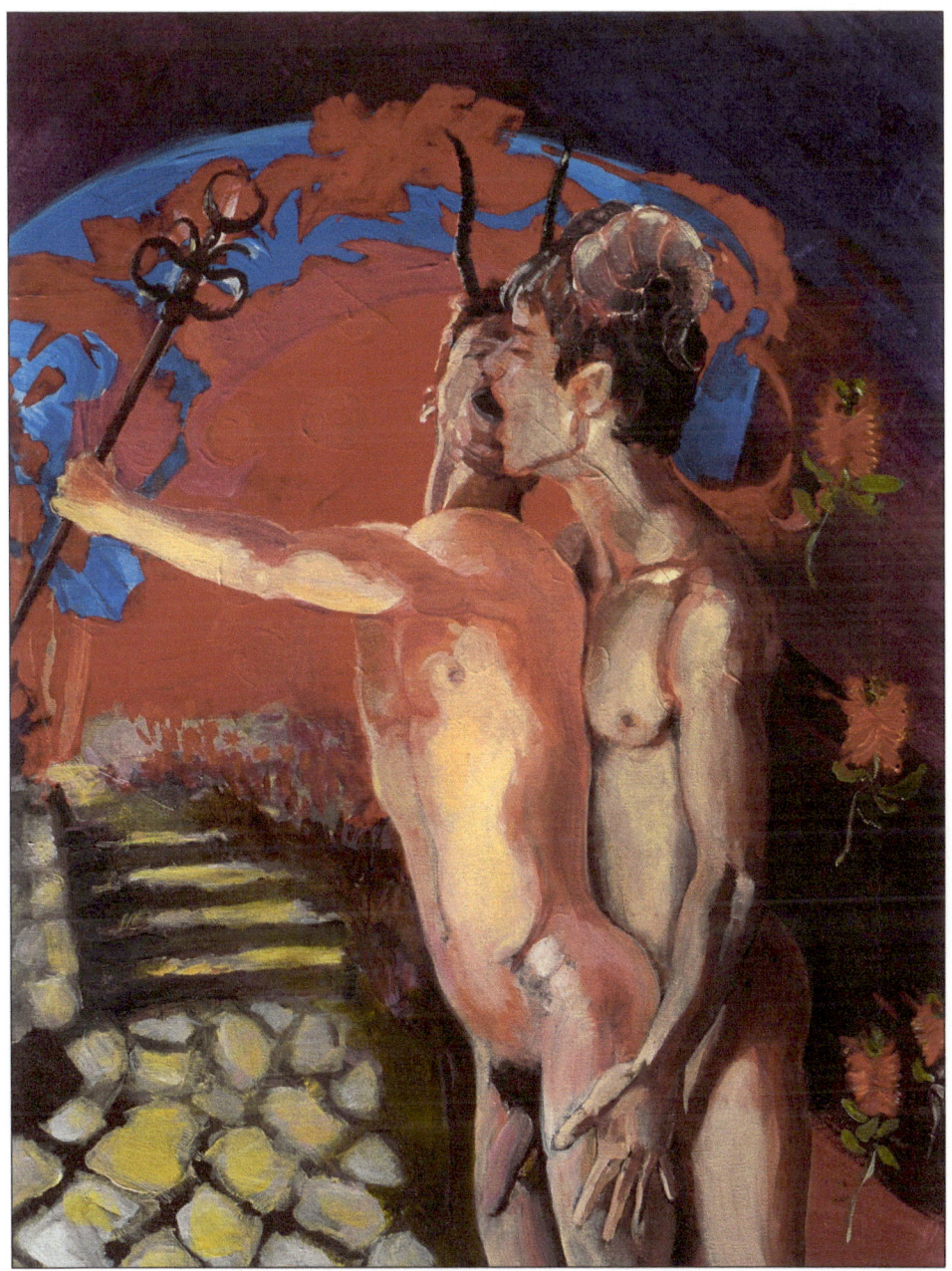

"Creatures In The Grove", acrylic, 18"x24", 2000

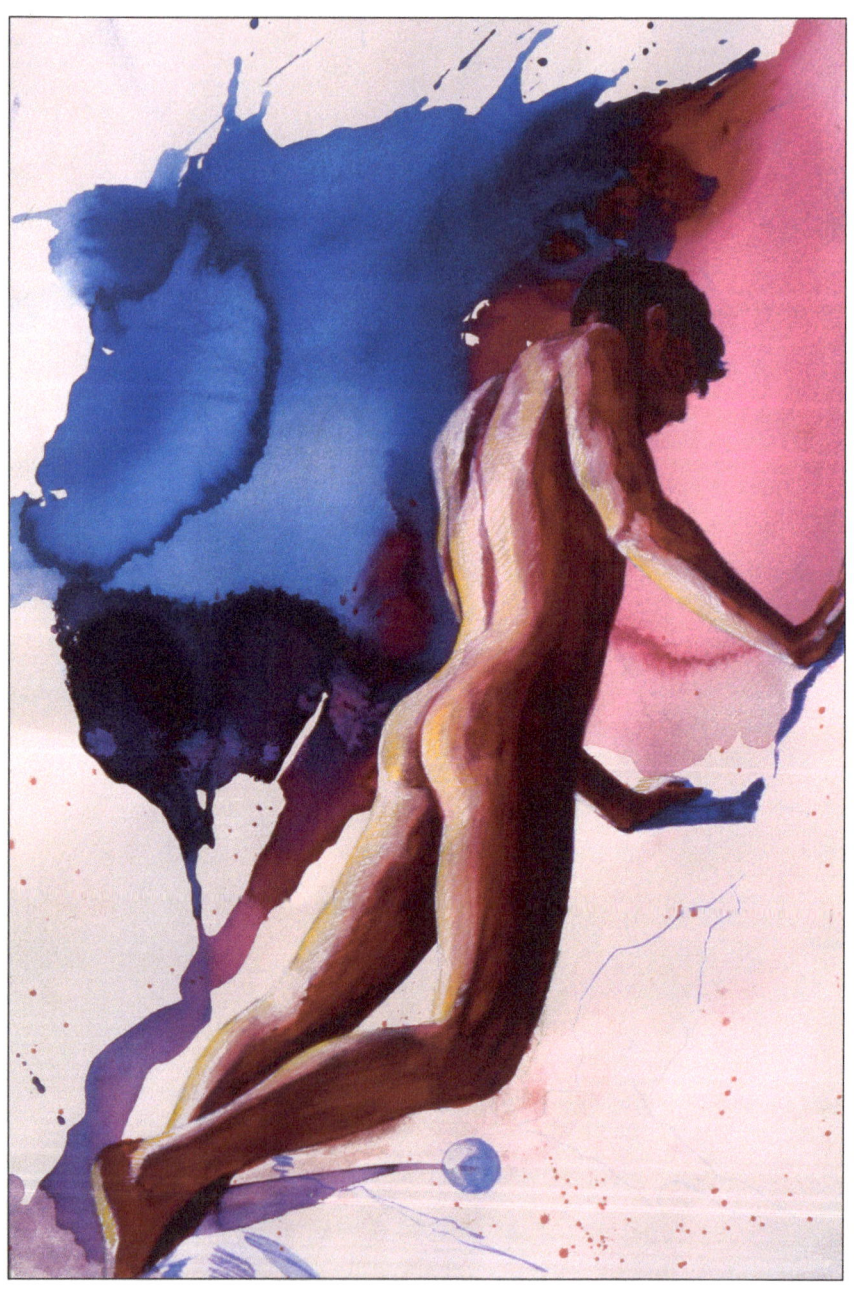

"I've Always Been A Storm", watercolor, 22"x30", 2000

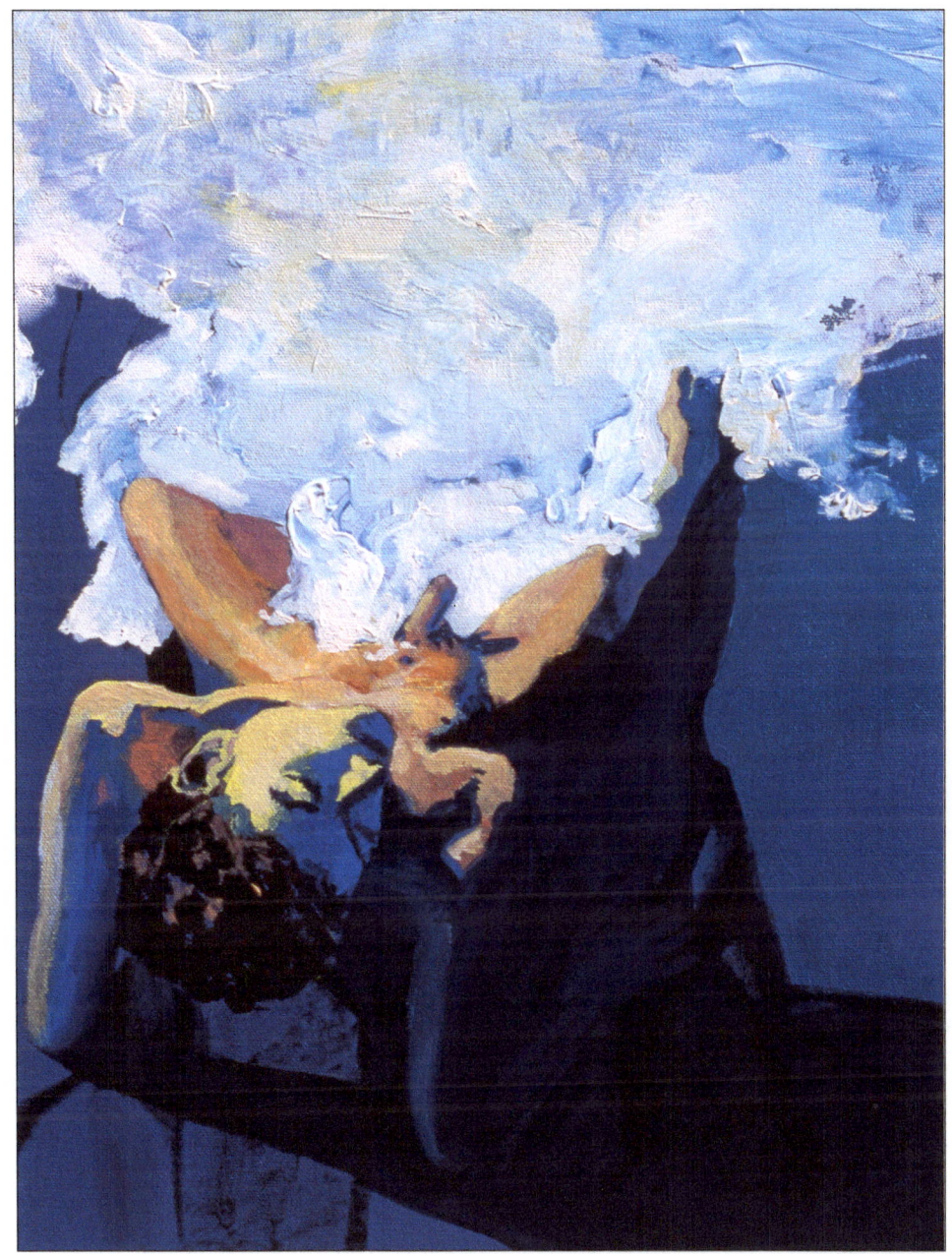

"Salt", acrylic, 12"x14", 2000

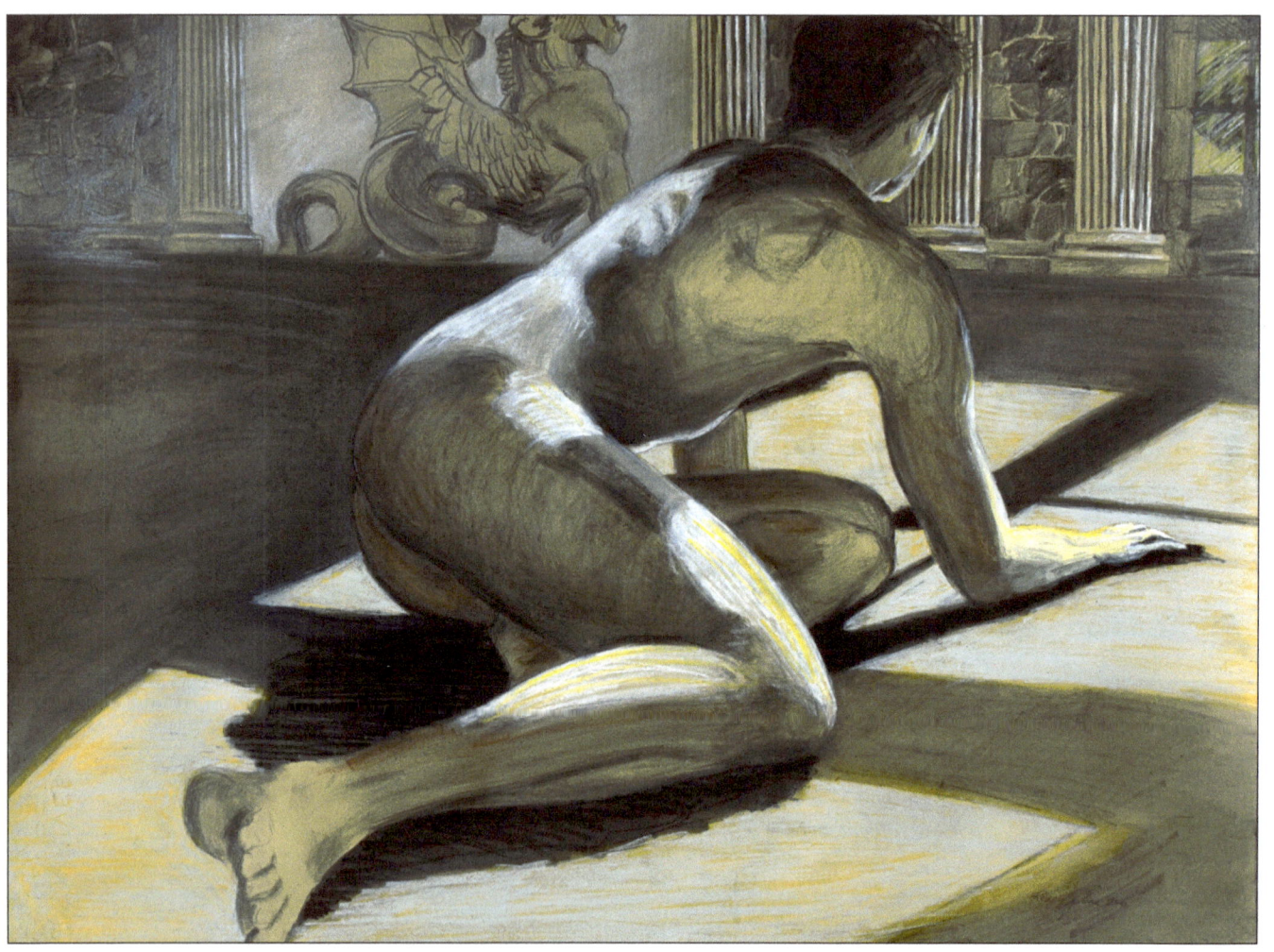

"Admitting Our Falls", ink wash and watercolor, 22"x30", 2002

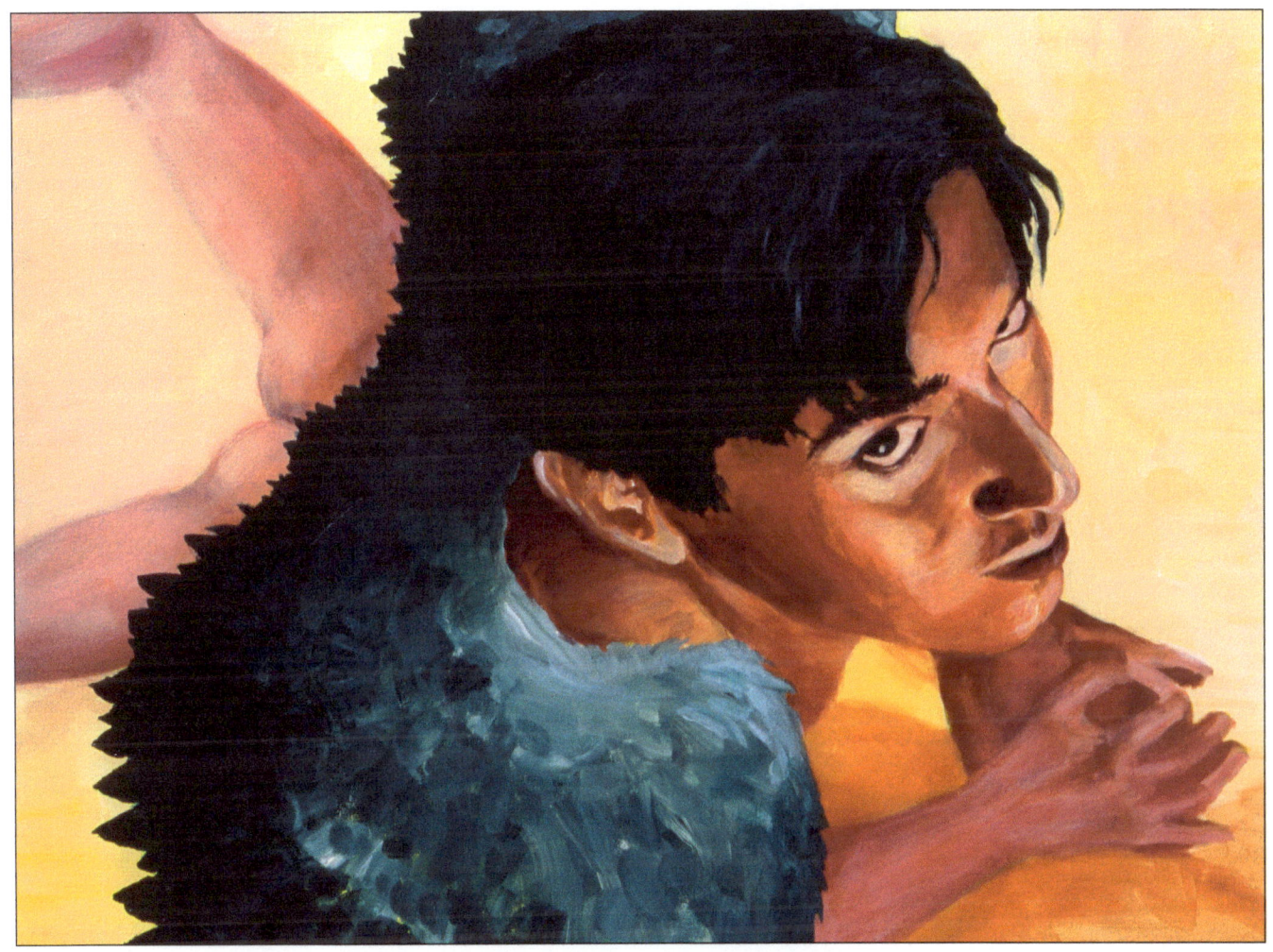

"Fallen", acrylic, 30"x40", 2000

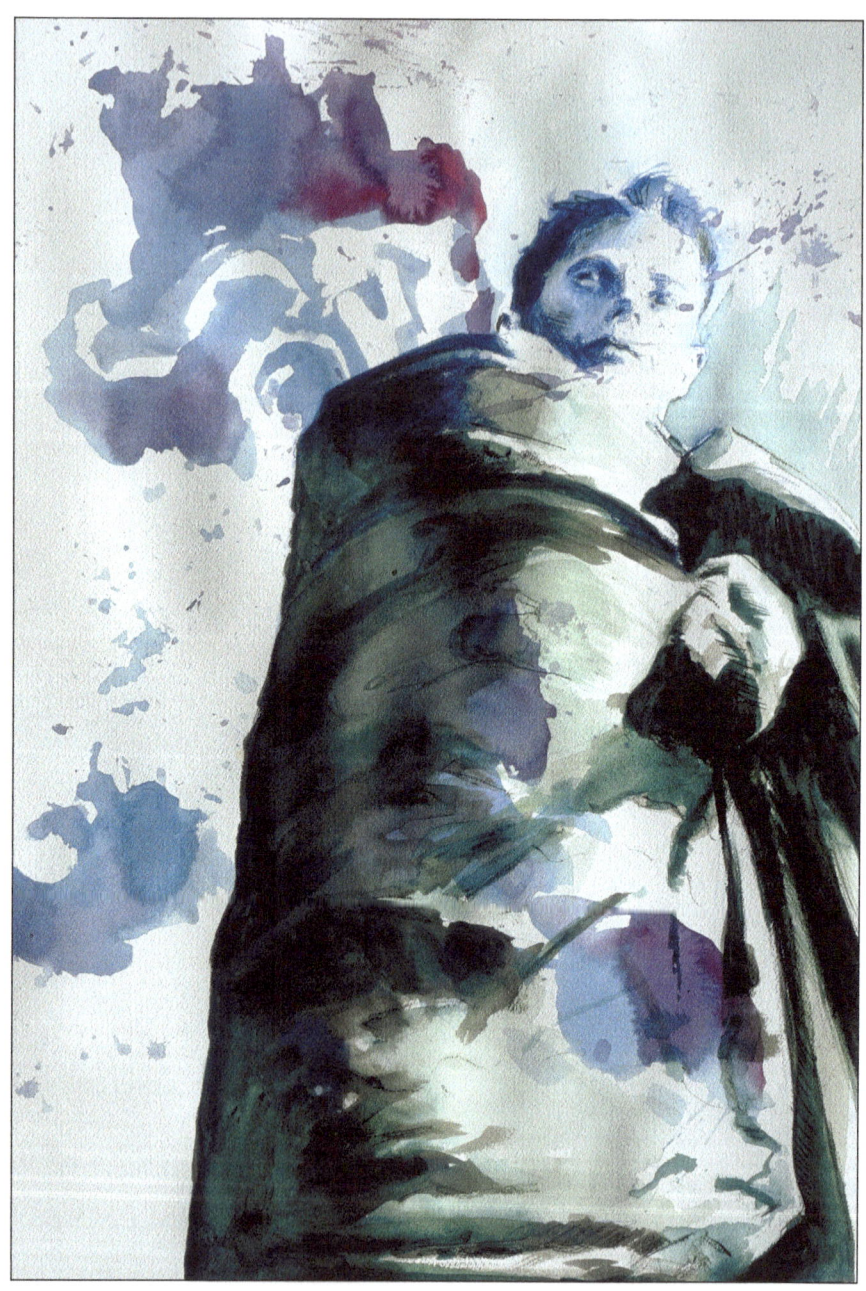

"Safety", watercolor, 22"x30", 1999

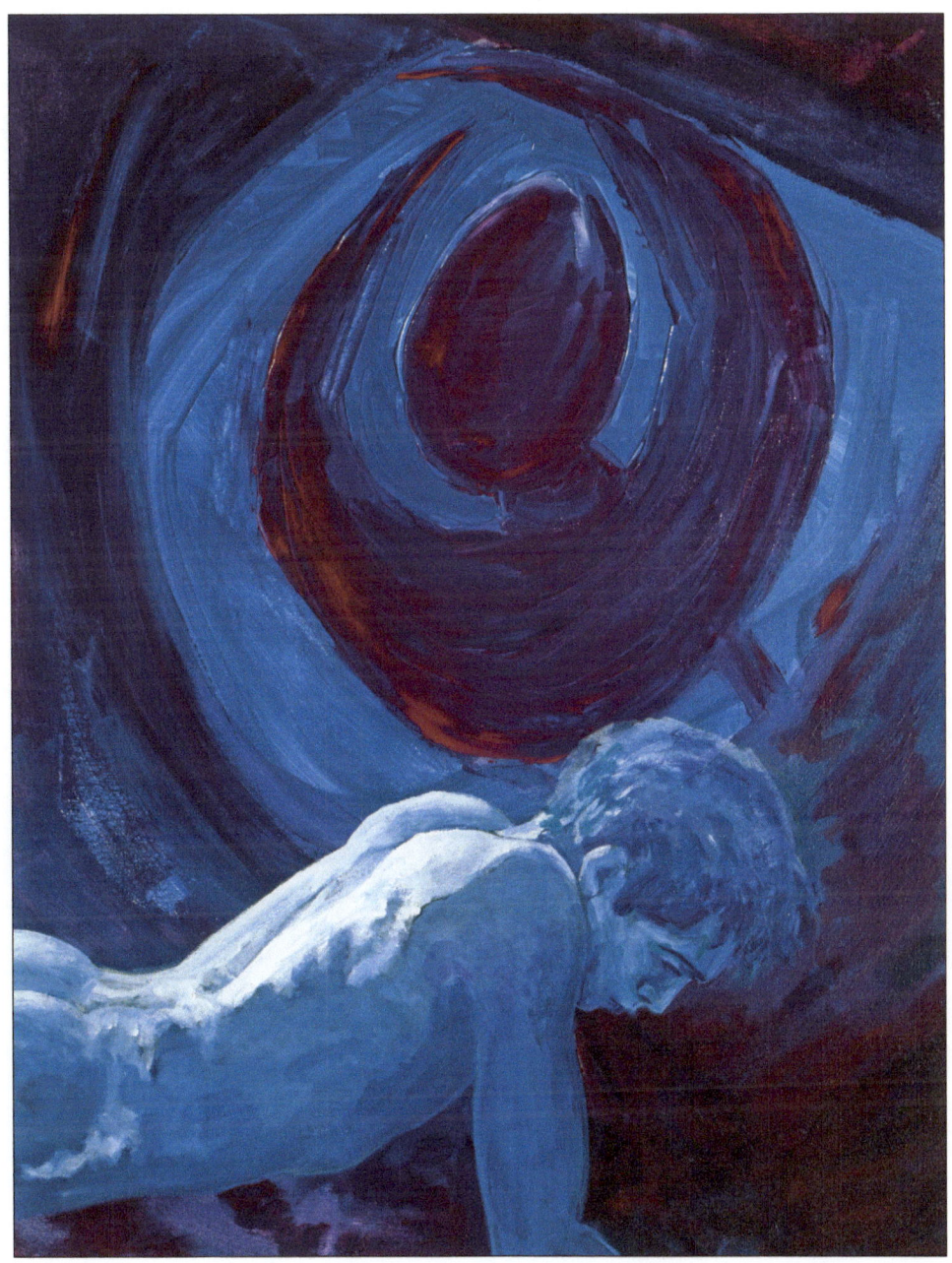

"Remorse", acrylic, 18"x24", 1999

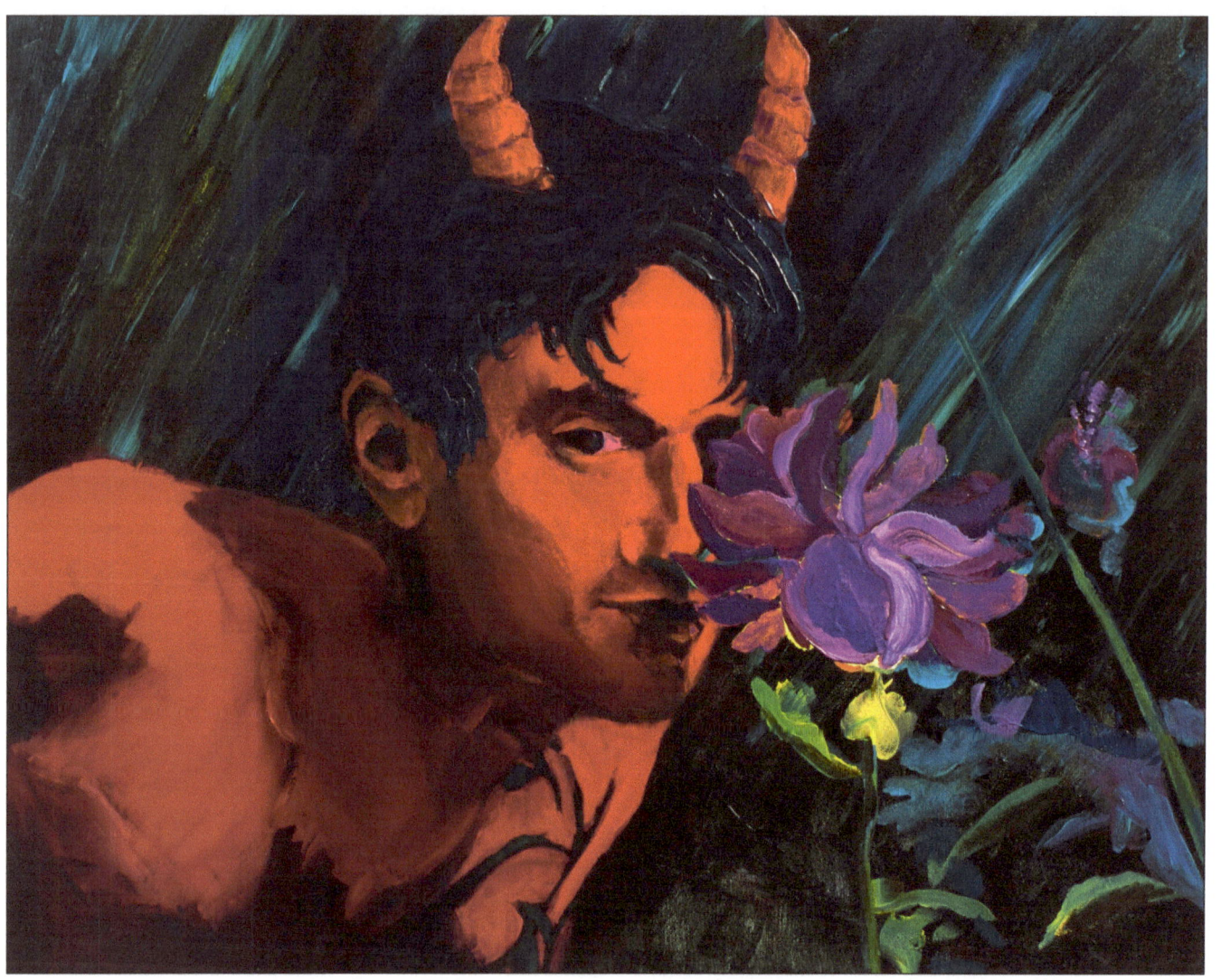

"Liar, Liar", acrylic, 20"x24", 2000

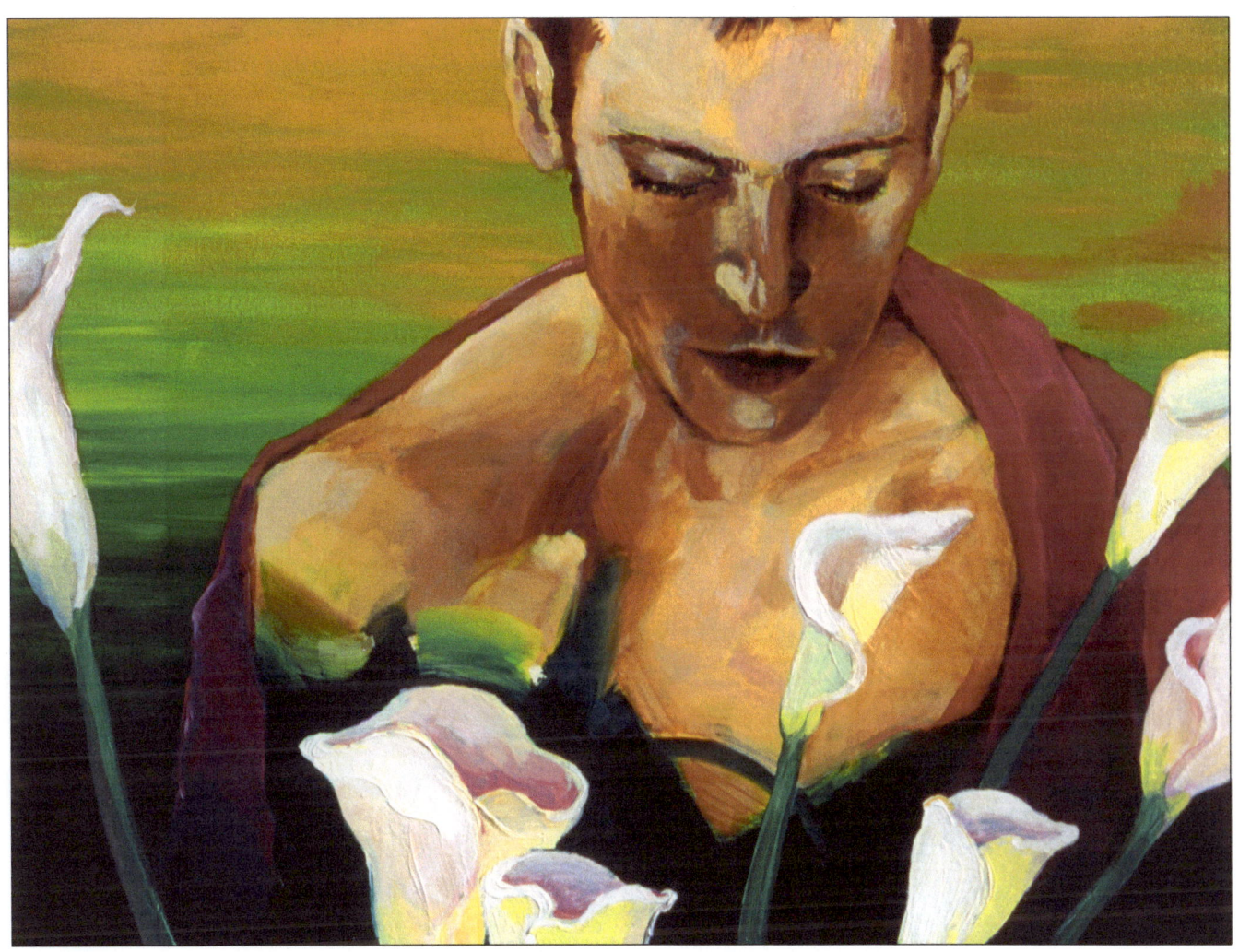

"Vergil's Dawn, acrylic, 24"x30", 2001

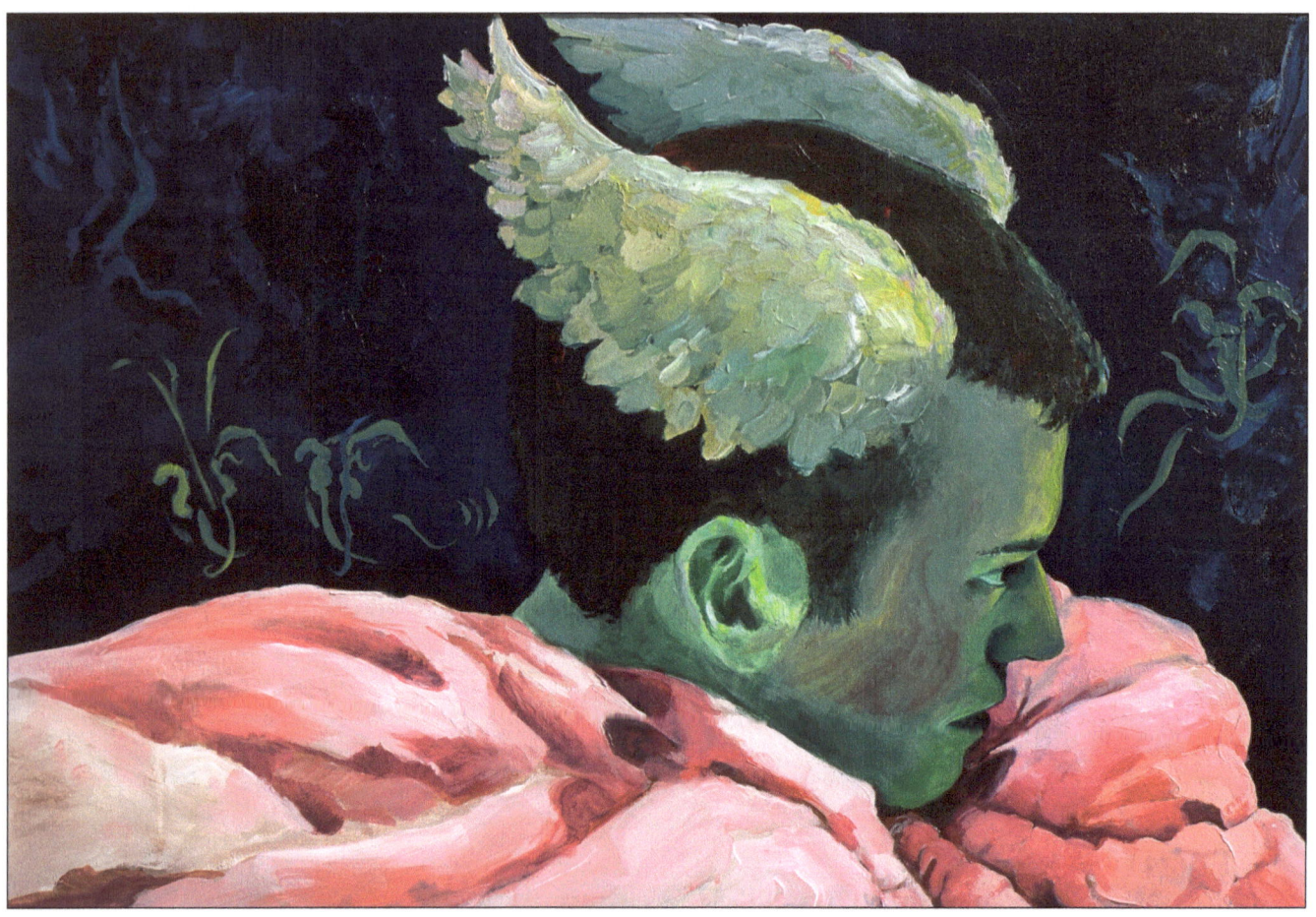

"First Sight", acrylic, 24"x36", 2000

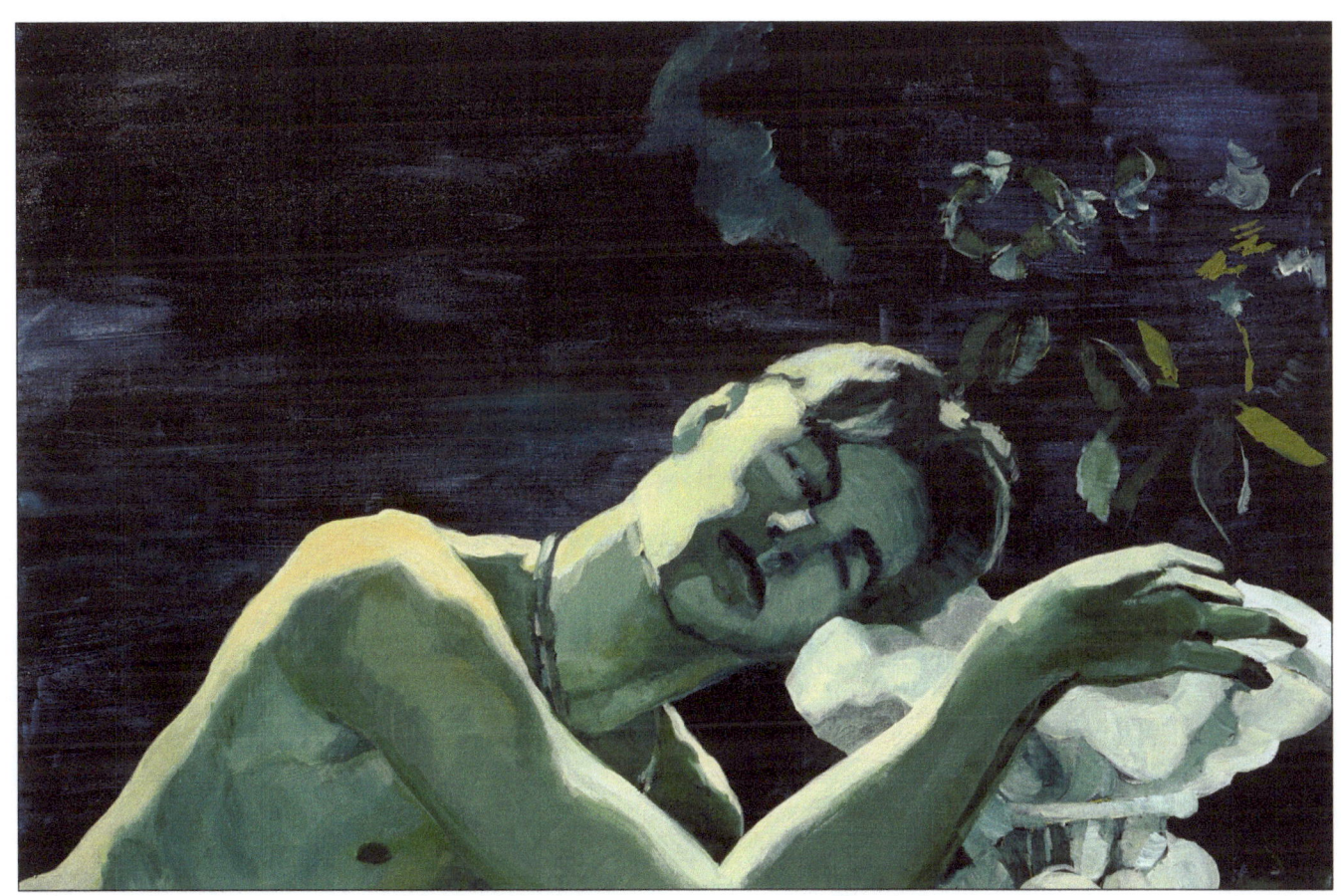

"In The Garden", acrylic, 24"x36", 2000

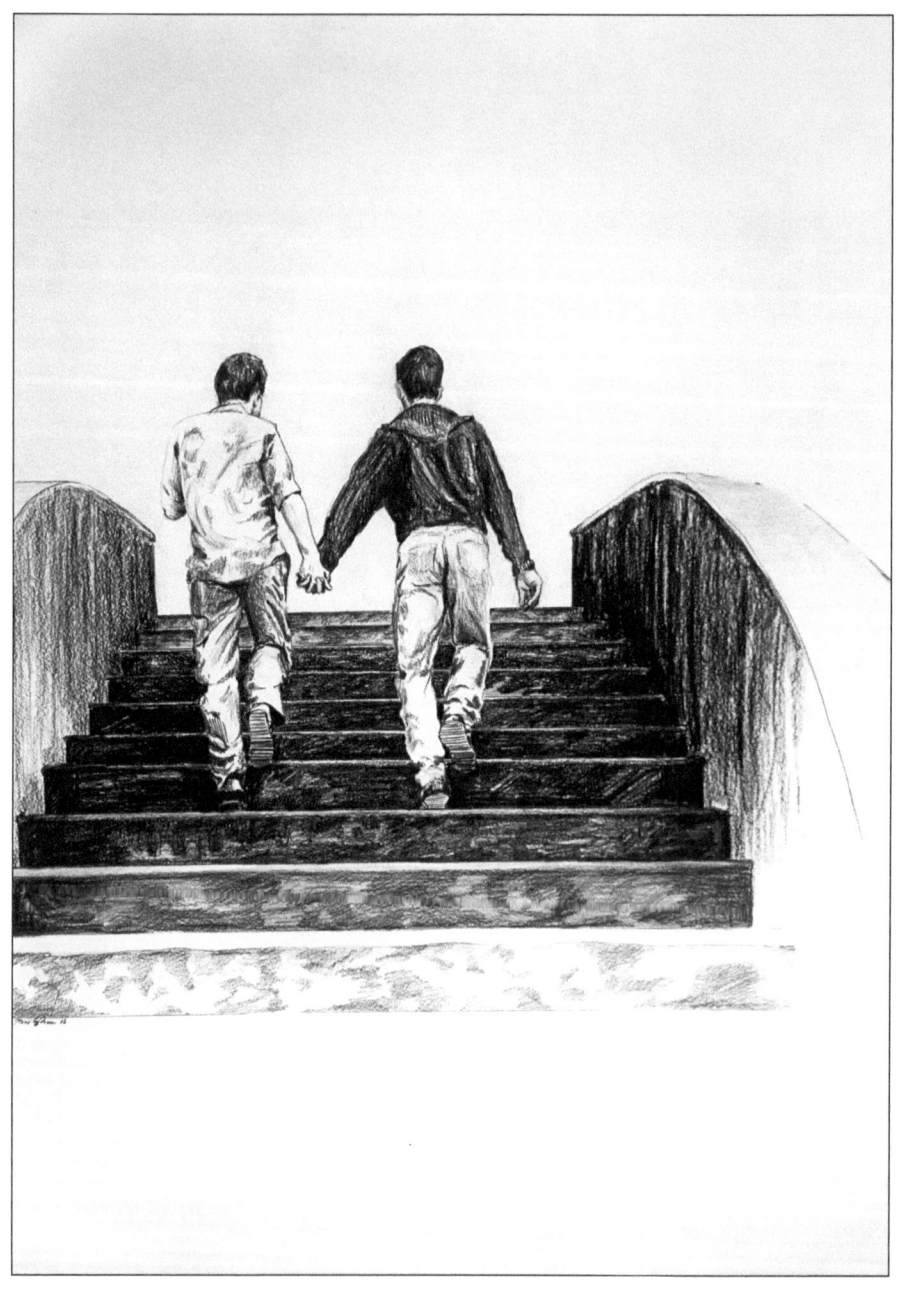

"Two Boys", pencil, 24"x36", 2002

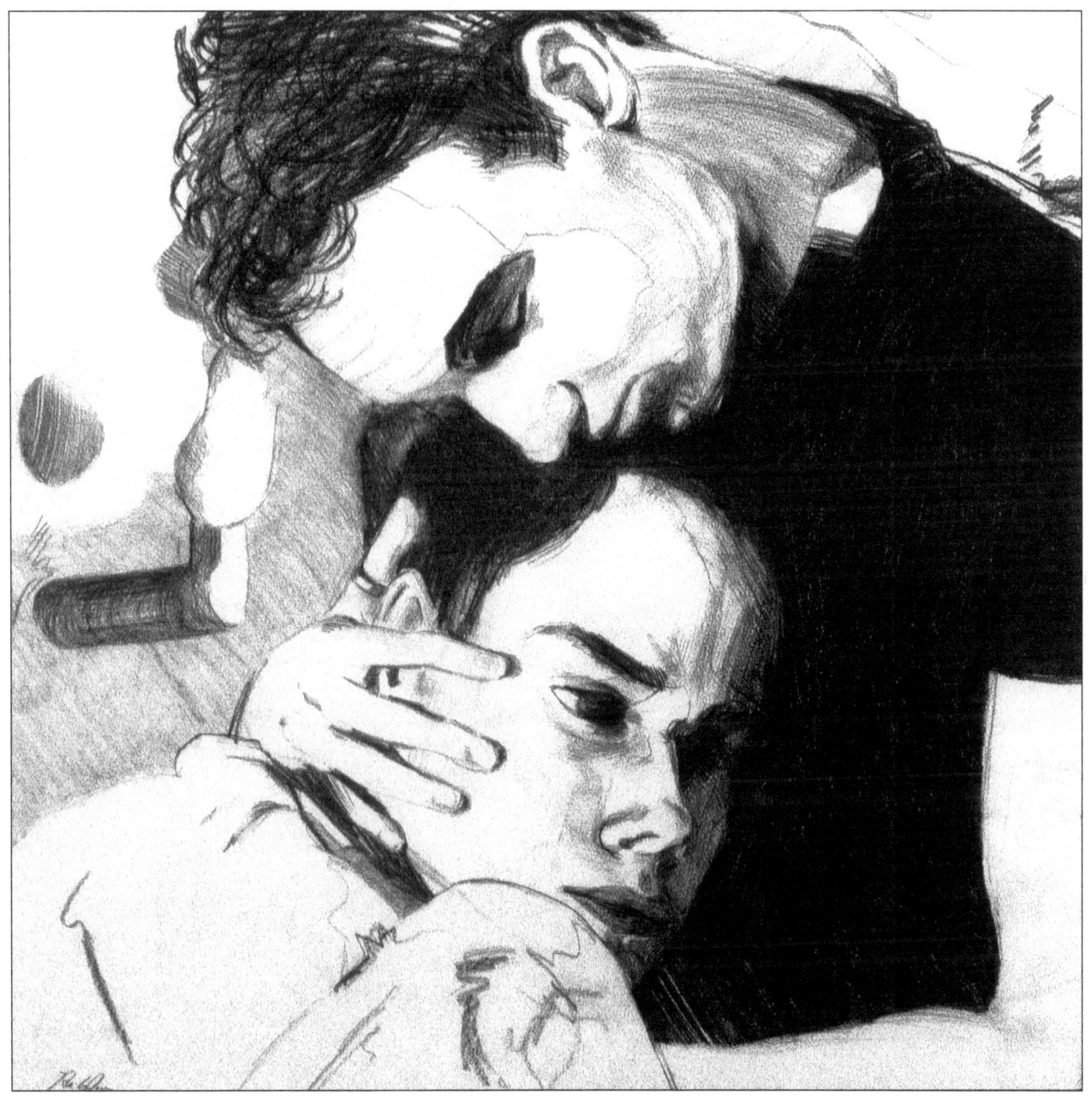

"Running Out Of Reasons", pencil, 24"x24", 2000

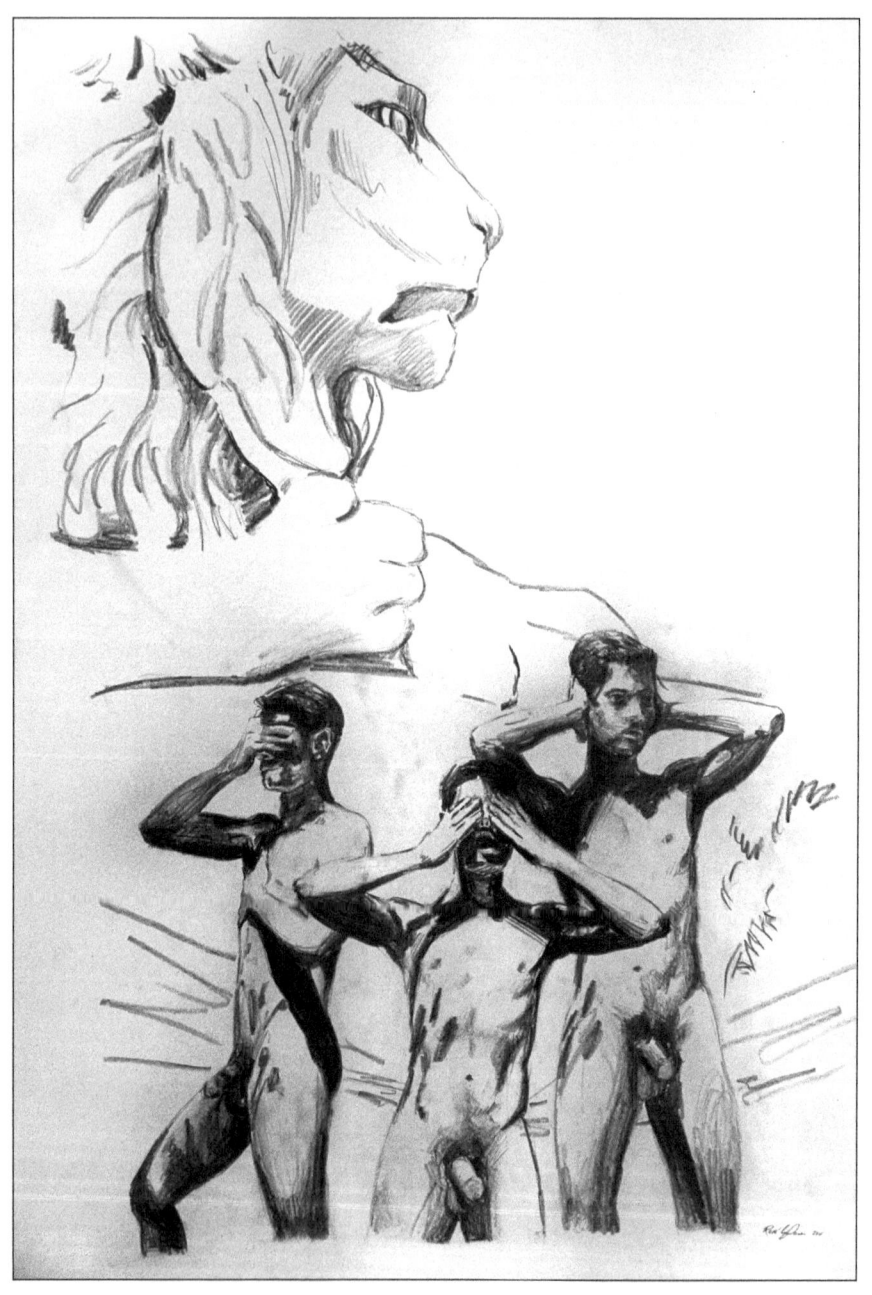

"See No Evil", pencil, 22"x30", 2000

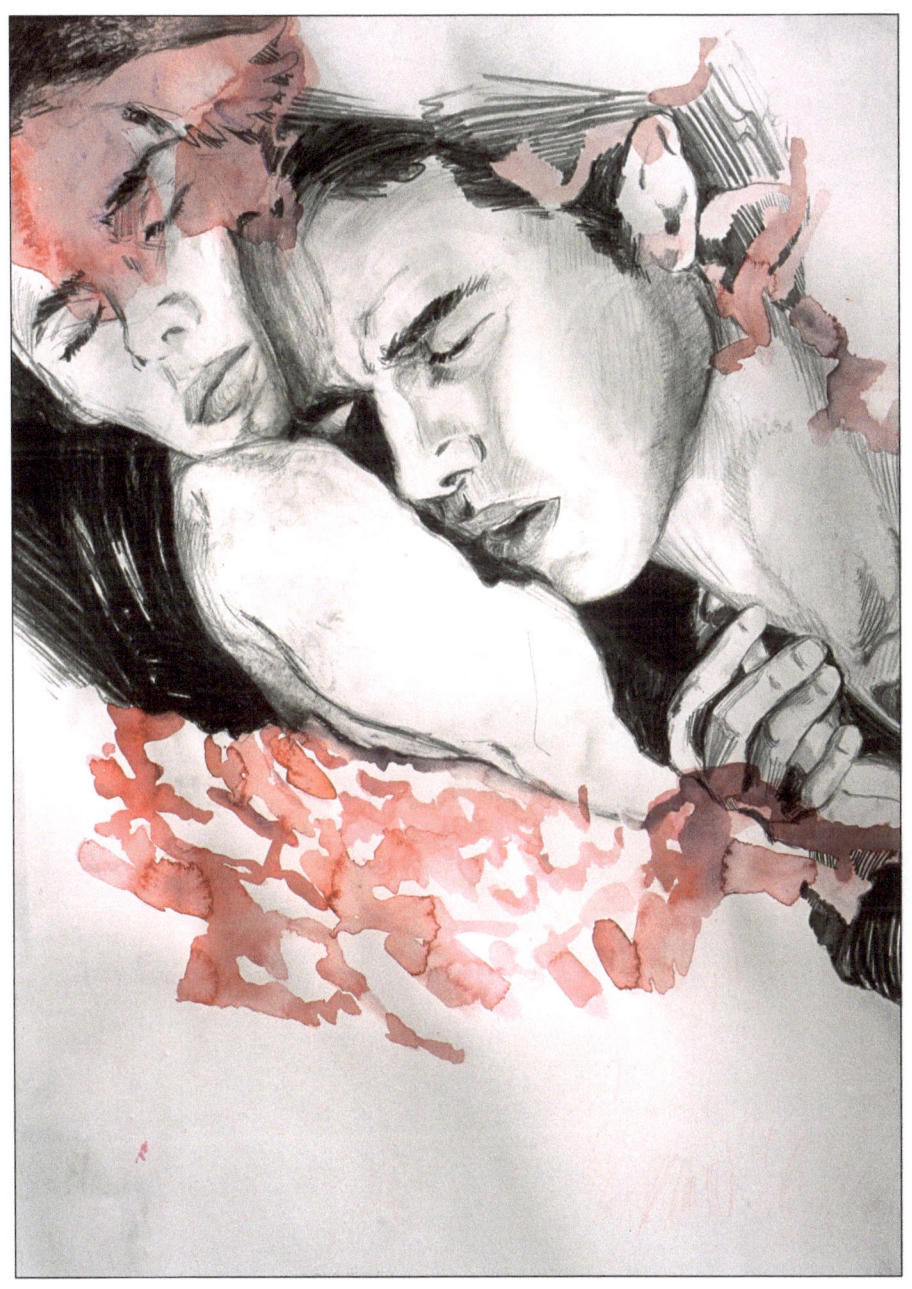

"Prodigal Lover", pencil and watercolor, 22"x30", 2001

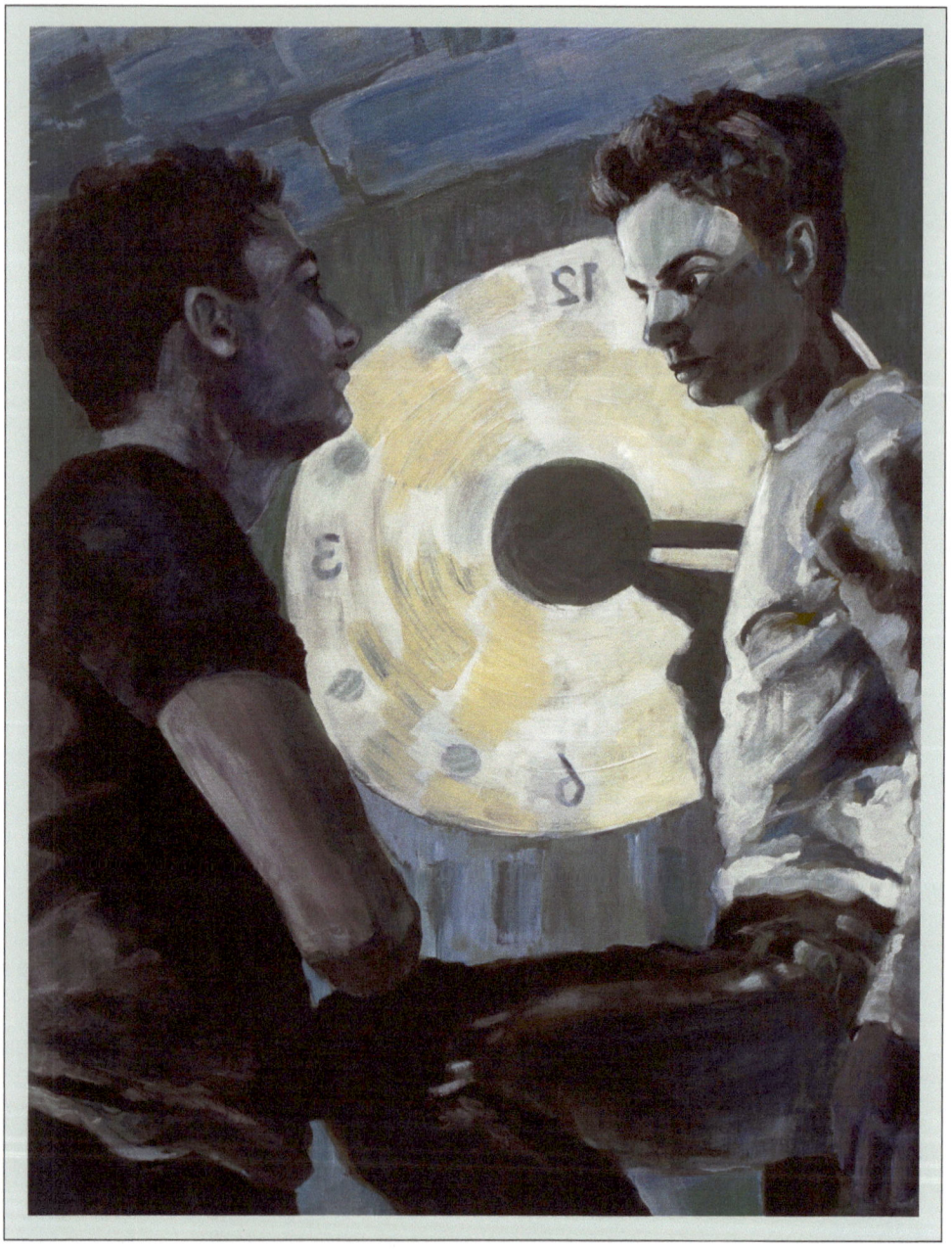

"Time", acrylic, 20"x24", 2001

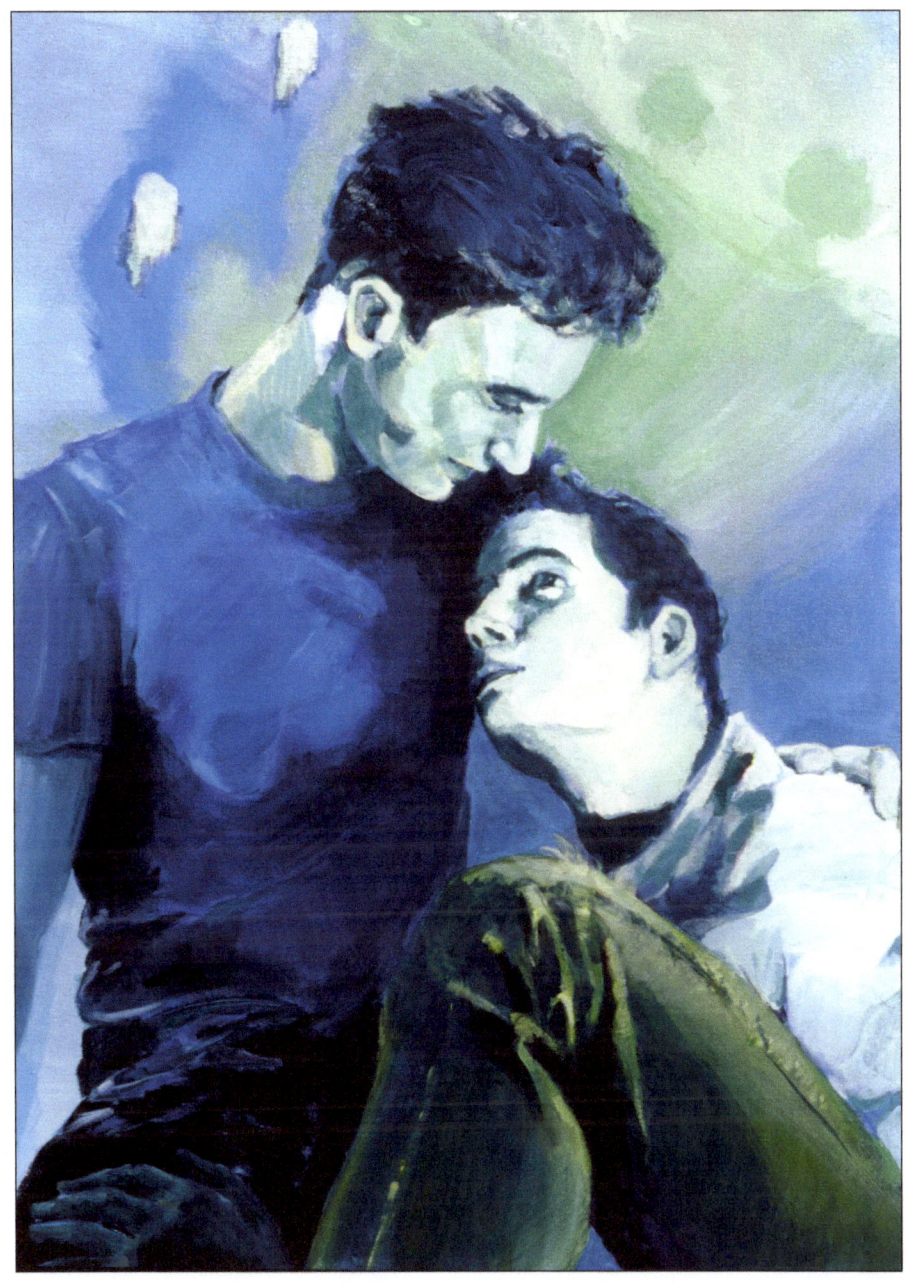

"Cradle My Heavy Heart", acrylic, 18"x20", 2001

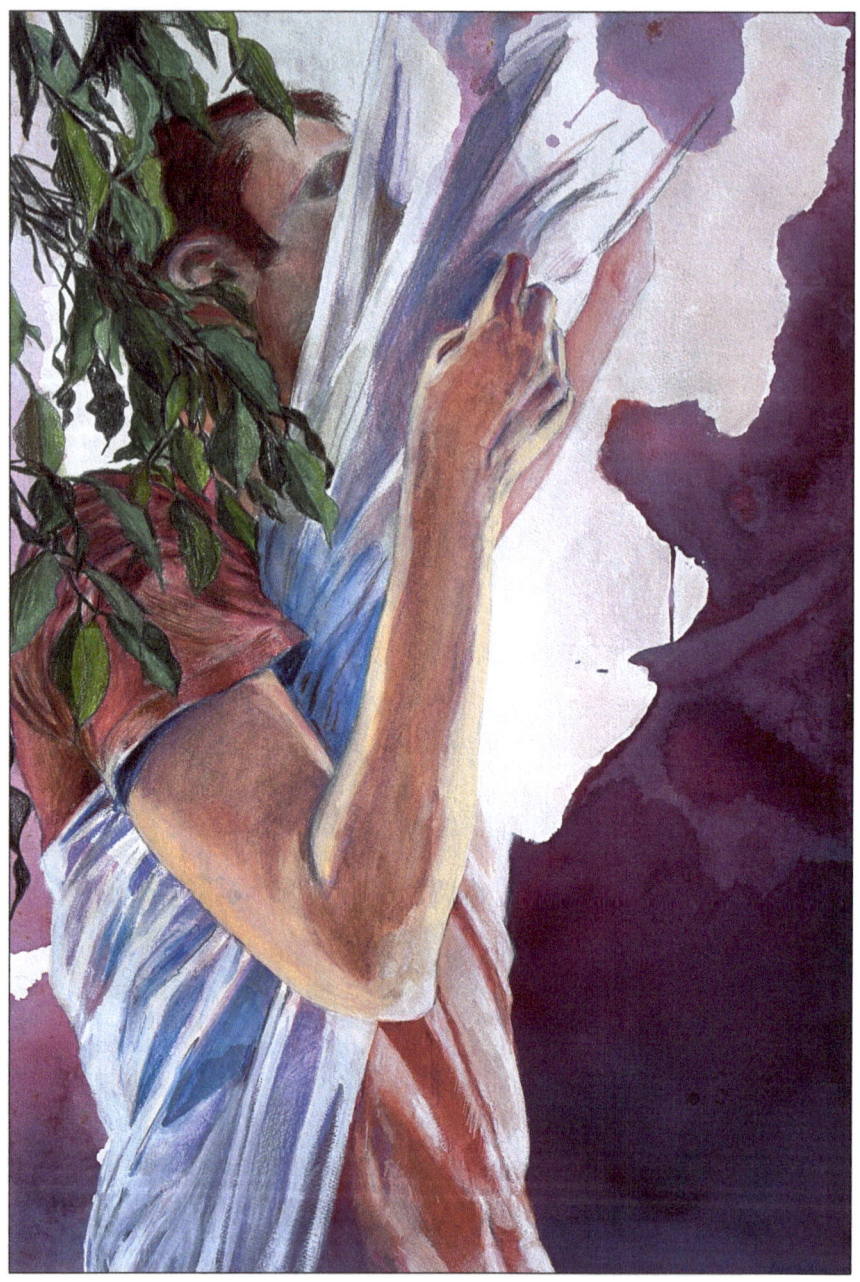

"Chrysalis", watercolor and color pencil, 22"x30", 2002

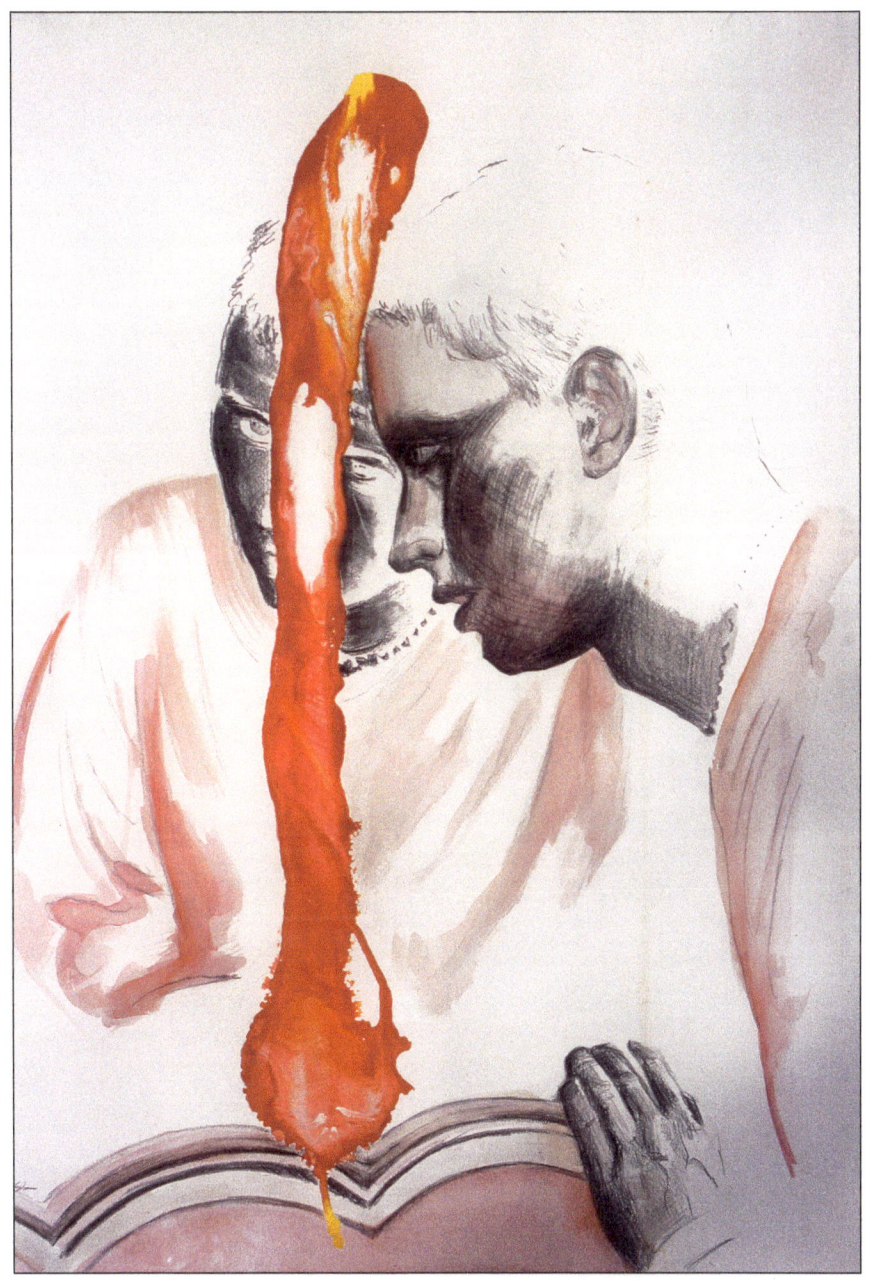

"Two Part Personality", watercolor and pencil, 22"x30", 2002

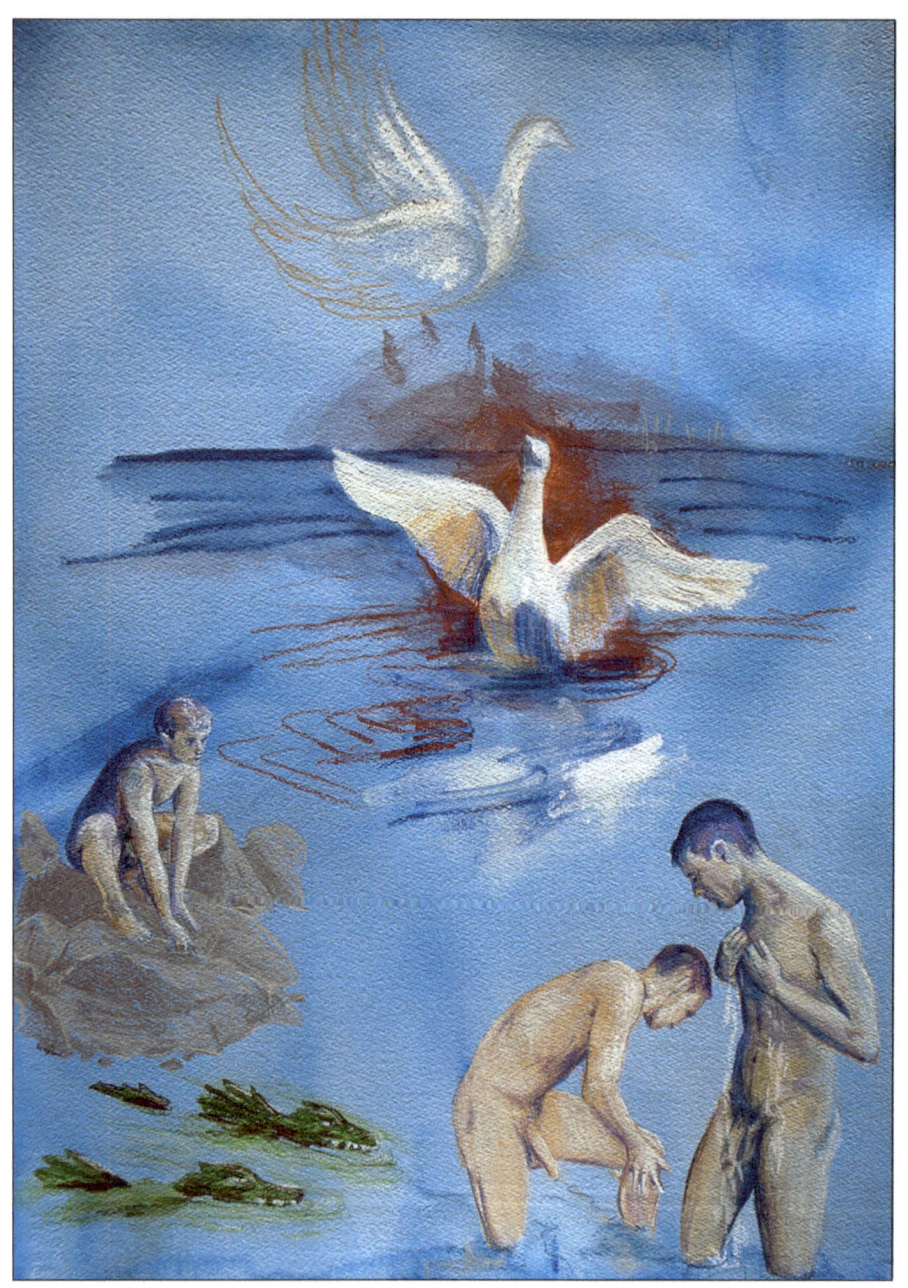

"In Hope and Danger", watercolor and color pencil, 22"x30", 2002

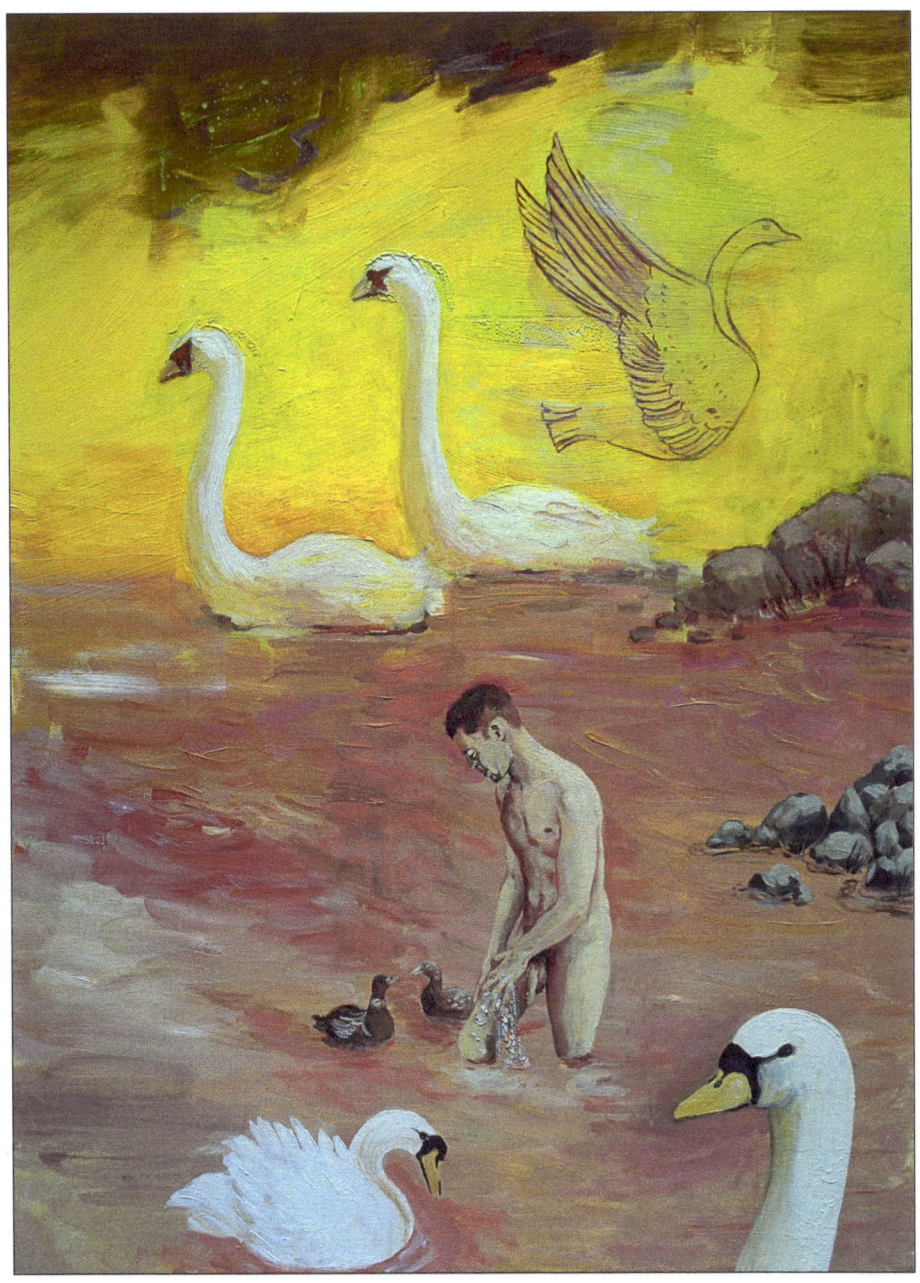

"White Swans", acrylic, 36"x48", 2002

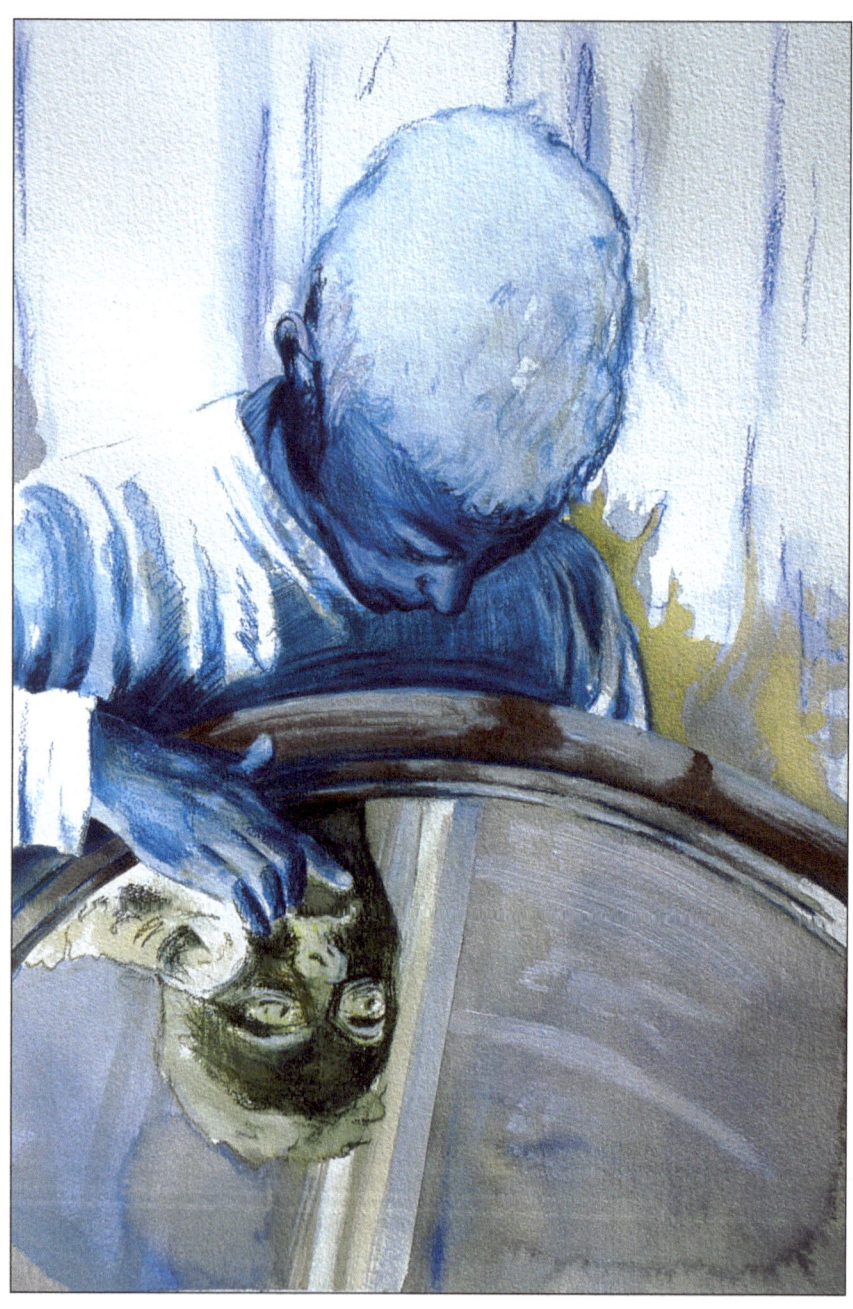

"Mirror, Mirror", watercolor, 22"x30", 2002

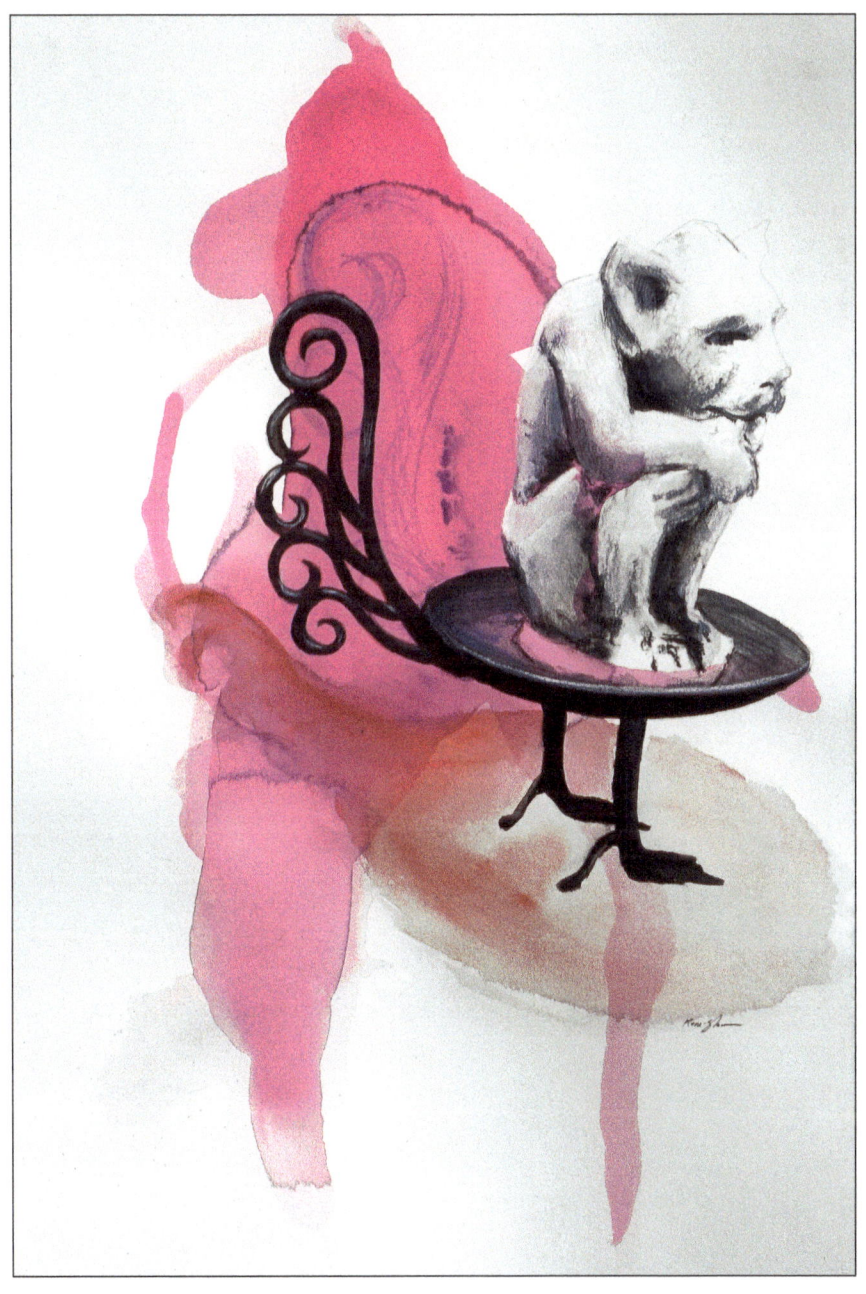

"Jealous Gargoyle", watercolor and color pencil, 22"x30", 2002

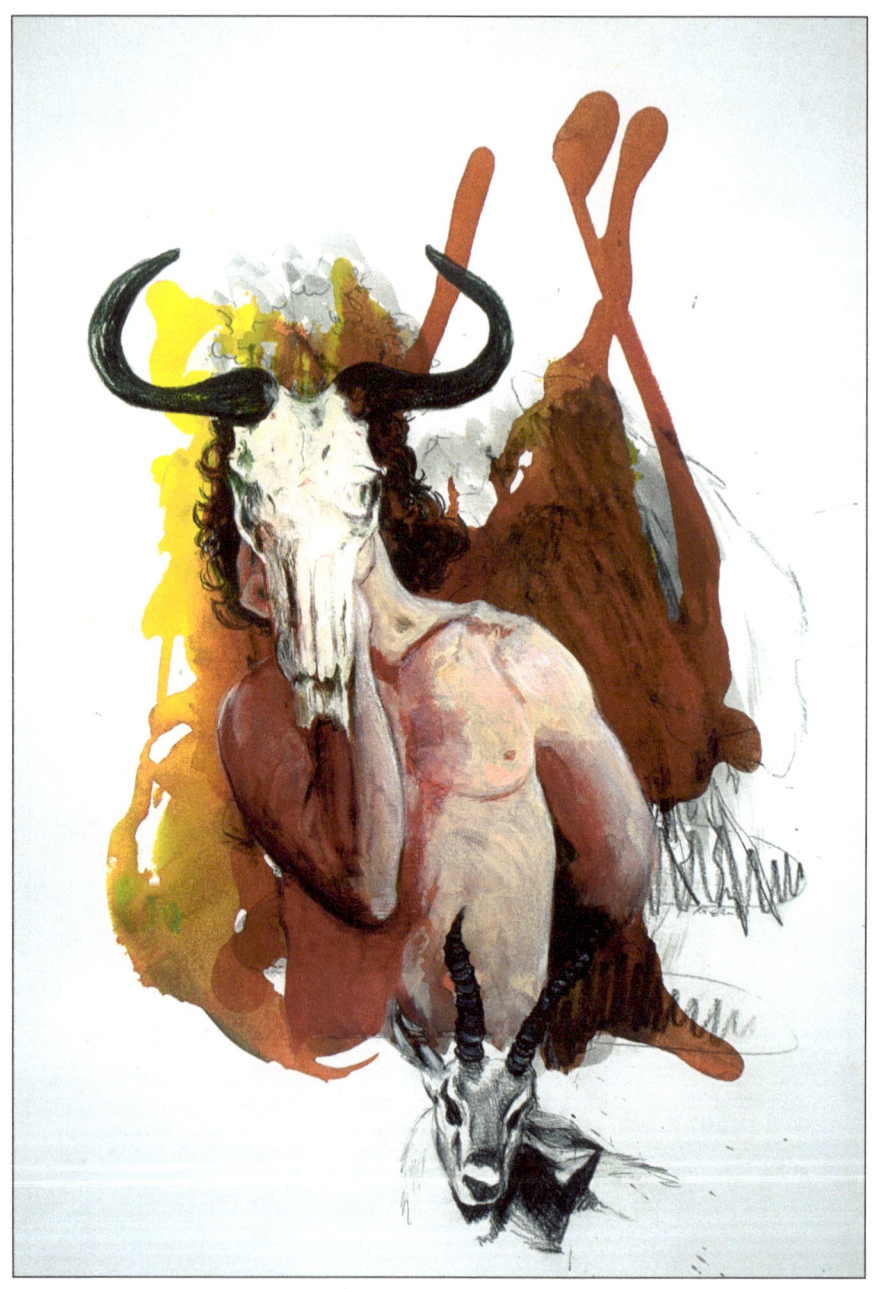

"Before and After", watercolor and color pencil, 22"x30", 2003

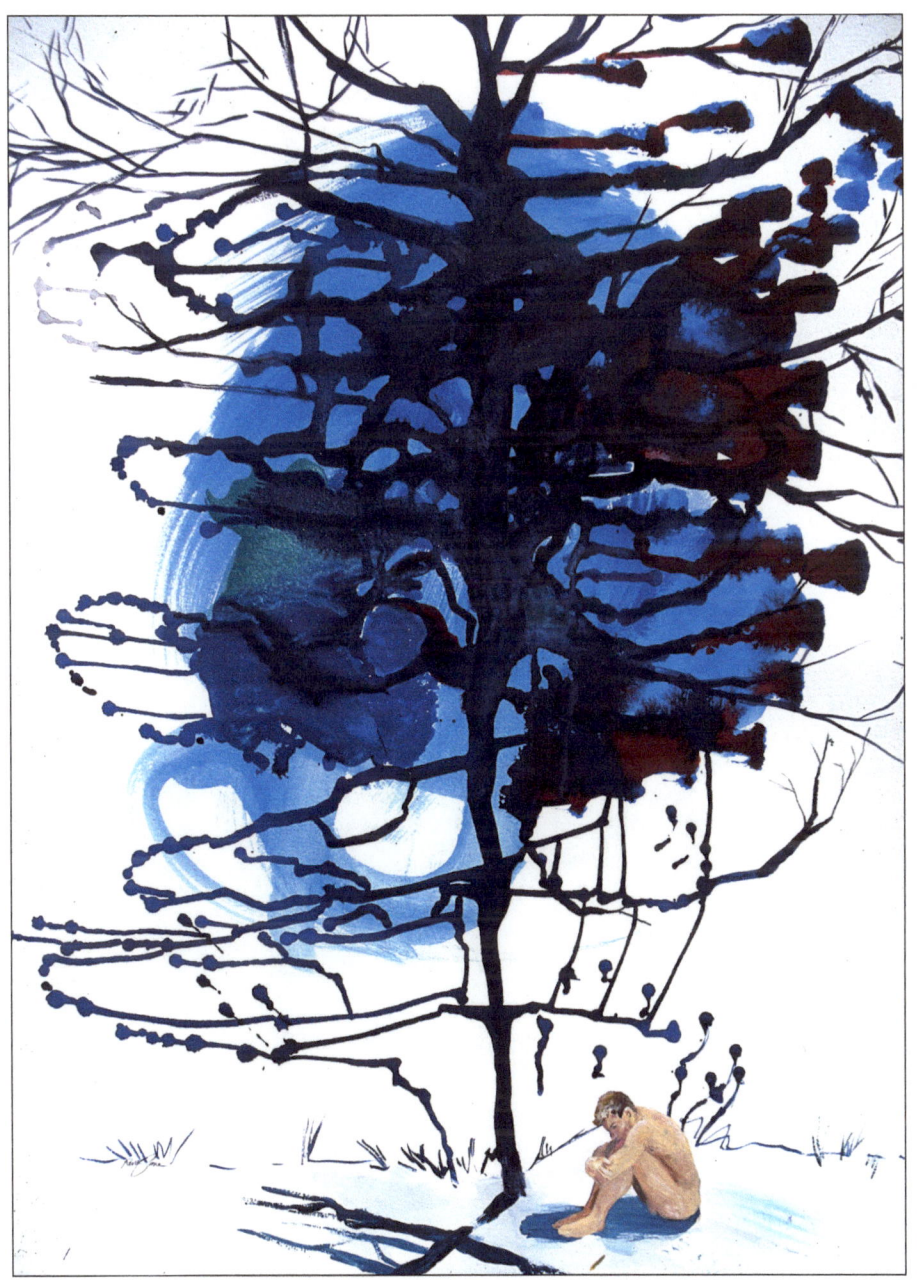

"All That I Really Know", watercolor and color pencil, 22"x30", 2003

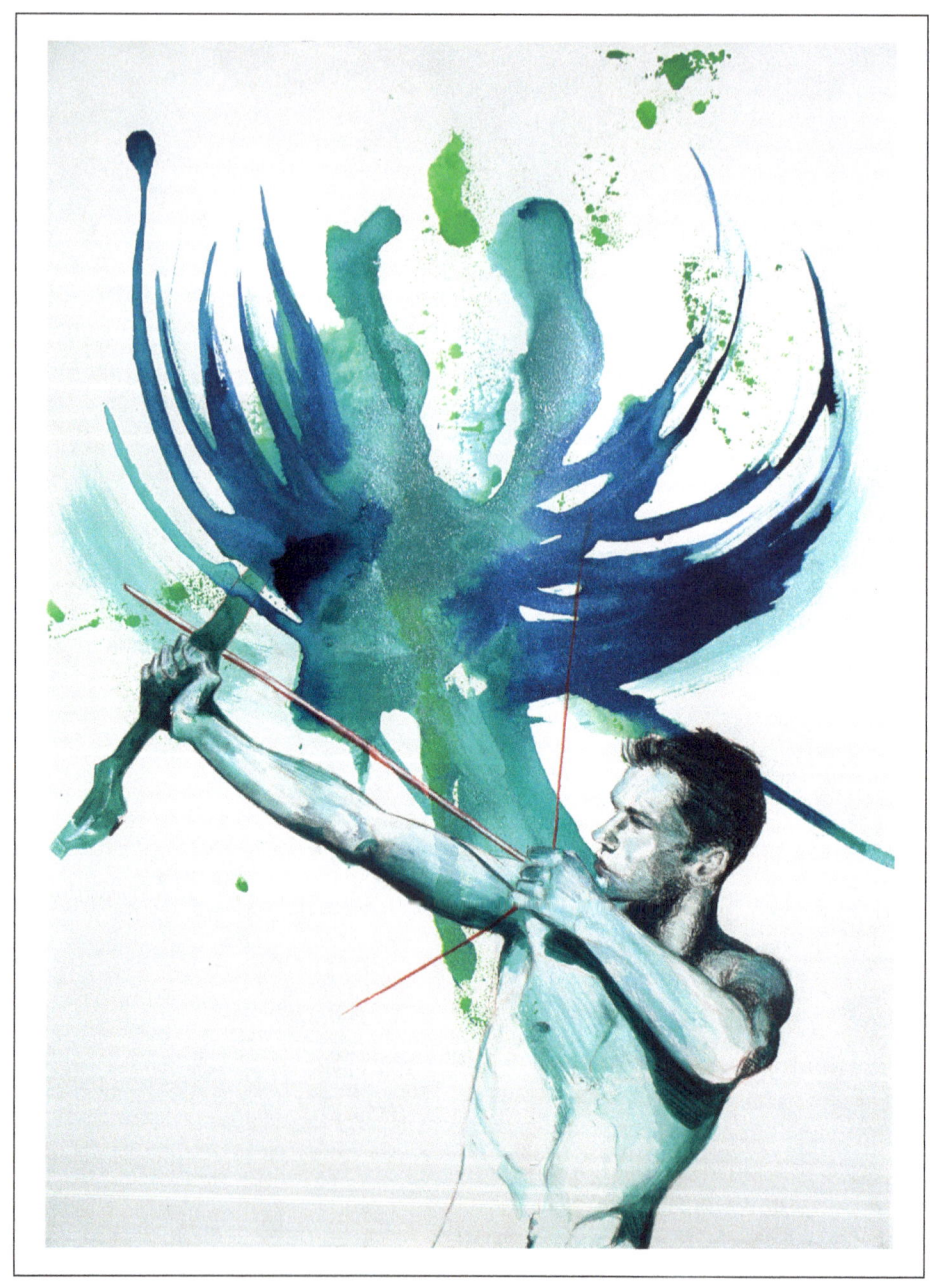

"Archer", watercolor, metallic ink and color pencil, 22"x30", 2003

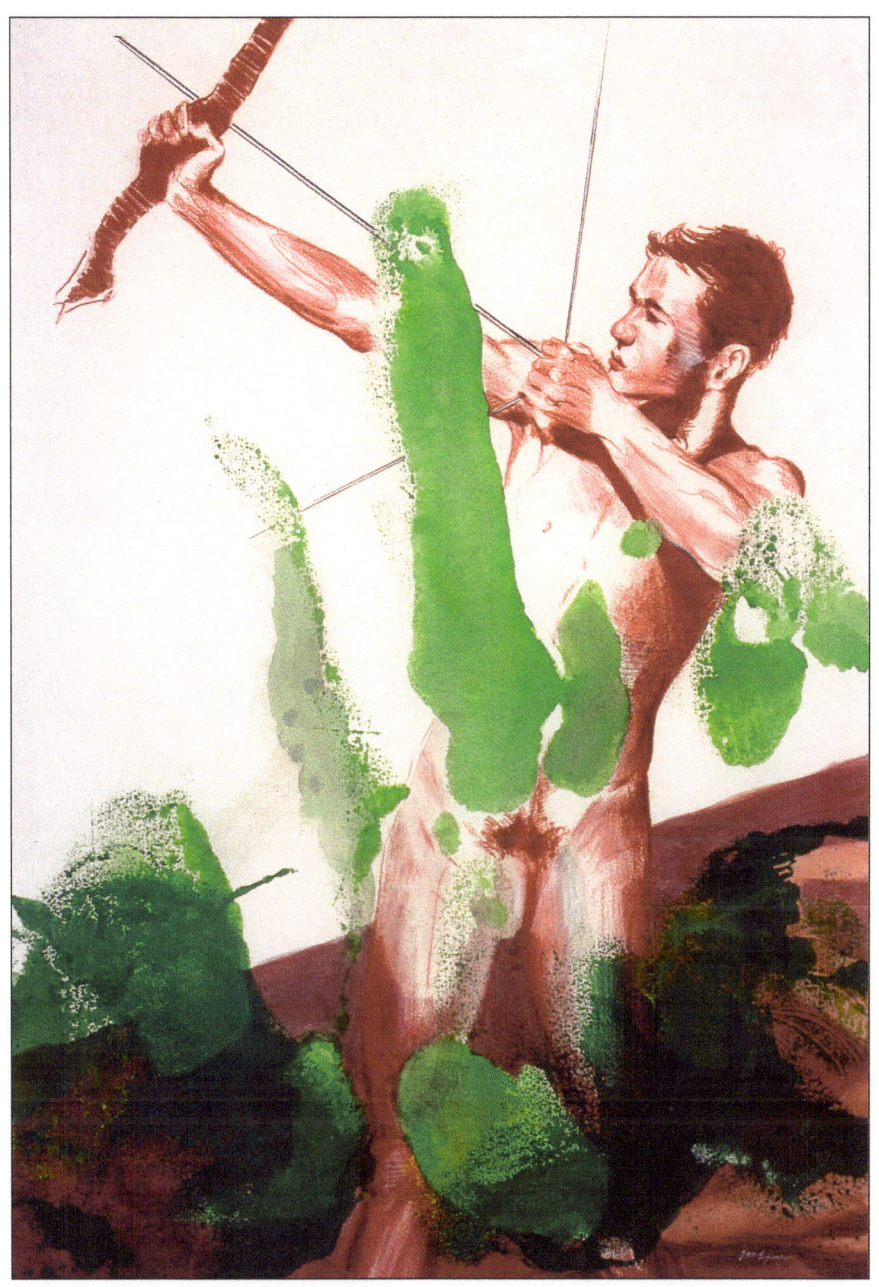

"Red Archer", watercolor and pencil, 22"x30", 2003

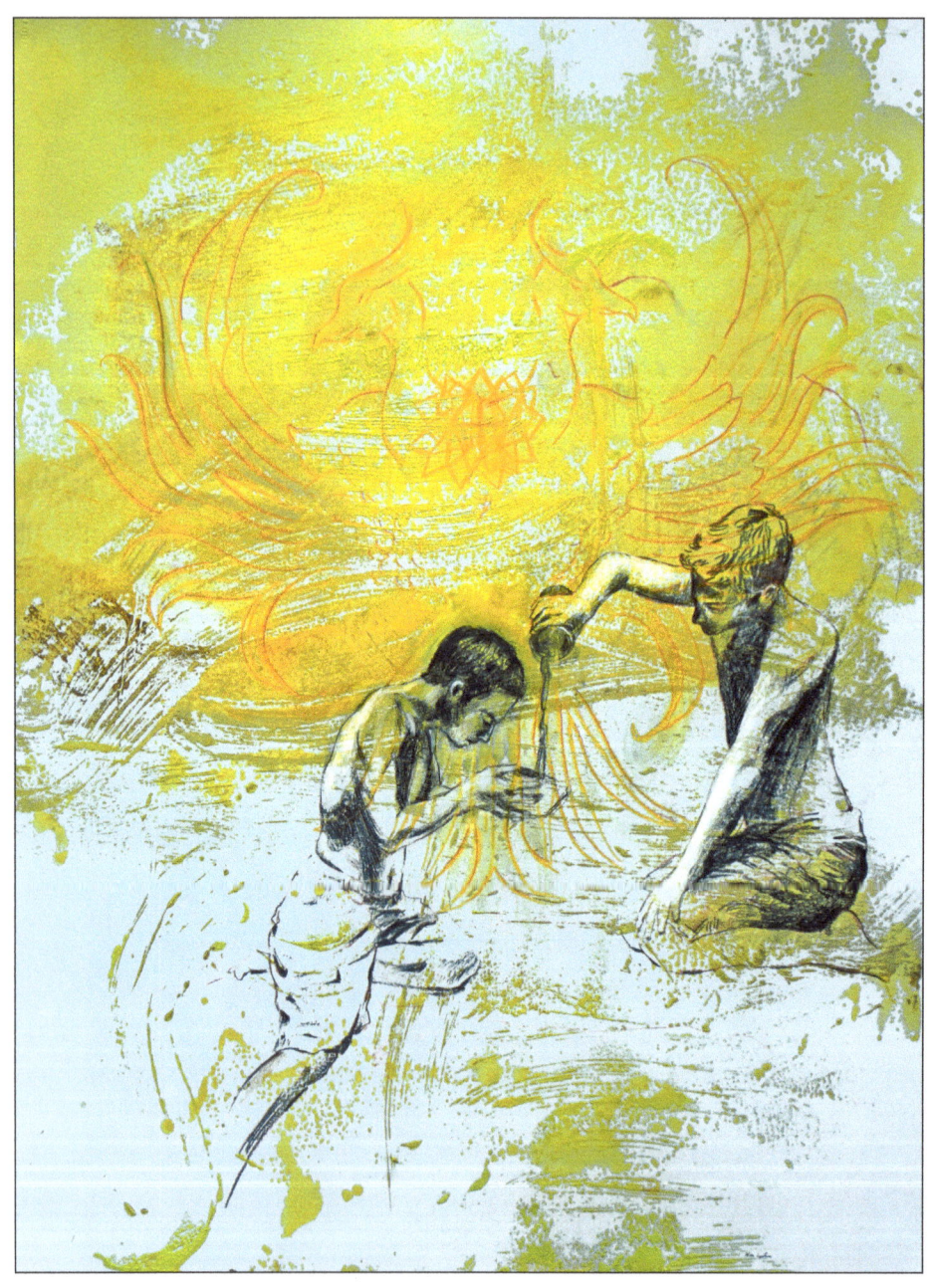

"Prey", watercolor and pencil, 22"x30", 2003

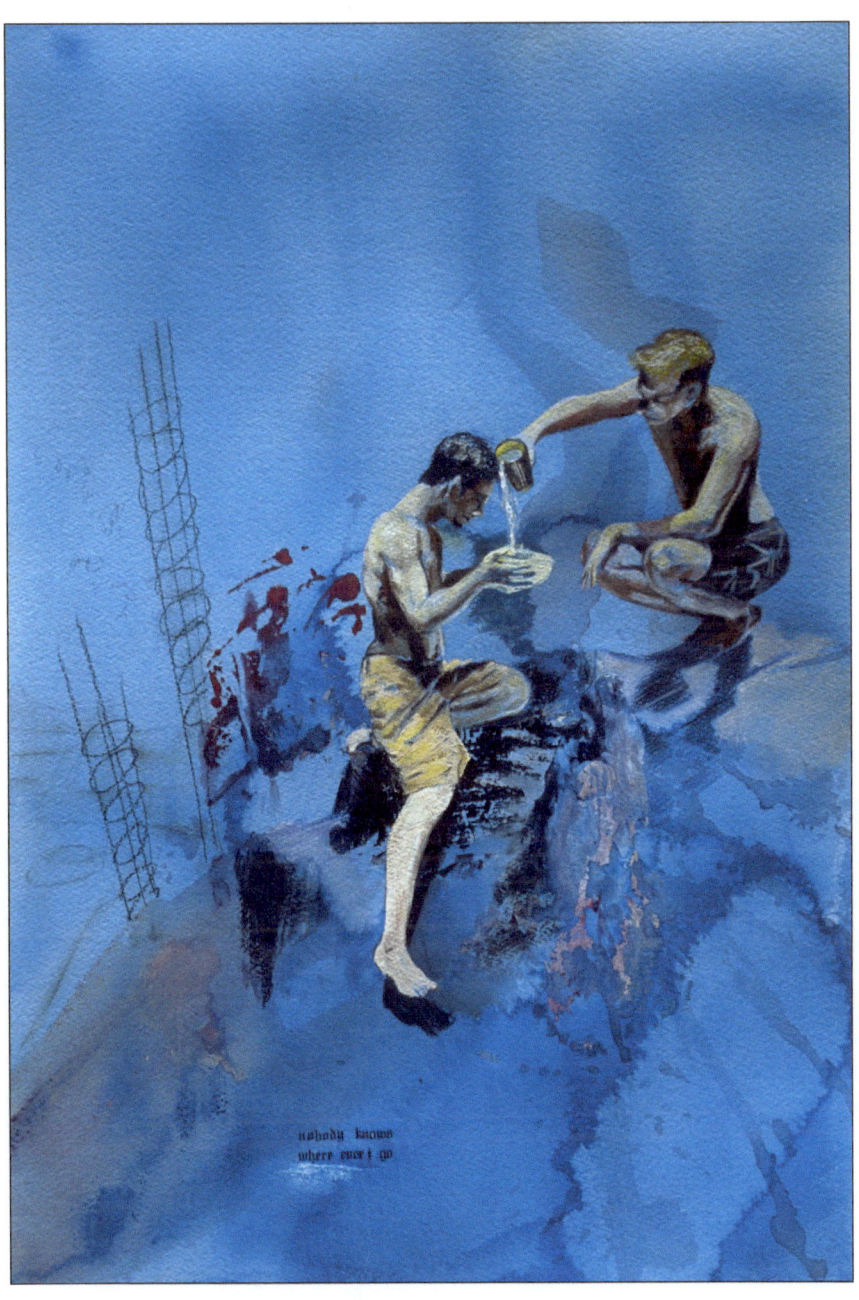

"Nobody Knows", watercolor and pencil, 22"x30", 2003

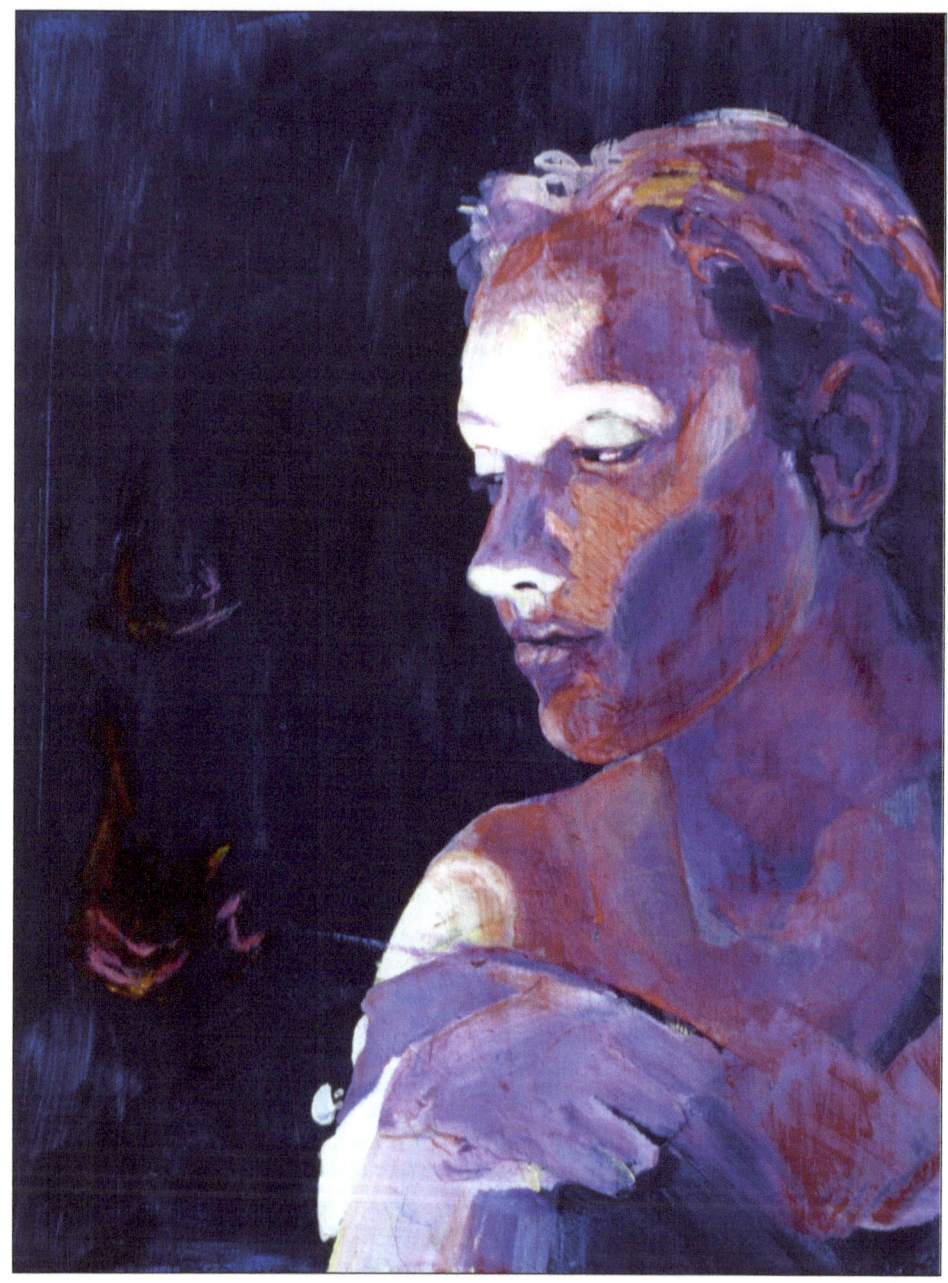

"Beauty", acrylic, 18"x24", 2001

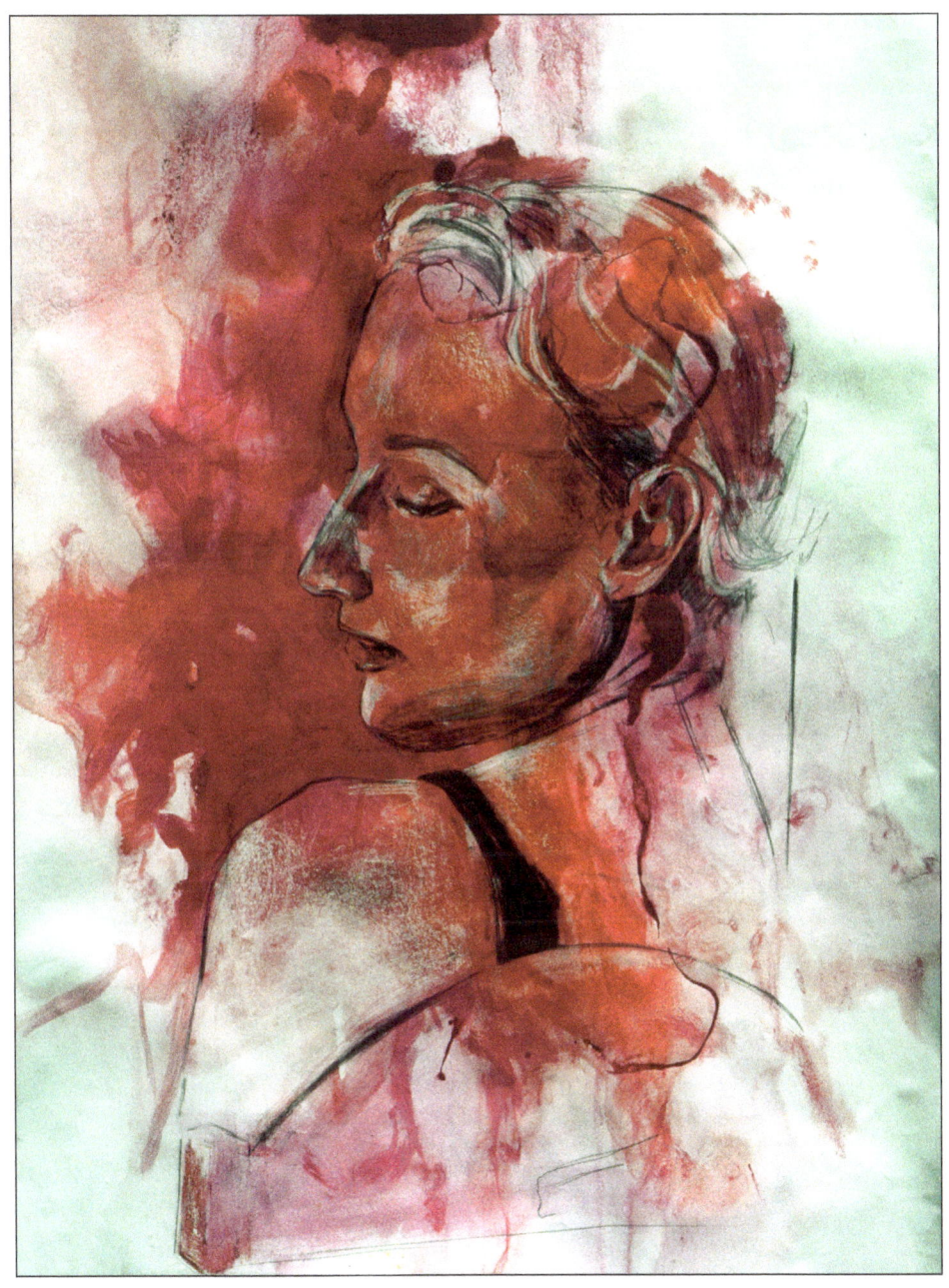

"Elegance", watercolor and pencil, 23"x34", 2000

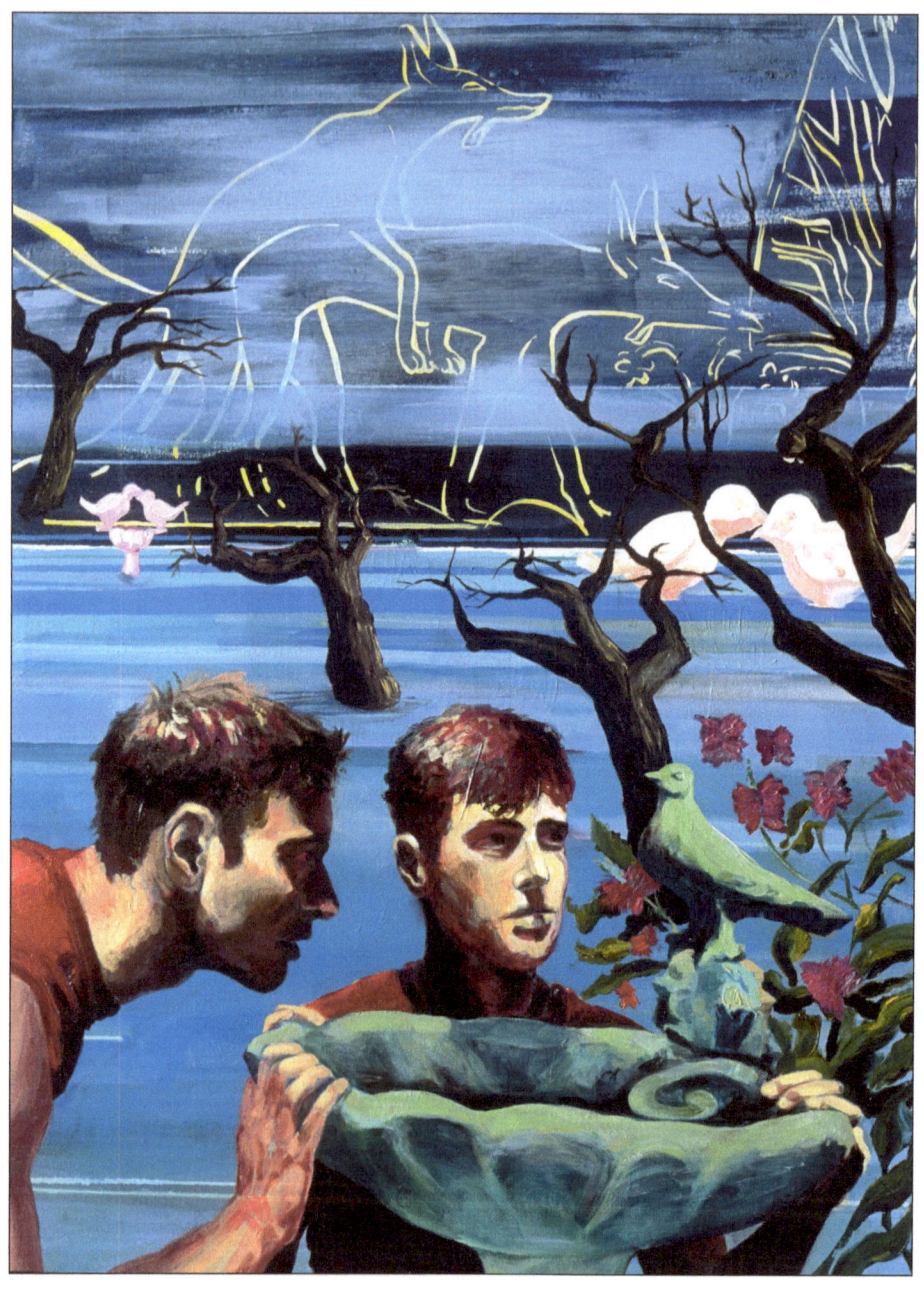

"Student of Expectation", acrylic, 36"x48", 2001

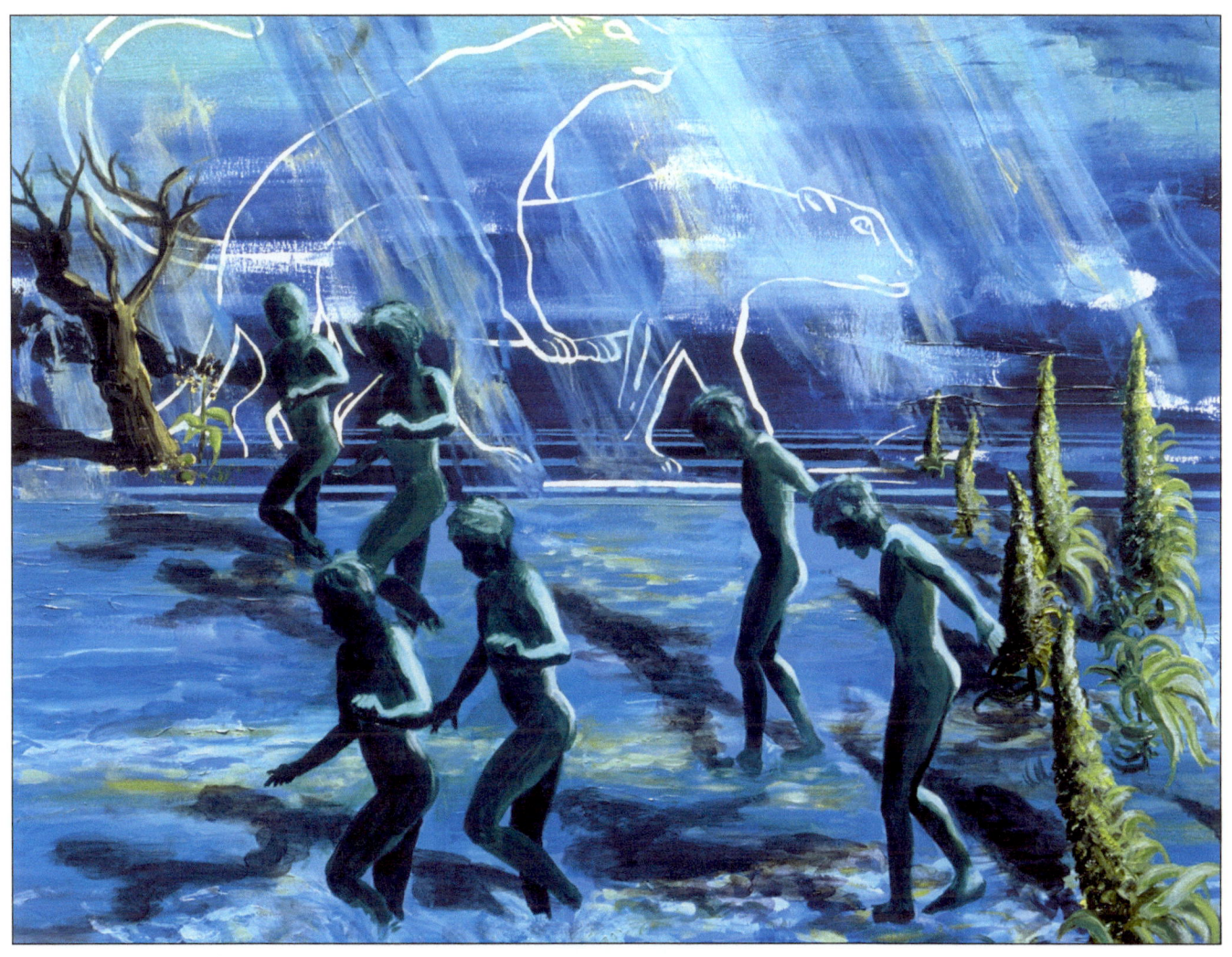

"Run", acrylic, 36"x48", 2001

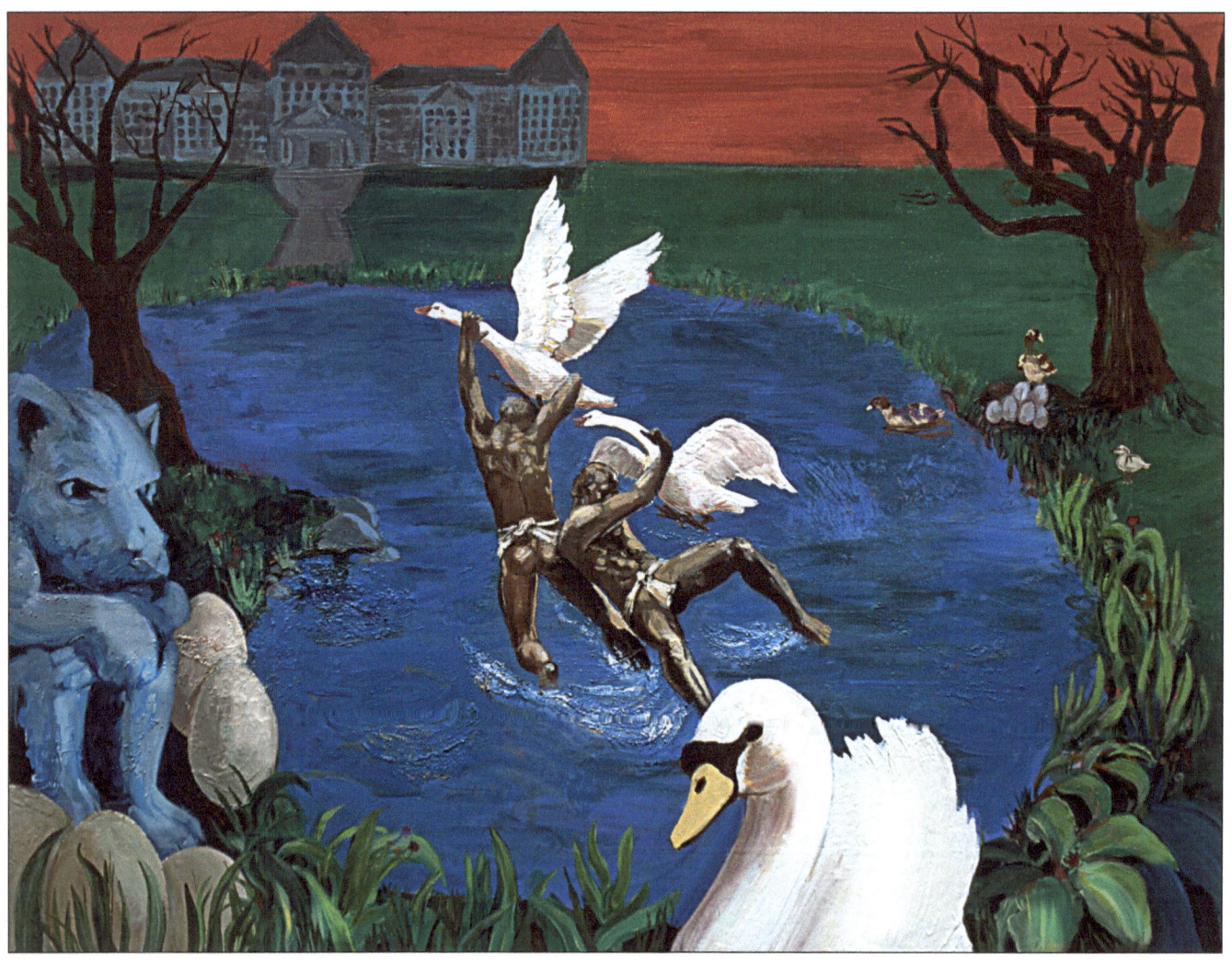

"Bedlam", acrylic, 24"x30", 2003

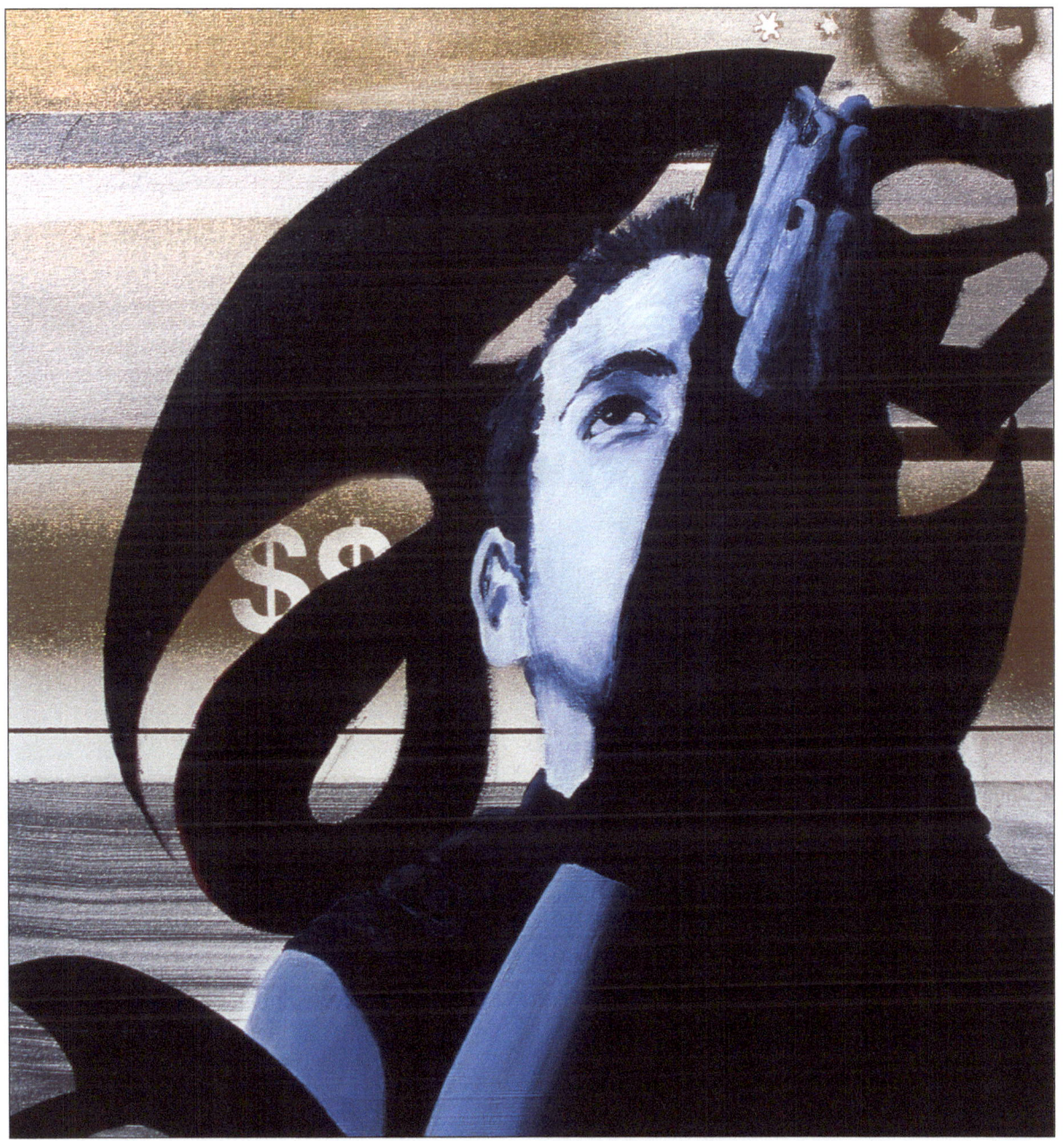

"Love or Money", acrylic, 24"x28", 2003

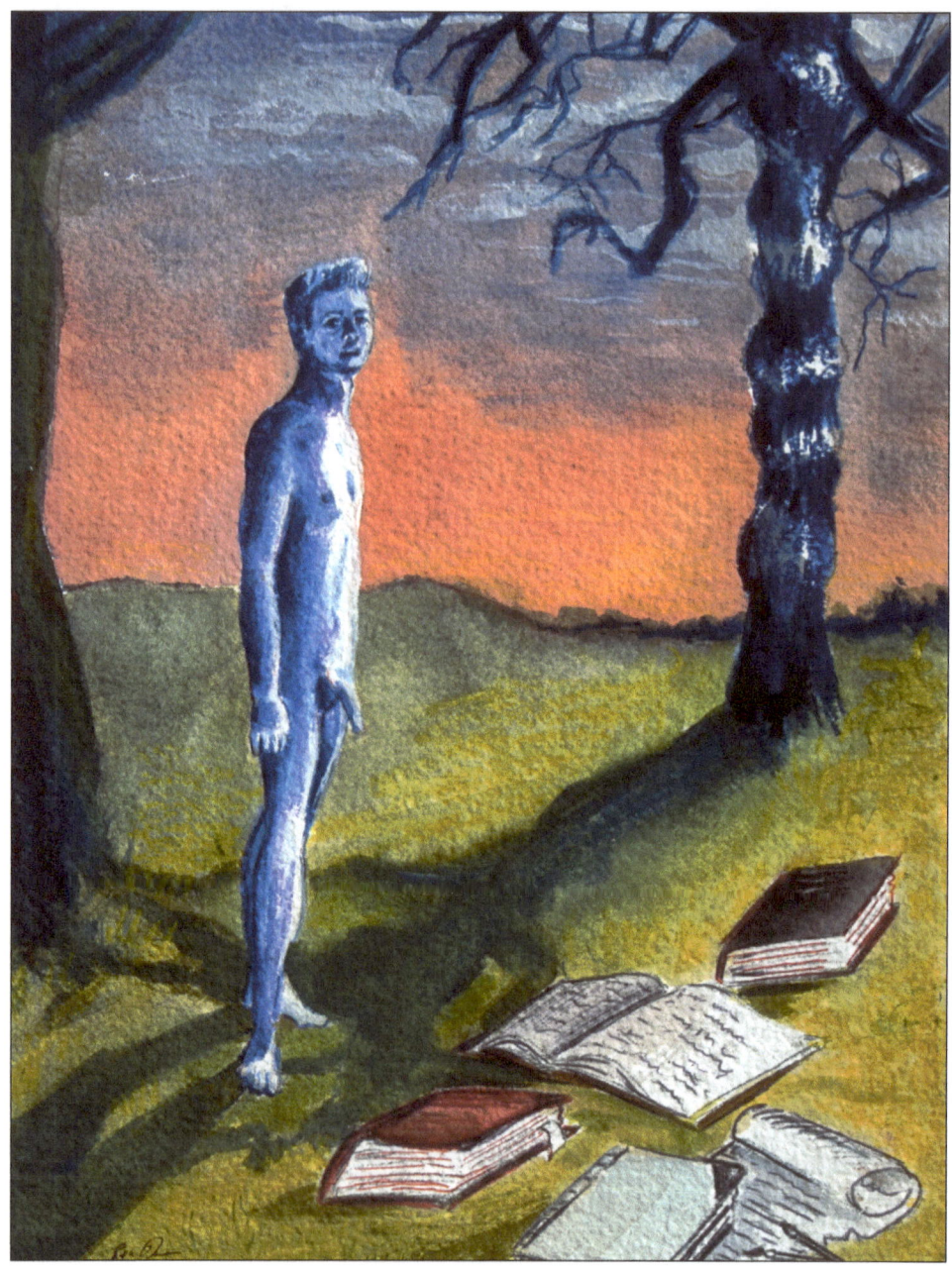

"Lost", watercolor, 8"x10", 2004

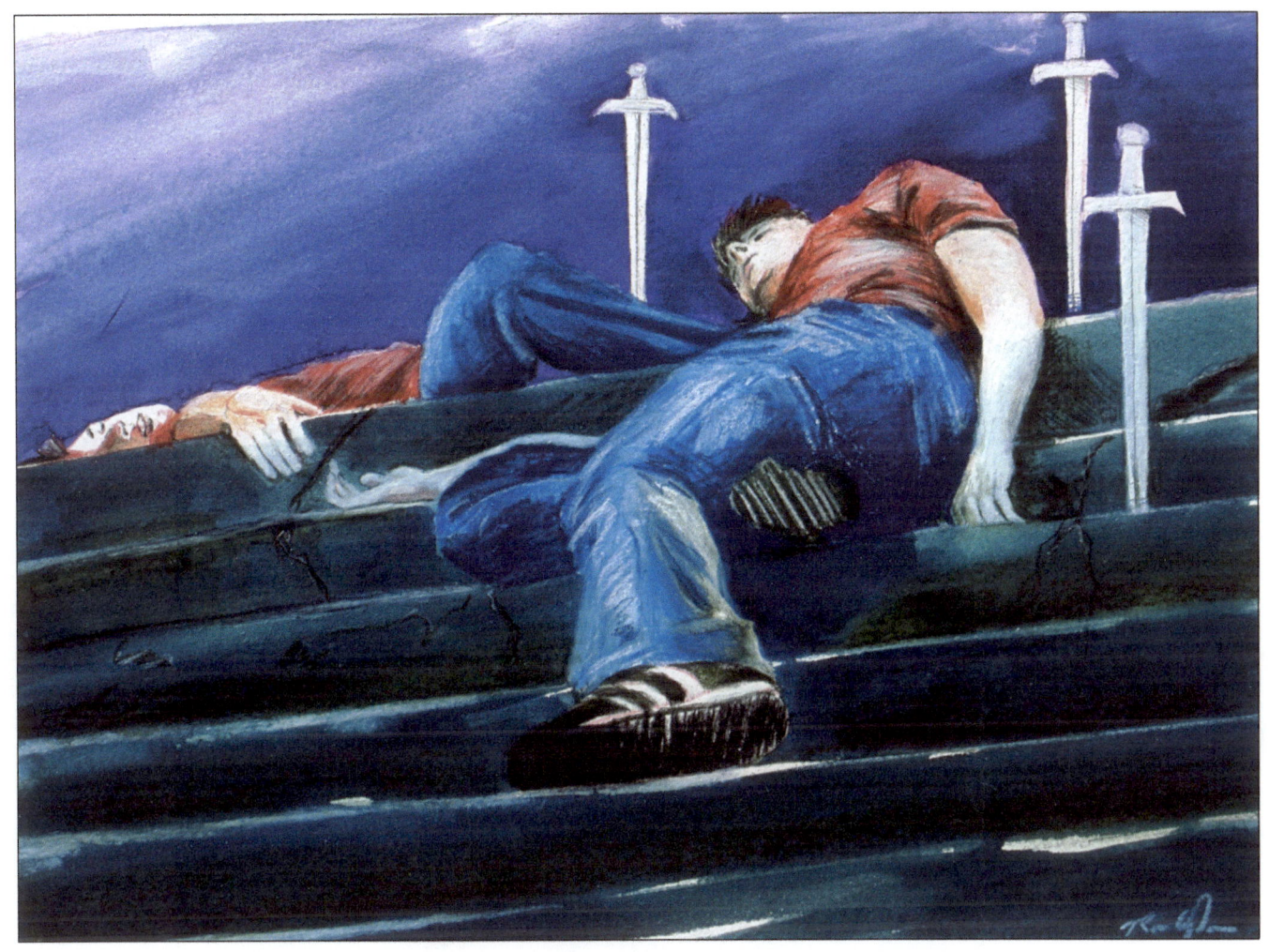
"Three of Swords", watercolor, 9"x12", 2004

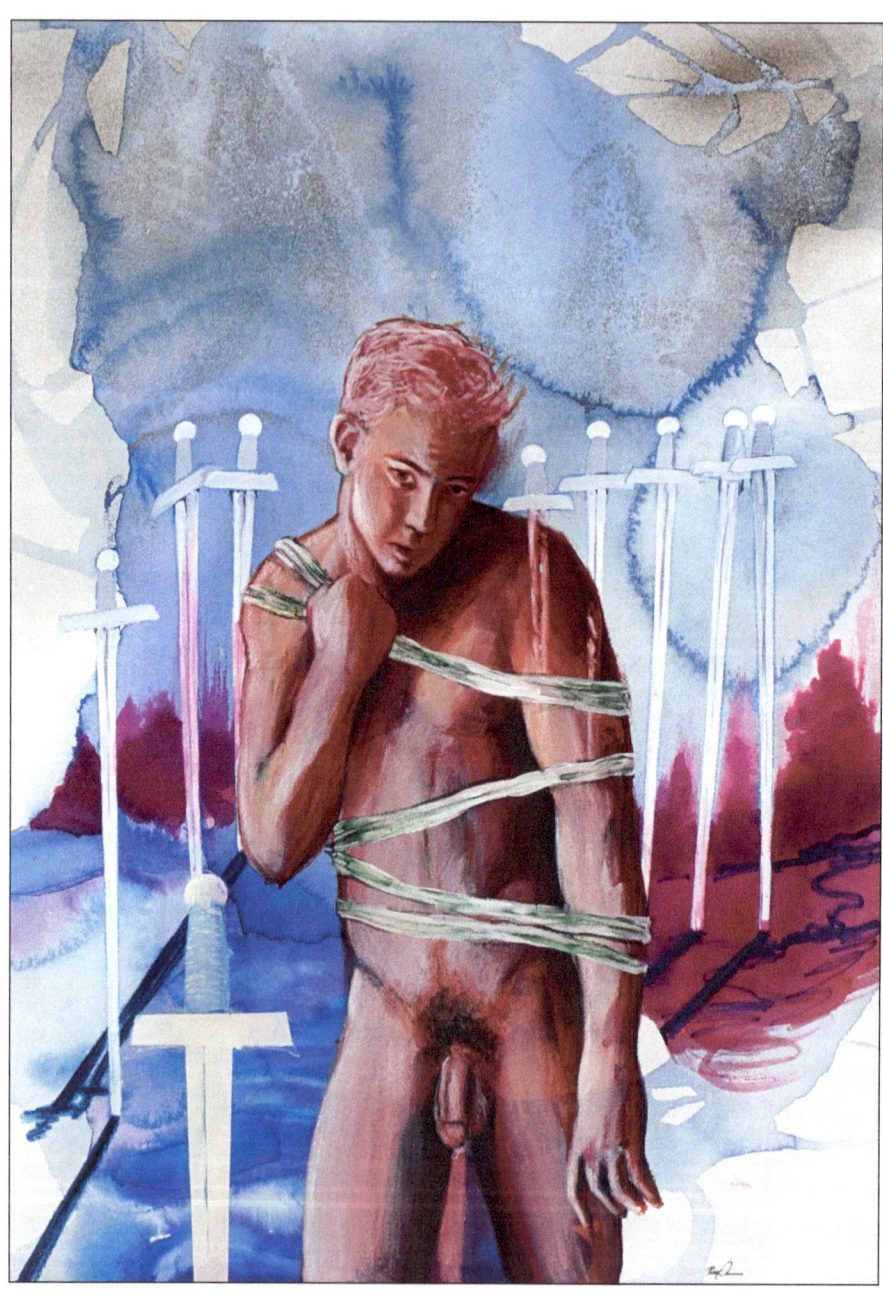

"Nine of Swords", watercolor, 22"x30", 2004

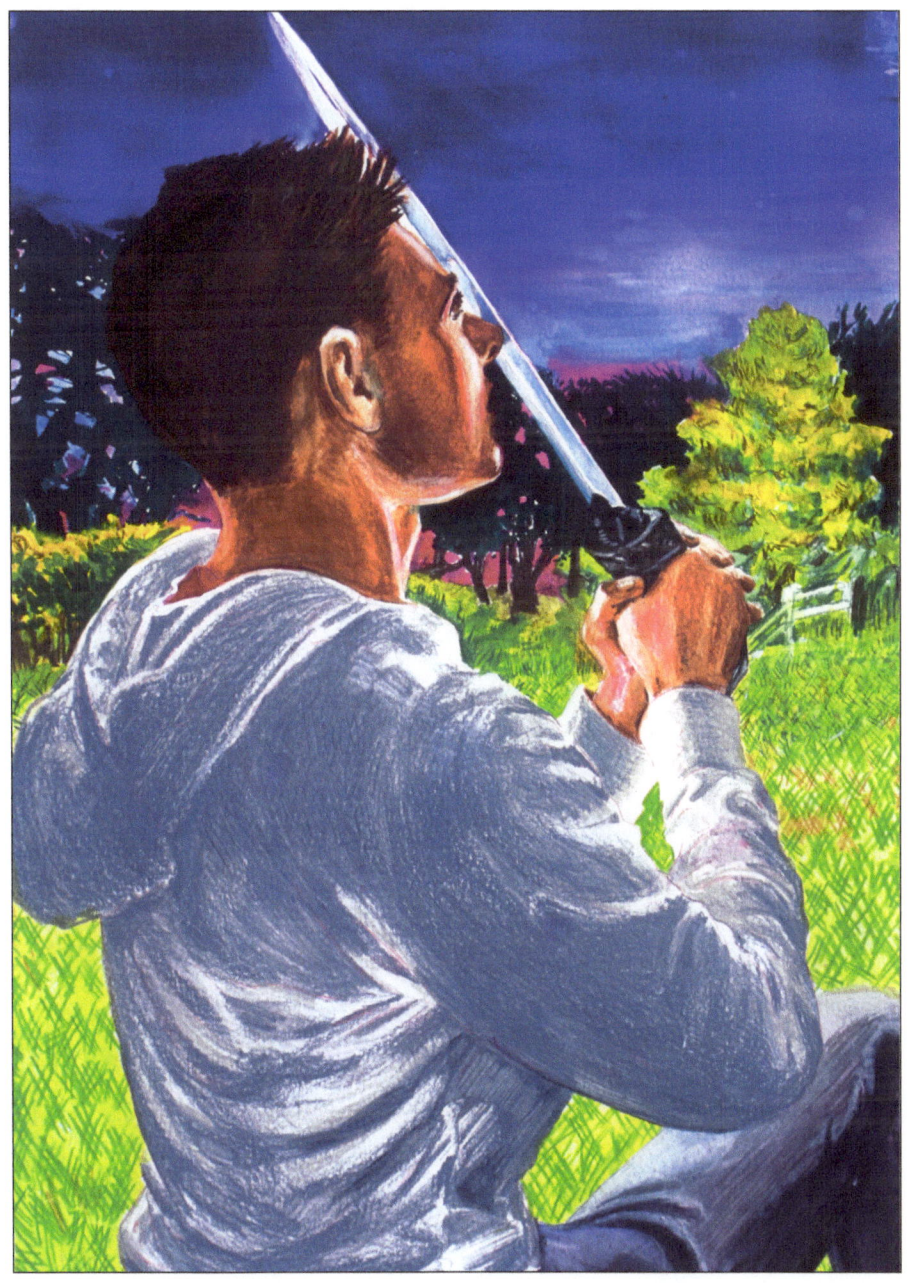

"Before the Blade", watercolor and color pencil, 22"x30", 2004

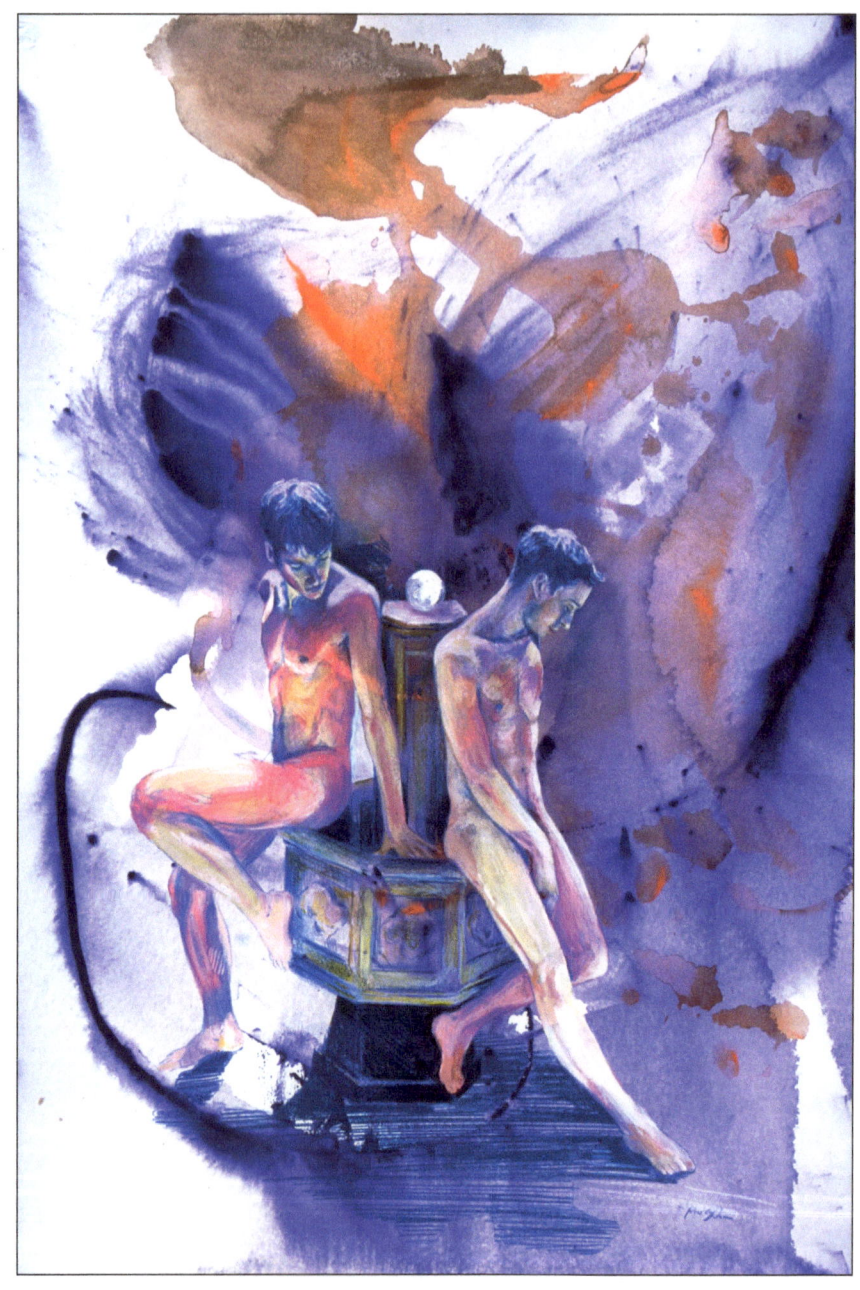

"Reluctant Grace", watercolor, 22"x30", 2000

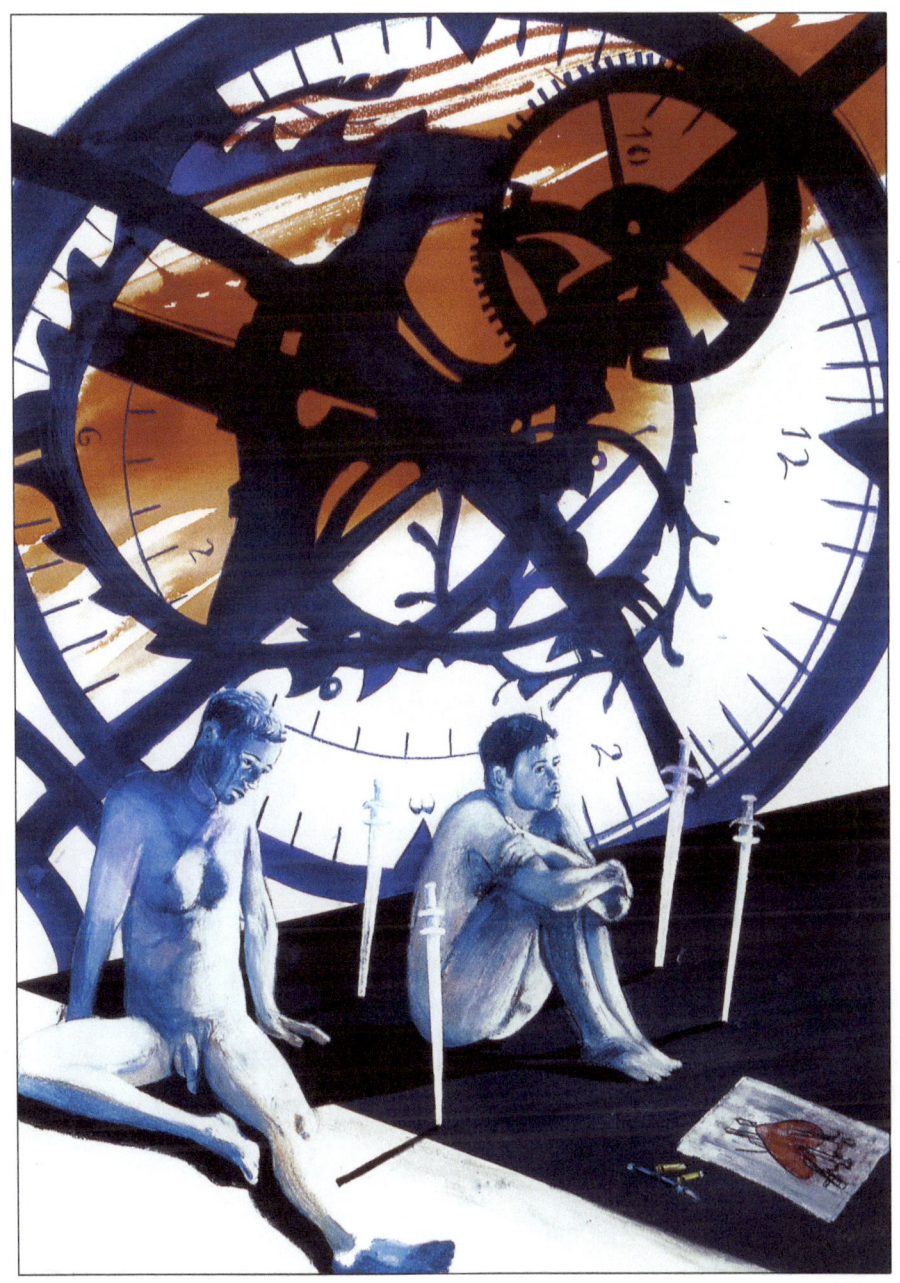

"The End of A Dream", watercolor, 22"x30", 2004

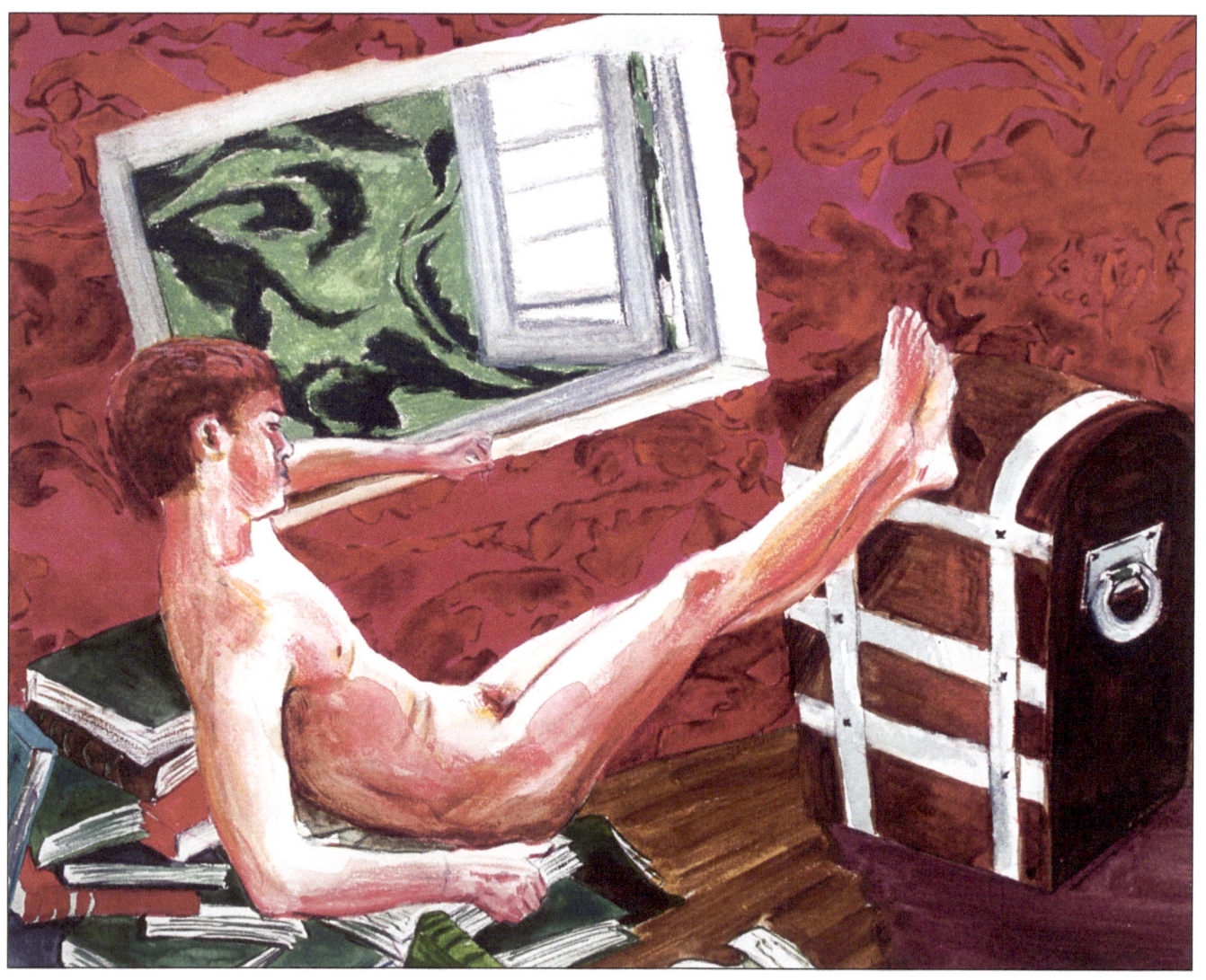

"Waiting for Your Return", watercolor, 9"x12", 2005

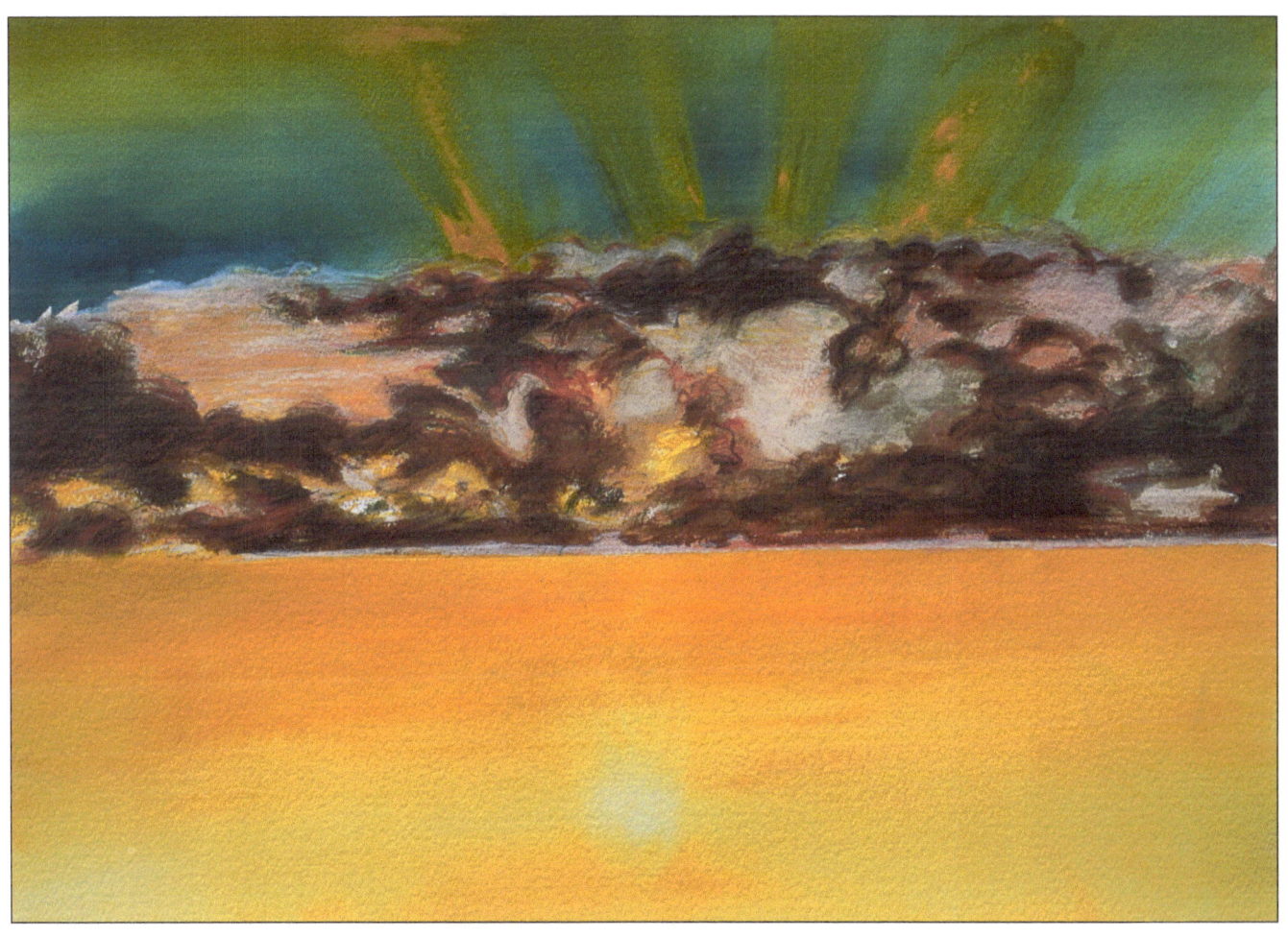

"No Peace in My Sunrise", watercolor, 22"x30", 2005

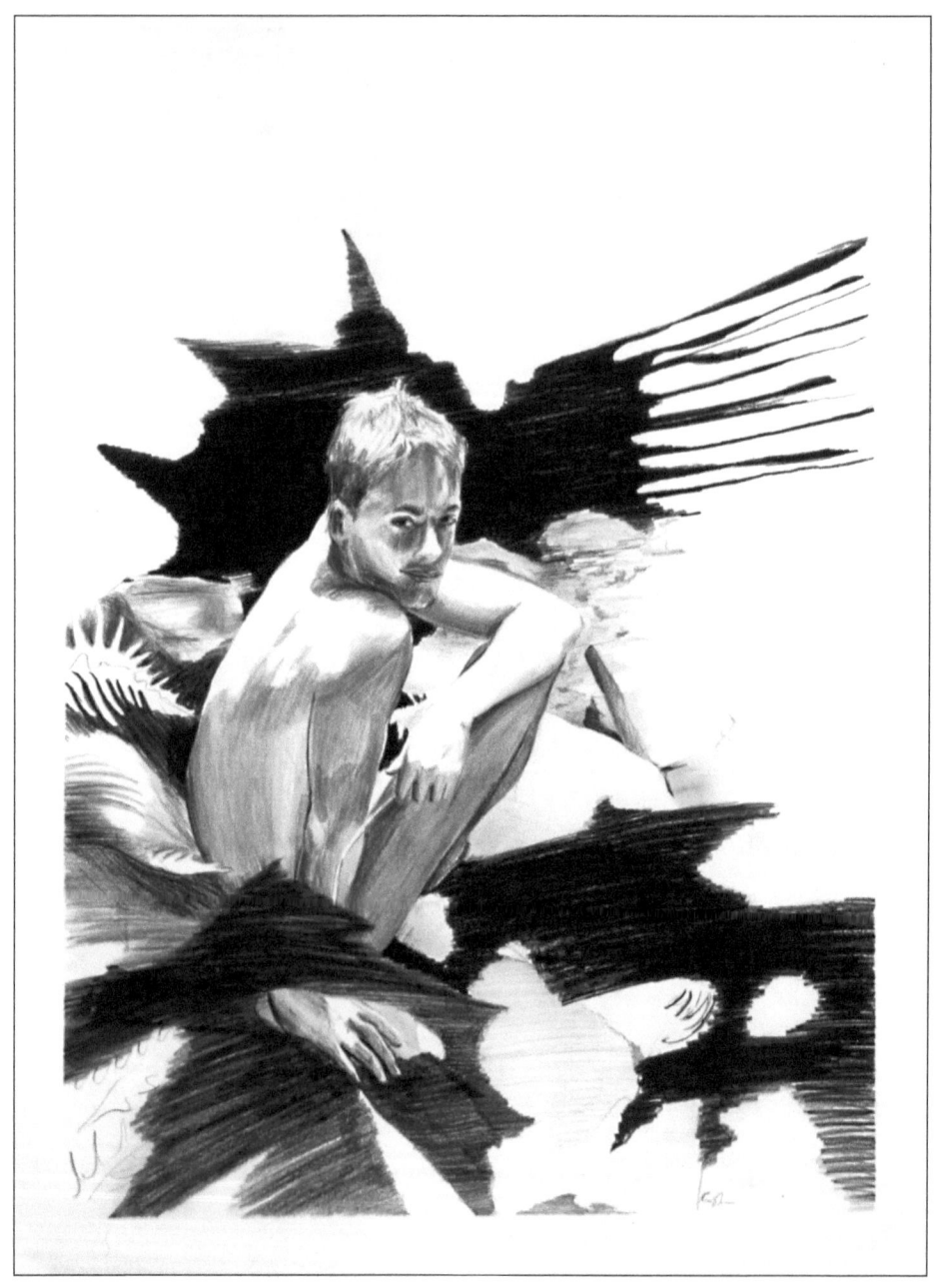

"Bathed in White Light", pencil and charcoal, 22"x30", 2004

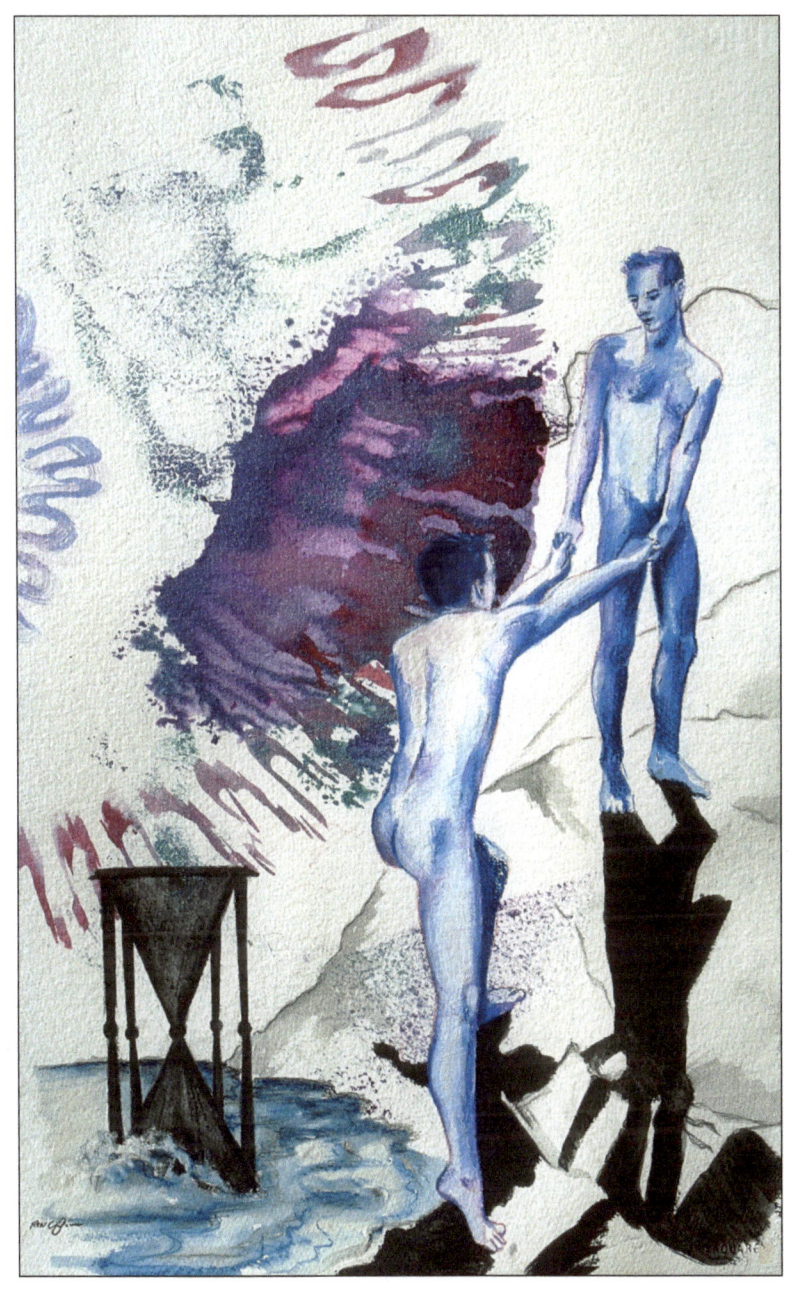

"Love Metaphor", watercolor, 14"x16", 2004

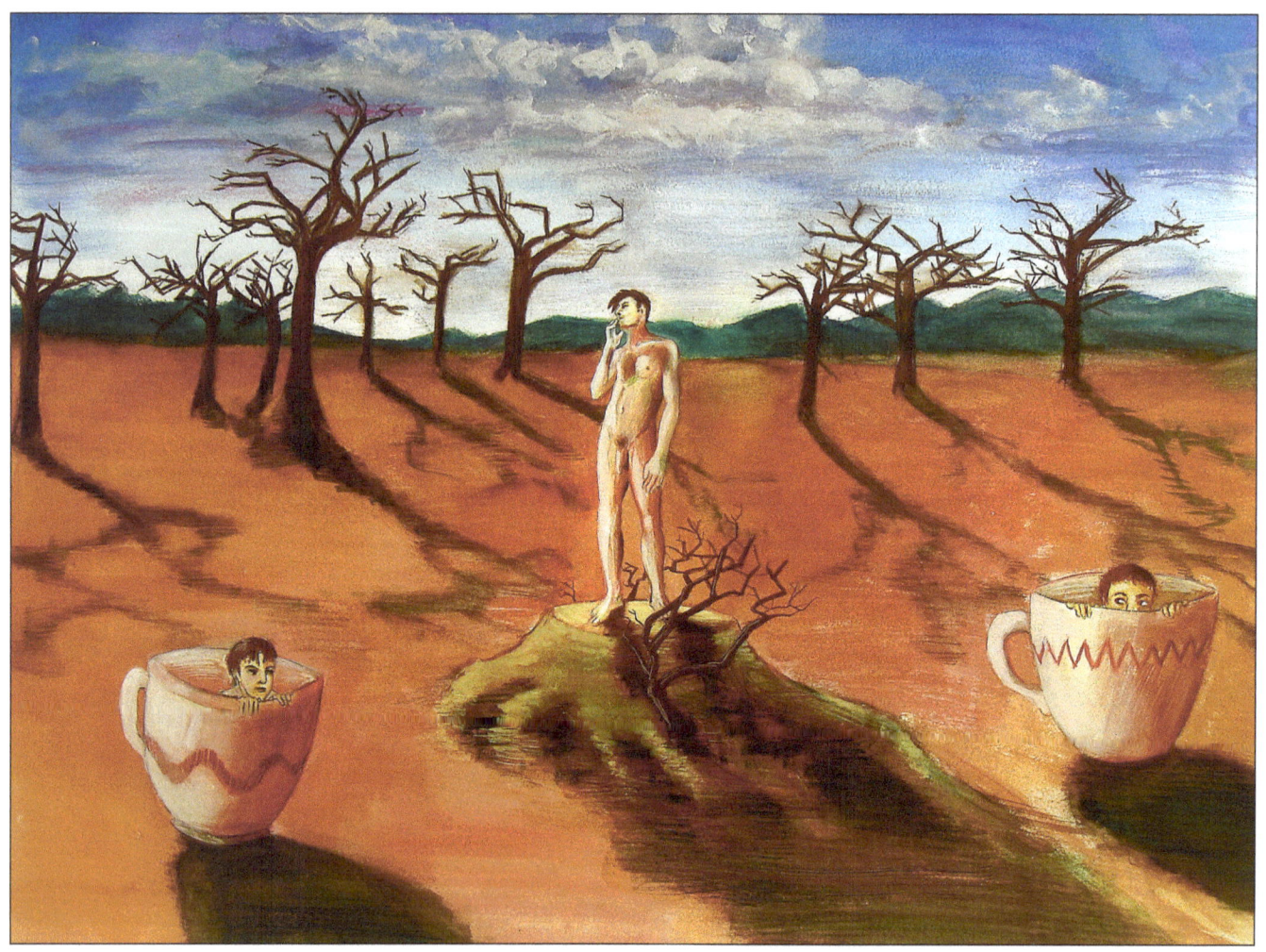

"Two of Cups", watercolor, 22"x30", 2007

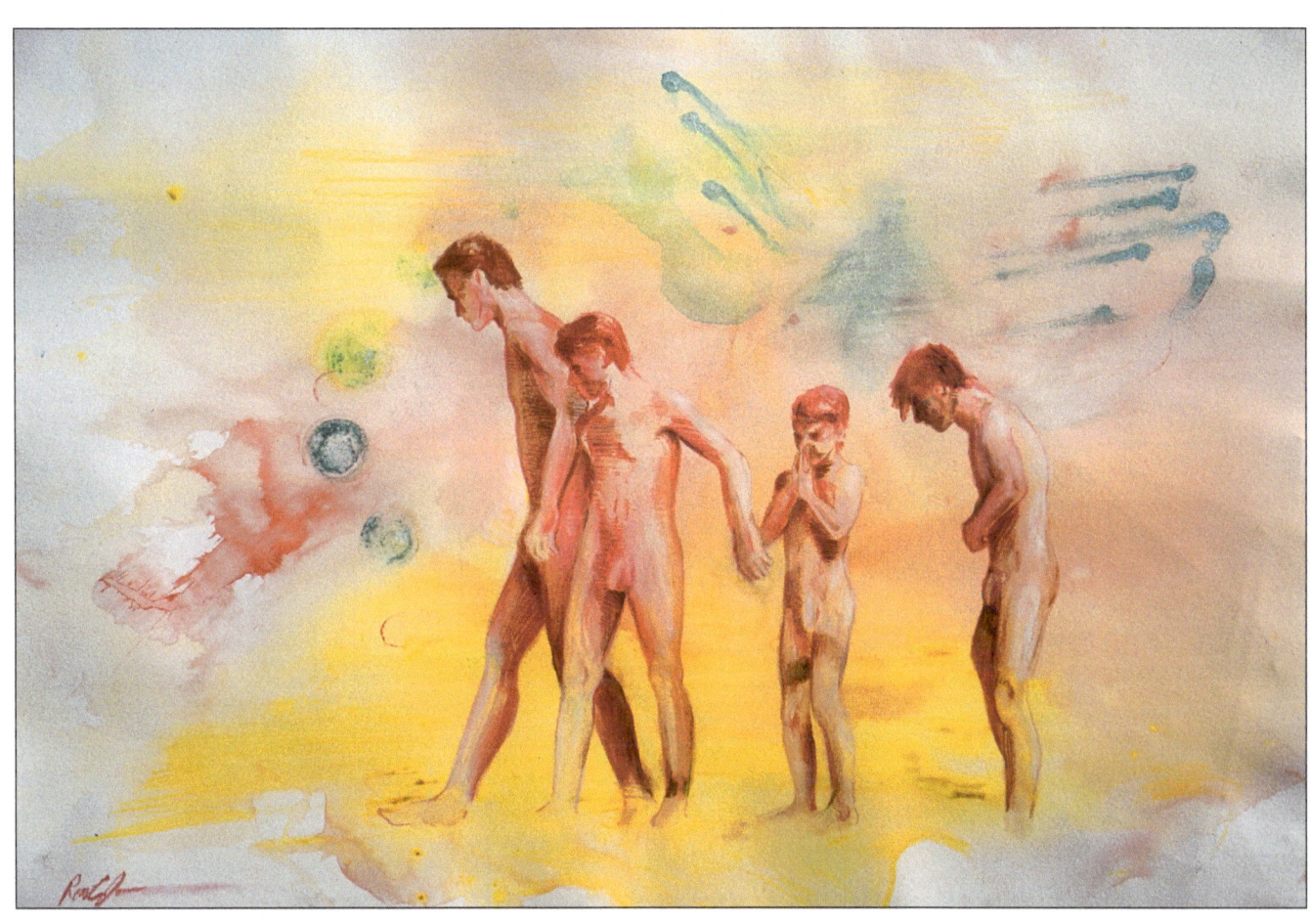

"Yellow Fog", watercolor, 11"x14", 2005

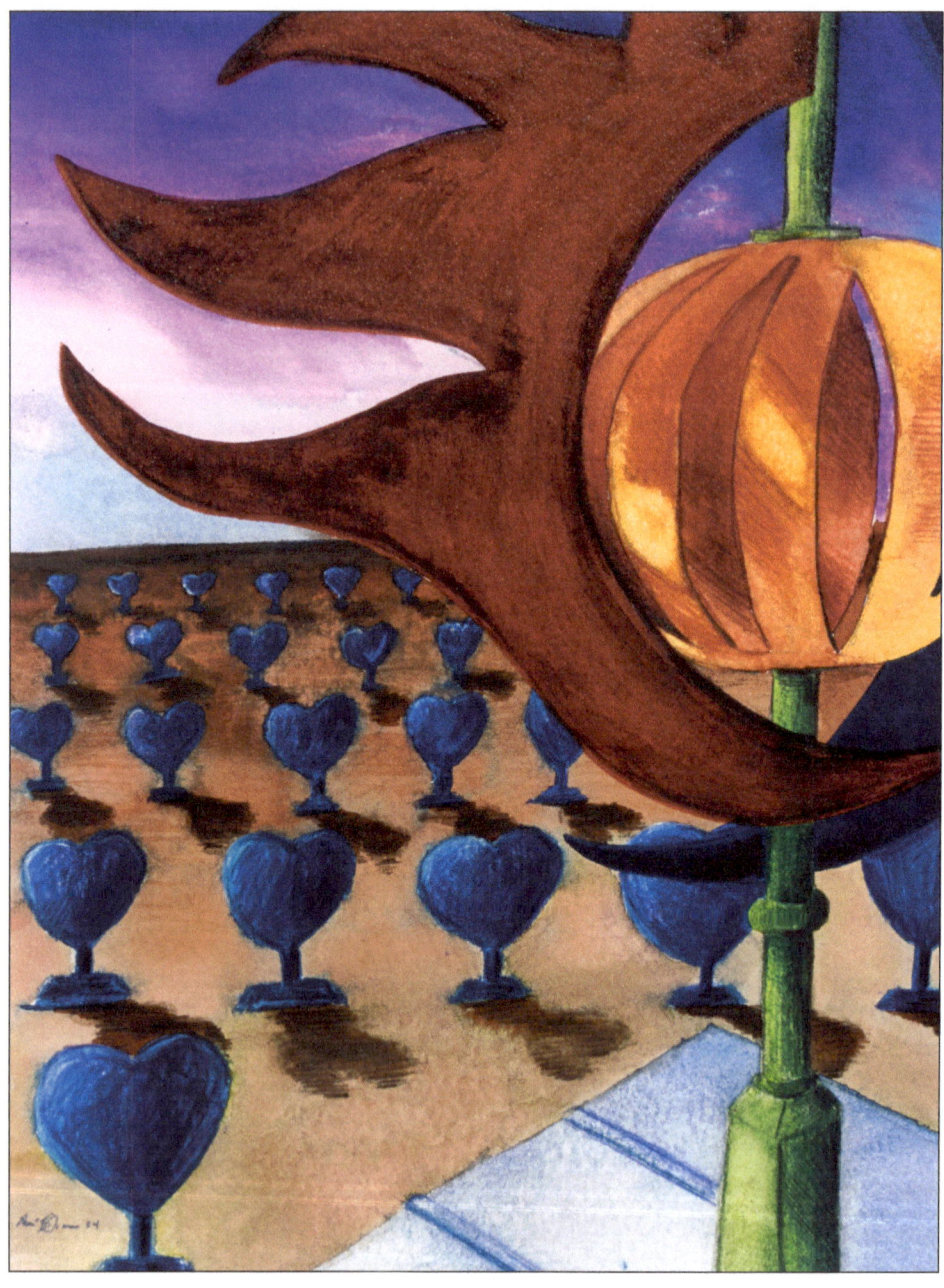

"Watchtower Over San Francisco", watercolor, 11"x14", 2004

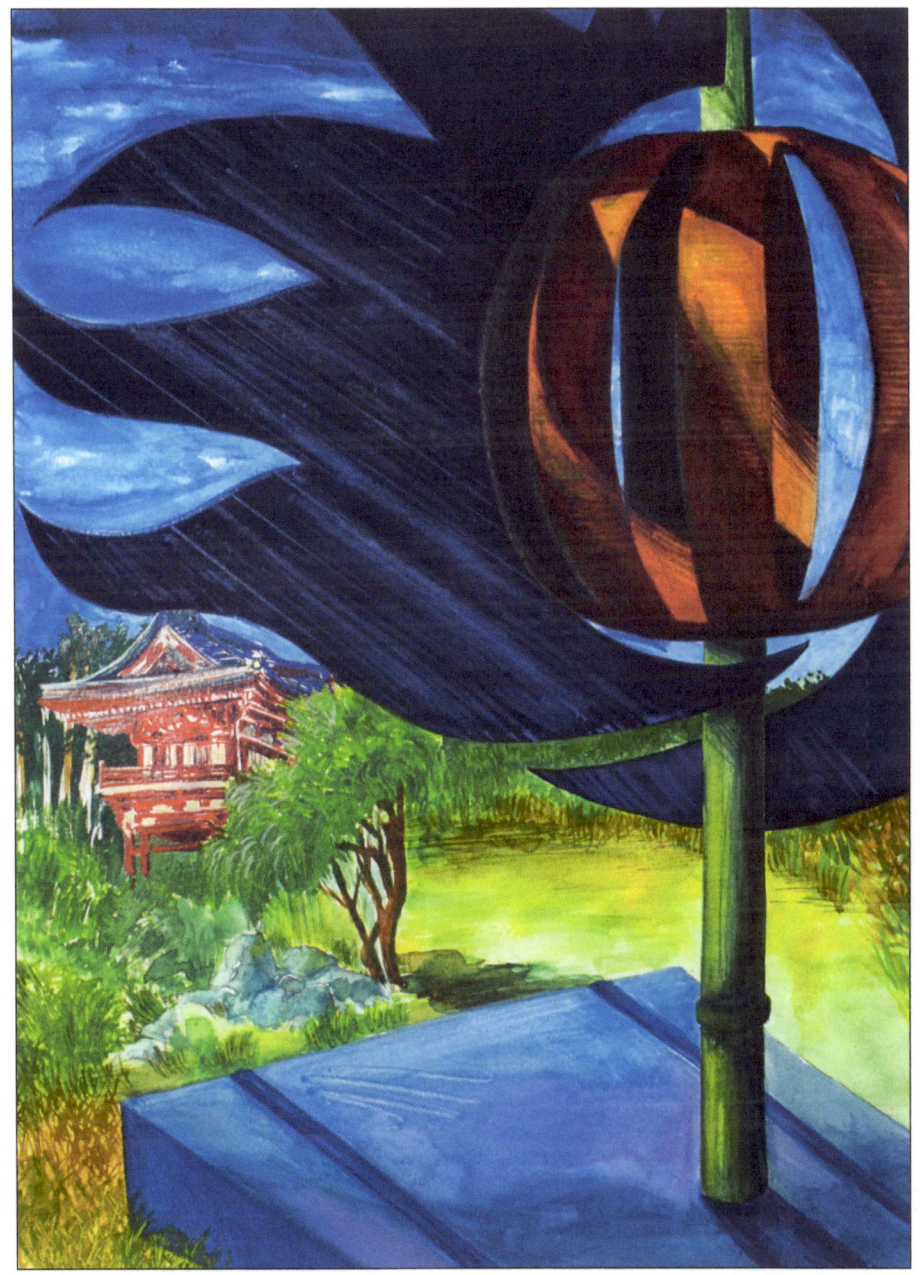

"Watchtower Over a Garden", watercolor, 22"x30", 2005

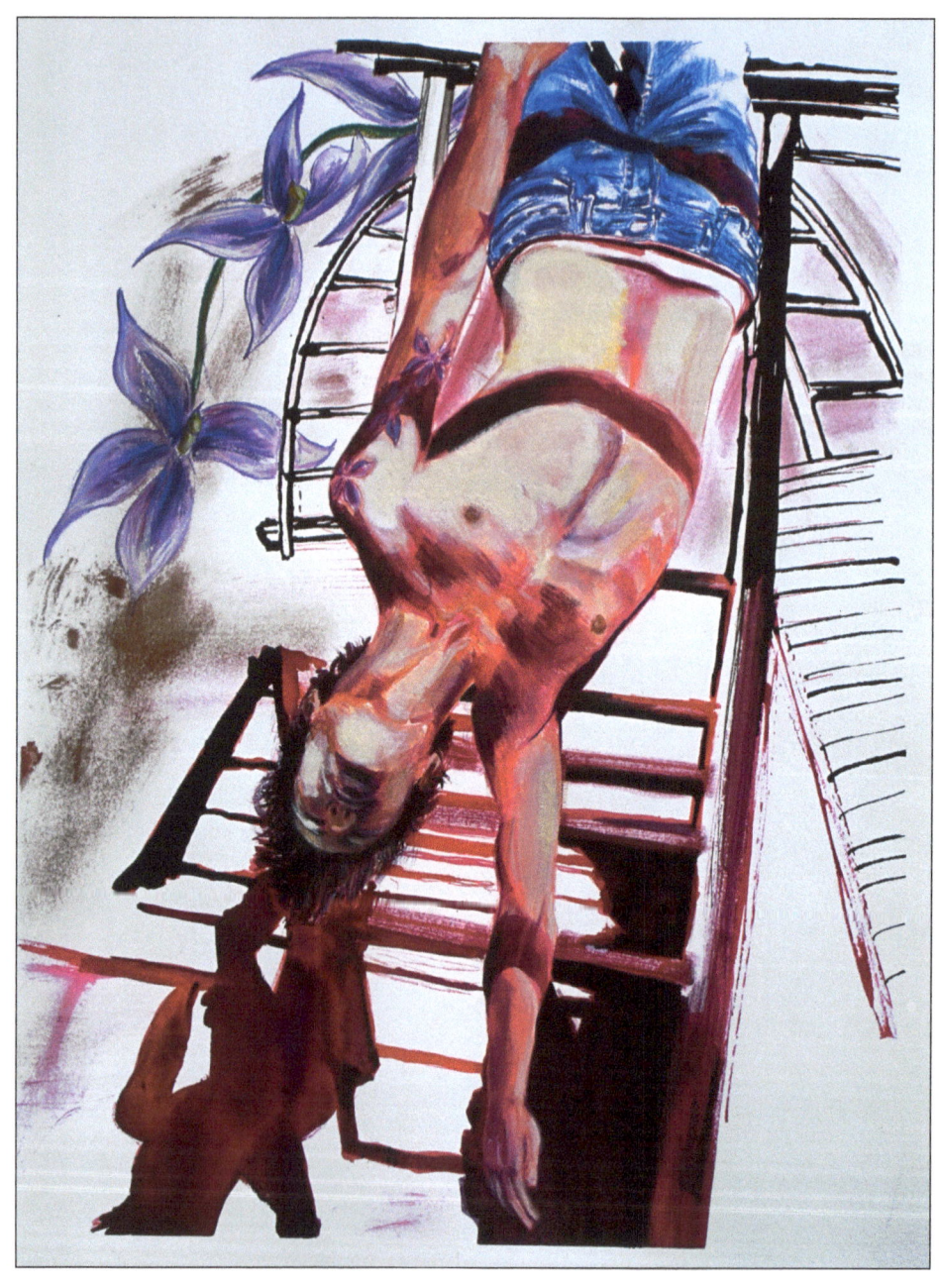

"David", watercolor and gouache, 22"x30", 2005

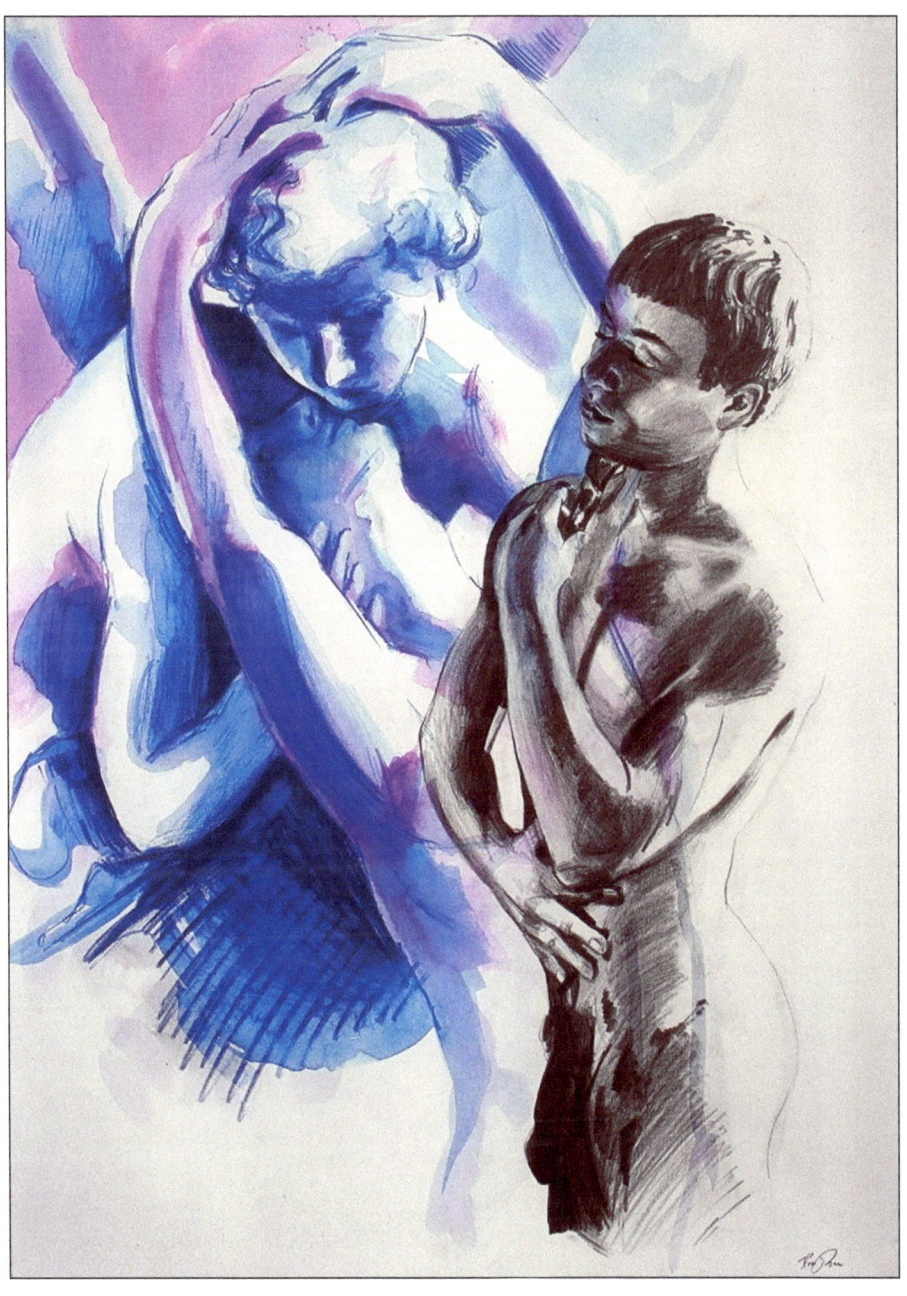

"Love's Discovery", watercolor and pencil, 22"x30", 2004

René Capone Artwork 1999 - 2011

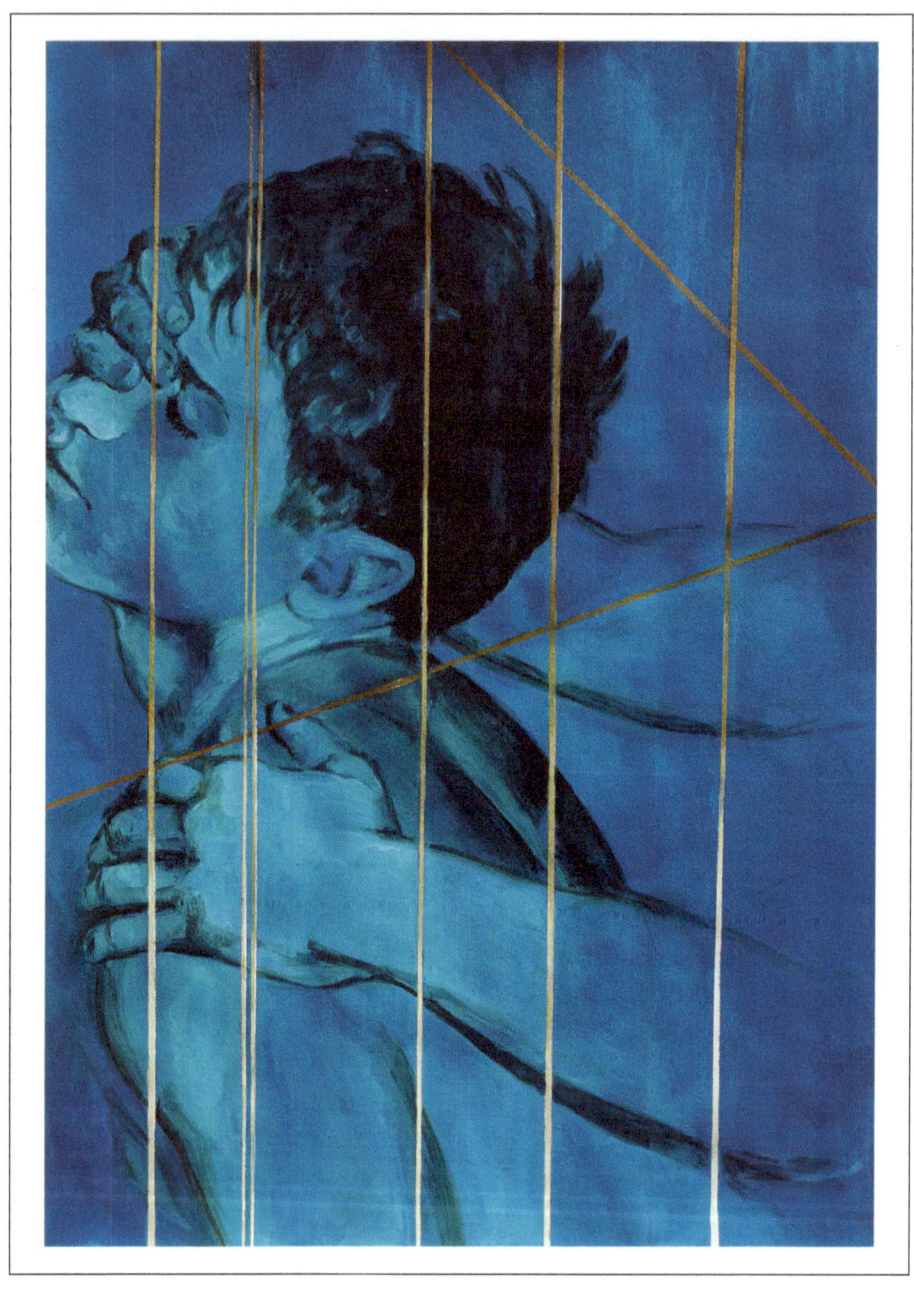

"Touch", watercolor, 22"x30", 2000

"Stolen Kisses", silver paint and acrylic, 8"x10", 2005

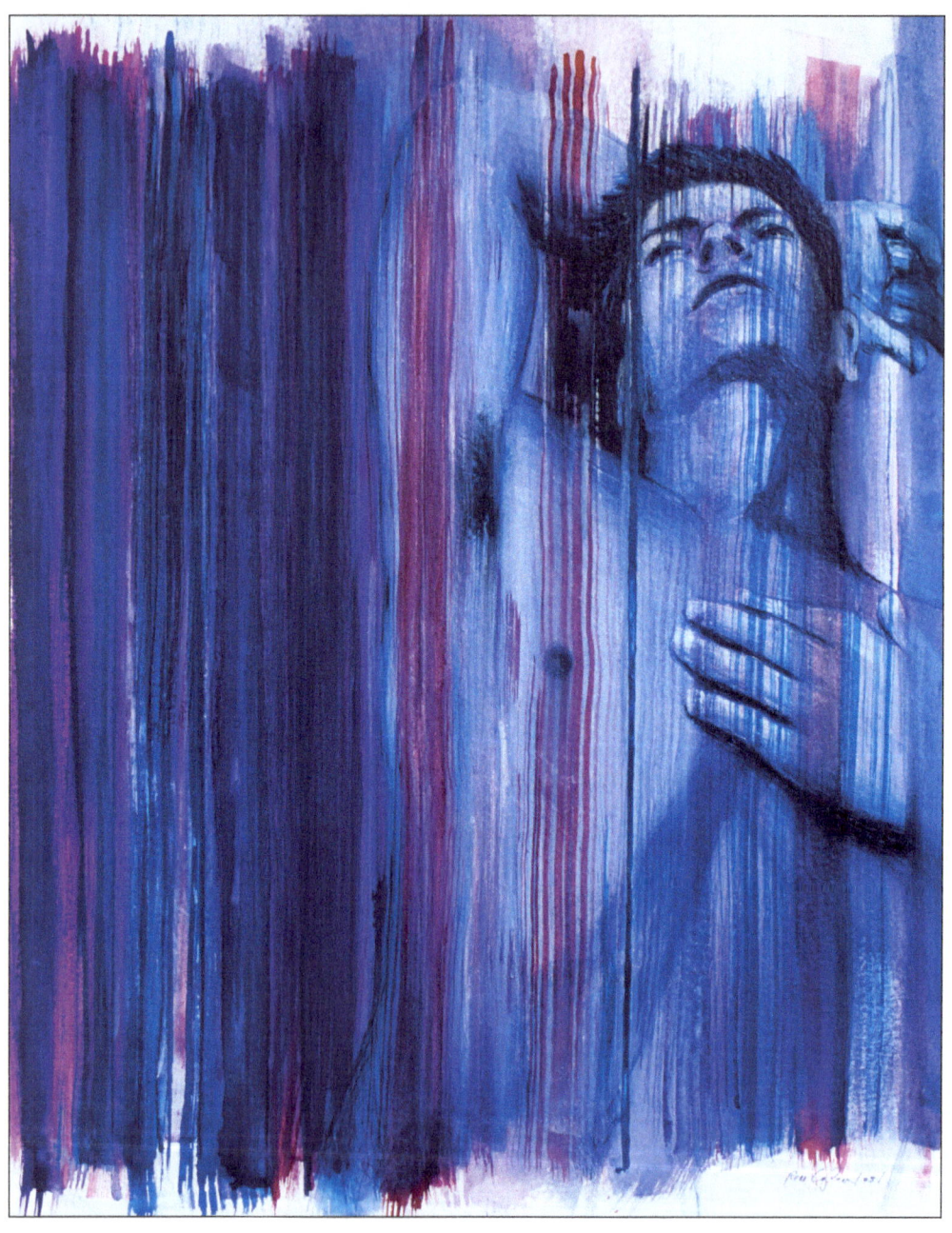

"Chill", watercolor, color pencil and gouache, 16"x20", 2005

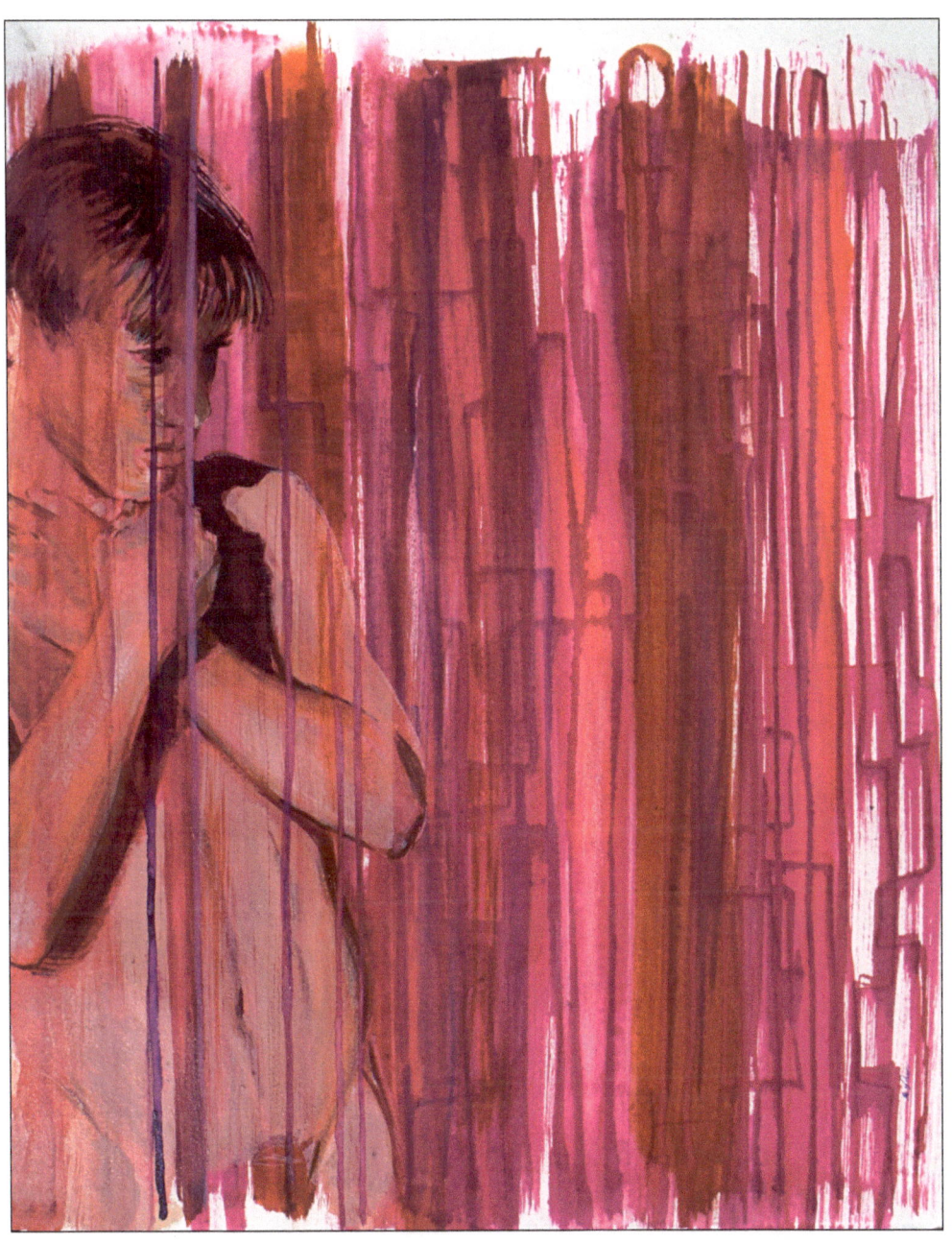

"Tremble", watercolor, color pencil and gouache, 16"x20", 2005

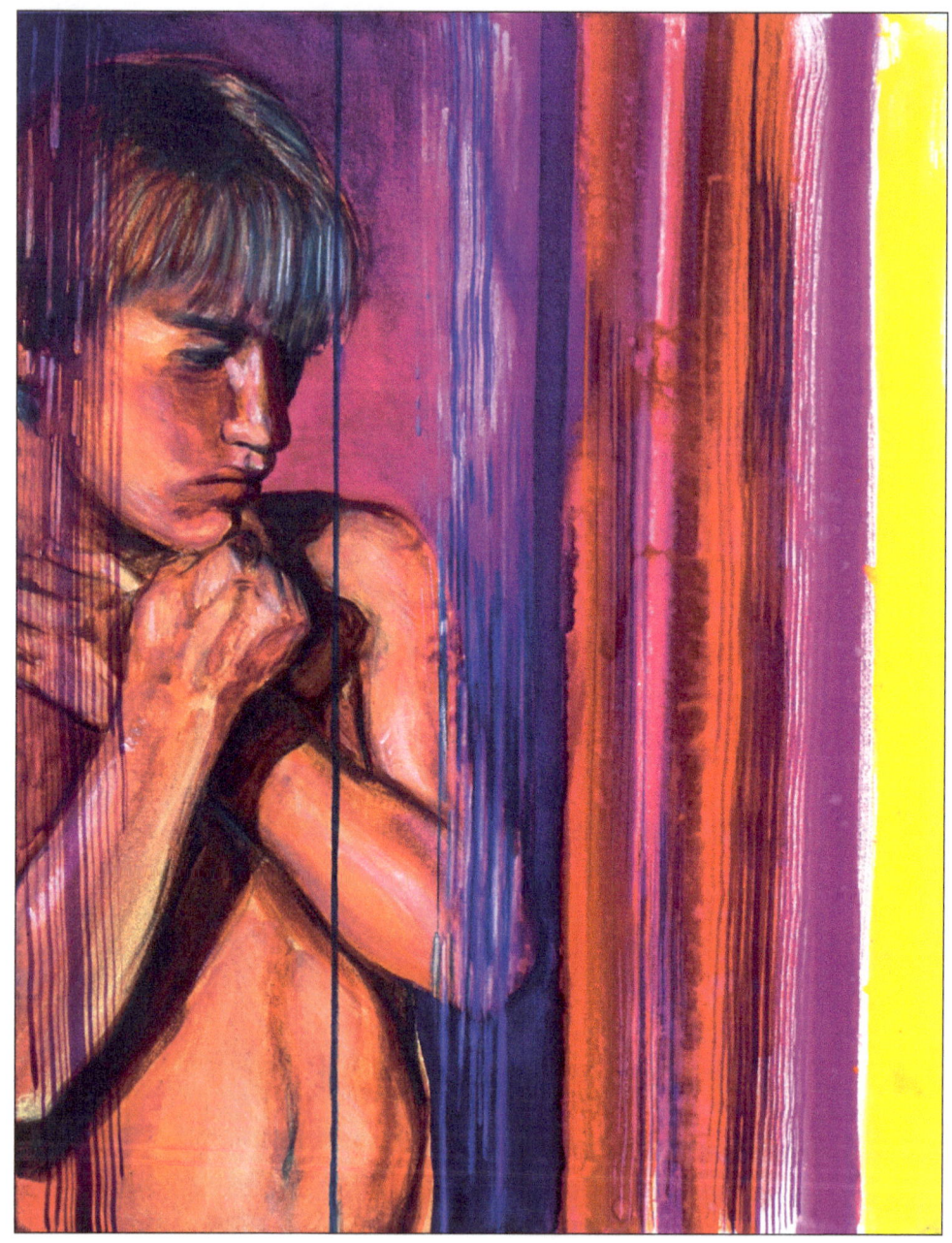

"Tremble #2", watercolor, color pencil and gouache, 16"x20", 2007

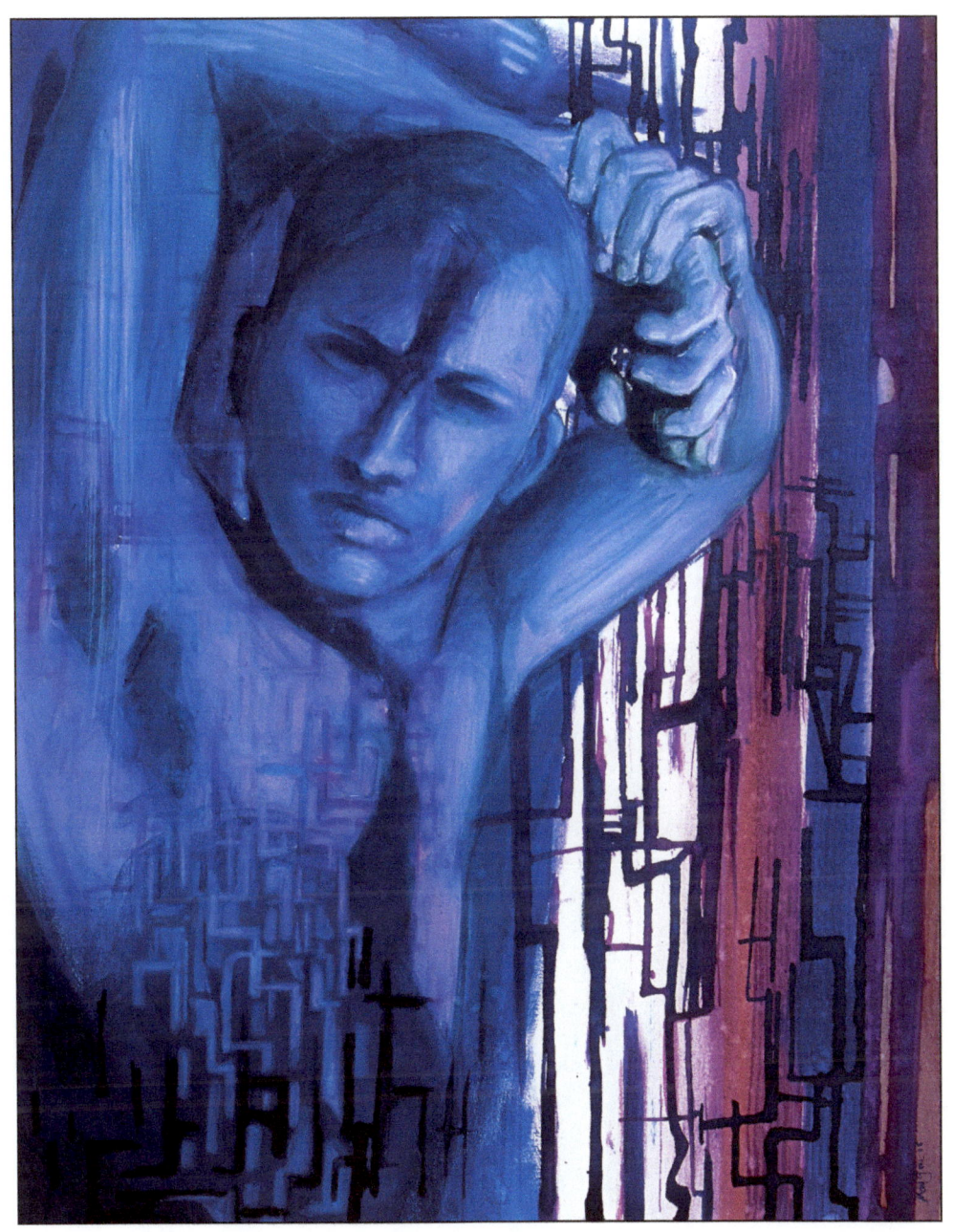

"Broken & Blue", watercolor, color pencil and gouache, 16"x20", 2006

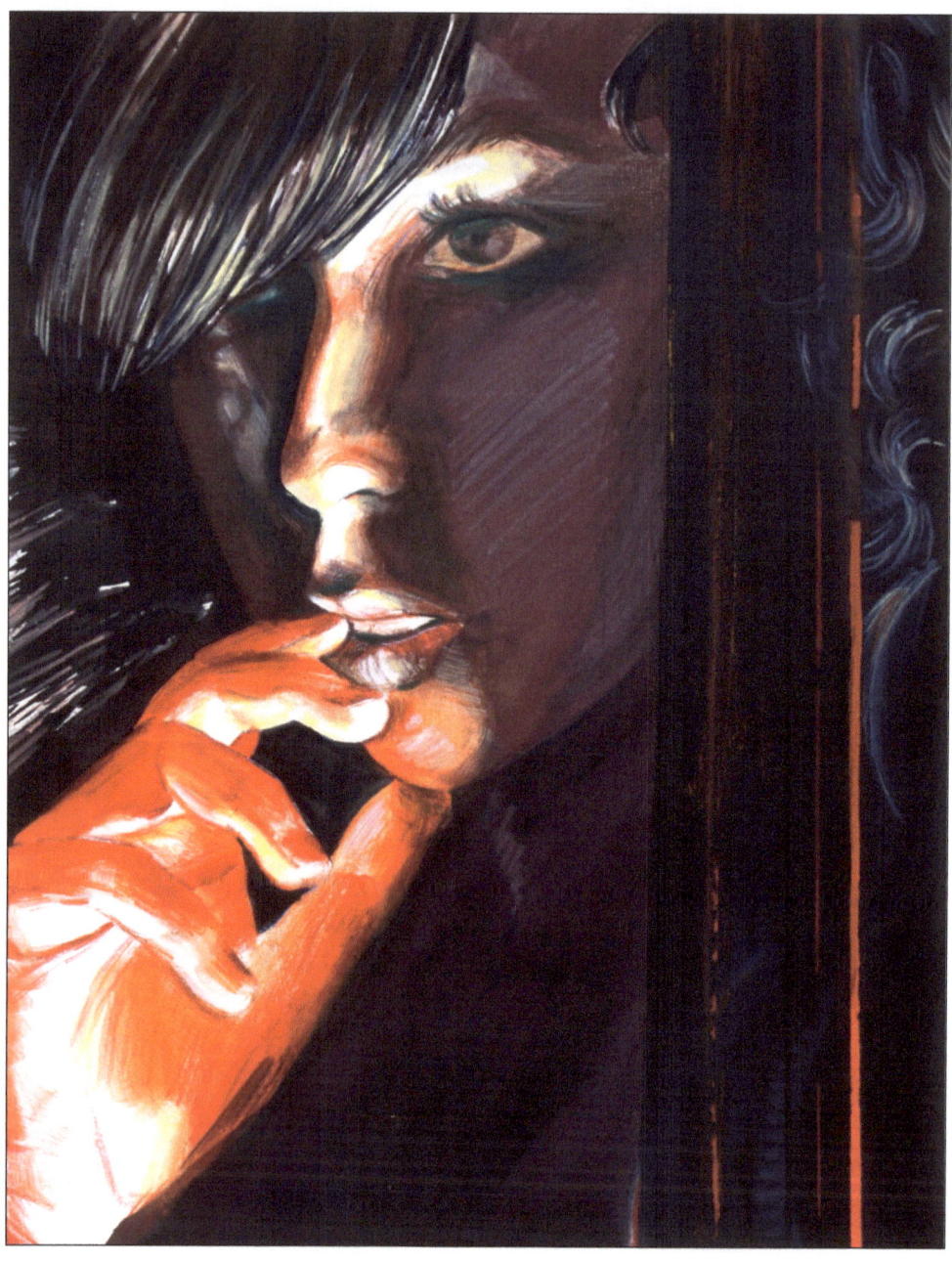

"Shell Girl", watercolor, color pencil and gouache, 16"x20", 2006

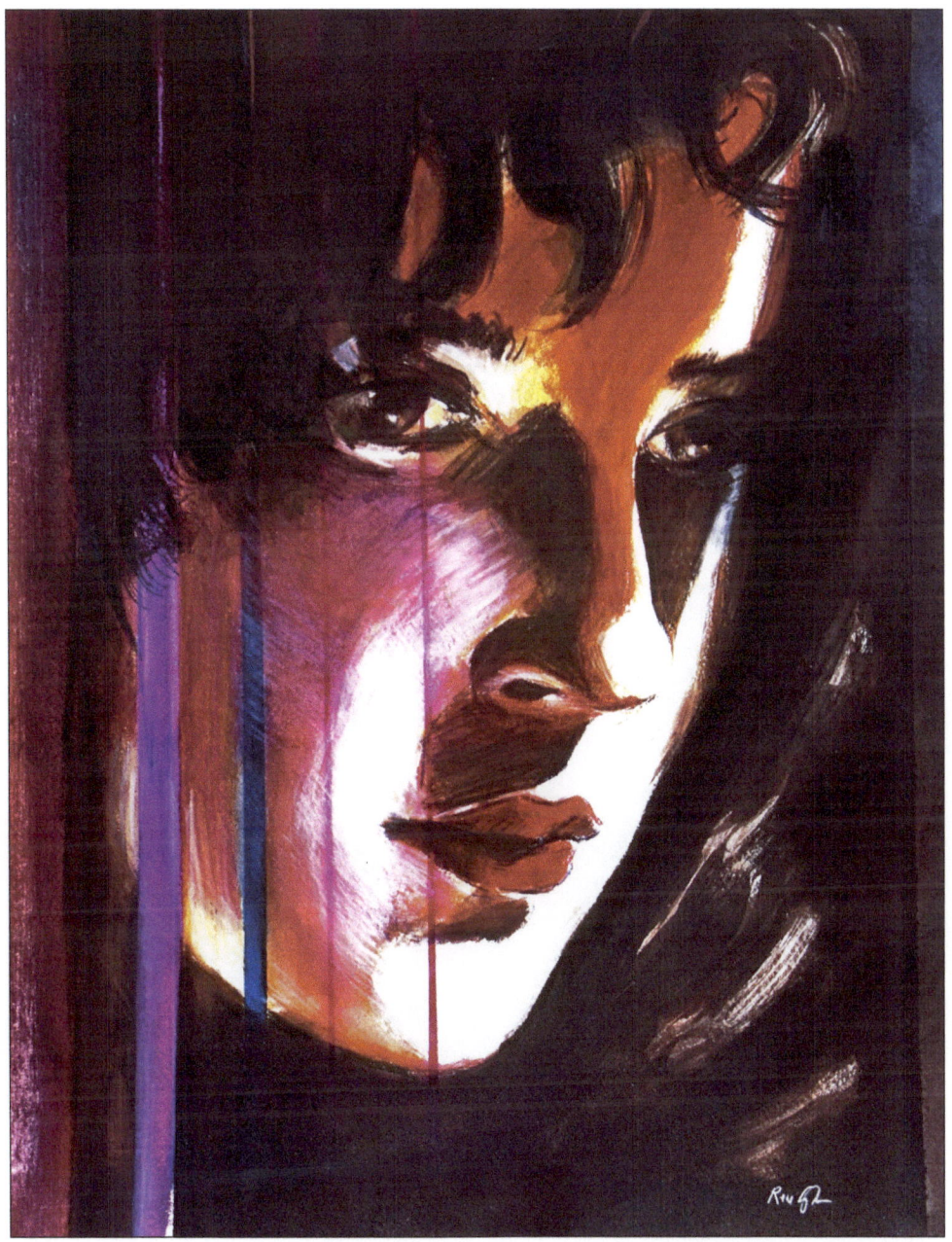

"Aurora", watercolor, color pencil and gouache, 16"x20", 2006

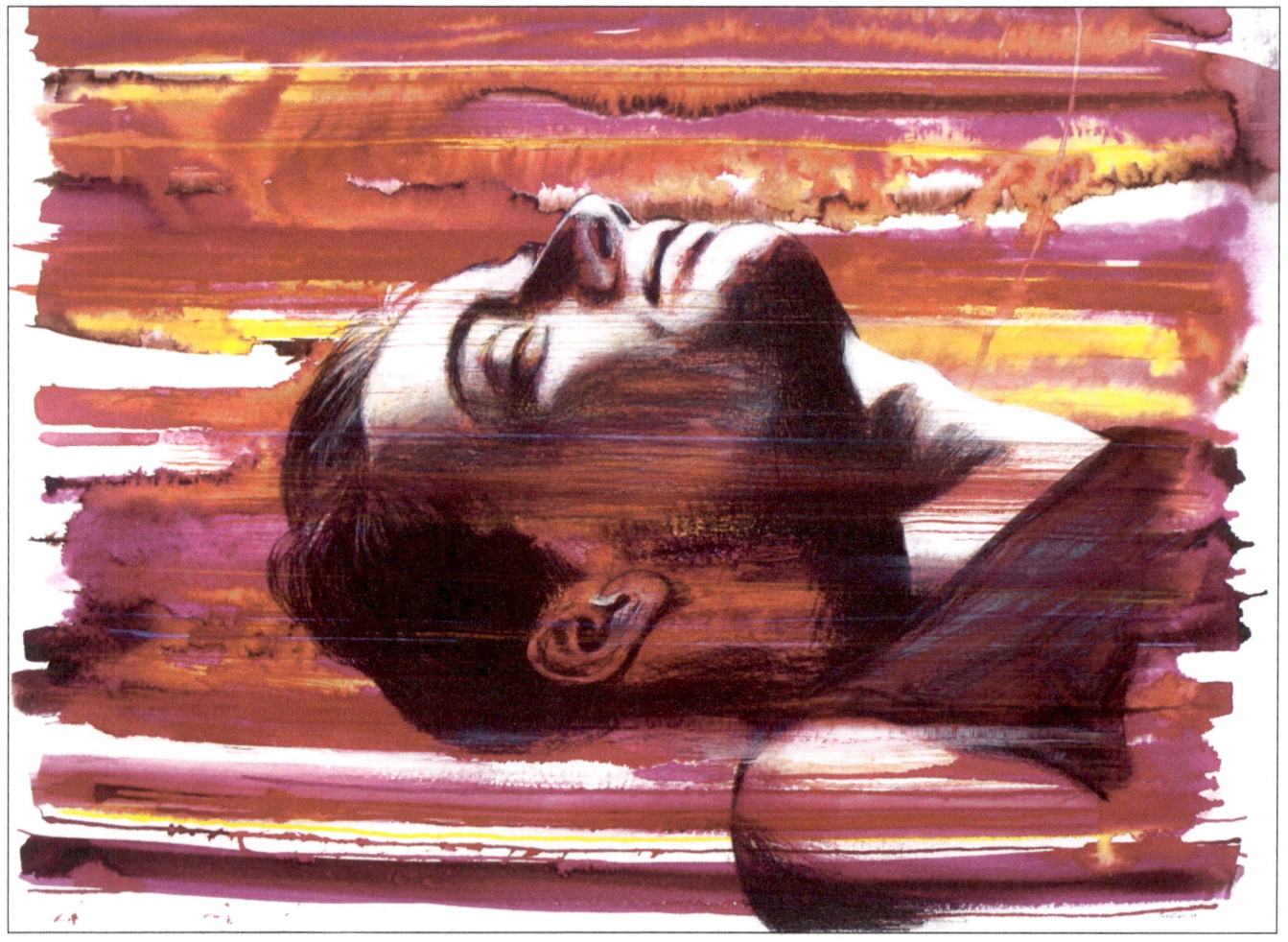

"Currents", watercolor, color pencil and gouache, 19"x30", 2005

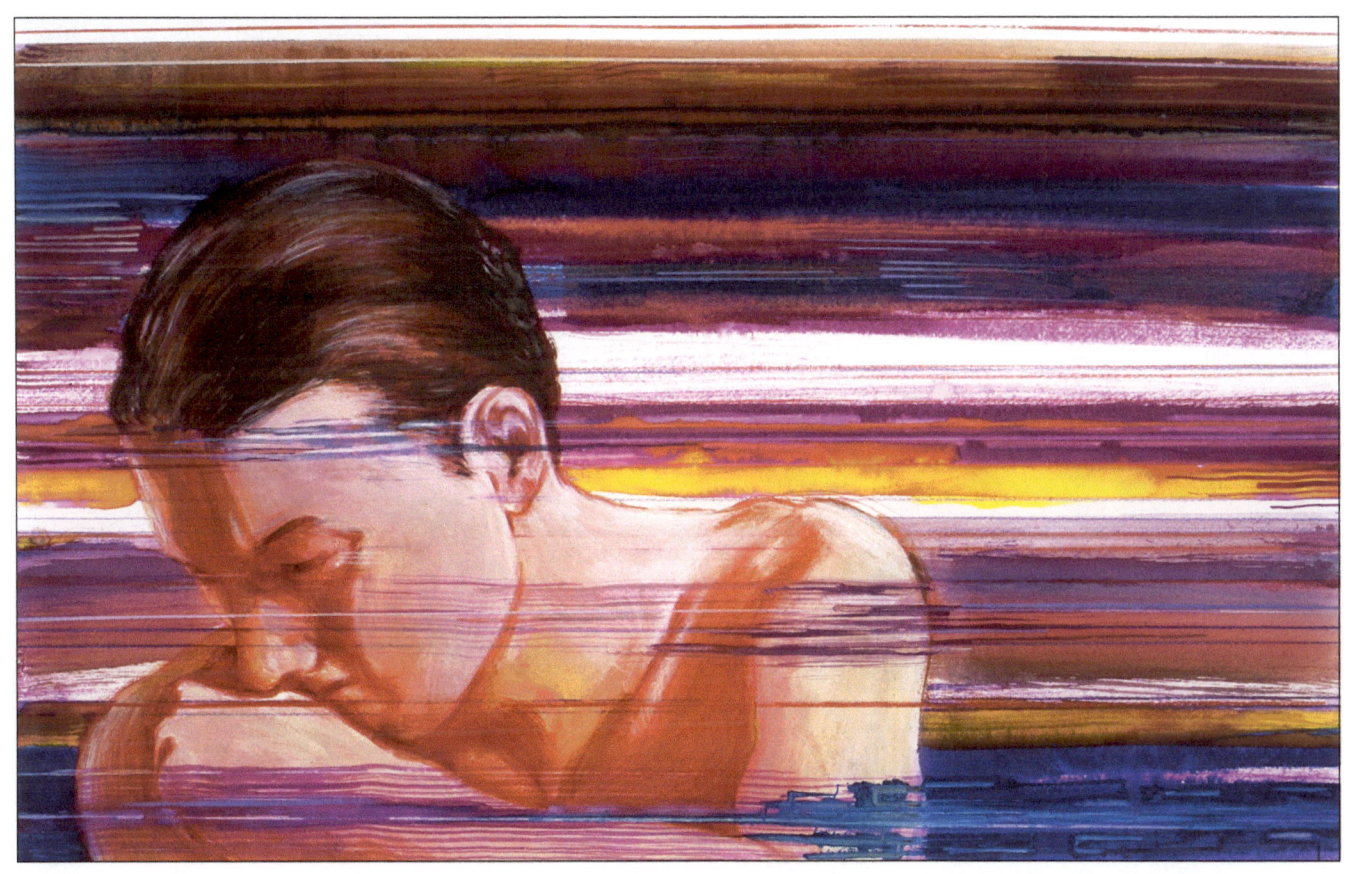

"Bright Silence", watercolor, color pencil and gouache, 19"x30", 2006

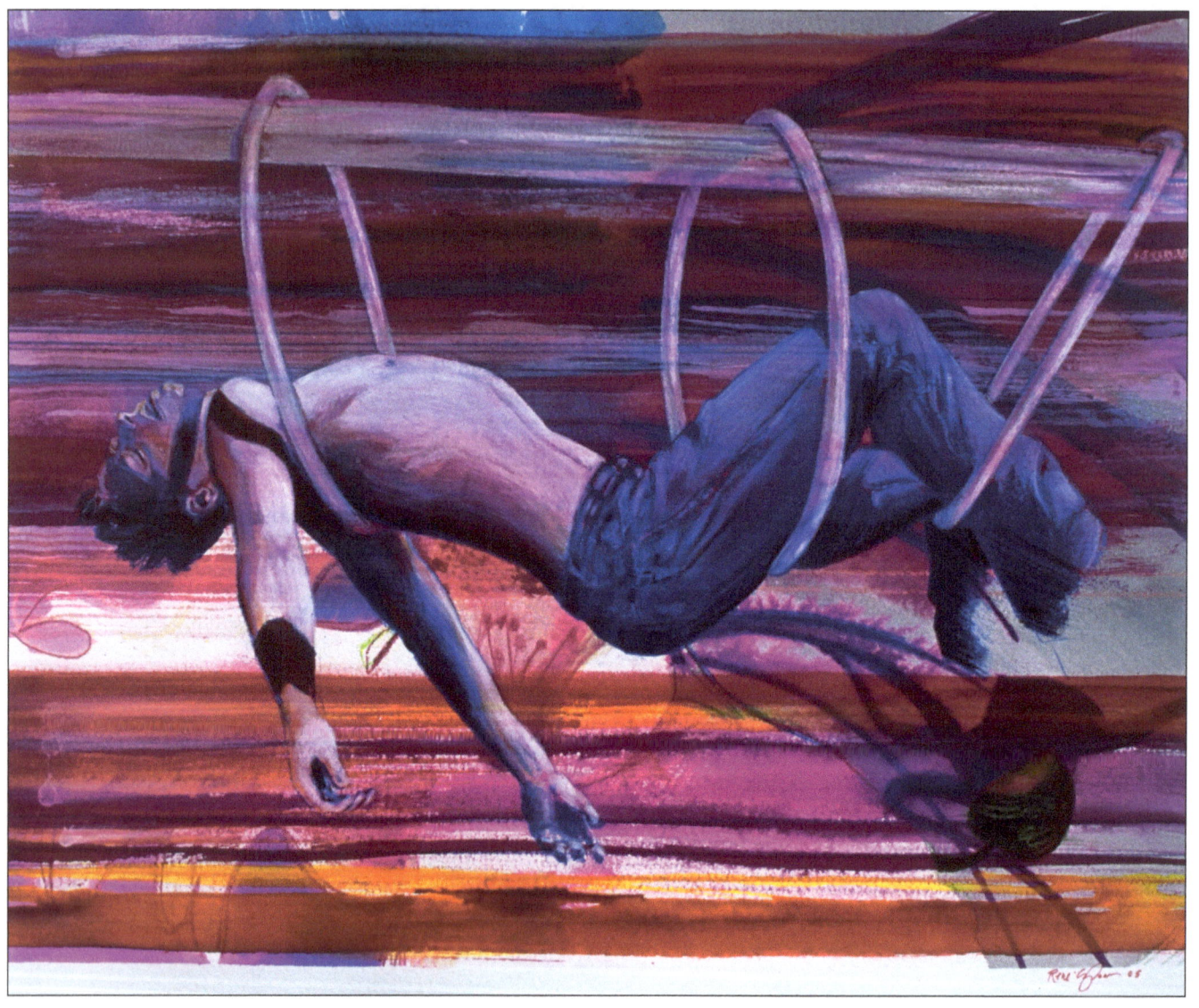

"Suspension #2", watercolor and gouache, 16"x20", 2005

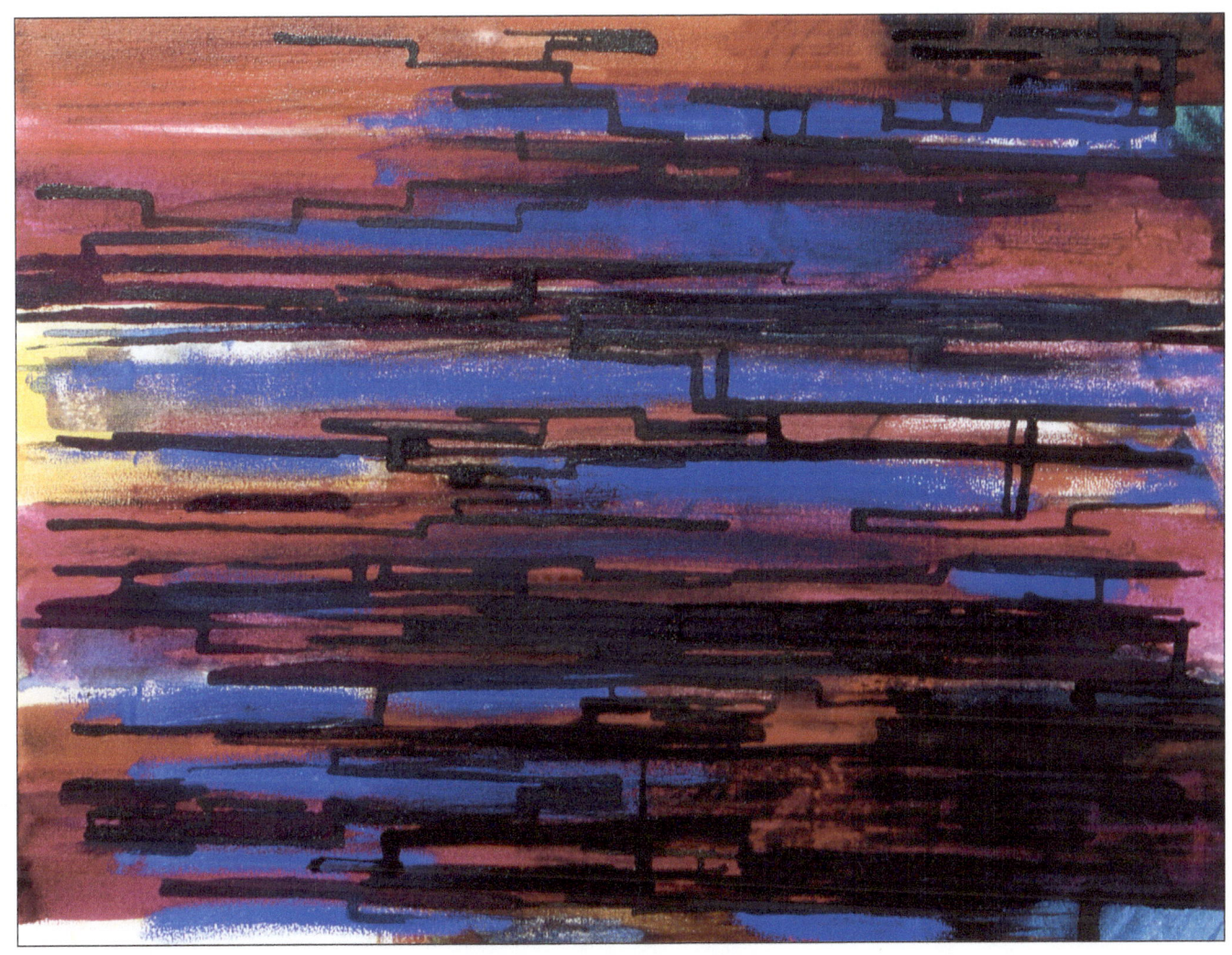

"Evidence of a Computer Thinking Like a Human", watercolor, ink and gouache, 9"x12", 2005

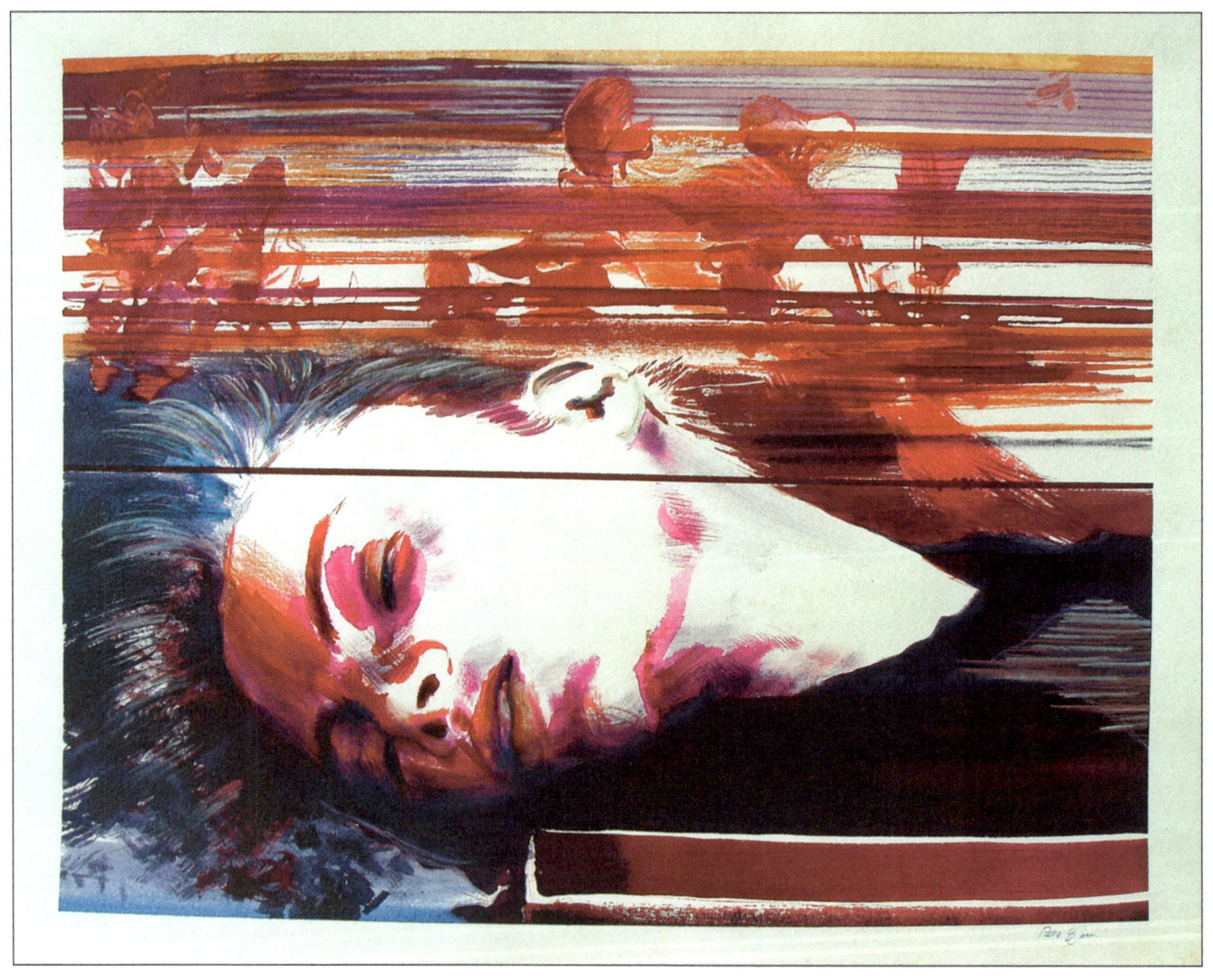

"Autumn's Waiting", watercolor, 16"x20", 2006

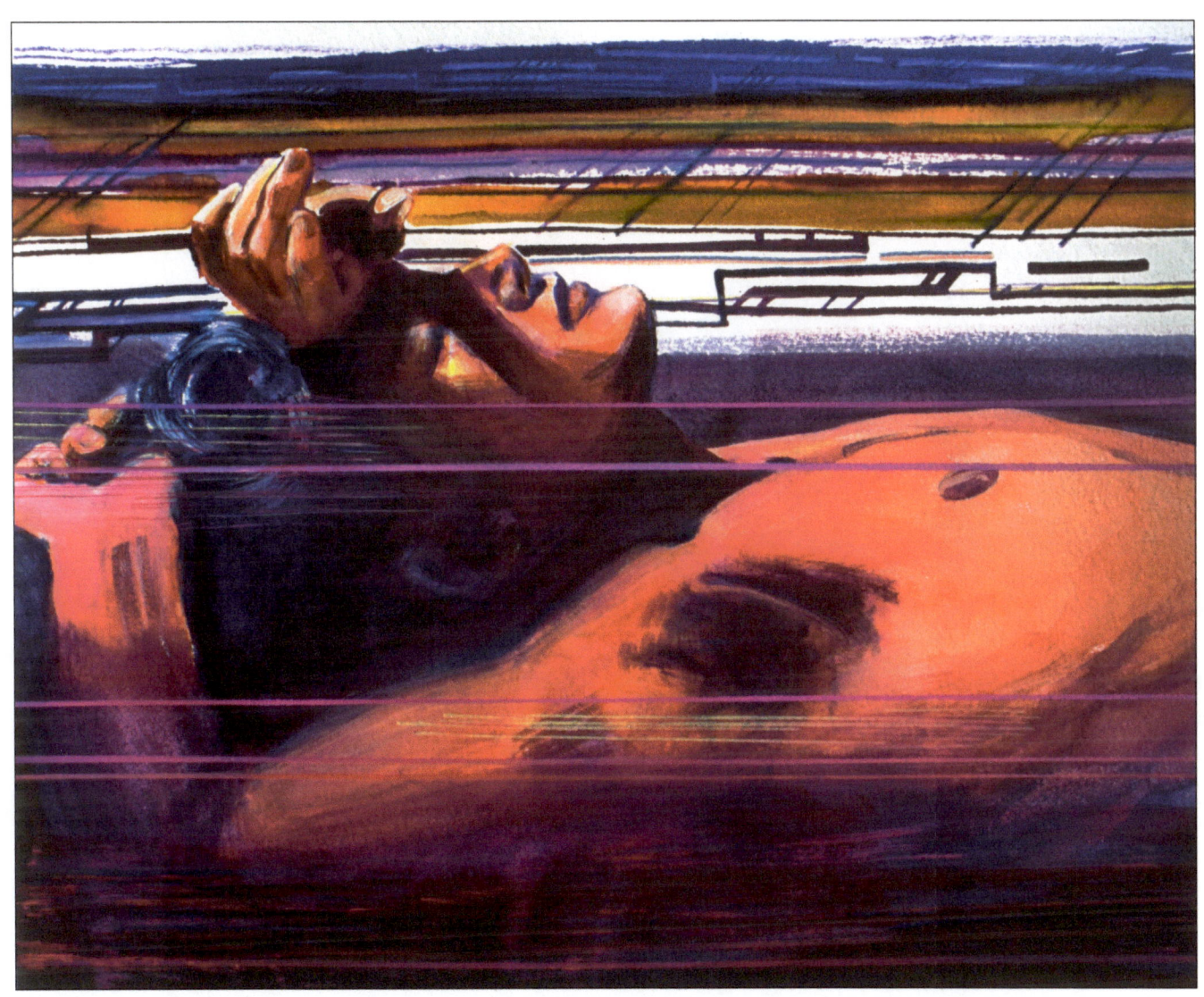

"Underlying Currents", watercolor, 16"x20", 2006

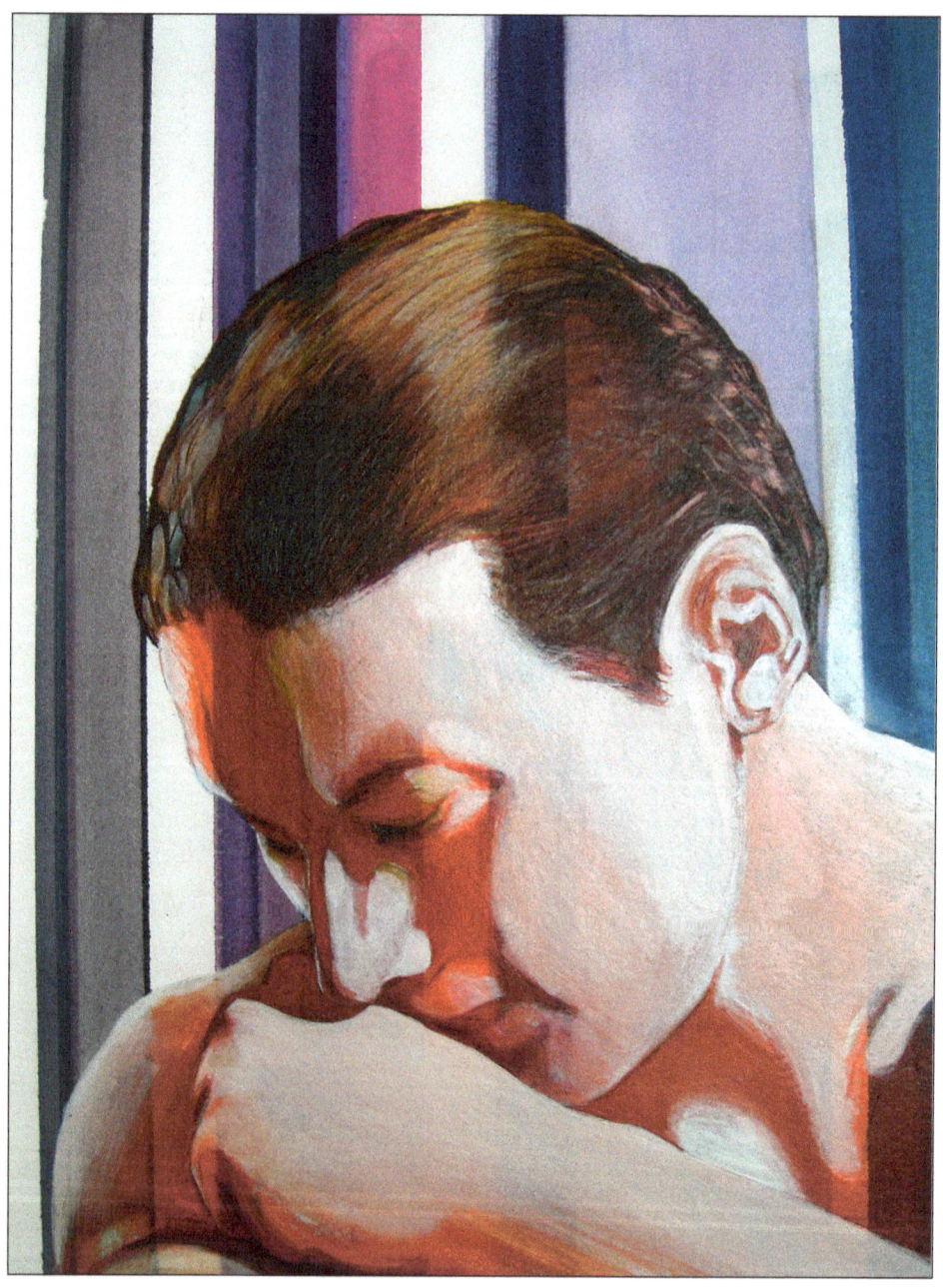

"Beginning With You", watercolor, 16"x20", 2006

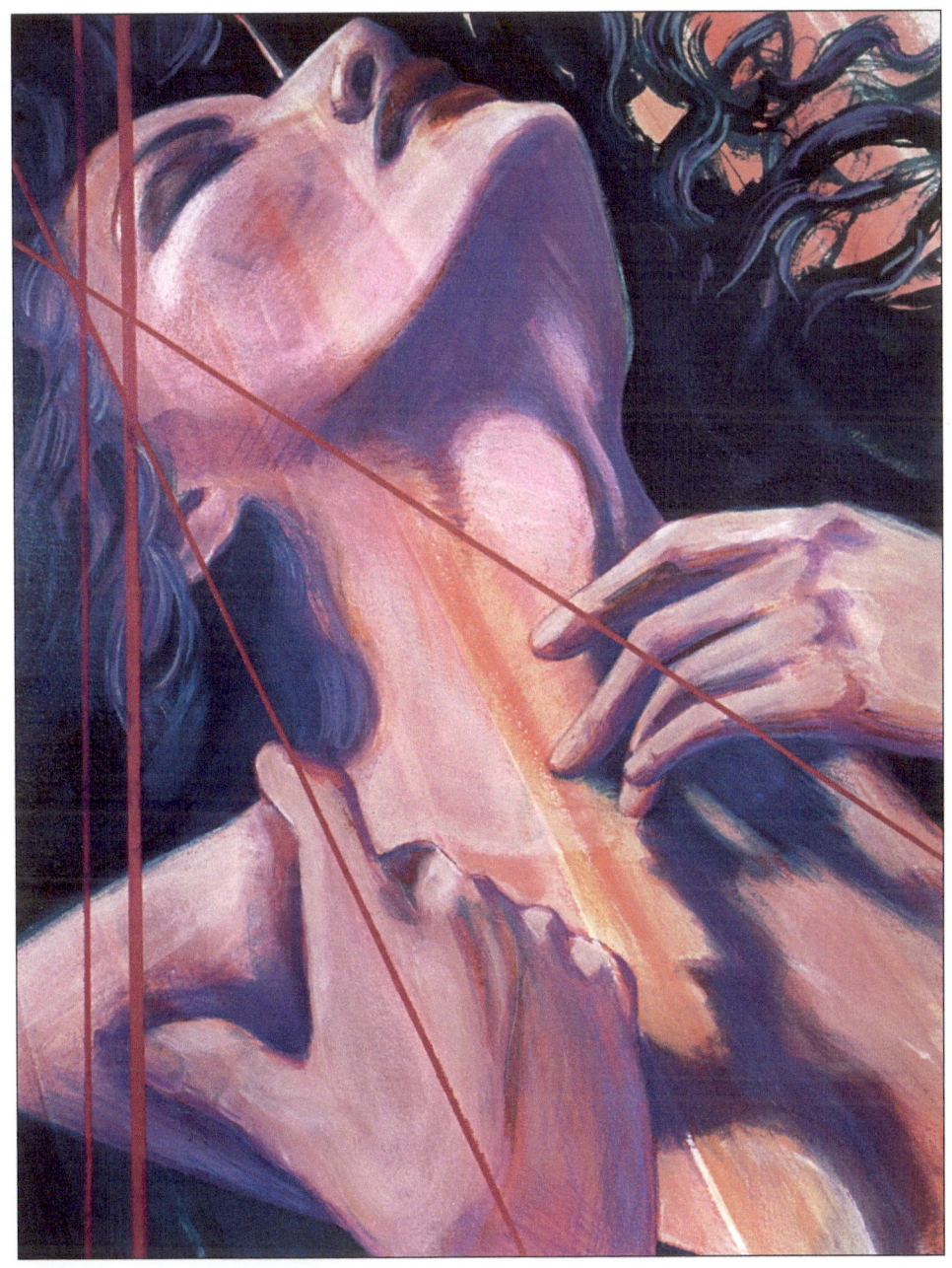

"Goddess", watercolor and gouache, 16"x20", 2006

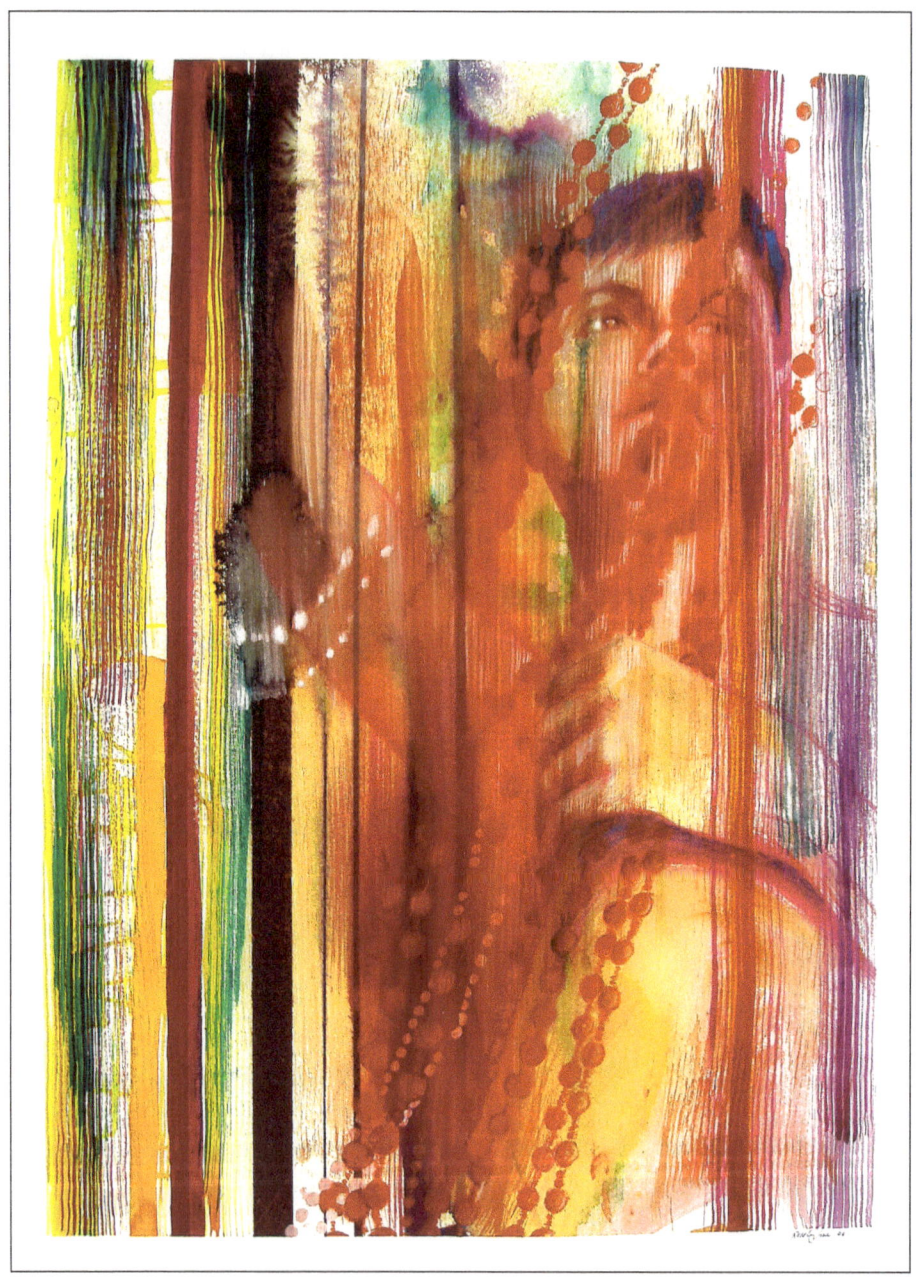

"Blood Red Jewels", watercolor and gouache, 22"x30", 2006

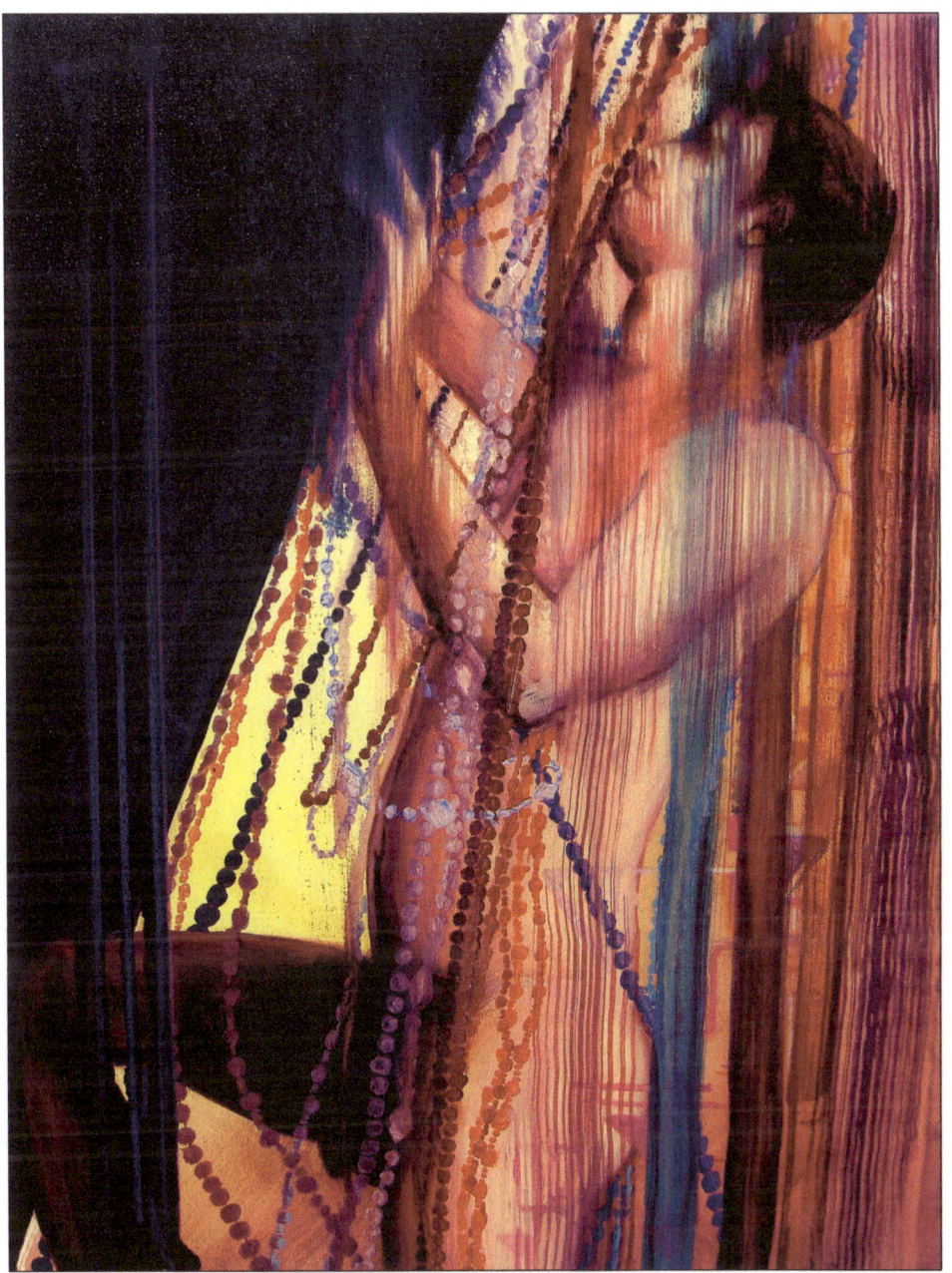
"Veil of Jewels", watercolor and gouache, 16"x20", 2006

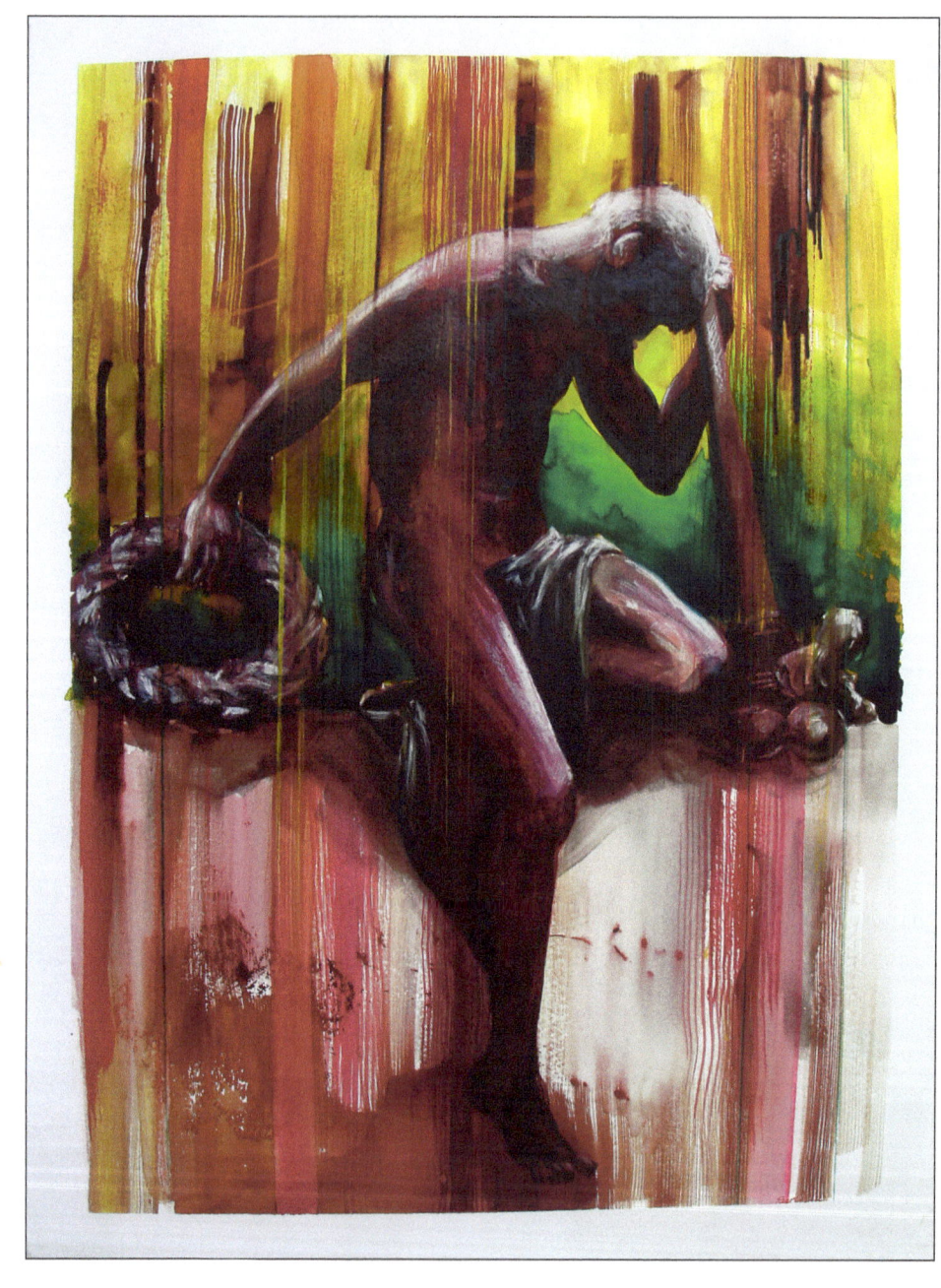

"Sorrowing Genius", watercolor and gouache, 22"x30", 2007

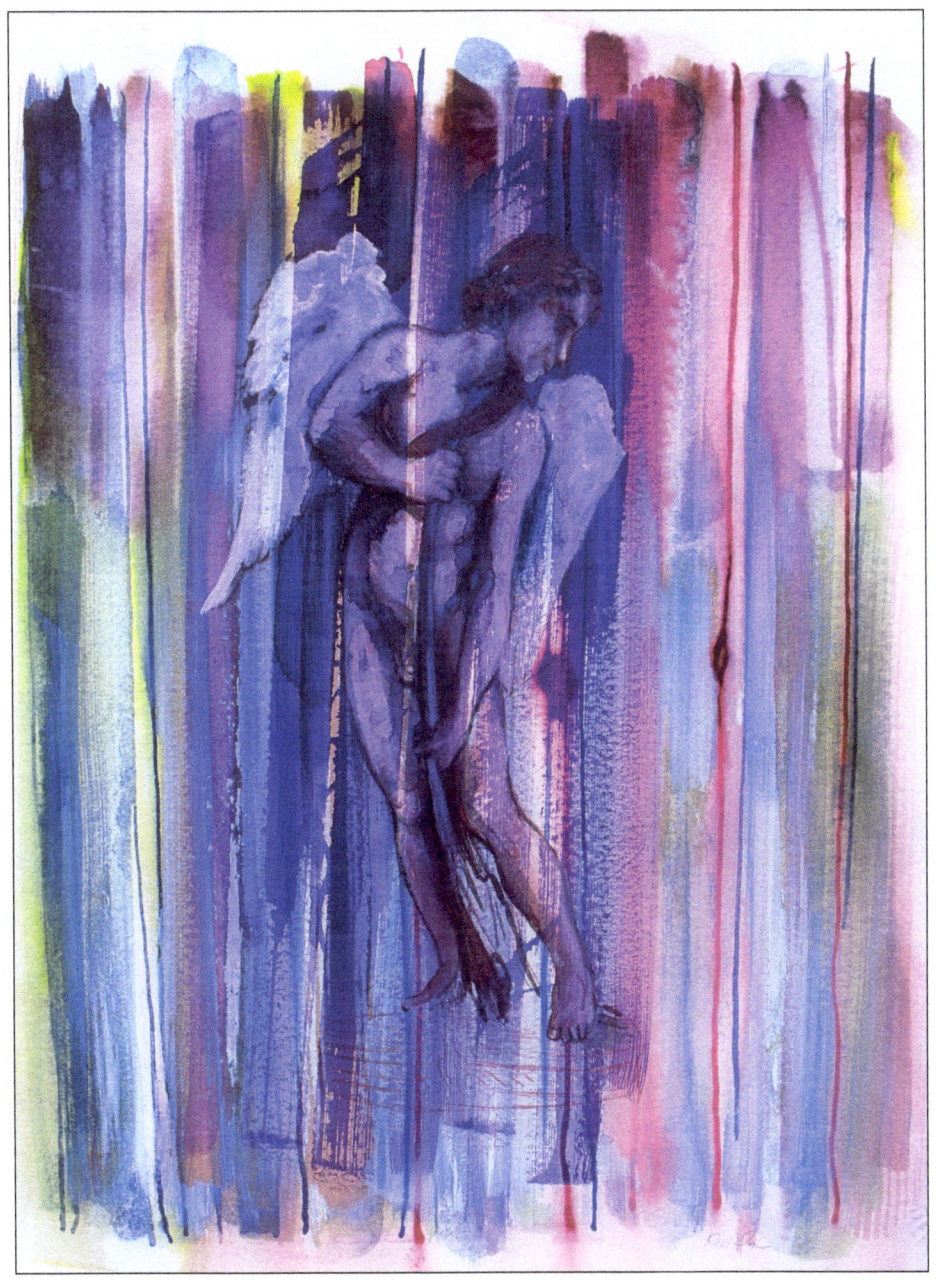

"Faded Angel", watercolor, 16"x20", 2007

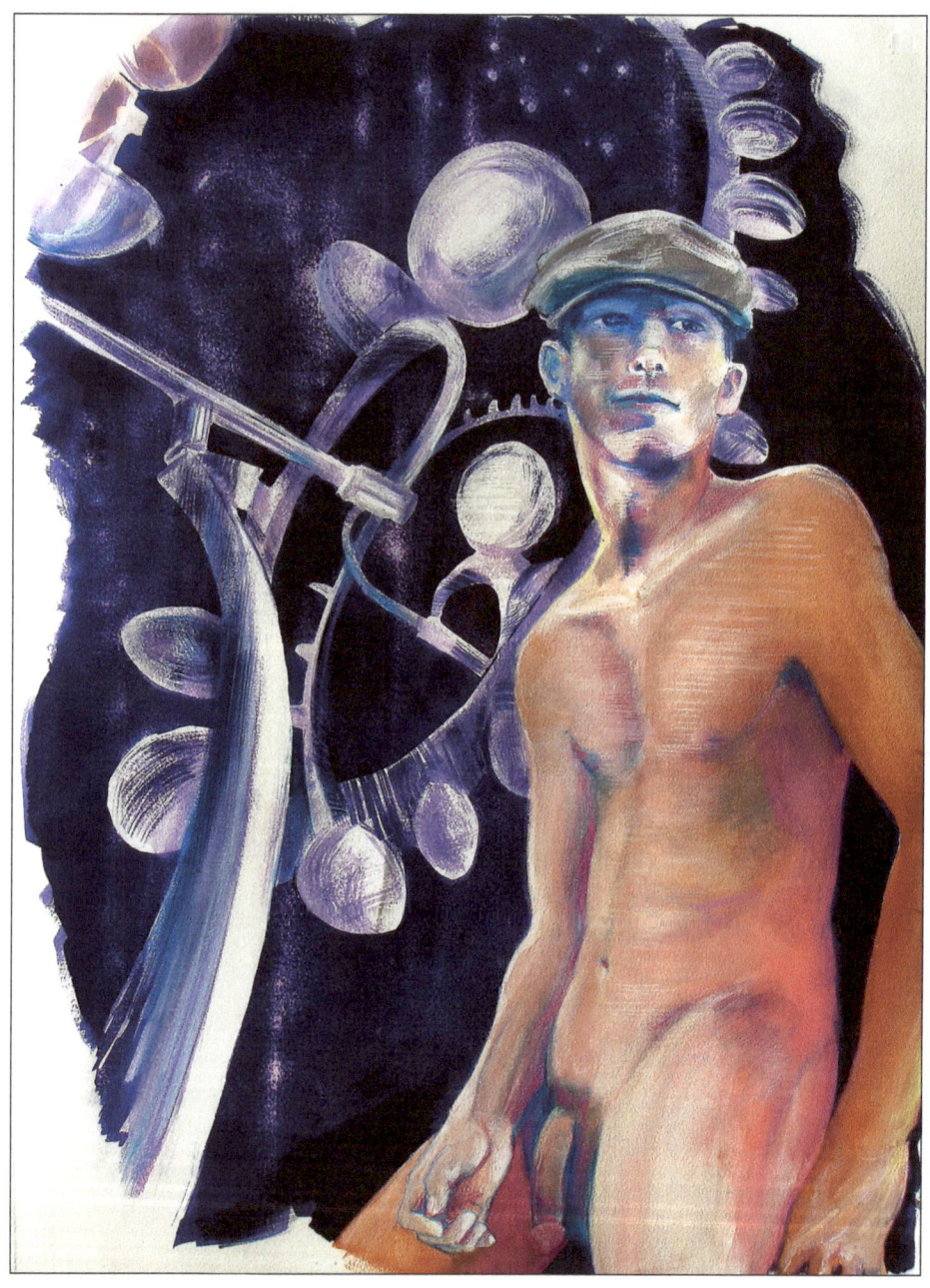

"Parking Lot Eyes", watercolor and gouache, 22"x30", 2007

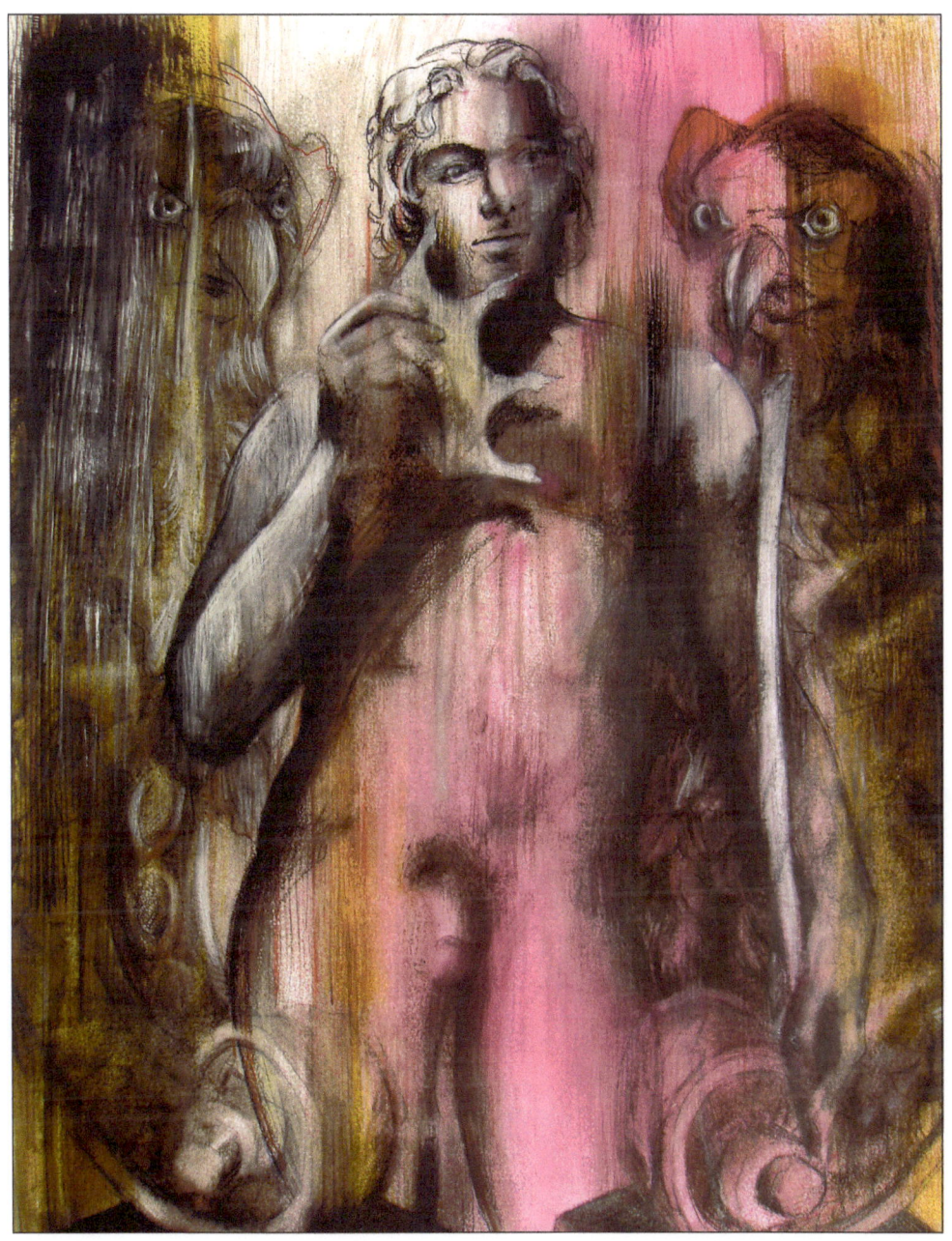

"Steal Your Crown", watercolor, ink and charcoal, 22"x30", 2007

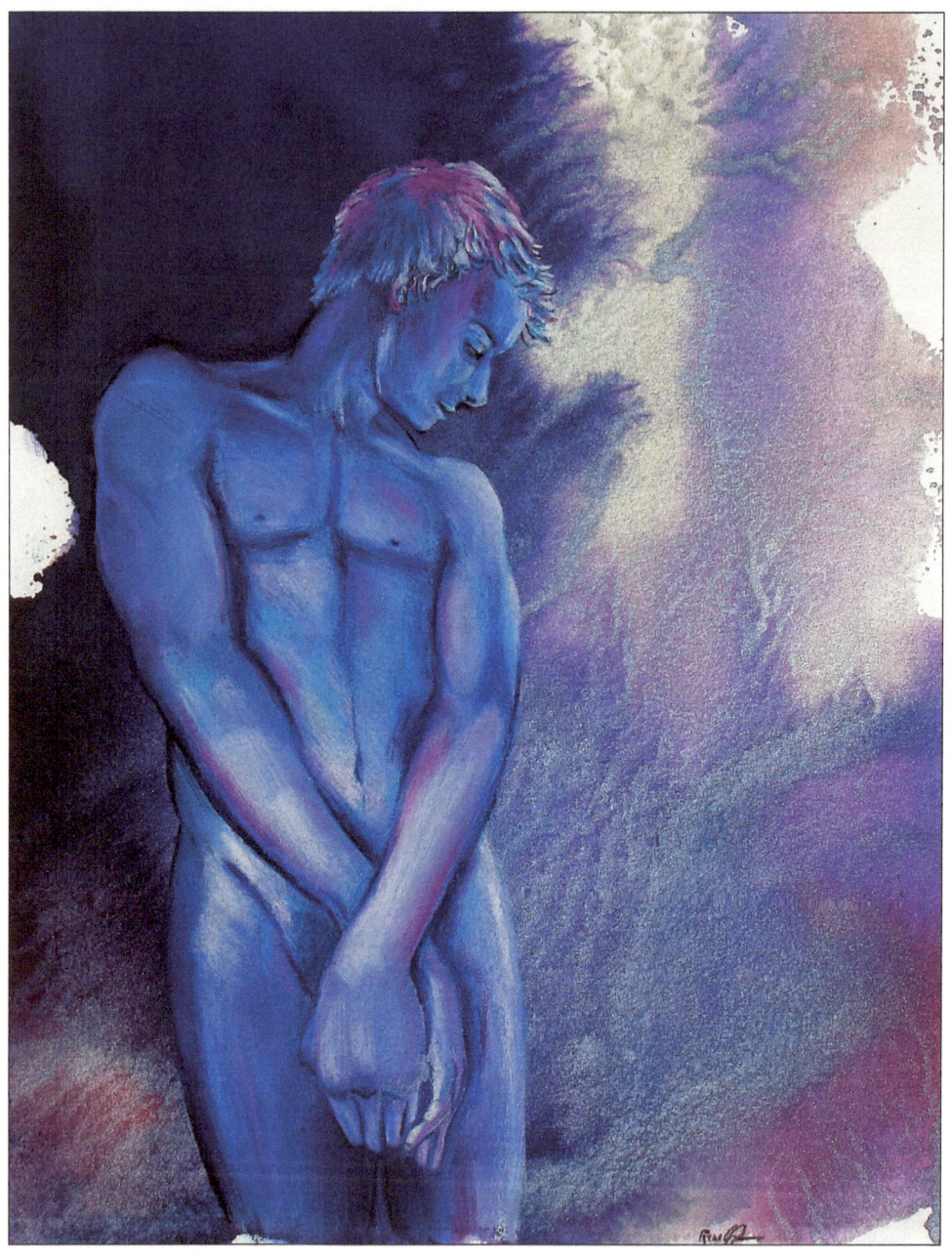

"After Midnight", watercolor and gouache, 16"x20", 2007

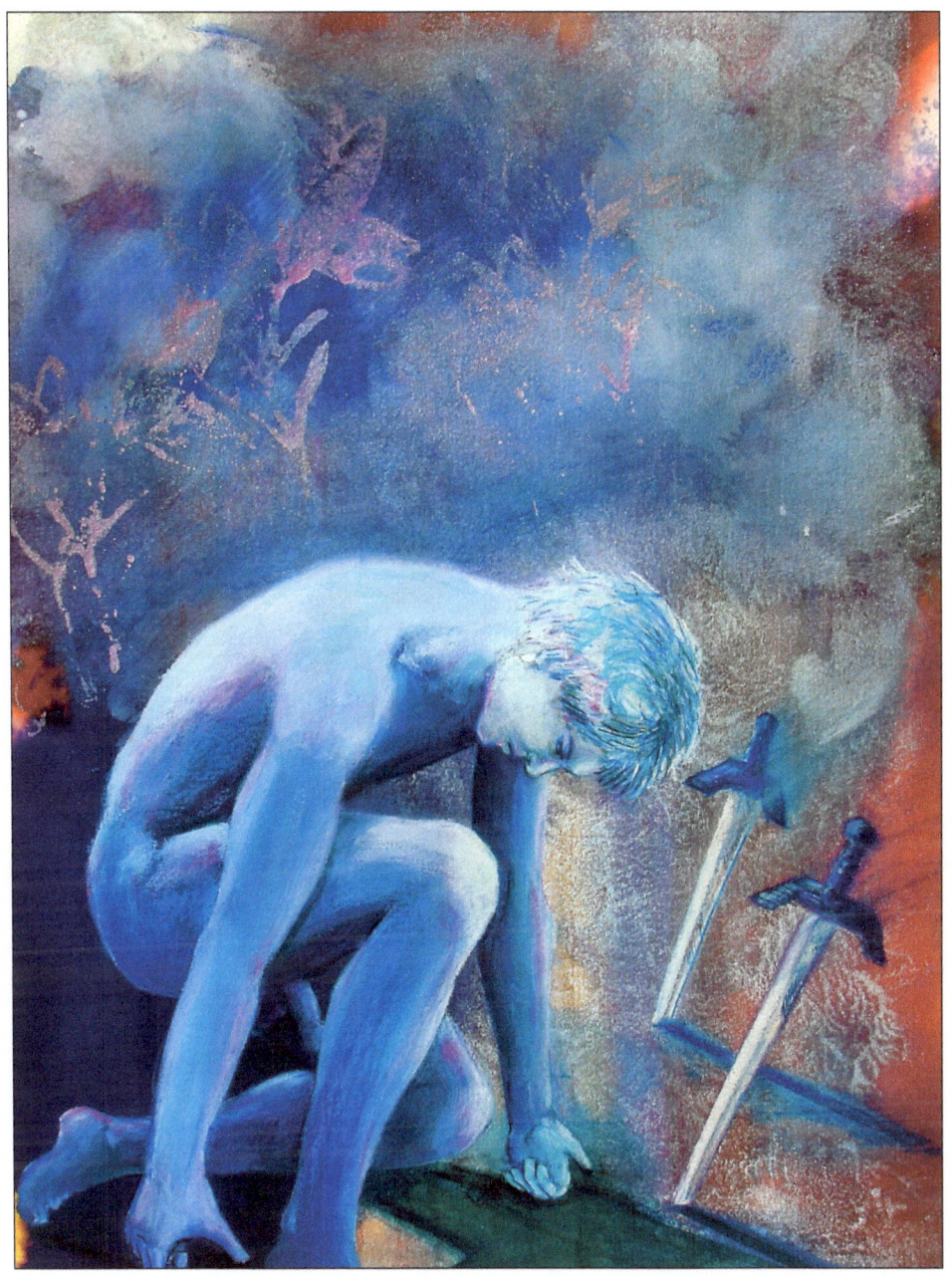

"Two of Swords", watercolor and gouache, 16"x20", 2007

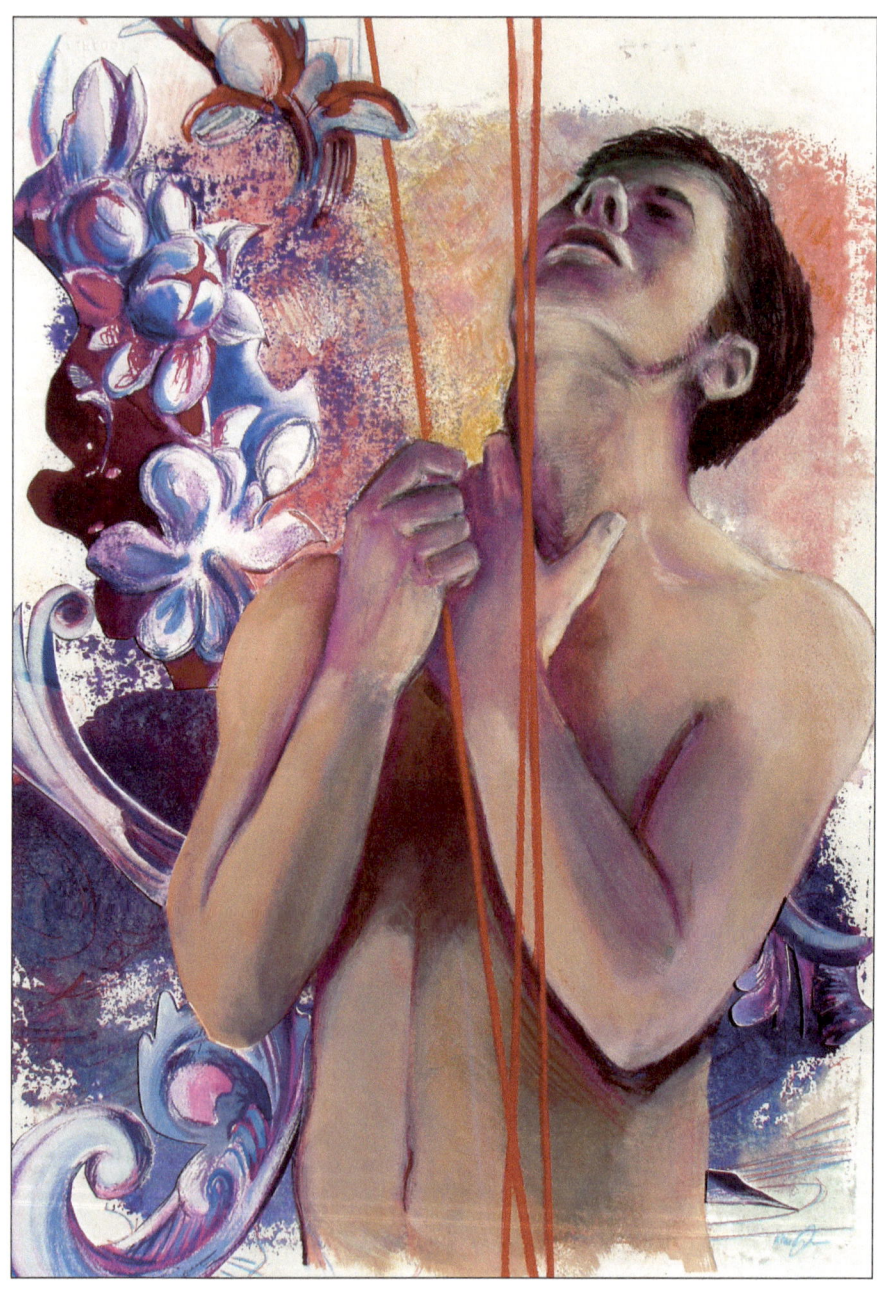

"Sex & Melancholy Flowers", watercolor, gouache and collage, 16"x20", 2007

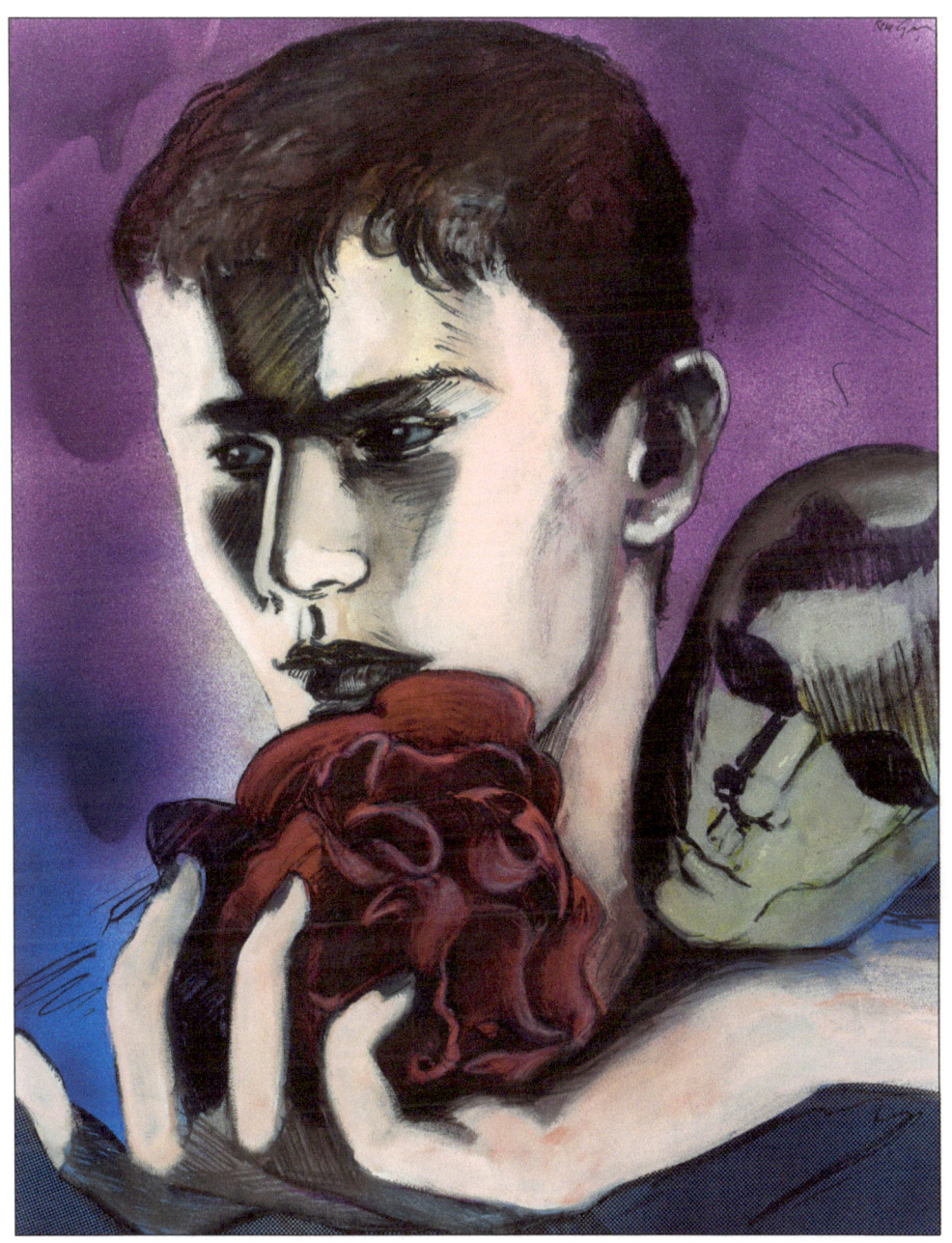

"Sometimes Your Eyes", watercolor, spray paint and ink, 16"x20", 2007

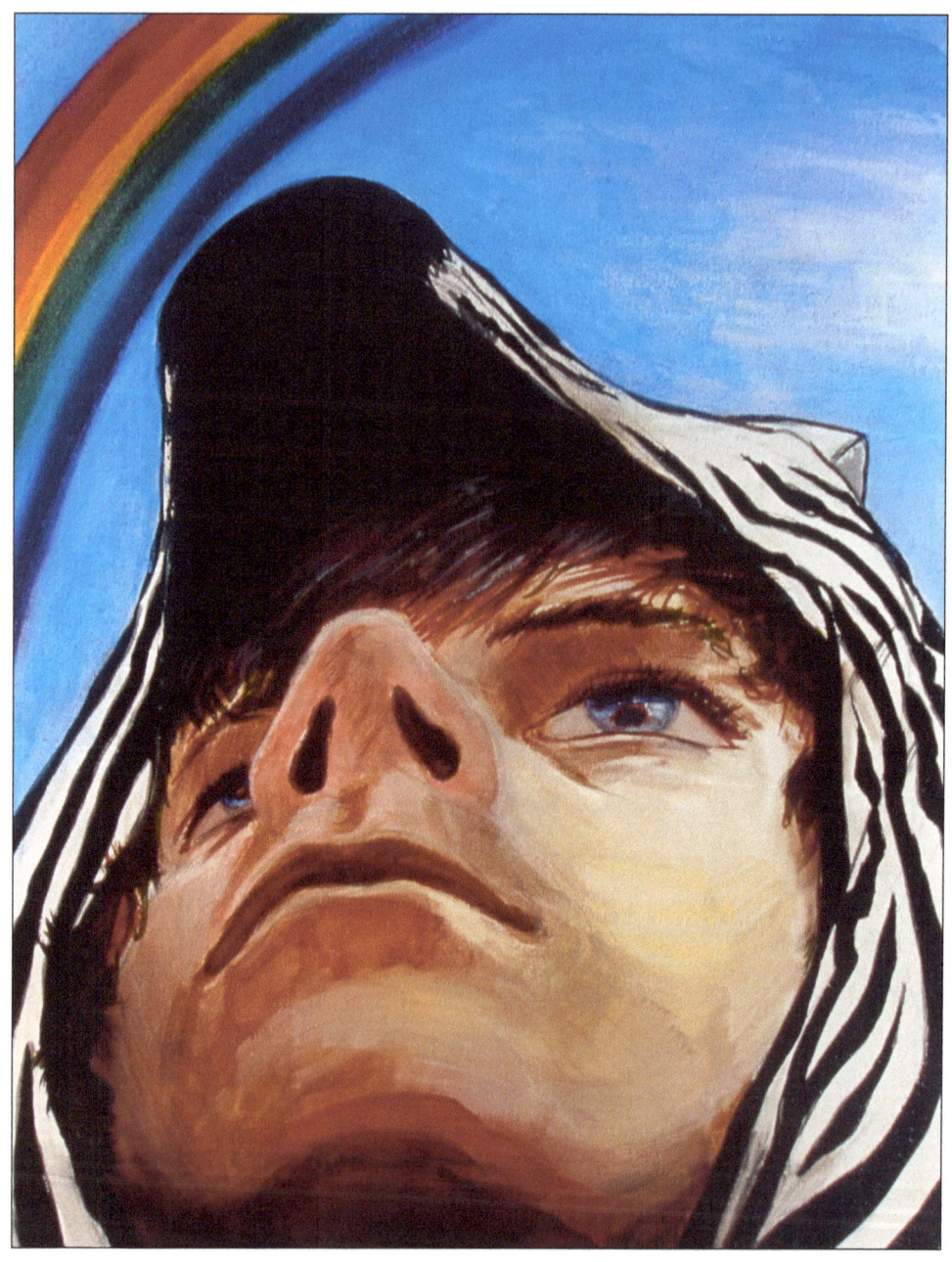

"Zebras Always Look For Rainbows", watercolor, 20"x24", 2007

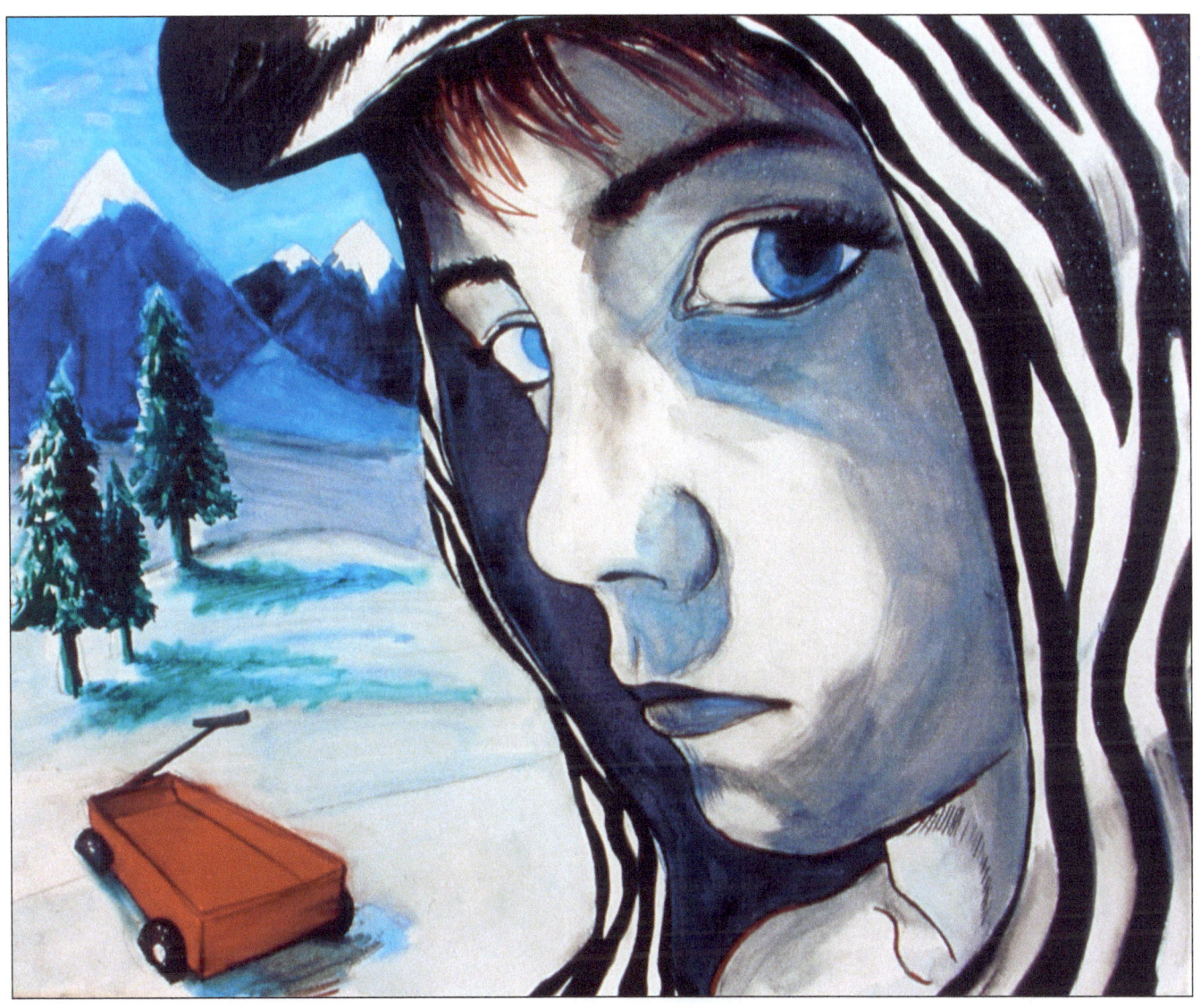
"Zebras Often Use Red Wagons", watercolor, 16"x20", 2007

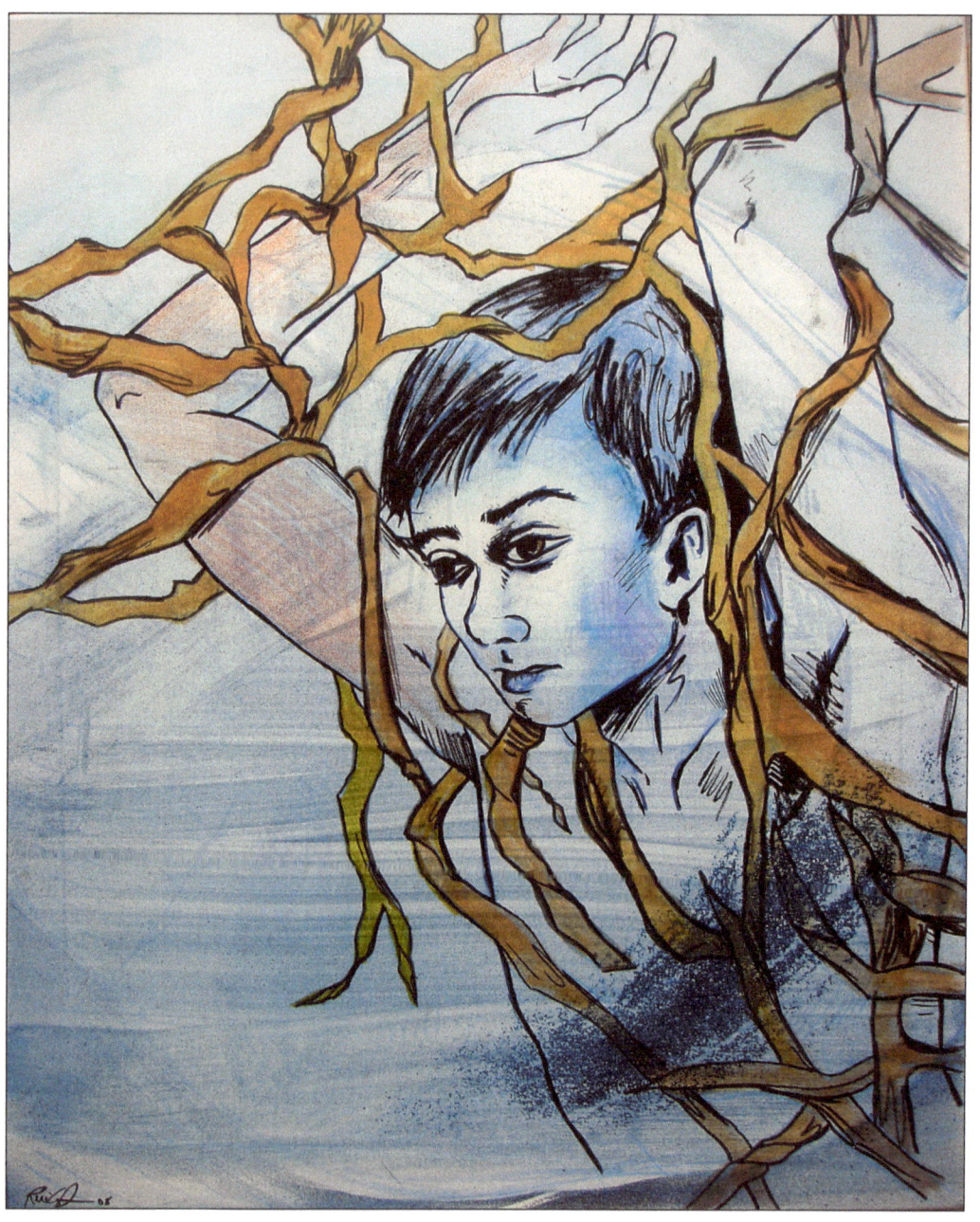

"Vines", watercolor and marker, 20"x24", 2008

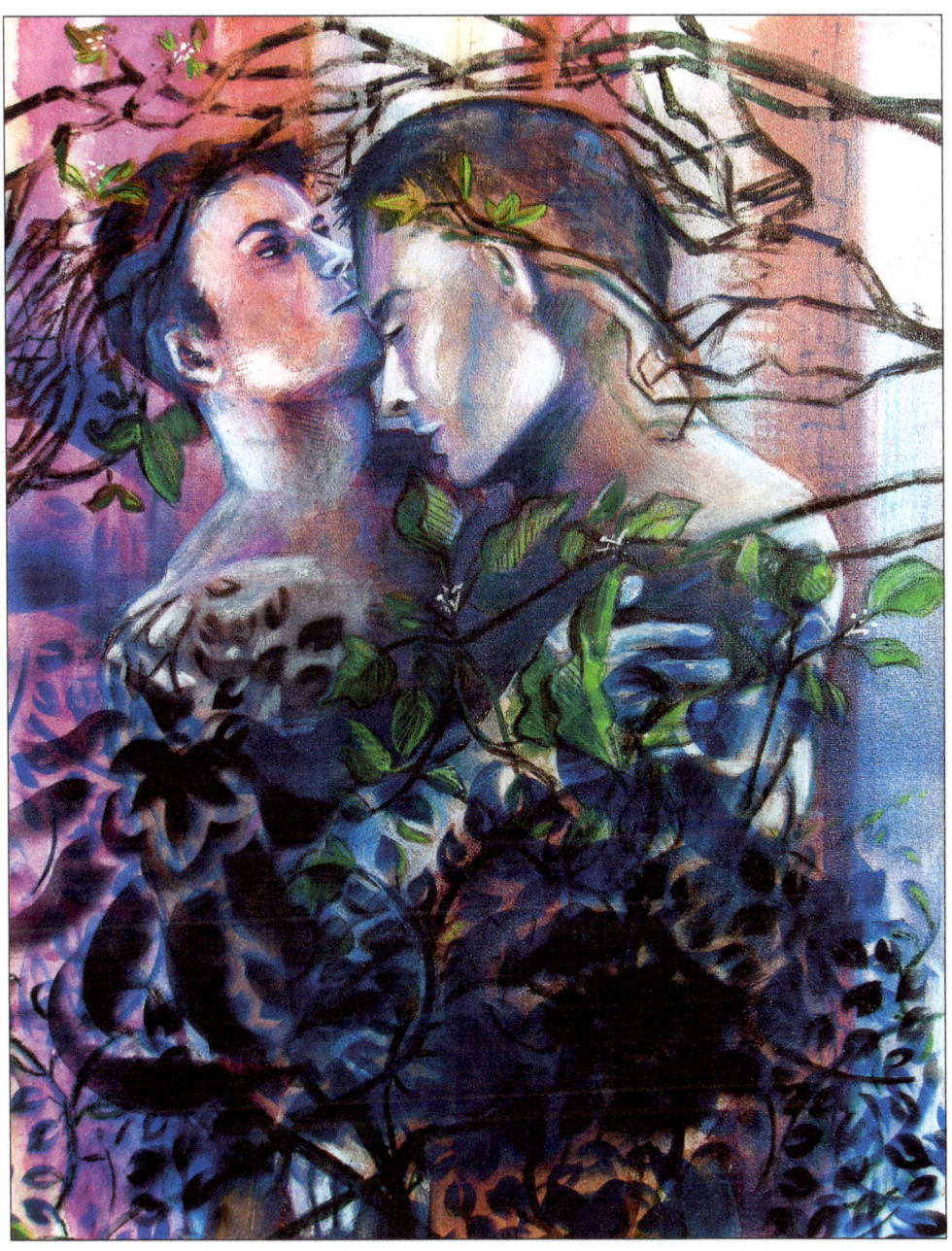

"The Cool Breeze Before an Earth Sign", watercolor and spray paint, 16"x20", 2007

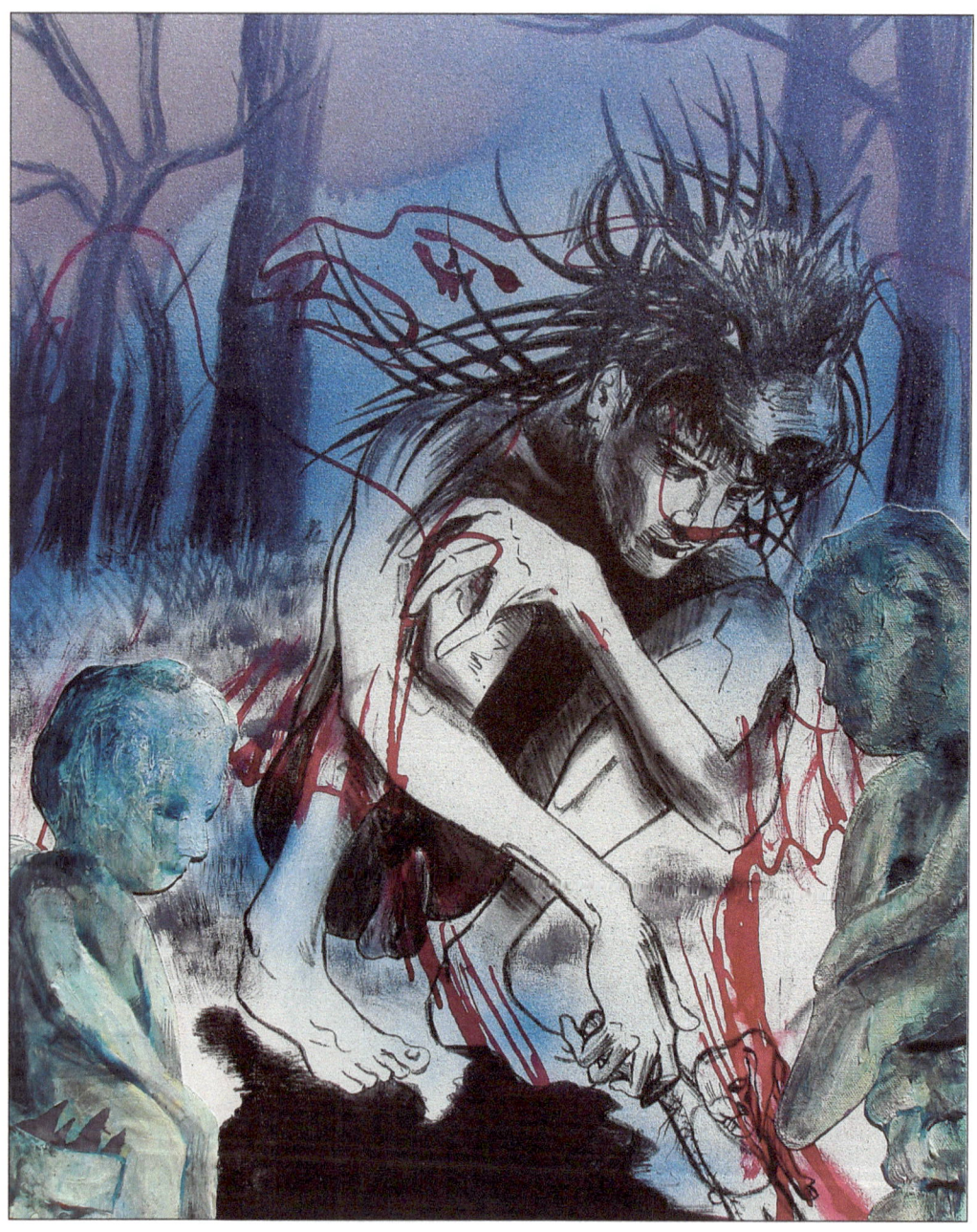

"Birth of Hedgehog Boy", watercolor, ink and spray paint, 20"x24", 2007

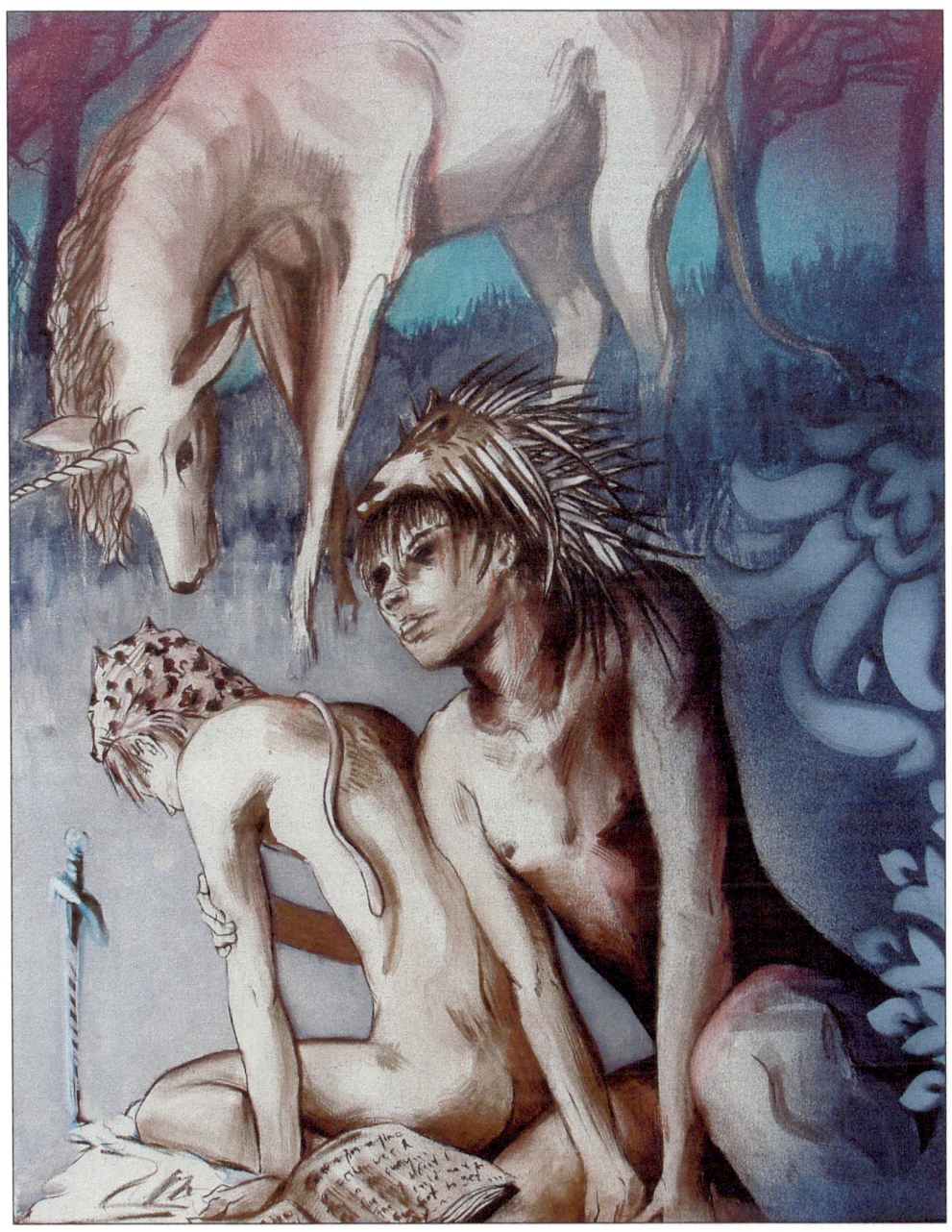

"Legend", watercolor, ink and spray paint, 20"x24", 2007

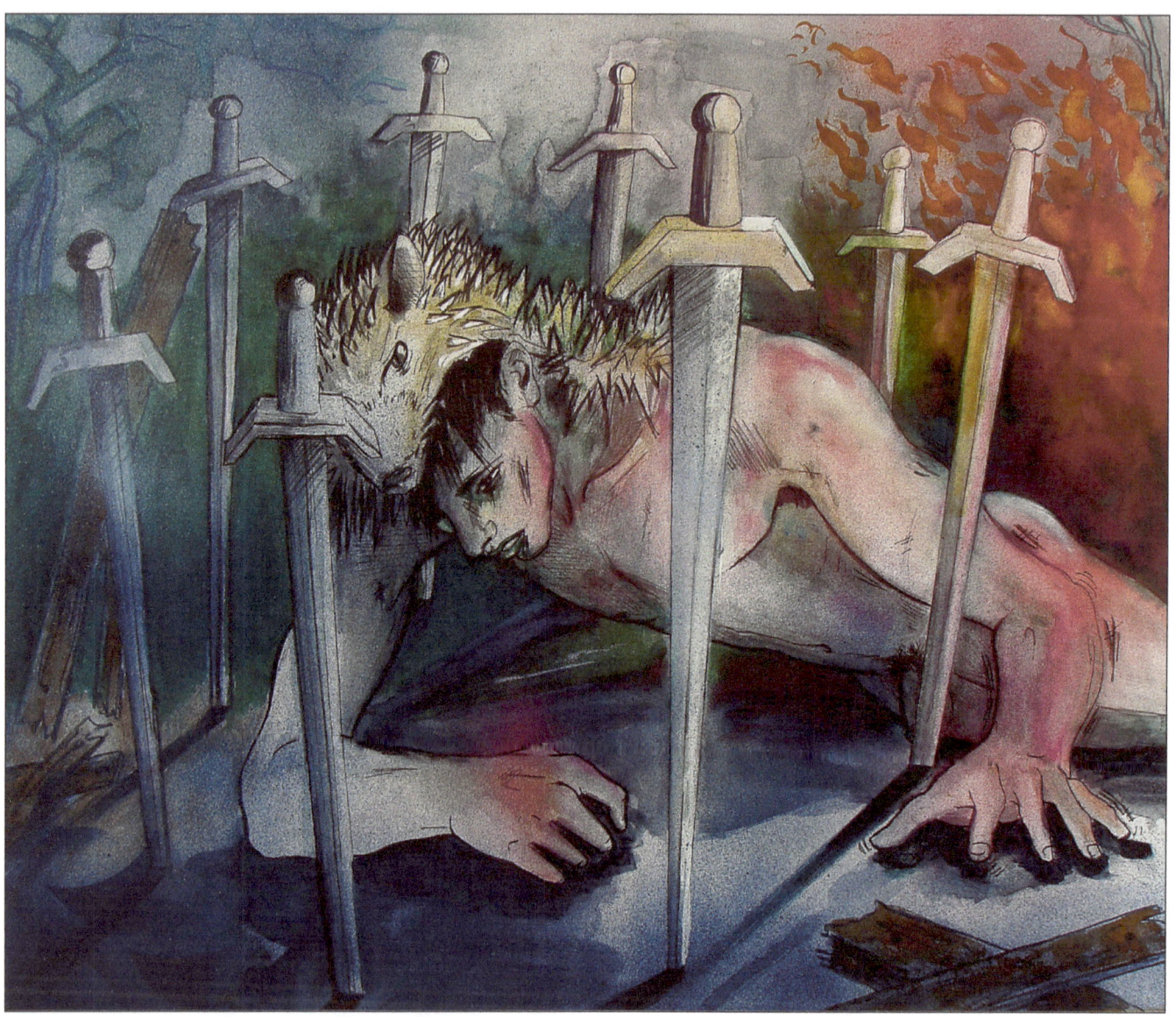
"Fallen", watercolor, ink and spray paint, 20"x24", 2007

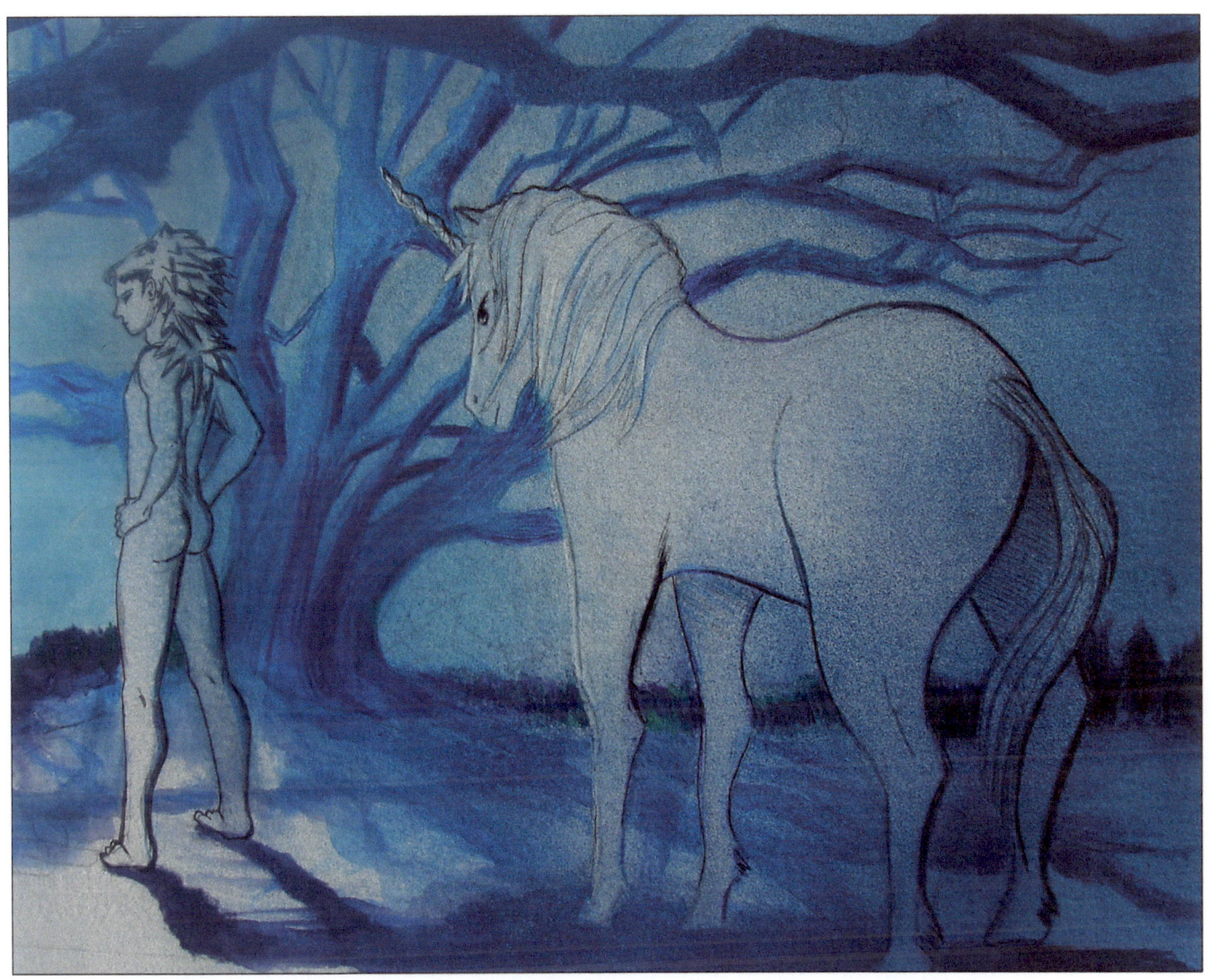

"Blue Unicorn", watercolor, ink and spray paint, 11"x14", 2007

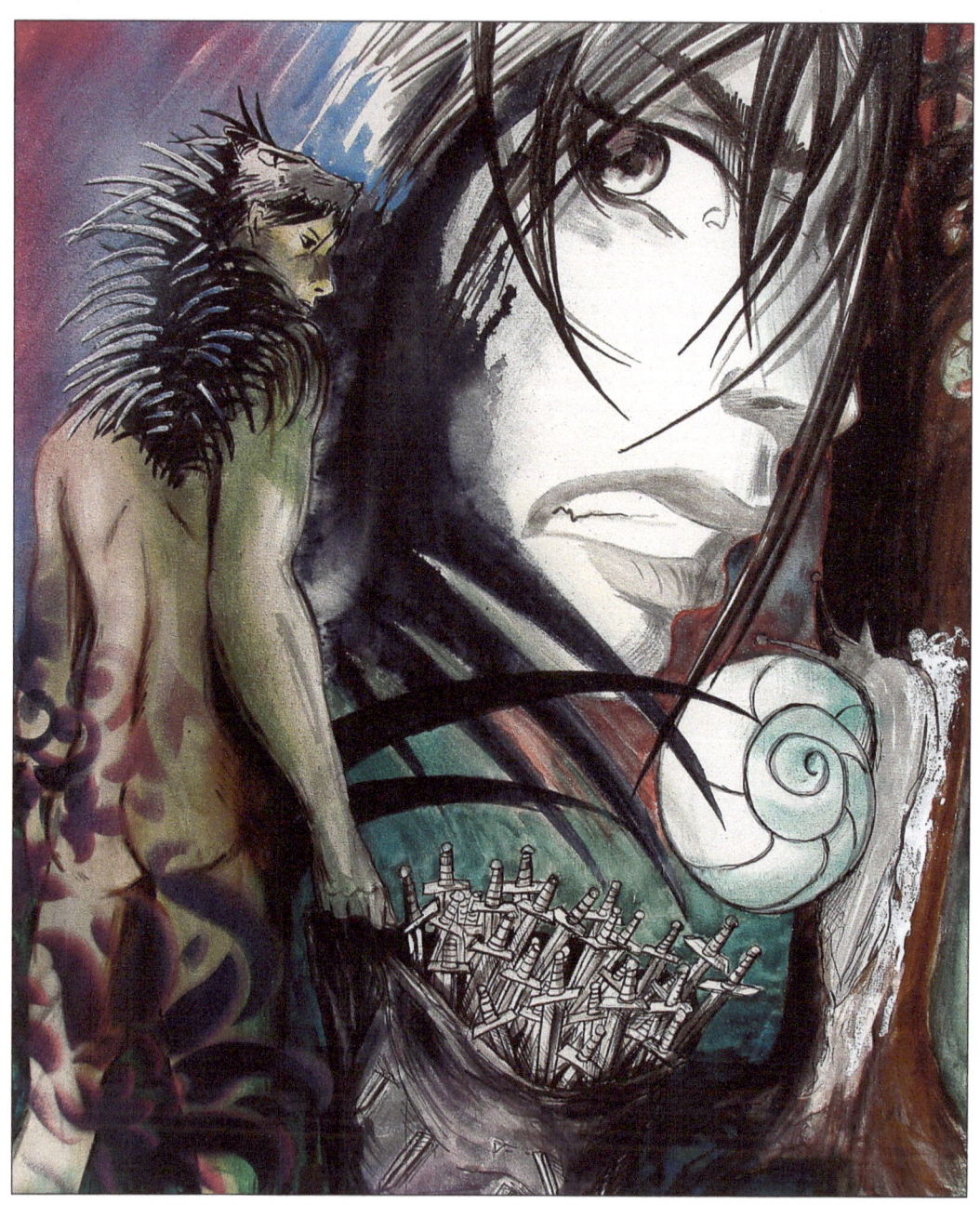

"Burden of Swords", watercolor, ink and spray paint, 20"x24", 2007

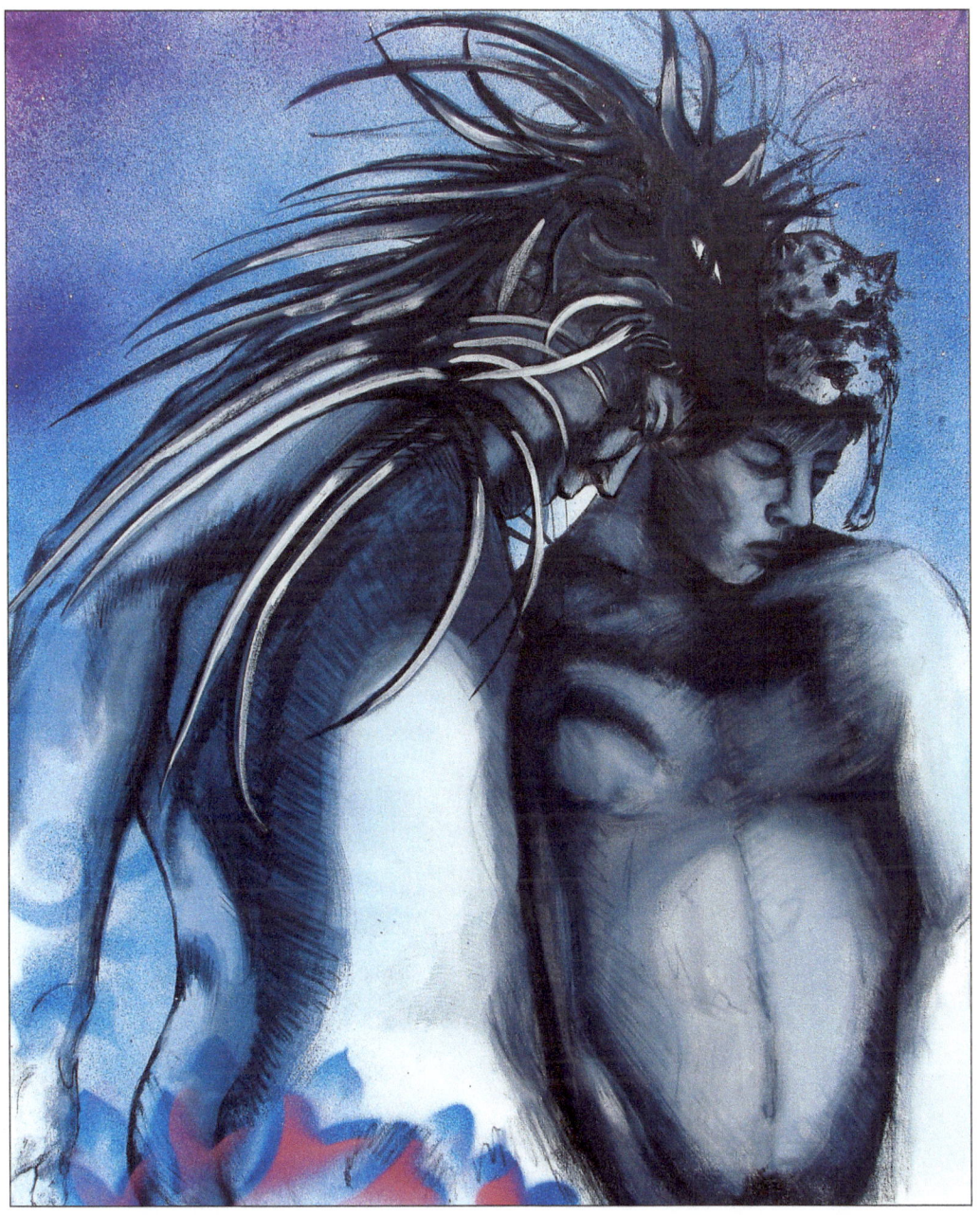

"Hedgehog Boy & Kitty", watercolor, ink and spray paint, 20"x24", 2007

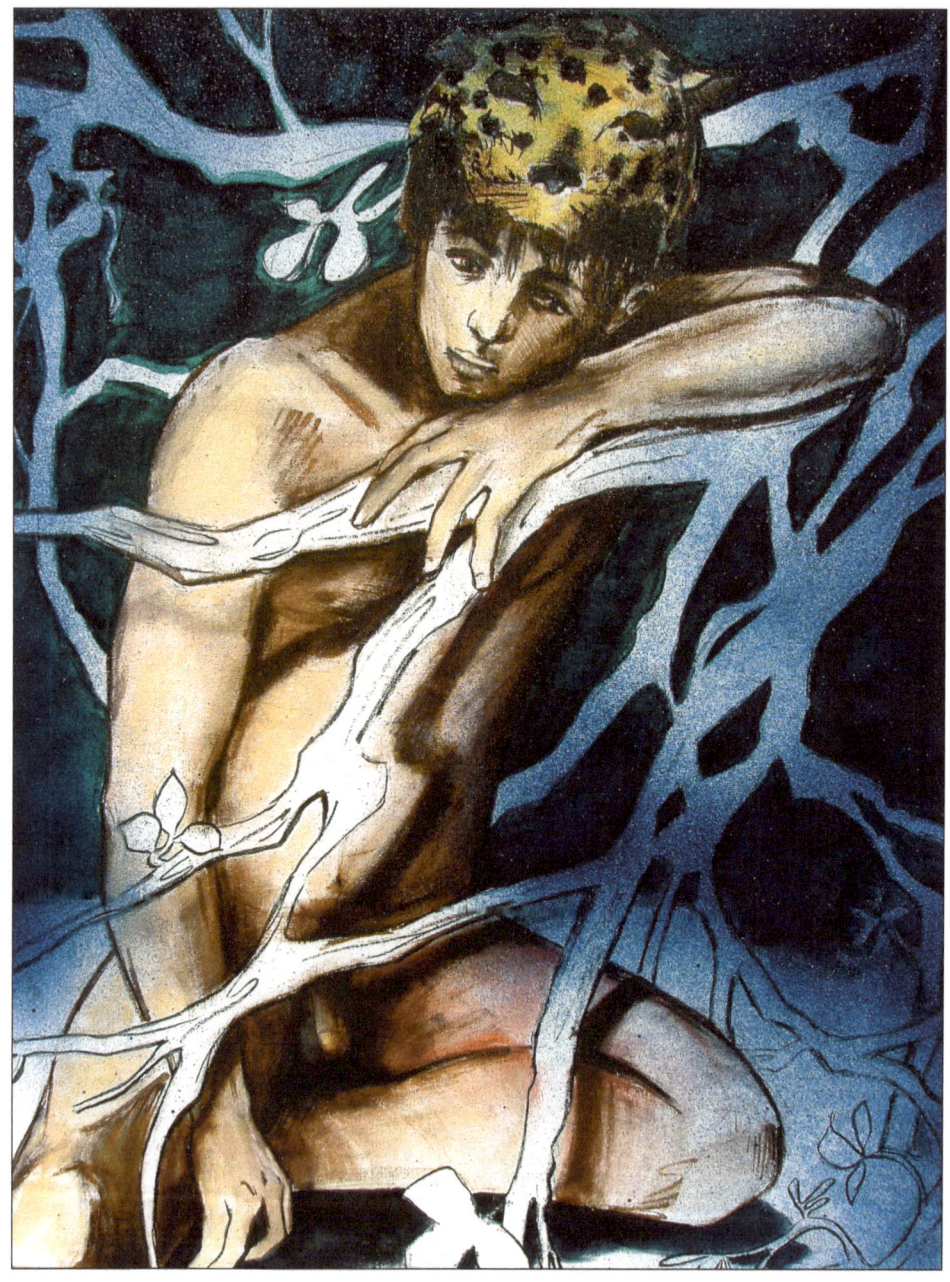

"Kitty" (Savior of Squirrels) watercolor, ink and spray paint, 16"x20", 2007

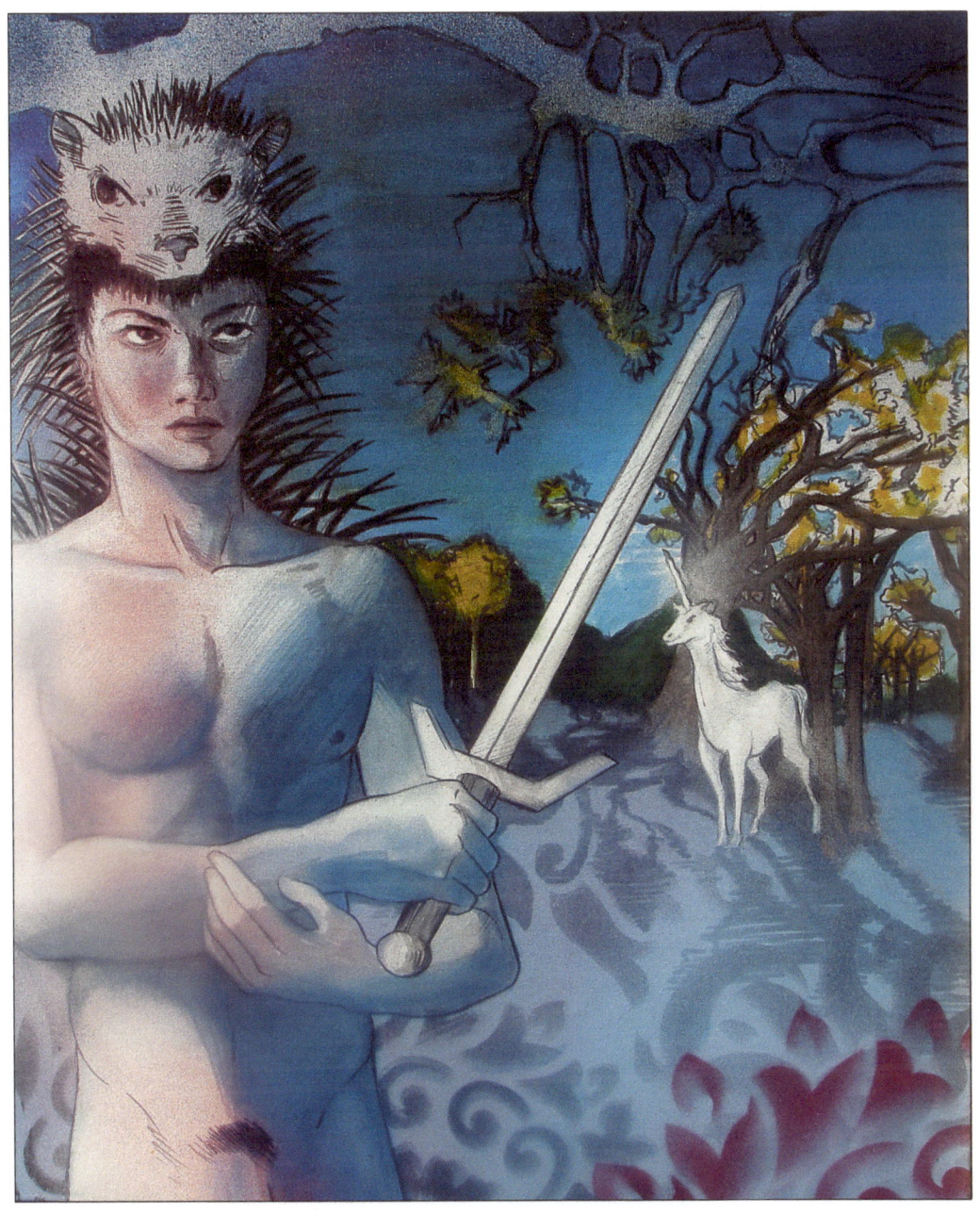

"All I Need is a Unicorn and a Sword", watercolor, ink and spray paint, 20"x24", 2008

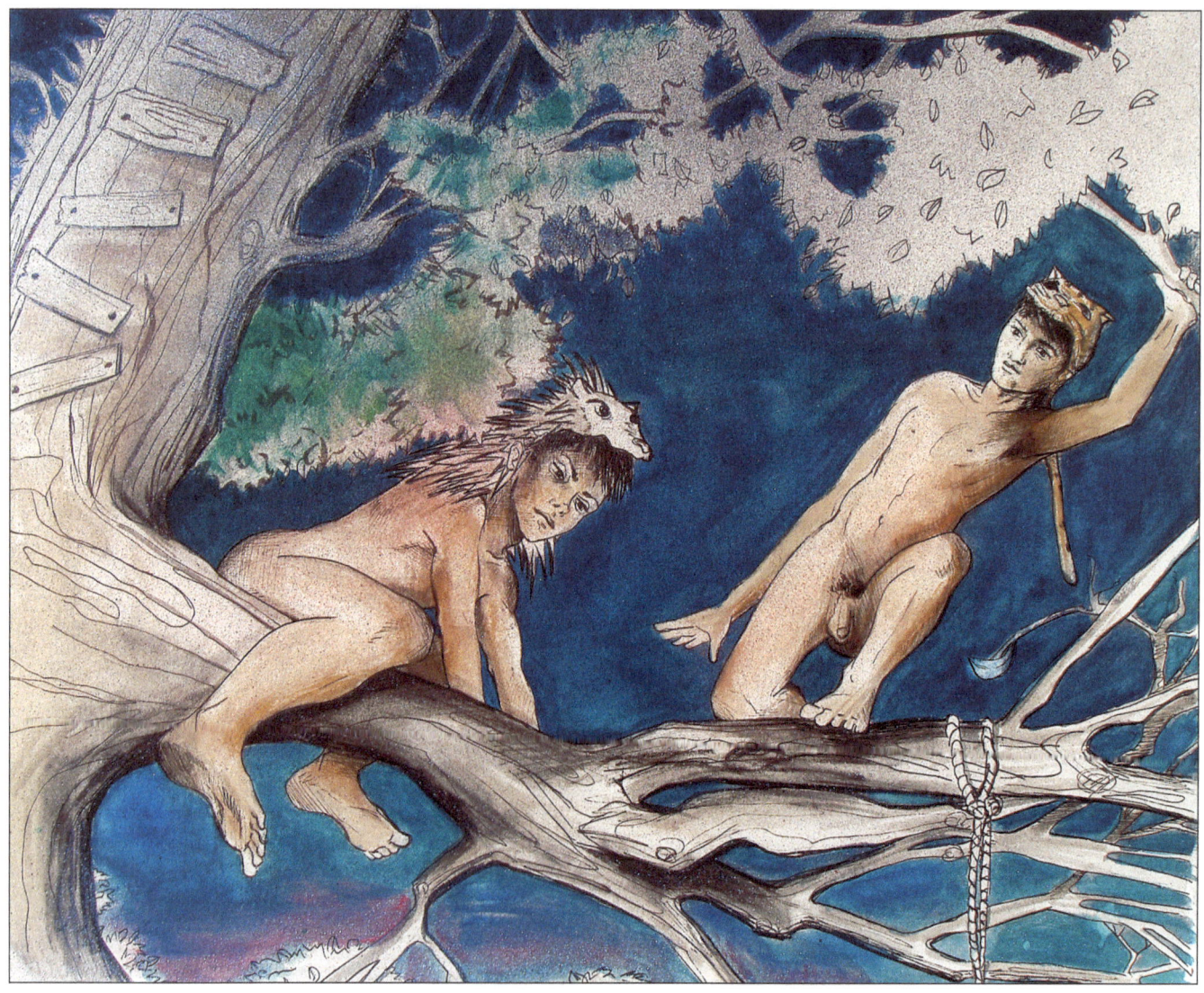

"To the Trees", watercolor and ink, 11"x14", 2008

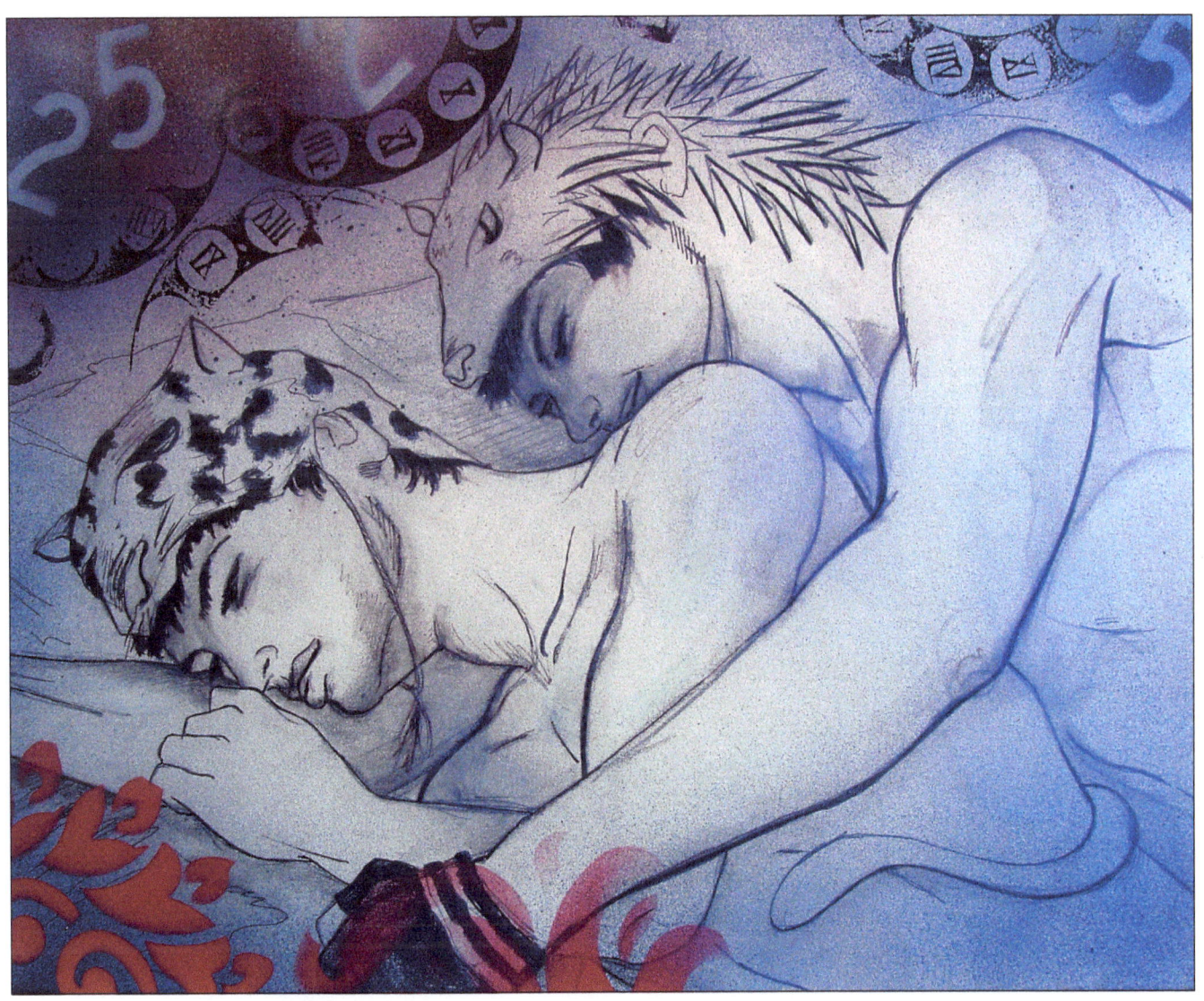

"Hedgehog Nap", watercolor, ink and spray paint, 16"x20", 2008

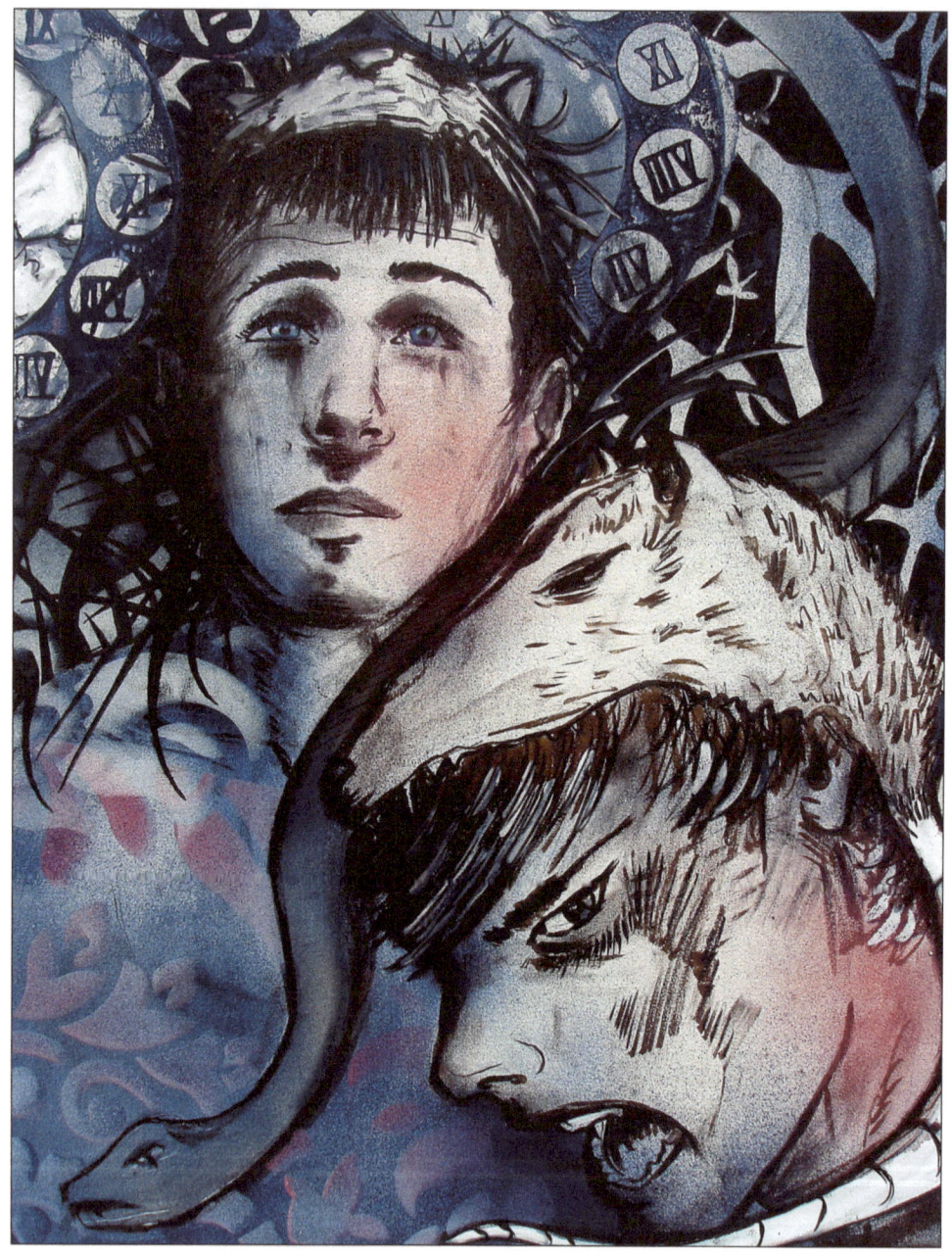

"Enemies", watercolor, ink and spray paint, 16"x20", 2007

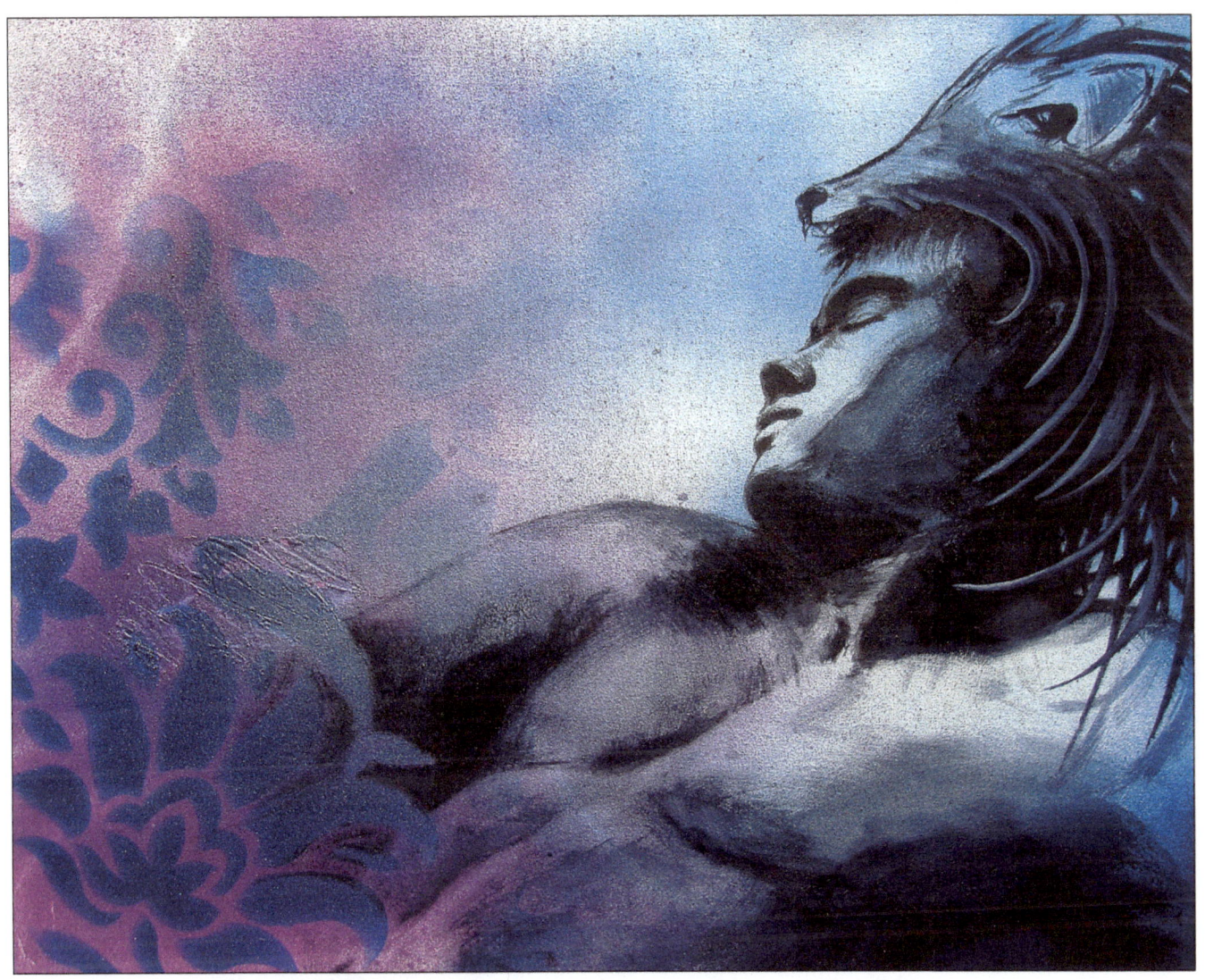

"Even Monsters Have to Sleep", watercolor, ink and spray paint, 16"x20", 2007

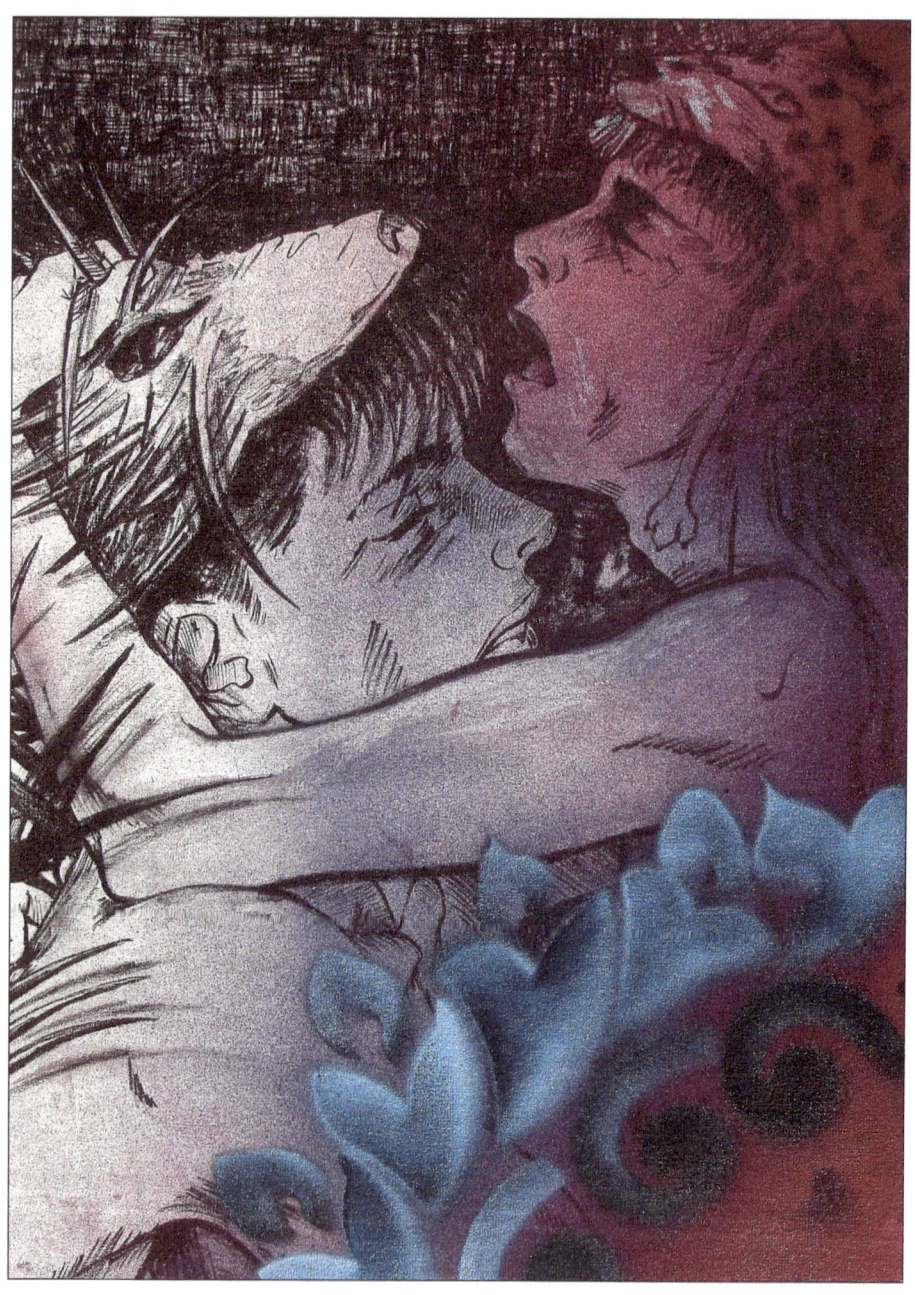

"Sex", watercolor, ink and spray paint, 12"x14", 2007

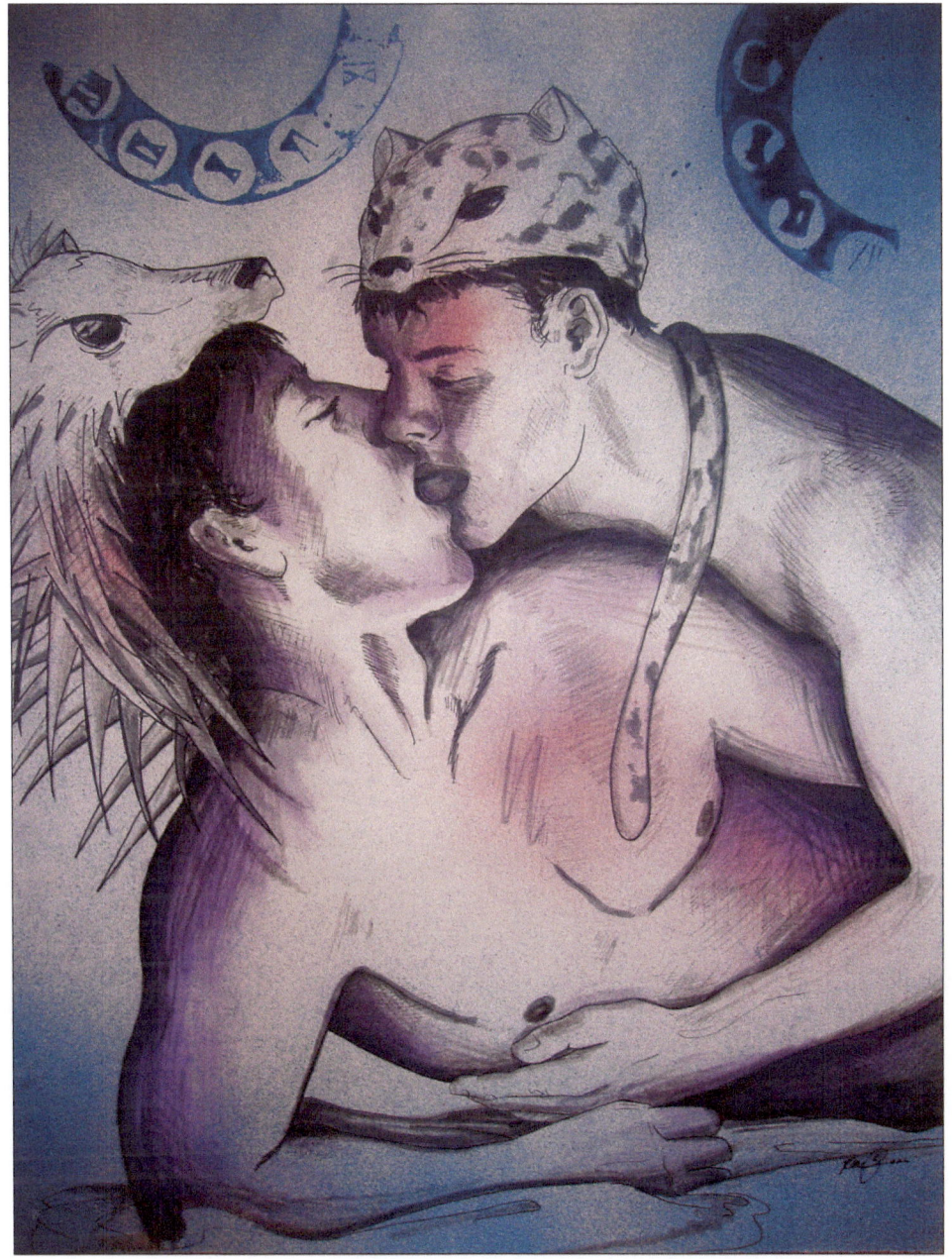

"Kiss & Kill", watercolor, ink and spray paint, 20"x24", 2008

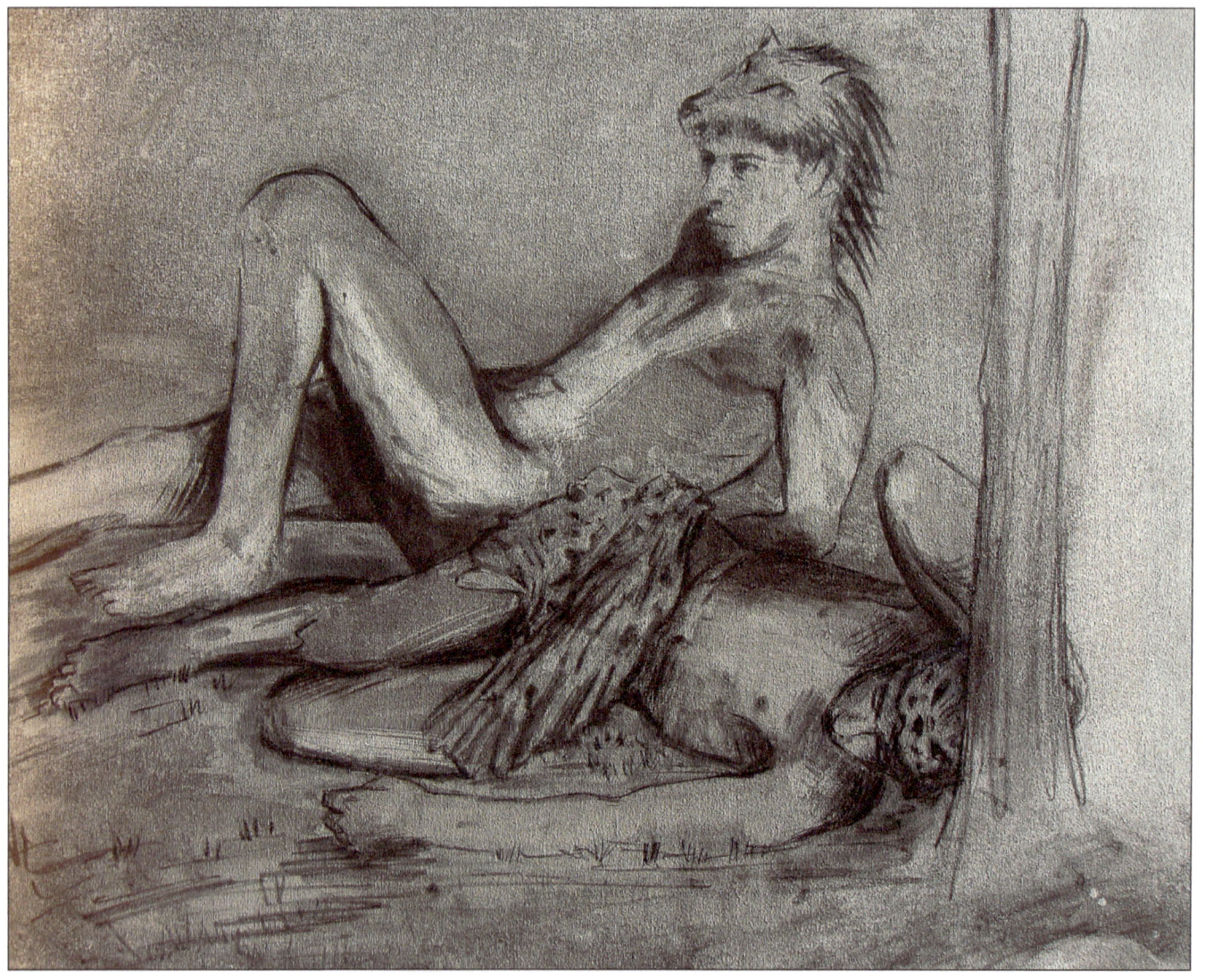

"Watchdog", watercolor and ink, 16"x20", 2008

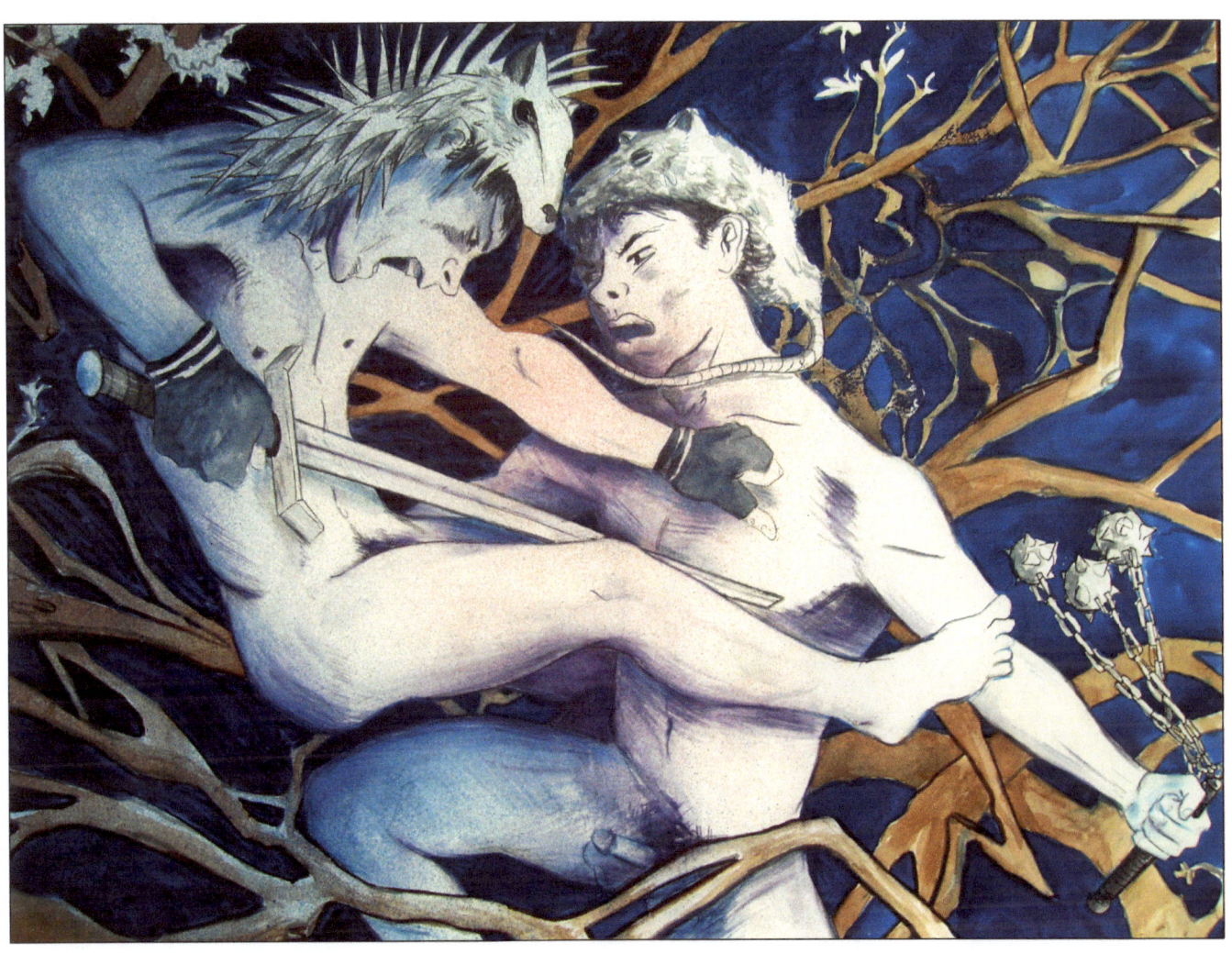
"War", watercolor, ink and color pencil, 22"x30", 2008

"Red Morning", watercolor, ink and spray paint, 12"x12", 2008

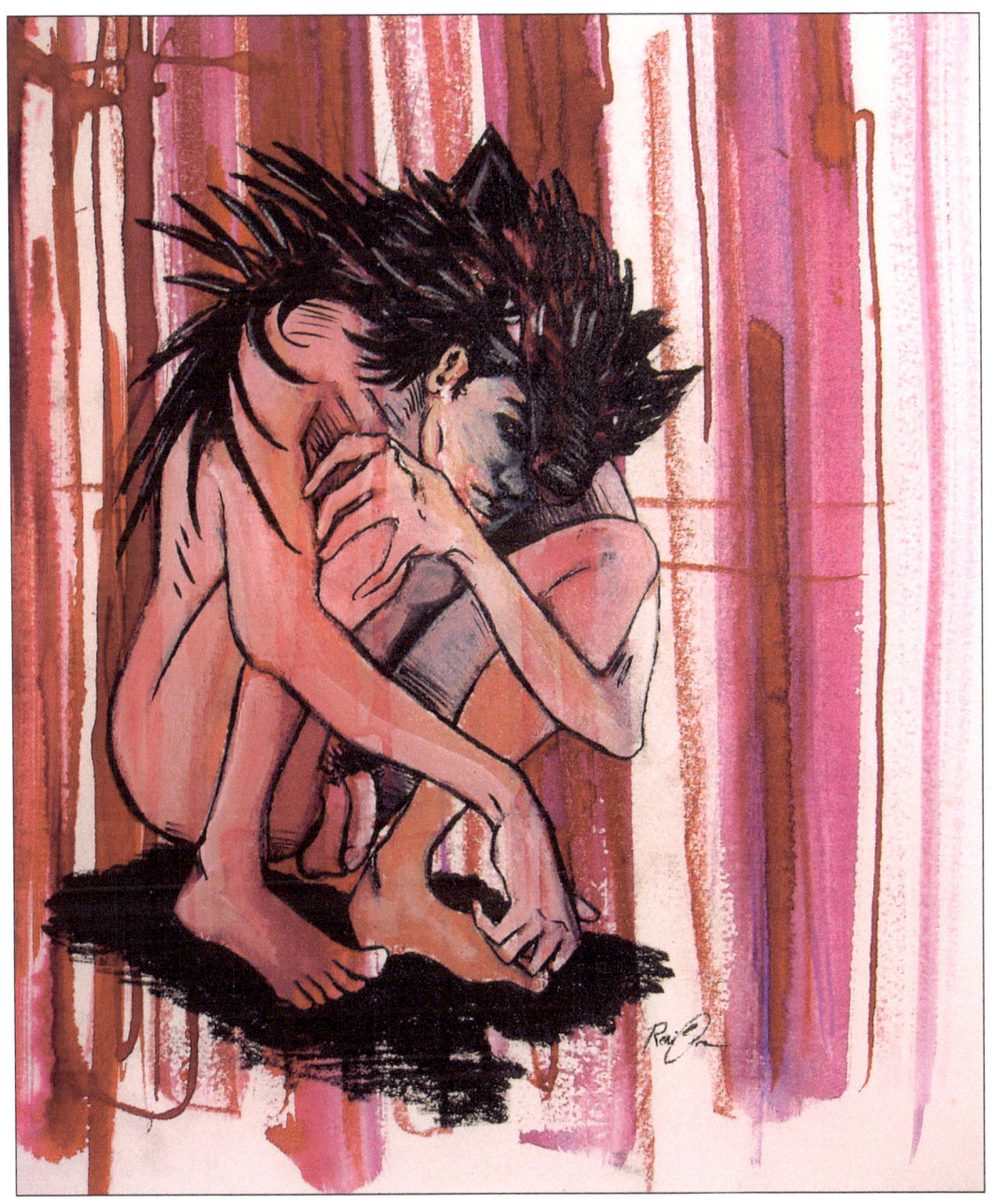

"Pink Hedgehog", watercolor, color pencil and ink, 8"x10", 2007

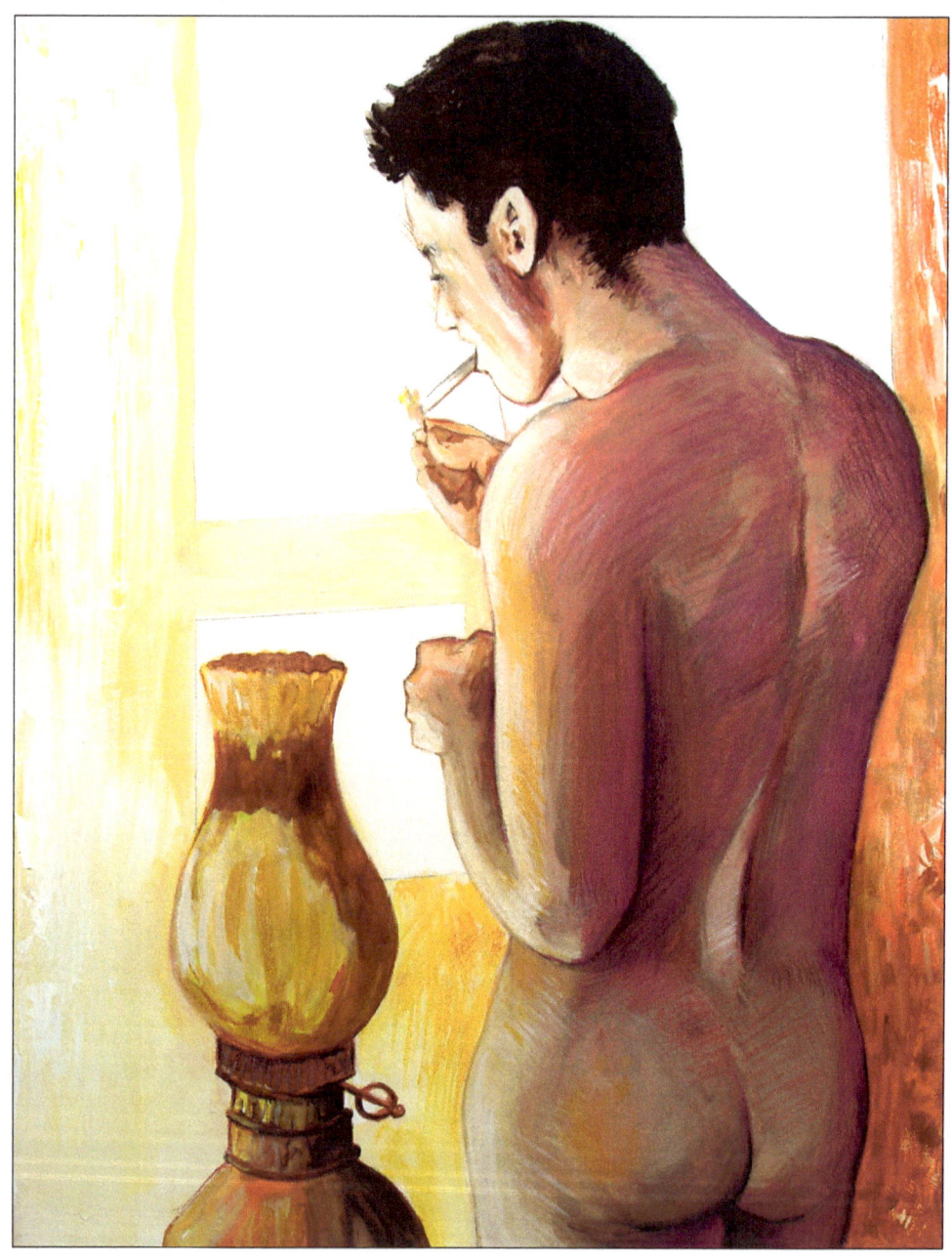

"Yellow Cigarette", watercolor, ink and color pencil, 16"x20", 2009

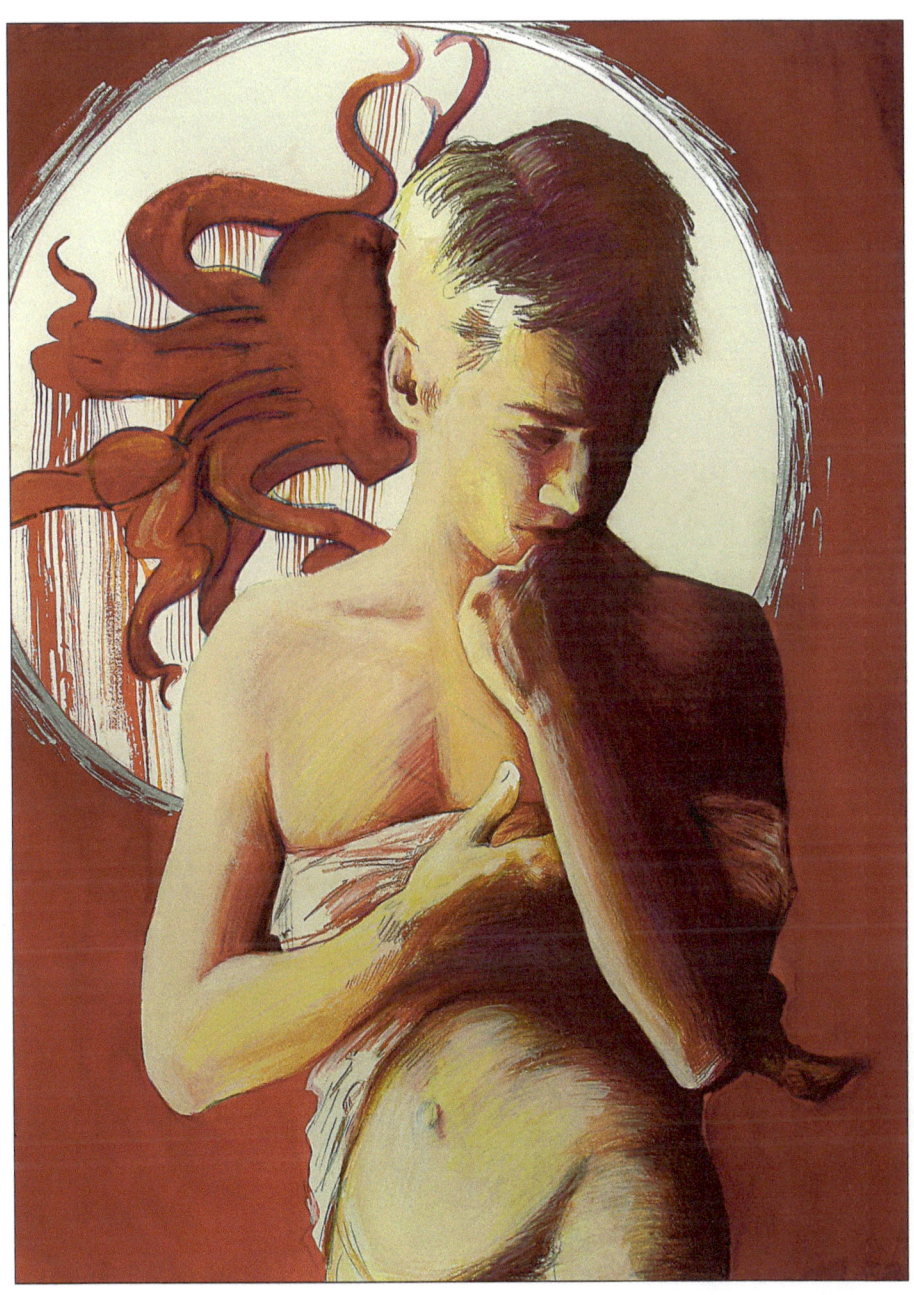

"Red Snap Dragon Moonset", watercolor, ink and color pencil, 22"x30", 2010

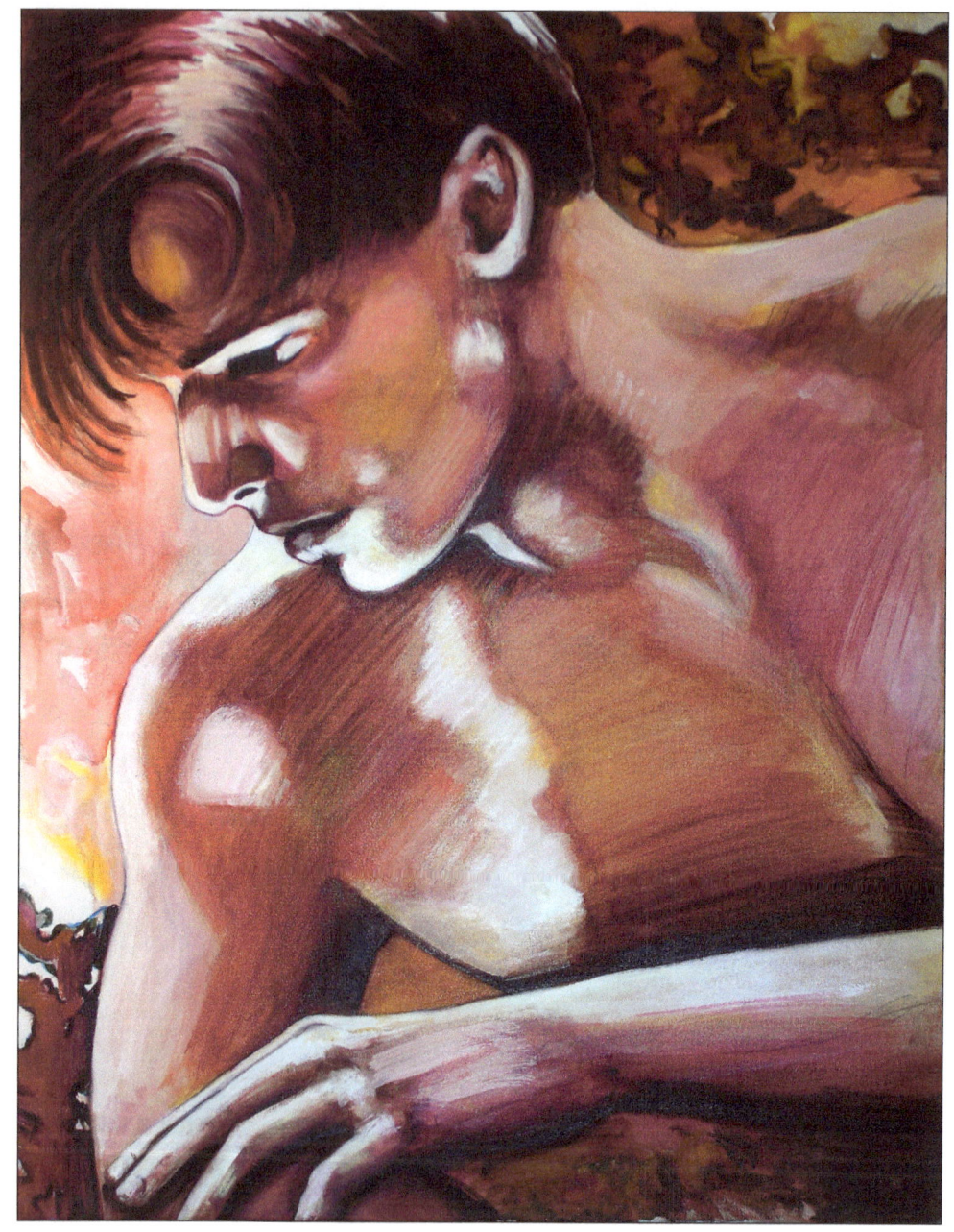

"Centerfold", watercolor and color pencil, 16"x20", 2010

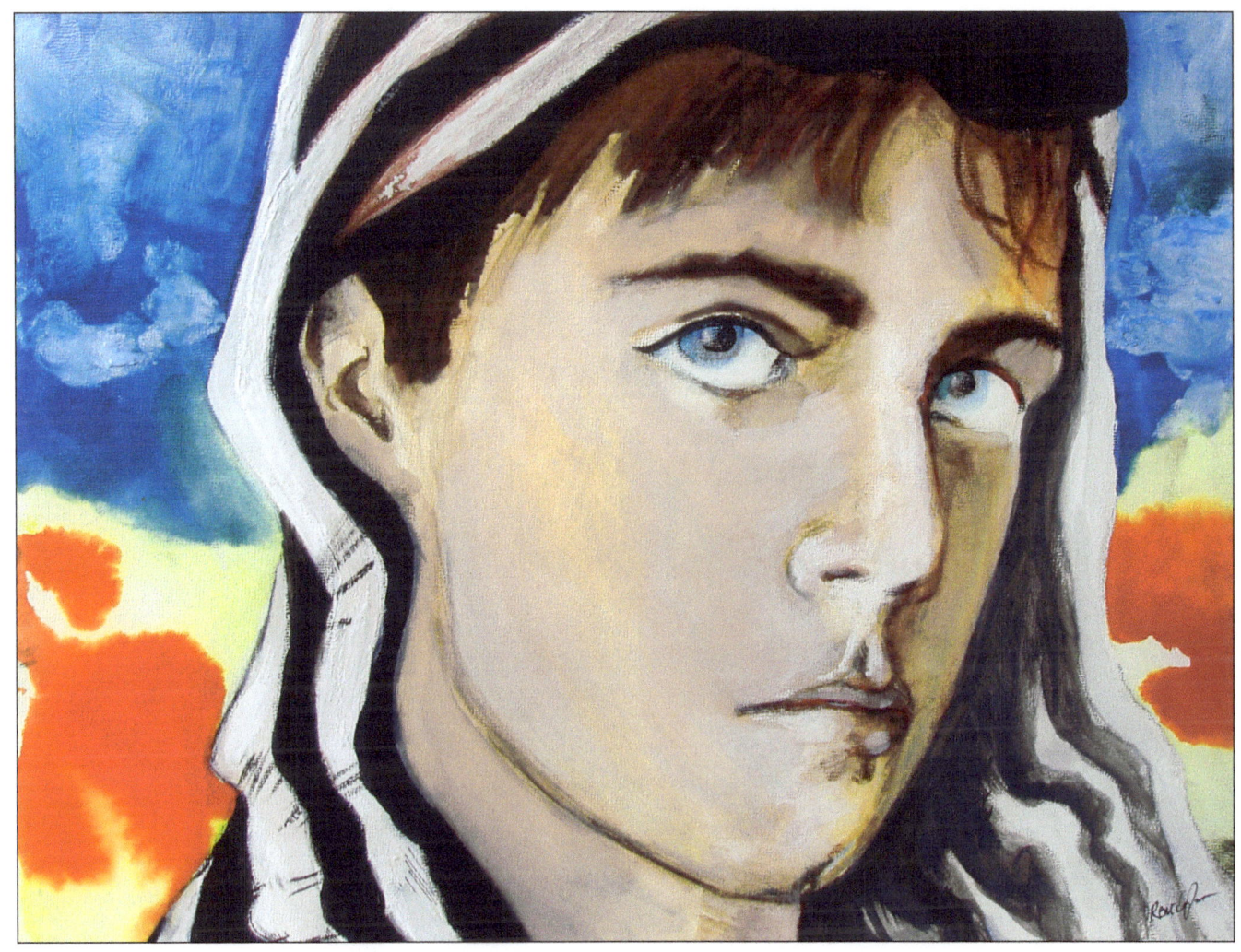

"Zebra Boy 2010", watercolor, ink and color pencil, 22"x30", 2010

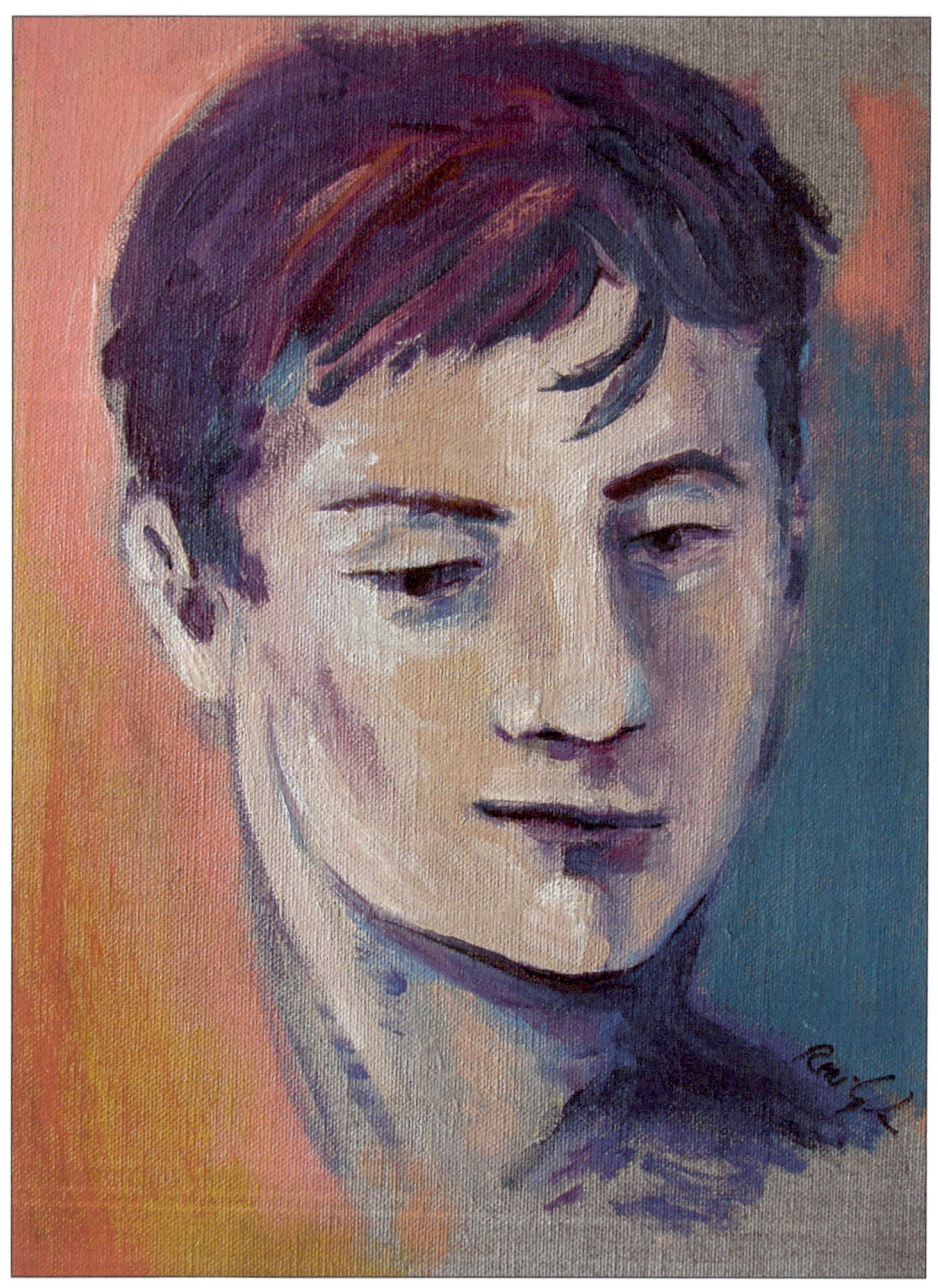

"Self Portrait"(commission), oil, 9"x12", 2010

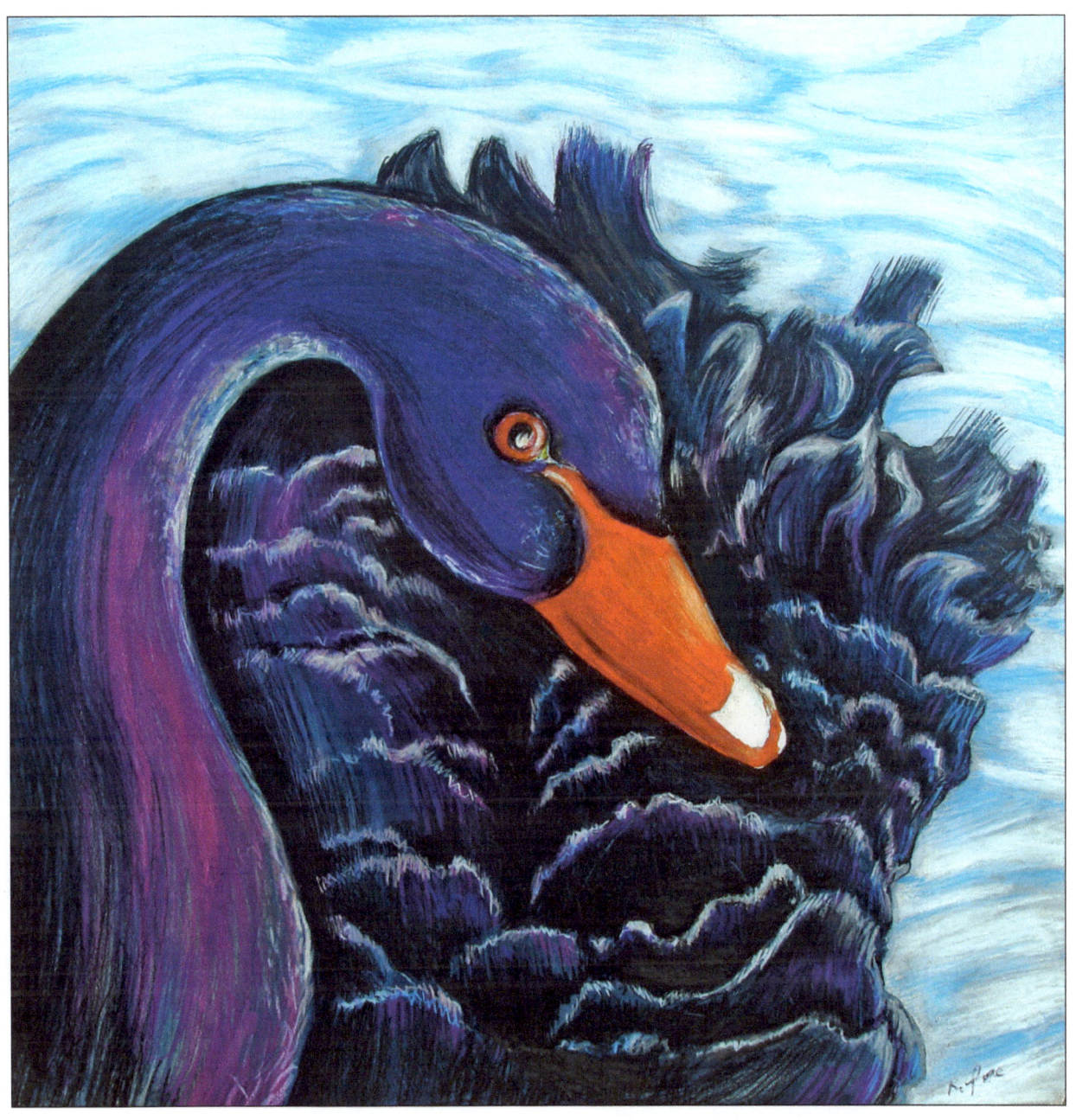

"Black Swan", watercolor and color pencil on clay board, 12"x12", 2010

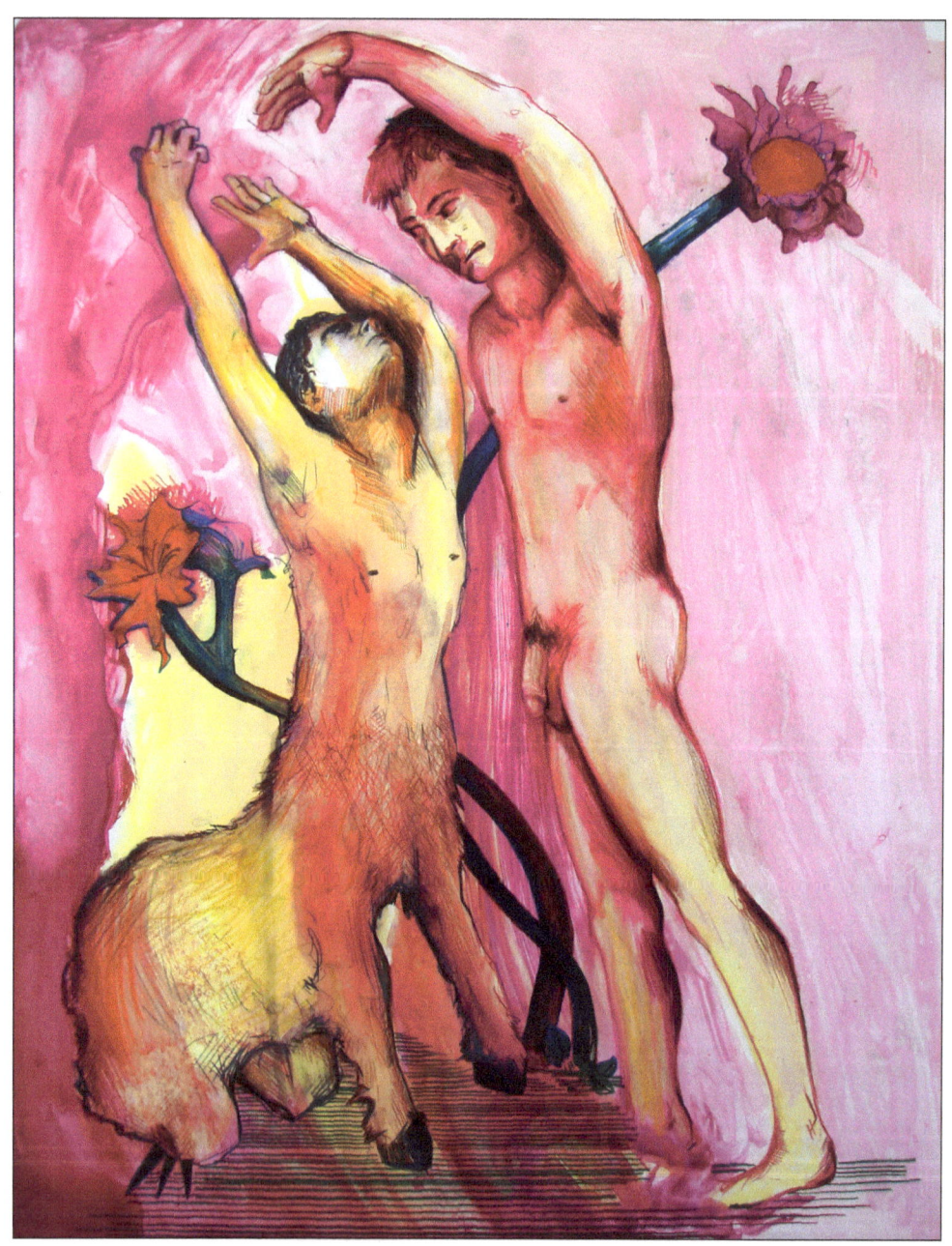

"Taming Shape Shifting Monsters", watercolor and color pencil, 16"x20", 2011

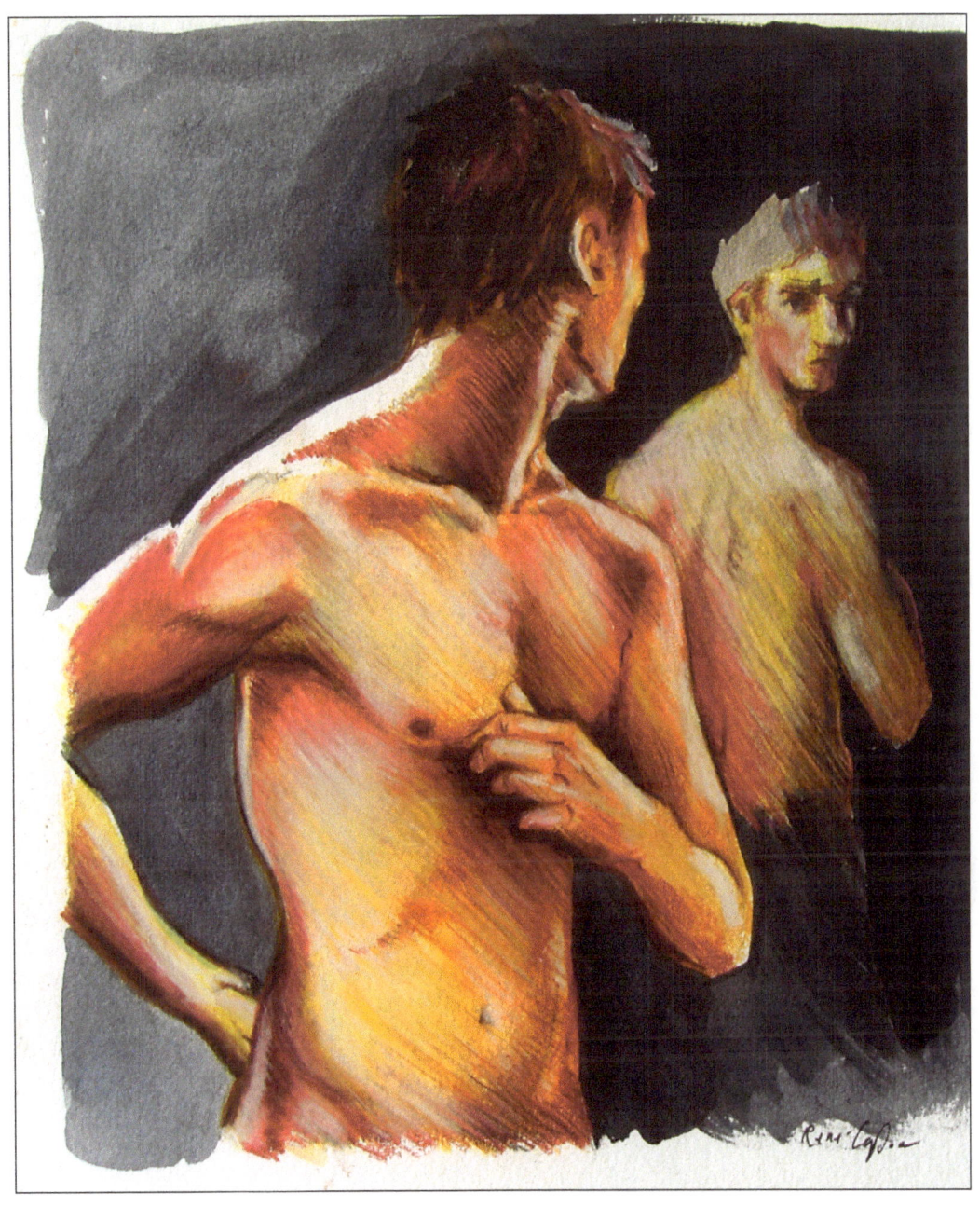

"Look Over Your Shoulder", watercolor and color pencil, 8"x10", 2011

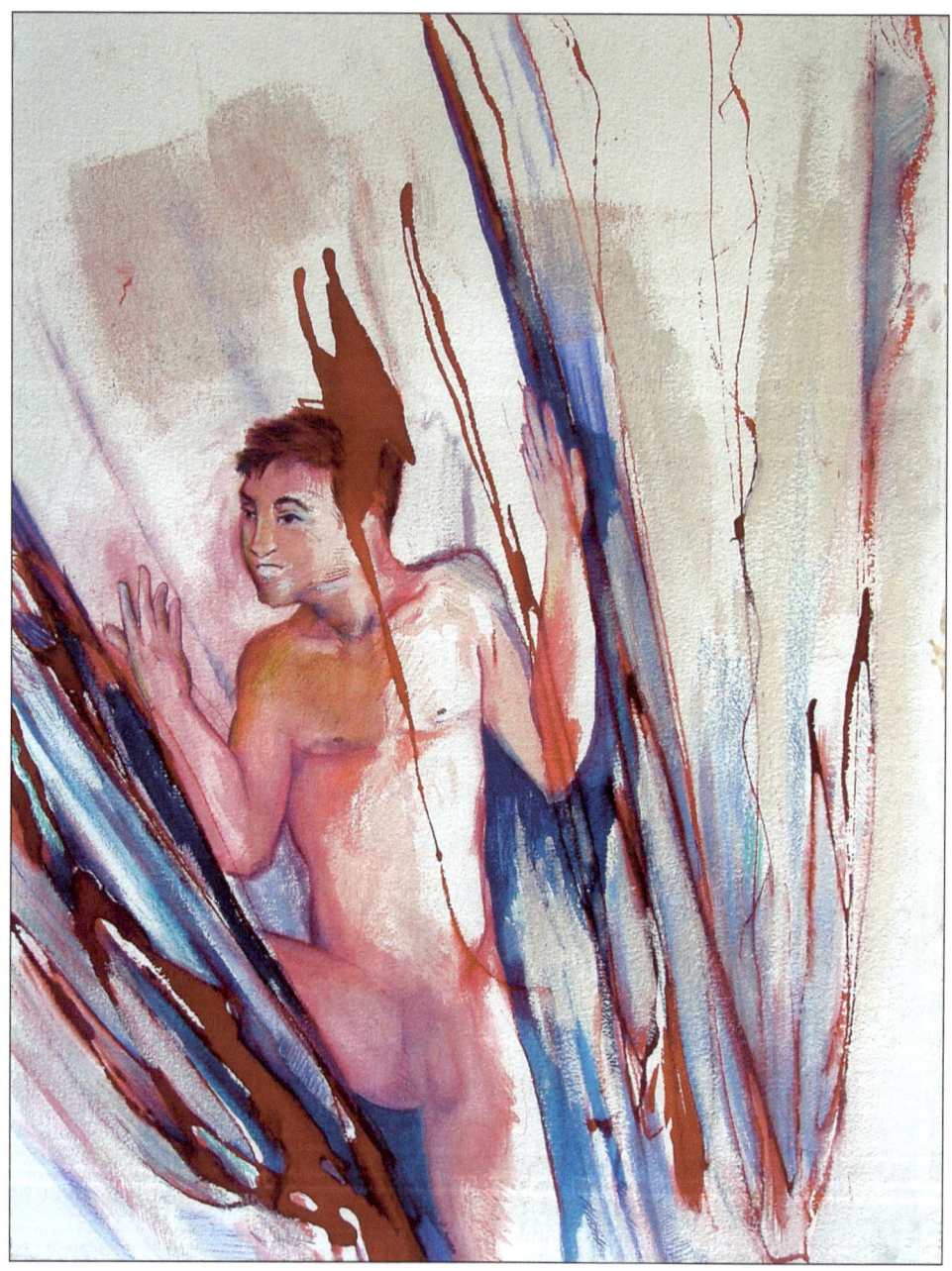

"Boy Trapped in a Glacier of His Own Mind", watercolor and color pencil, 22"x30", 2011

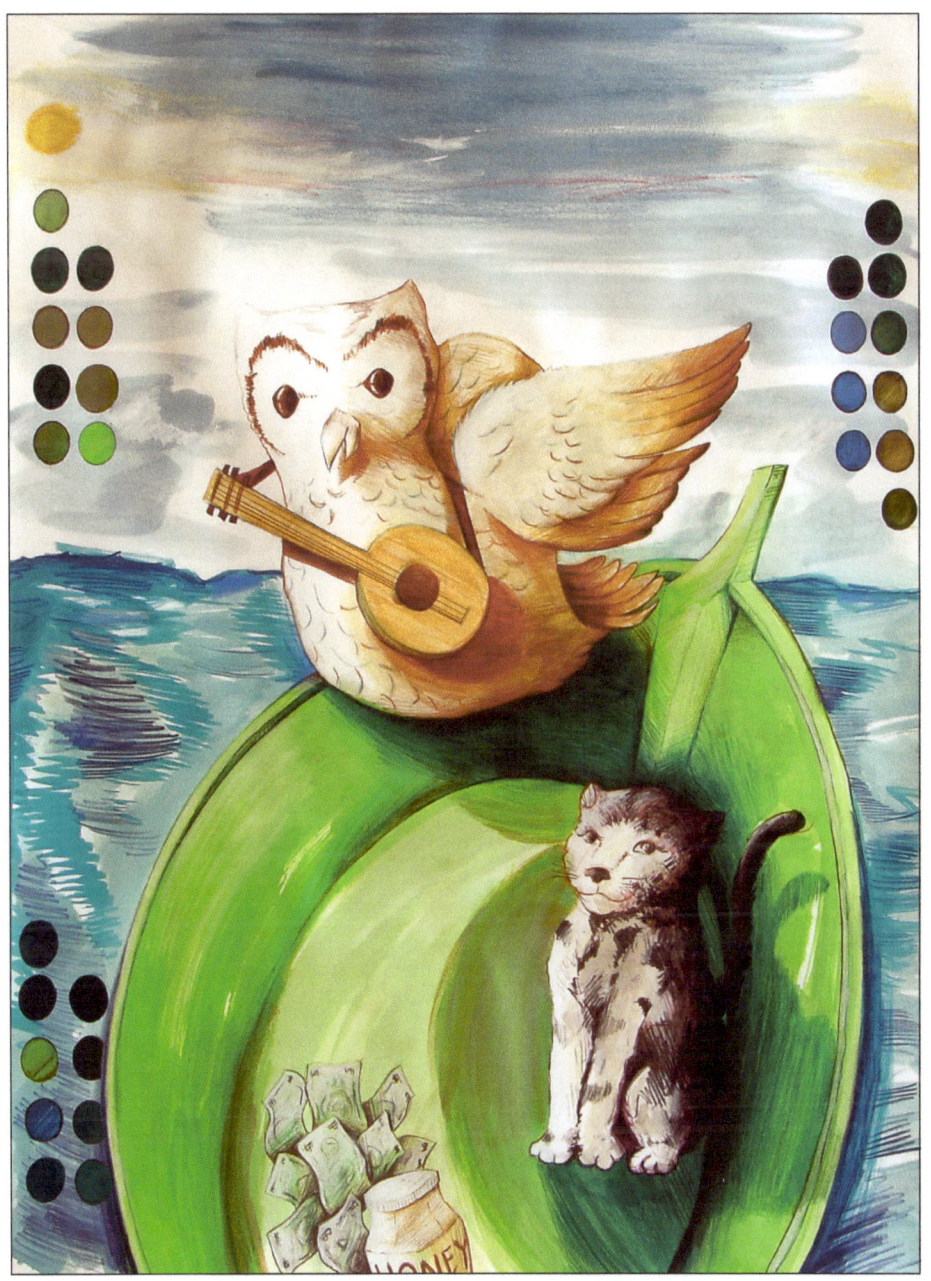

"The Owl & the Pussy Cat", watercolor and color pencil, 22"x30", 2011

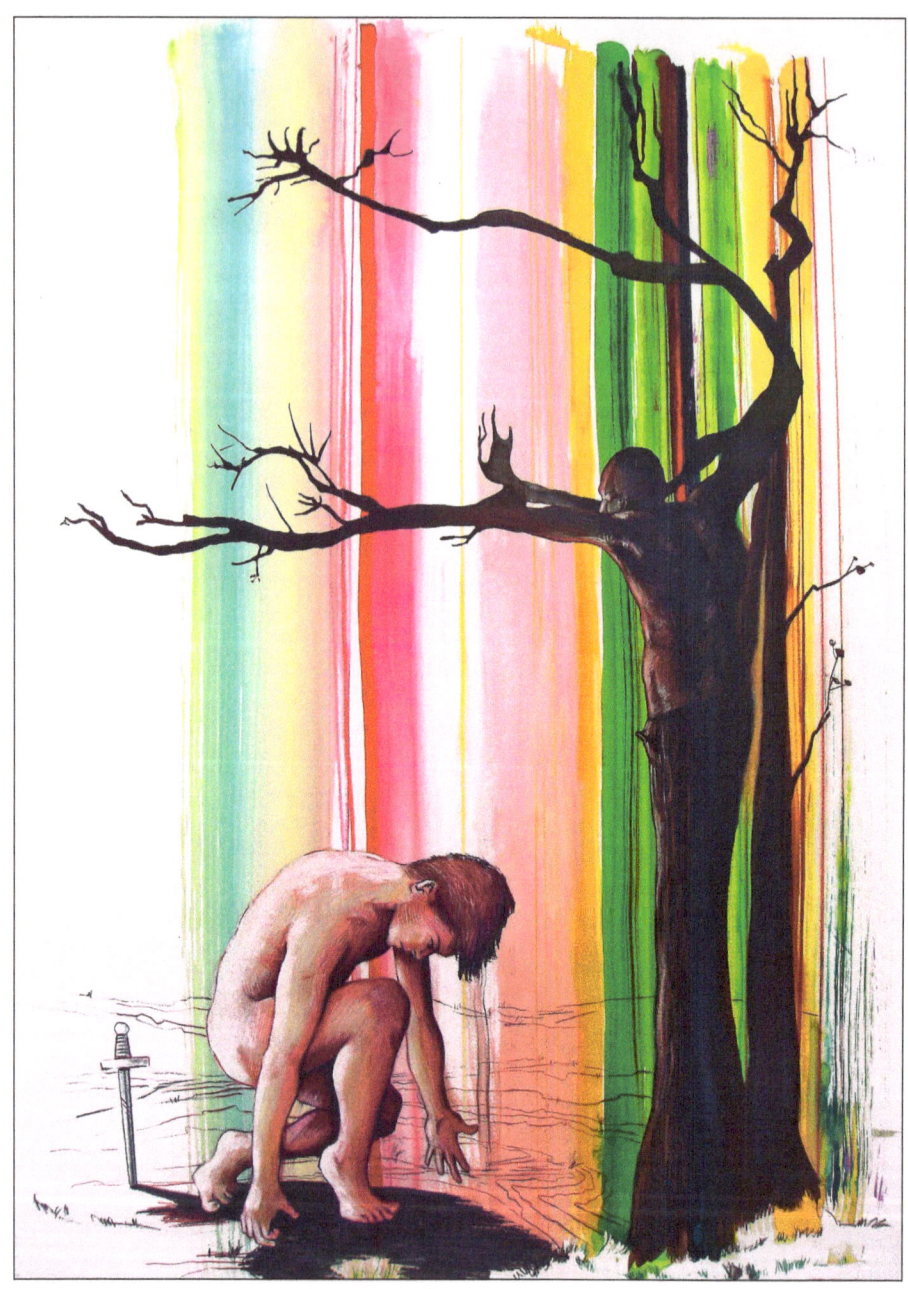

"Council of Trees", watercolor and color pencil, 22"x30", 2011

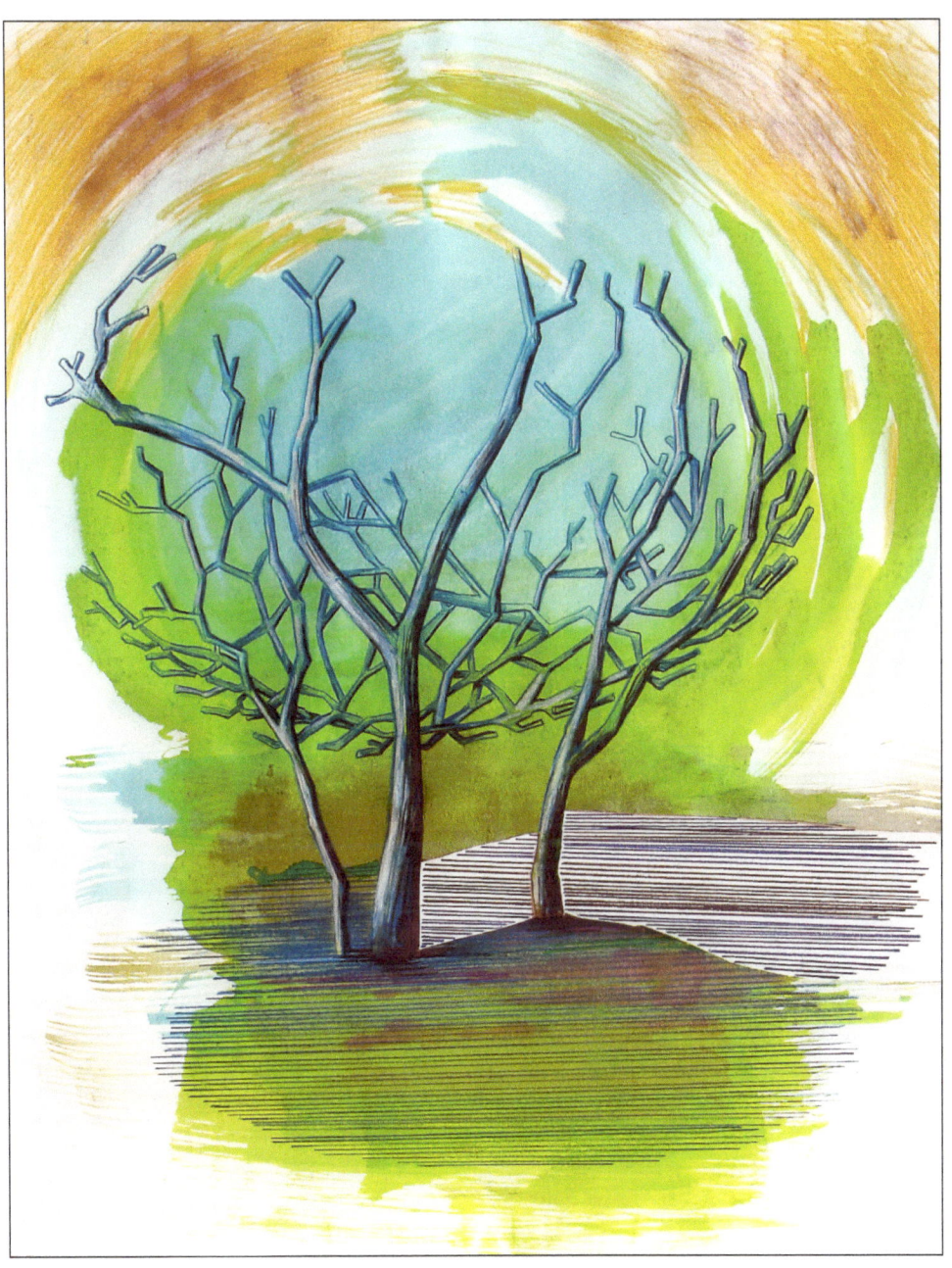

"Beautiful By Mistake", watercolor color, pencil and collage, 19"x24", 2011

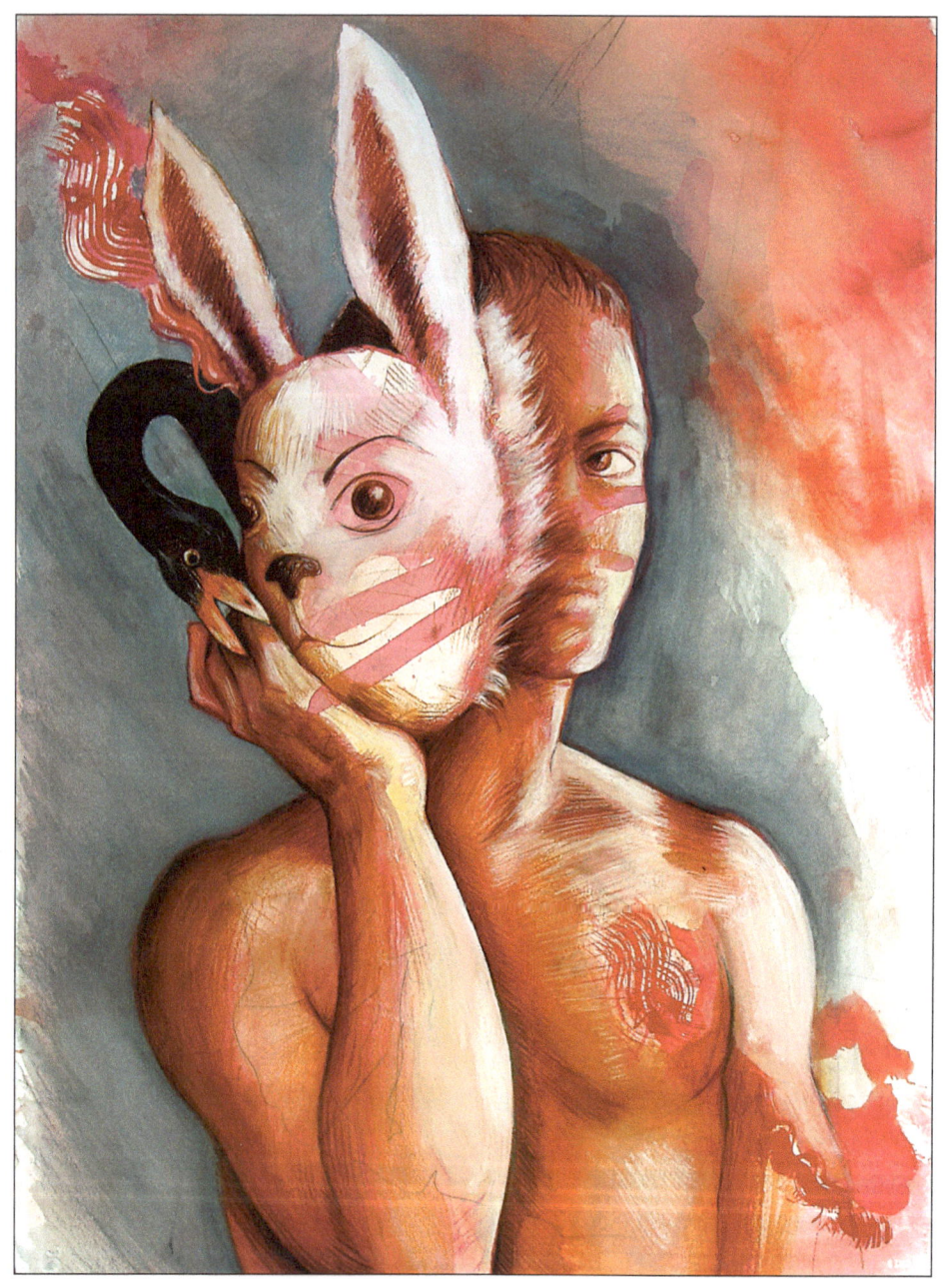

"Between Bunnies and Swans", watercolor color, pencil and ink, 22"x30", 2011

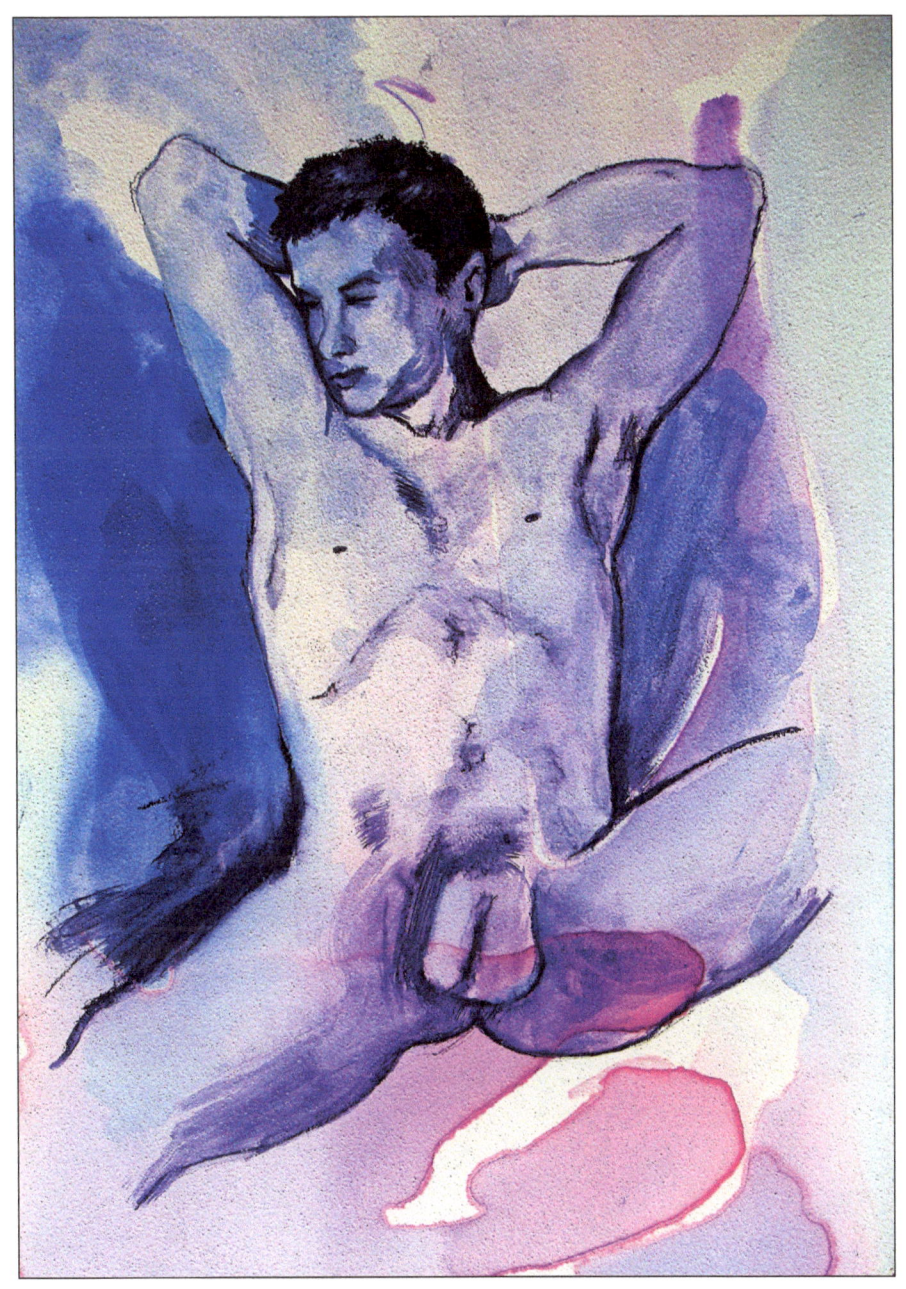

"Blue", watercolor, 9"x12", 2009

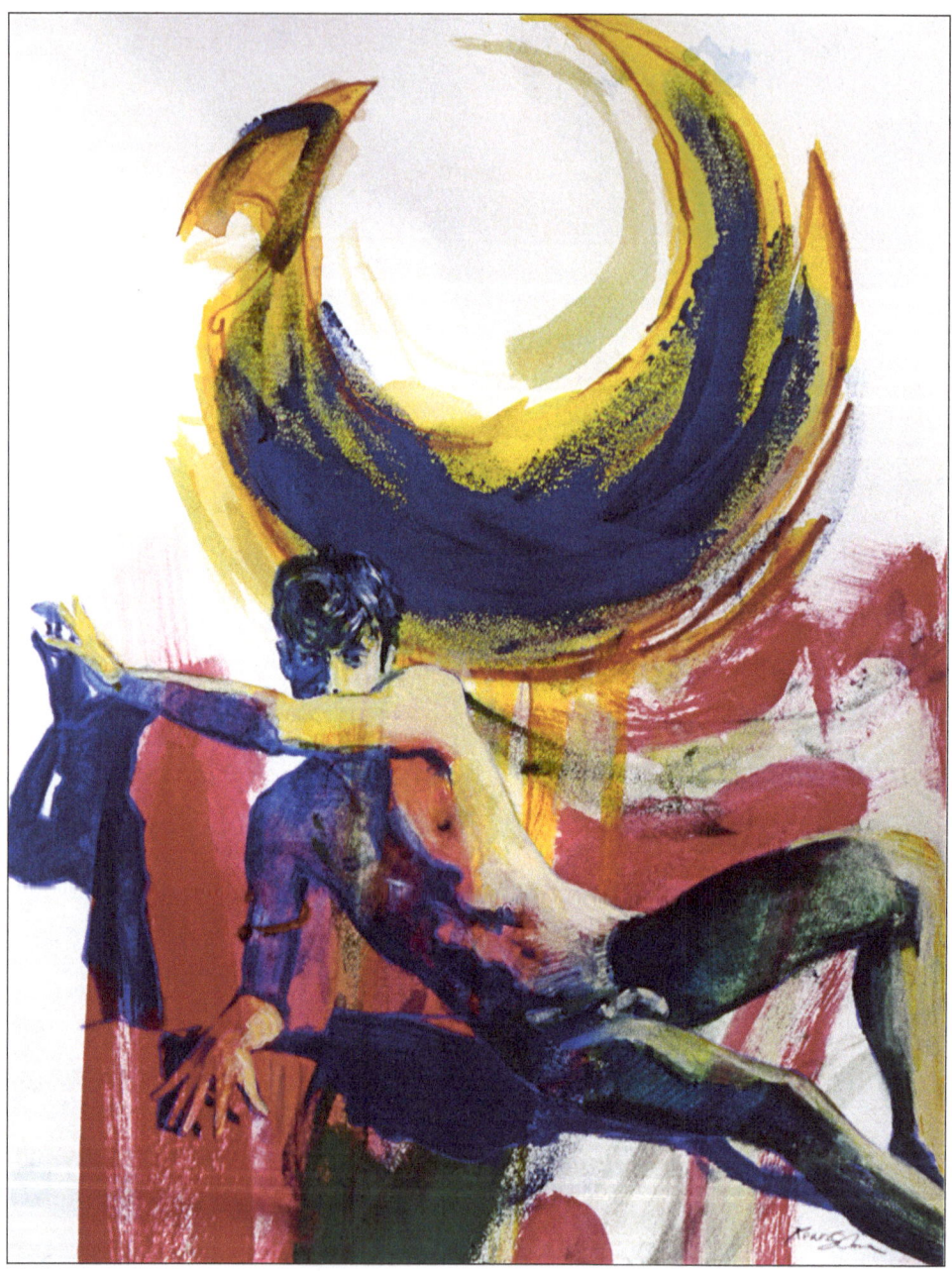
"Bringing Down the Moon", watercolor, color pencil and ink, 8"x10", 2001

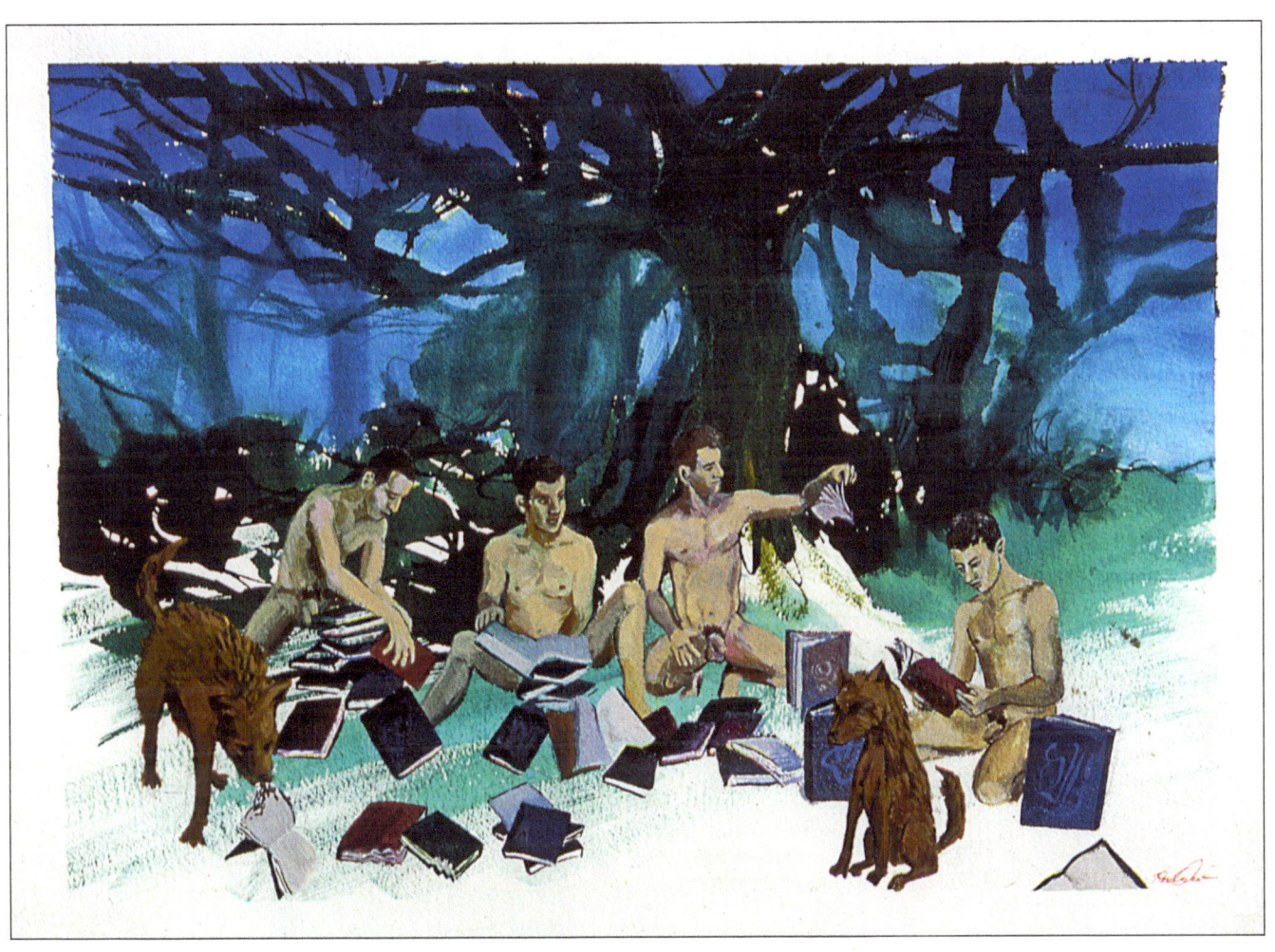

"Passages", watercolor, color pencil and ink, 11"x14", 2005

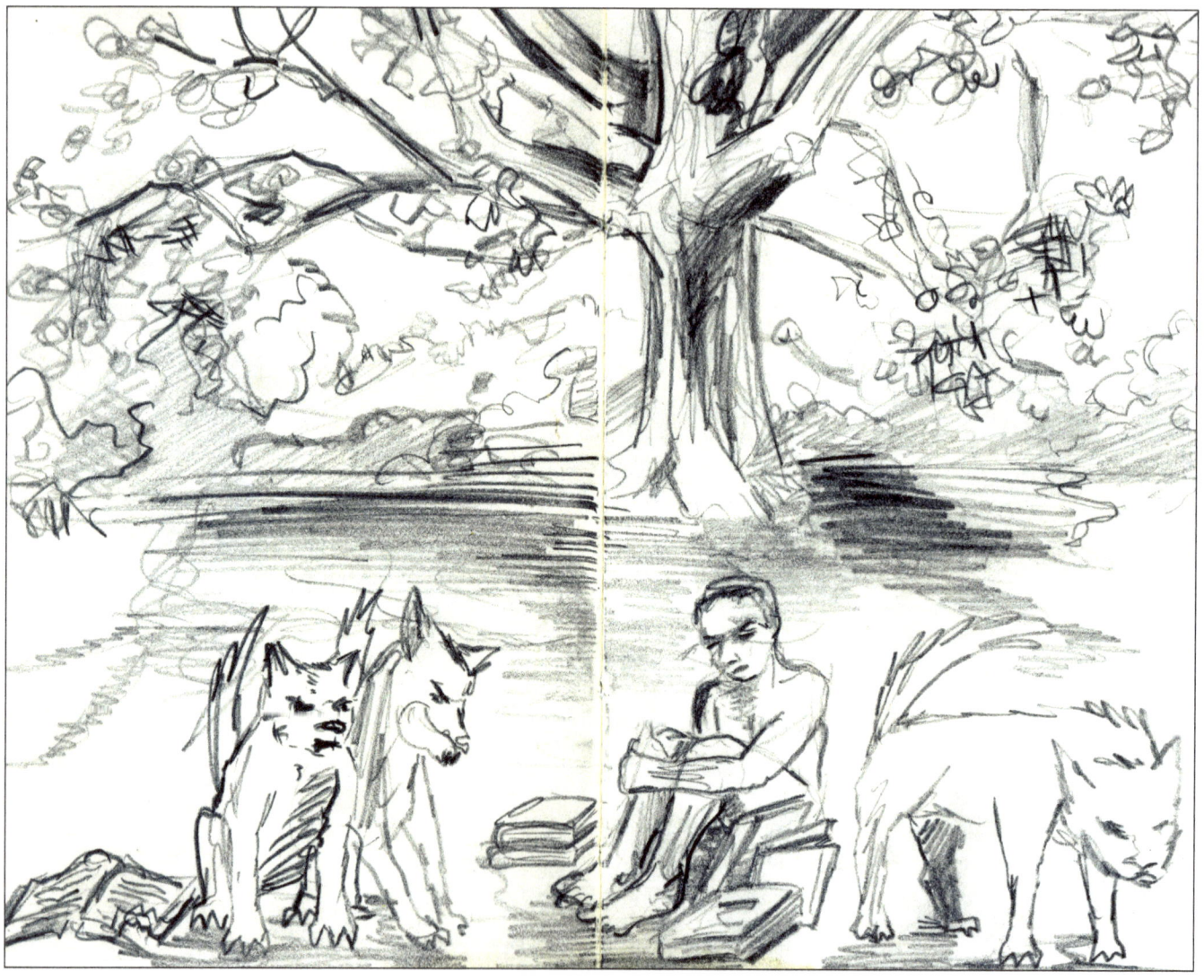

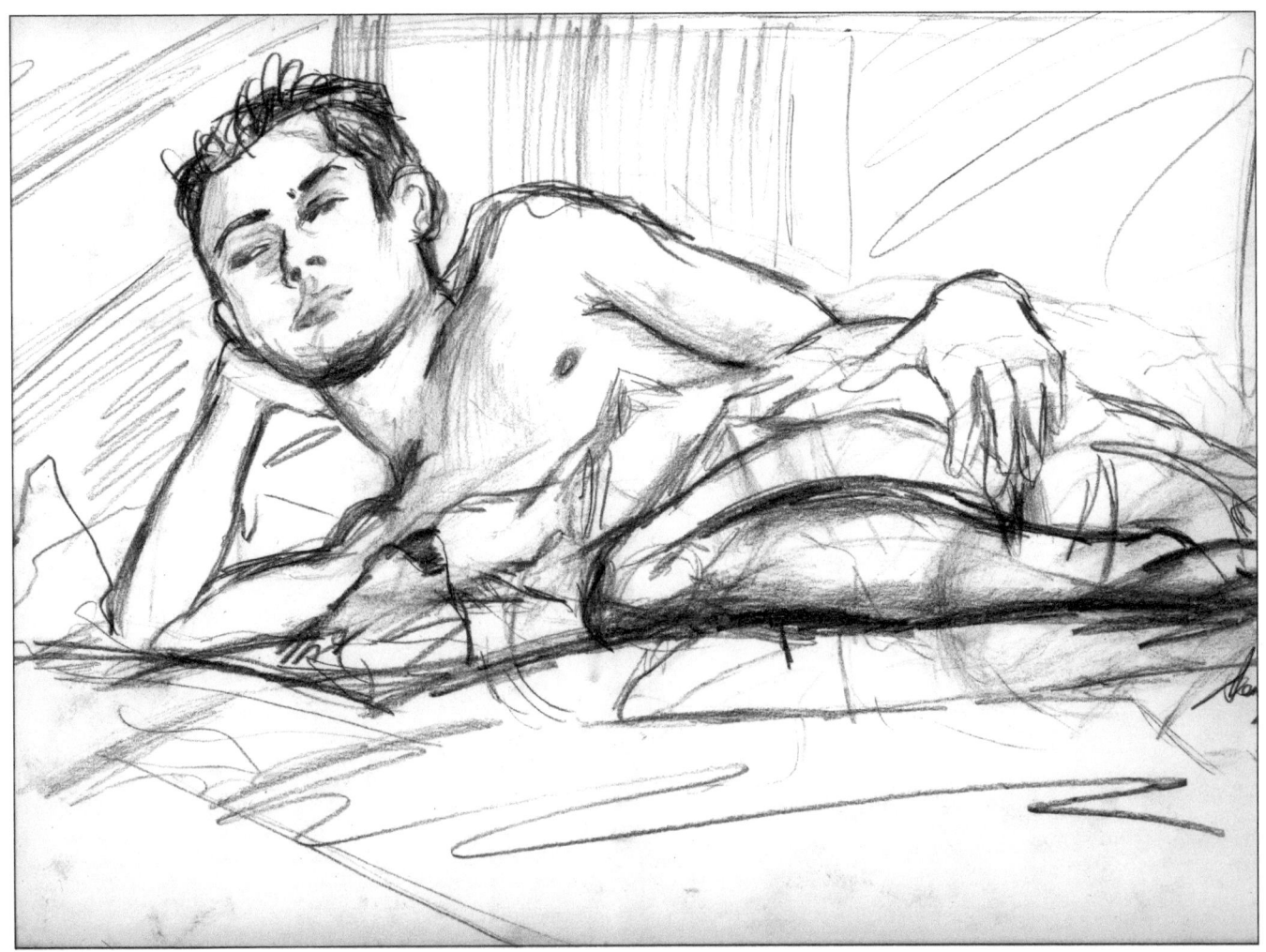

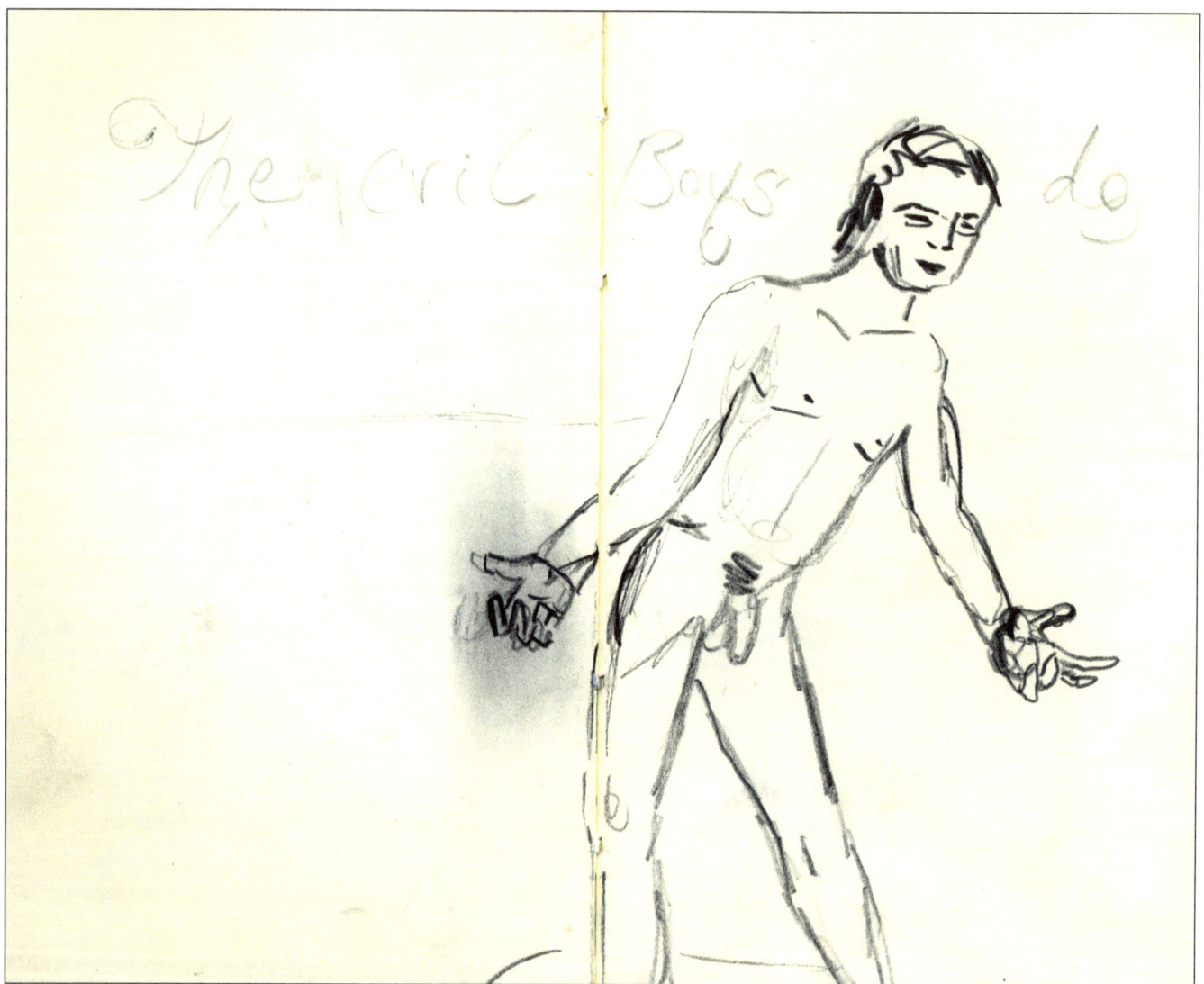

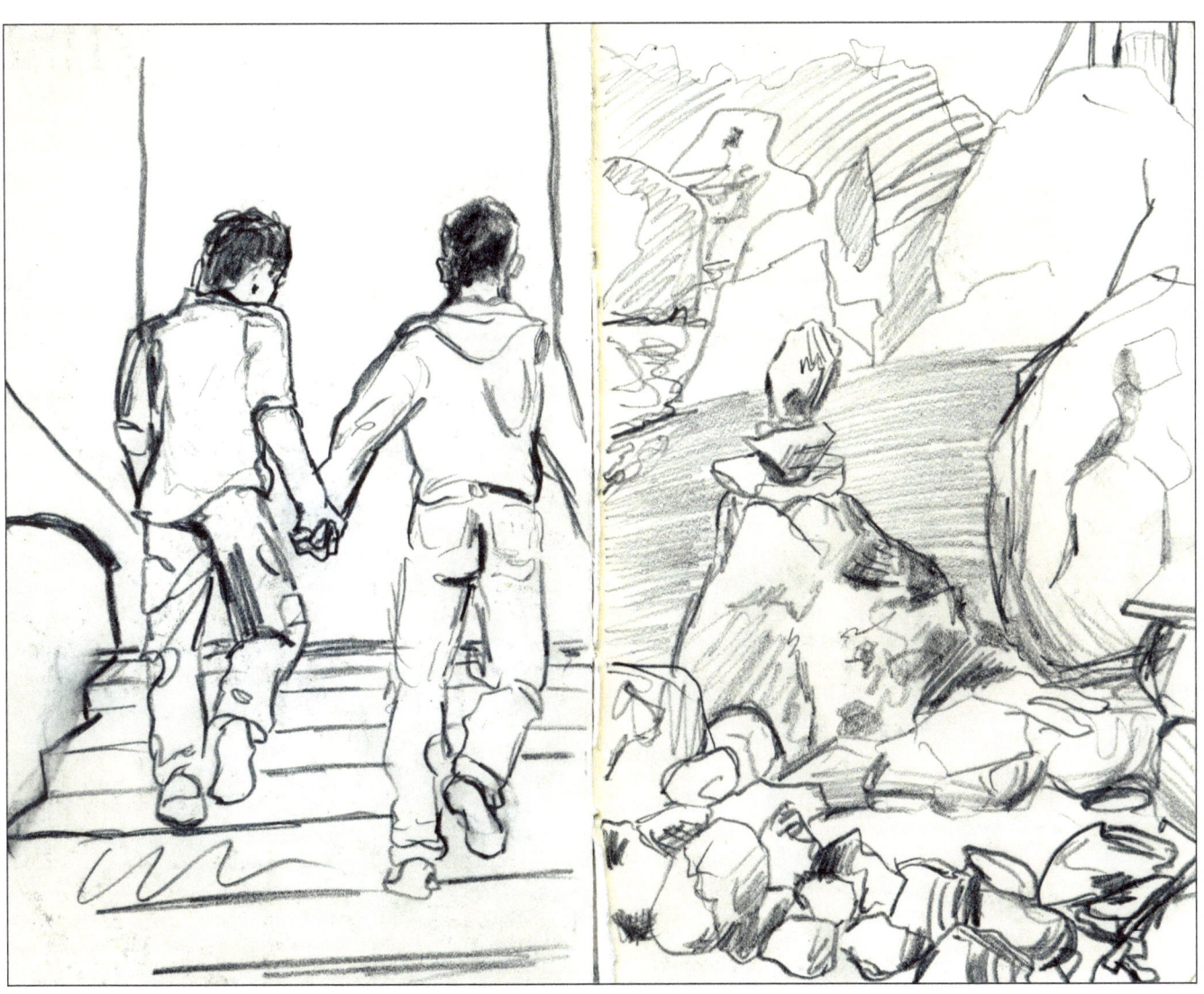

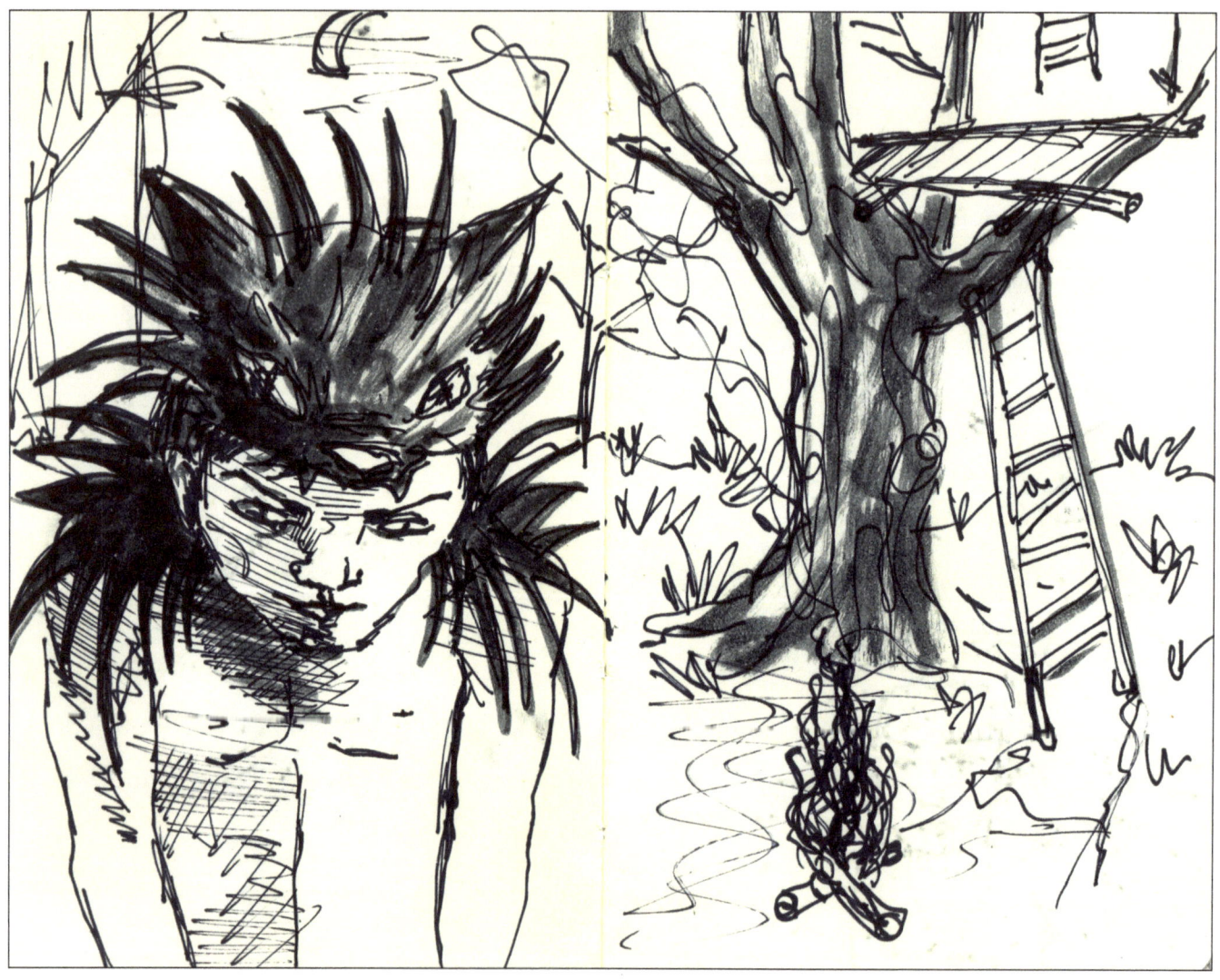

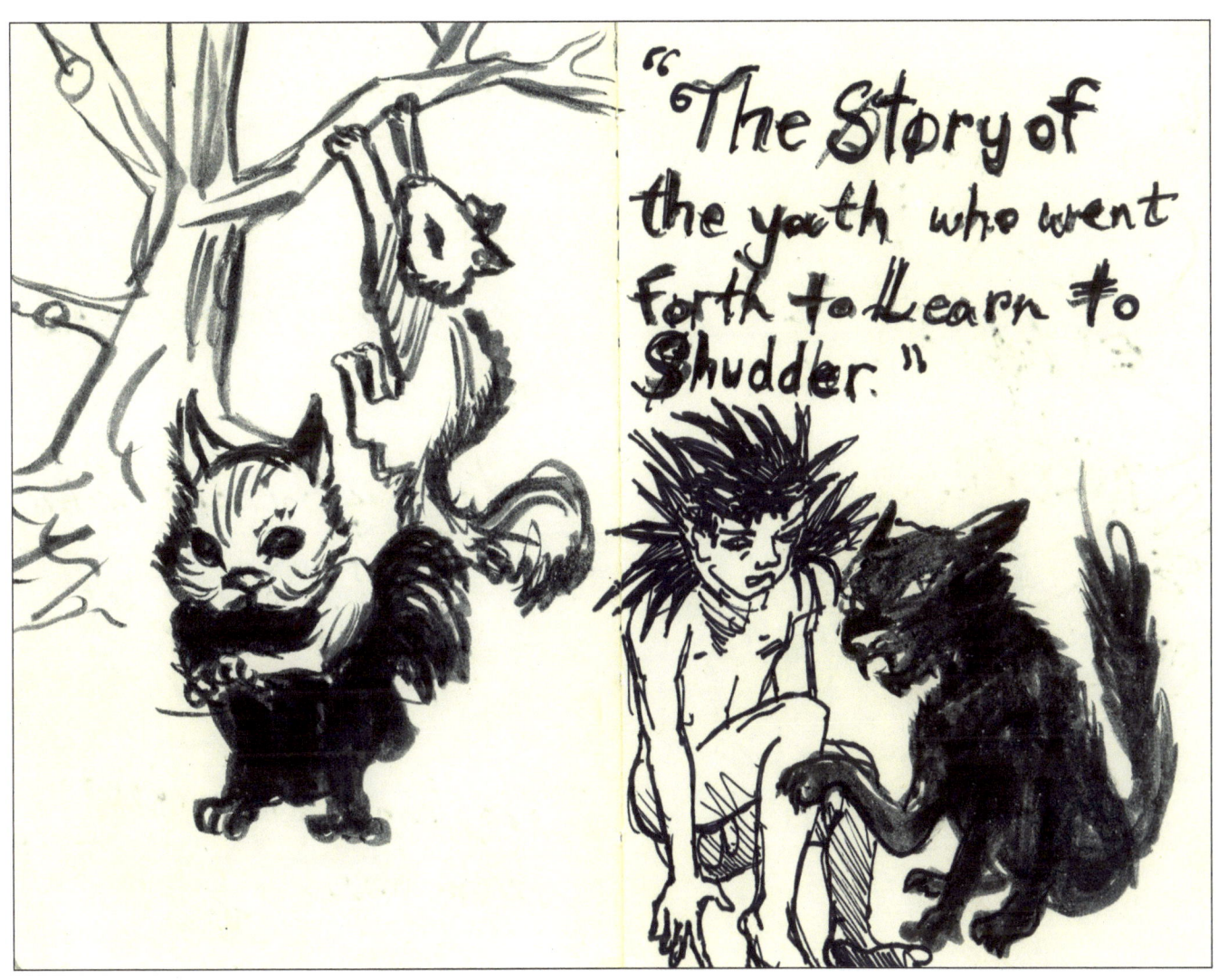

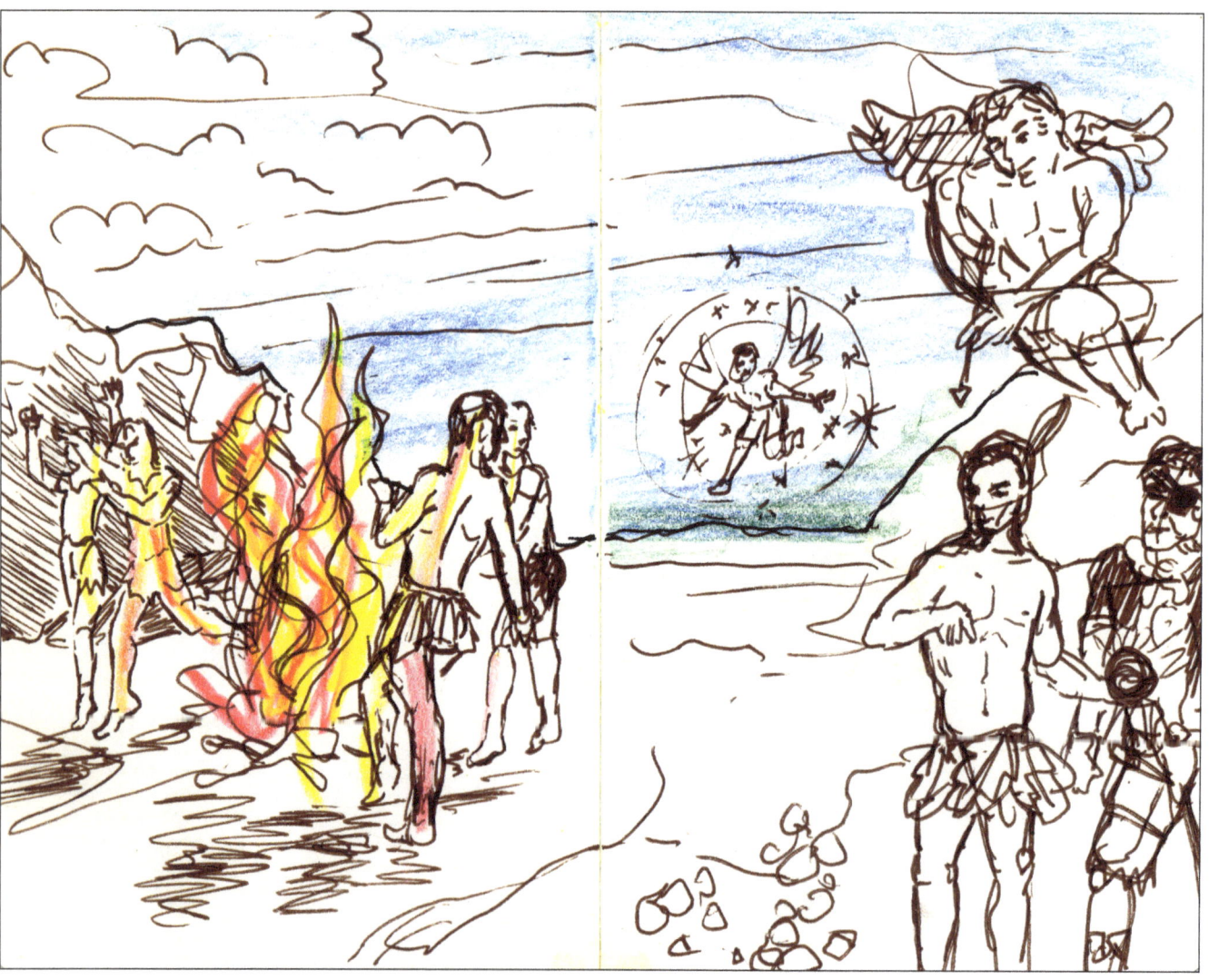

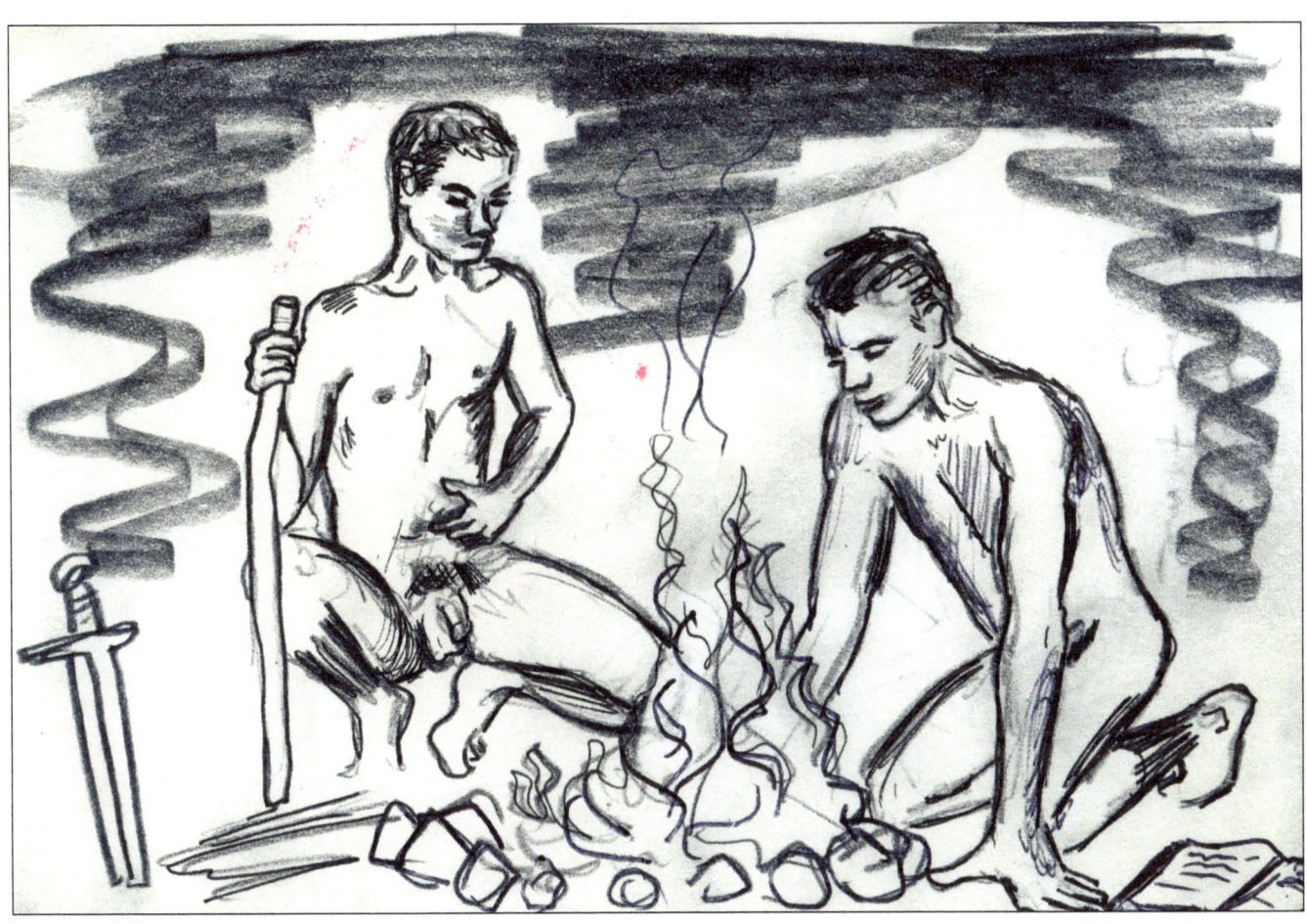

photo: Michael Johnstone

René Capone grew up in upstate New York, the oldest of four children and the product of a broken home, which he escaped at the age of 15.

In school he developed a love for making art at a very young age. He loved it when other children would look over his shoulder to see what he was making, but it wasn't until later in life that he realized the full potential of creating art. René realized while watching the reactions of others that expression and creation could be used as a universal tool for communicating where words fail.

René attended art college at New York City's Parsons School Of Design, majoring in fine art and focusing on the figure. New York fed his appetite for excitement, but the big city was not for him, so he settled in San Francisco, where he currently lives and works. In a city full of runaways, René fits in.

He is still exploring the possibilities of meaning by rendering the figure. His work has developed into story, including *The Legend of Hedgehog Boy*, his graphic novel about a boy who runs away from home to the forest to explore his new identity.

Any Given Moment is his first art compilation.

photo: Steven Underhill

When one creates, the endless noise surrounding us gets worked through, and for a time, the world makes sense. After it is done, you have something that communicates. The greatest themes in life are explored through art: love, hate, jealousy, fear, anger, passion and anything else you can imagine. I believe an artist's job is to tell these stories. -- René Capone

www.renecapone.com